THE FORGE OF VISION

# THE FORGE OF VISION

*A Visual History of Modern Christianity*

David Morgan

UNIVERSITY OF CALIFORNIA PRESS

University of California Press, one of the most distinguished university presses in the United States, enriches lives around the world by advancing scholarship in the humanities, social sciences, and natural sciences. Its activities are supported by the UC Press Foundation and by philanthropic contributions from individuals and institutions. For more information, visit www.ucpress.edu.

University of California Press
Oakland, California

Library of Congress Cataloging-in-Publication Data

Morgan, David, author.
    The forge of vision : a visual history of modern Christianity / David Morgan.
        p.   cm.
    Visual history of modern Christianity
    Includes bibliographical references and index.
    ISBN 978-0-520-28695-5 (cloth : alk. paper) —
    ISBN 978-0-520-96199-9 (electronic)
    1. Imagination—Religious aspects—History.   2. Christianity and art—Catholic Church—History.   3. Christianity and art—Protestant churches—History   4. Jesus Christ—Art—History.   5. Catholic Church—Relations—Protestant churches.   6. Protestant churches—Relations—Catholic Church.   7. Word (Theology)   8. Christianity—Philosophy.
9. Church history—Modern period, 1500–   I. Title.   II. Title: Visual history of modern Christianity.
    BR115.16M67   2015
    246—dc23

                                                                            2015003677

24   23   22   21   20   19   18   17   16   15
10   9   8   7   6   5   4   3   2   1

The paper used in this publication meets the minimum requirements of ANSI/NISO Z39.48–1992 (R 2002) (*Permanence of Paper*).

*For Larissa*

# CONTENTS

# ILLUSTRATIONS

## FIGURES

**PLATES**

# ACKNOWLEDGMENTS

I would like to express my gratitude to several colleagues who answered queries, recommended literature, provided imagery, and occasionally read drafts of this book. These include Kwabena Asamoah-Gyadu, Jeff Korum, Julie Byrne, Erika Doss, Jane Garnett, Shalom Goldman, Marc Brettler, Richard Howells, Sandy Brewer, Asonzeh Ukah, and Stephen Pattison. My thanks to research assistants Jamie Brummitt and Brenna Keegan for reading the entire manuscript and providing greatly appreciated assistance in copyediting, tracking down citations, hunting information on images, and reading entire drafts of the manuscript. Special thanks go to Stephen Pattison and Edmond Tang of the University of Birmingham for inviting me to deliver the 2012 Cadbury Lectures, which were the origin of this book, and for hosting me and my wife so cordially while we were in Birmingham. Stephen read drafts and generously commented on them and has continually proven to be a wonderful friend and colleague.

In addition to the Cadbury Lectures, several other venues were very helpful in allowing me to develop my ideas. A portion of chapter 4 was presented in a seminar hosted by the faculty of theology at Cambridge University several years ago. Chapter 6 was presented in various forms in the department of art history at Columbia University and at the Philadelphia Museum of Art. Chapter 2 was the basis of a lecture in the department of art history at the University of Chicago, and chapter 3 at Heidelberg University. I thank each institution, the colleagues who invited me, and the audiences assembled for their instructive comments and suggestions.

Small bits and pieces scattered throughout this book have been drawn from essays previously published. A short portion of chapter 2 appeared in *American Art Journal* and part of chapter 4 in the journal *Culture and Religion*. A few paragraphs in chapter 5 appeared as part of an essay in the online forum *Religion and Politics*. A paragraph or two of chapter 6 appeared in an essay published in the exhibition catalogue, *James Tissot: The Life of Christ,* which accompanied an exhibition on Tissot at the Brooklyn Museum.

Finally, it is my pleasure to dedicate this book to my wife, Larissa Carneiro, whose patience and support made writing it a possibility.

The Edward Cadbury Lectureship was established in 1941 by Edward Cadbury Esquire, LL.D. for the furtherance of the study of Theology in the University of Birmingham, according to the Regulations there shall be an annual course of Lectures, usually eight in number, to be delivered in either the Autumn or Spring Term. The theme of the Lectures shall be concerned with some aspect of the Christian faith, the original intention of the Founder being that it should be concerned with the relations past, present and future, of Christianity or civilisation and culture.

# INTRODUCTION

In the 1559 Latin edition of his monumental *Institutes of the Christian Religion,* John Calvin excoriated humanity's inclination to substitute its conceptions of deity for the true God. Human ingenuity, he said, was a "perpetual forge of idols" *(idolorum fabricam).*[1] The phrase recalls the biblical tradition of denouncing the production of idols from wood and metal. Whatever else one may think of it, Calvin's critique of the imagination or the visual operation of cognition surely gets one thing right: human beings manufacture their worlds with the images they craft. Even if they are not worshipped, images exert powerful effects over those who use them. We believe them, cherish them, hoard them, exchange them, remember by means of them, and use them to protect ourselves, to glorify ourselves, to recreate ourselves. Imagination is how we put images to work inside and outside our minds in order to accomplish all these things.

## IMAGINATION

I have called this book *The Forge of Vision* not because I wish to endorse Calvin's views on idolatry, but because I like very much that he recognizes the cultural work seeing performs, even if he regards it in a very negative light. Moreover, the phrase acknowledges that vision is a cultural operation. The forge of vision is the cultural formation of seeing at any number of levels. Human beings are in the business of fashioning imagery that acts as their understanding of the world. Modernity has facilitated this brain function with conceptual innovations and a steady stream of new techniques in science, technology, education,

commerce, art—and in religion. Each of these areas of modern culture has generated images, visual practices, and image-making devices that serve as instruments for shaping imagination and grasping the world around us.

Yet perhaps because of the power and scope of such visual technologies, seeing has come under considerable suspicion in the modern era, much of it charged with an antagonism comparable to Calvin's epistemological critique. Vision is often conceived as a distant, disembodied sense, and vision as contemplation or philosophical reflection in particular has been criticized as taking the shape of a remote and magisterial gaze that reduces everything it sees to its object.[2] At first glance, seeing might appear a spectral, immaterial event, consisting of nothing more than light and thought. But for those who attend to vision as a social, embodied, material range of practices, vision is forged from objects and places, bodies and desire, ruler and compass, frescoed walls and engraved pages. To see is to enter into a host of relationships that stretch across time and space. In this regard, seeing is not different from any of the other senses. Sensation in all its forms is a robust engagement of the body with the world around it. Thomas Hobbes put the matter very succinctly at the outset of his masterpiece, *Leviathan* (1651), where he defined sensation in aptly physical terms: "The cause of sense is the external body, or object, which presseth the organ proper to each sense, either immediately, as in the taste and touch, or mediately, as in seeing, hearing, and smelling; which pressure, by the mediation of nerves and other strings and membranes of the body, continued inwards to the brain and heart, causeth there a resistance, or counter-pressure, or endeavor of the heart to deliver itself; which endeavor, because *outward*, seemeth to be some matter without. And this *seeming*, or *fancy*, is that which men call *sense*."[3] With this and other such mechanical explanations of human interiority, modernity took shape and the forge of vision began to emerge as an engine of cultural construction.

But fancy continued to bear the stigma of deception and the marginal status of contrivance as the faculty of *seeming*. The tradition of Enlightenment thought came to recognize the power of imagination for its constructive activity in conception, but also expressed wariness regarding its results. In setting out his guidelines for the proper interpretation of nature in 1620, Francis Bacon warned readers of the "specious meditations, speculations, and theories of mankind" that skewed genuine understanding.[4] Human conception should submit itself, Bacon contended, to the great subtlety of nature rather than to the mind's predisposition for useless abstractions and axiomatic thinking, which is unreliable because it begins with received doctrines. Moreover, human understanding "admits a tincture of the will and passions, which generate their own system accordingly; for man always believes more readily that which he prefers."[5] Experimental method was the indispensable means for avoiding this error. "There is no small difference between the *idols* of the human mind, and the *ideas* of the divine mind; that is to say, between certain idle dogmas, and the real stamp and impression of created objects, as they are found in nature."[6] The best way to read the mind of God was to adhere to the physical evidence of nature.

Bacon's empiricism exerted enormous influence. When it came to the imagination's influence on religious sentiment, David Hume could portray the imagination as bearing responsibility for human self-deception. In his *Natural History of Religion* (1757), Hume explained the origin of religion as a kind of inexorable epistemological mistake. Unable to resolve by abstraction the "unknown causes" behind natural events, human beings objectify their fears and anxieties, and rely fundamentally upon imagination to do so: "By degrees, the active imagination of men, uneasy in this abstract conception of objects, about which it is incessantly employed, begins to render them more particular, and to clothe them in shapes more suitable to its natural comprehension. It represents them to be sensible, intelligent beings, like mankind; actuated by love and hatred, and flexible by gifts and entreaties, by prayers and sacrifices. Hence the origin of religion: And hence the origin of idolatry or polytheism."[7] For all of his free-thinking, Hume continued to entertain a view of human nature that was remarkably similar to Calvin's: "The feeble apprehensions of men cannot be satisfied with conceiving their deity as a pure spirit and perfect intelligence."[8] To Hume, the mind was a forge of idols, and that was, simply put, the origin of religion: the production of false images of God. Both concluded that the only way to discipline this unruly human nature was to submit it to texts—the Bible for Calvin, and history and philosophy for Hume: "The frail memories of men, their love of exaggeration, their supine carelessness; these principles, if not corrected by books and writing, soon pervert the account of historical events, where argument or reasoning has little or no place, nor can ever recall the truth, which has once escaped those narrations."[9] Clearly, Protestantism and the European Enlightenment shared some very deep understandings about human nature, reason, and the power of print.

But there were countervailing views of imagination with roots in classical antiquity. Aristotle had contended in *De Anima* that "when the mind is actively aware of anything it is necessarily aware of it along with an image."[10] Luther echoed this view in his argument with those who stormed churches in the 1520s to remove or destroy imagery: "It is impossible for me to hear and bear in mind [the Passion of Christ] without forming mental images of it in my heart."[11] Renaissance Hermetic thinkers such as Marsilio Ficino and, later, Giordano Bruno celebrated other ancient sources of thought on image, memory, and imagination. Influenced by ancient works attributed to Hermes Trismagistus, Ficino and Bruno among many others believed that archetypal images were the privileged medium for organizing memory to reflect the structure of the universe. Frances Yates has characterized Hermeticism's project of imagistic reflection as "organized through the art of memory into a magico-religious technique for grasping and unifying the world of appearances through arrangements of significant images."[12] The Neoplatonic tradition in late antiquity also argued against the empiricist notion that imagination is limited to what it gathers from sensation, insisting that the mind knows certain things innately, such as the laws of numbers and geometrical forms. This view was endorsed for the Christian tradition by an authority no less than Augustine.[13] It allowed Augustine to affirm the view that Plotinus had taken earlier, correcting Plato's

dismissal of the art of painting as lowly and imitative. "For the beautiful objects designed by artists' souls and realized by skilled hands," Augustine wrote, "come from that beauty which is higher than souls."[14]

In the eighteenth century, Neoplatonism also informed the writings of the Third Earl of Shaftesbury, Anthony Ashley Cooper, who took quite a different view than Hume regarding the relationship of religion and imagination. For him, God was an artist who impressed ideas on matter. Like Plotinus, Shaftesbury interpreted Plato against himself, contending that artists do much more than superficially copy: they conceive and understand what they create because their creative activity, like God's creation of the cosmos, draws on the principles that inform material things. Aesthetic taste and judgment were therefore central to Shaftesbury's philosophy. In particular, the sublime was the felt revelation of the infinite. In 1714, Shaftesbury wrote a rhapsodic account of his mystical experience of the sublimity of nature, a Neoplatonic paean to divinity, which discloses itself to the imagination even as this faculty fails to encompass the grandeur of divine creative power:

> O glorious nature! supremely fair, and sovereignly good! All-loving and all-lovely, all-divine! [ ... ] O mighty nature! Wise substitute of providence! Impowered creatress! O thou impowering divinity, supreme creator! Thee I invoke, and thee alone adore. To thee this solitude, this place, these rural meditations are sacred [ ... ] Thy being is boundless, unsearchable, impenetrable. In thy immensity all thought is lost; fancy gives over its flight: and wearied imagination spends itself in vain; finding no coast nor limit of this ocean, nor, in the widest tract through which it soars, one point yet nearer the circumference than the first center whence it parted. Thus having oft essayed, thus sallied forth into the wide expanse, when I return again within myself, struck with the sense of this so narrow being, of the fullness of that immense one; I dare no more behold the amazing depths, nor sound the abyss of Deity.[15]

It was the aesthetic of the sublime that boosted the place of imagination in European philosophical and artistic thought in the course of the eighteenth century, leading to the heady spirituality of Romanticism. The sublime was a critical development in modern aesthetics because it became a way of understanding how the arts, creativity, and imagination shaped the human subject. Since antiquity, beauty had been considered a moral agent influencing character and improving behavior. The sublime appealed because it modulated and gave language to power in the immediate formation of the moral and spiritual self. The seventeenth and eighteenth centuries witnessed the ascent of the sublime, gendered male and hailed as dramatic, uplifting, and spiritually irresistible. Kant regarded the sublime as the version of the beautiful that transcended reason in its operation in the imagination. The sublime was the aesthetic lens under which the malleability of the soul became most evident and the modern subject emerged, formed by taste and refined feeling as much as by reason. Taking its place within what Michel Foucault

outlined as "the genealogy of the modern subject," the aesthetic sensibility of the sublime represented a significant development of the modern subject taking shape in and generating the imagined communities of sentiment, race, gender, religion, and nationhood.[16] This is not an operation of domination in which human selves are stamped by an industrial process over which they have no control. The allure of the sublime was precisely the self-culture it promised. The power of imagination was something that the modern citizen-subject could engage for himself (and the modern citizen-subject was normatively a "him"). In the eighteenth and nineteenth centuries, the forge of vision called the sublime was the self-crafting vision of the modern (male) subject.

As a way of stoking the coals of imagination, the sublime was an aesthetic that took many forms in artistic practice. A distinctive version of it is found in an early nineteenth century poem-painting by the visionary poet and artist William Blake. A detail from it appears on the cover of this book (see plate 7 for its original setting on the page). Blake's forge is virtually the opposite of Calvin's, yet both hammer out fundamentally modern conceptions of the human being. In Blake's poem and image, the character of Los is accosted by Spectre, the power of reason, one of four aspects of human nature—reason, imagination/emotion, desire, and the personality—that came asunder in their fall from primordial unity in the figure of Albion, dissolving when Albion fell asleep. Dedicated to recovering the lost union, Los acts as the power of inspiration, which is affixed to imagination and emotion. Reason, grown cold from the fall, is the driving force behind thought without passion, Blake's diagnosis of religious dogma and orthodoxy. One might say that Spectre is among the "mind-forg'd manacles" that Blake laments in *Songs of Experience* (see "London") as one of the forces concocted by humans that oppress humankind.

The rivalry of reason and imagination is rooted in the cultural history of modernity. Each faculty has been hailed at various times as the basis for freedom from external authority. The more liberty was associated with individual freedom and privacy, the more subjectivity was hailed as the basis of the person, the more imagination was celebrated as its proper domain and instrumentation. For Calvin, the mind was a forge of self-deception; reading scripture and thinking clearly about its revealed truths was the proper task of Christians. Blake's image, on the other hand, is a characteristically modern and very Romantic conception of the imagination, an engine or faculty long regarded by Protestantism as suspect, as Calvin's characterization of the mental forge indicates. But Blake was a fervent artist and seer for whom the creative faculty of imagination was the medium of revelation. For many of his contemporaries, such as Kant, imagination had become a faculty of cognition, one of the mind's sovereign capacities for making sense of the world in terms that could not be reduced to those of reason.

The idea of the imagination as an internal faculty that processes sensation was of course ancient. But in the modern era debates over its scope and reliability, its visual characteristics, and its relation to ideas and words came to occupy increasing attention with regard to the nature of art, cognition, and religious experience, particularly as each of these related to the vexing problem of religious authority in an age when its traditional

forms were rapidly changing. But the present book is not a history of ideas, but rather a cultural history of the visuality of Christian thought and practice since the sixteenth century. Its argument is that this history of visuality contributed importantly to the shape of modernity, which included both dispositions regarding imagination—as trustworthy and reliable and as deceptive or misleading.

I do not wish to celebrate modernity, but to understand its cultural and historical formation, especially with regard to visuality. This is not because I consider that seeing eclipses the other senses, or that visual culture triumphs over all other forms of thought and feeling, or that modern culture is quintessentially visual. Indeed, all of these arguments exemplify an exceptionalism that I find unpersuasive because it misses how deeply imbricated seeing is in the body and the entire sensorium. The forge of vision consists of more than an eyeball. It is the entire body and it is the social bodies to which any individual body belongs. In fact, this is why seeing should be taken seriously: if we study modern imagery and practices of imagination, we will be studying modern embodiment. Seeing is one important avenue to the fully embodied character of religions, even or especially those, like Protestantism, that are fond of insisting that they do not indulge imagery. And the modern forge of vision differs in characteristic ways from that of premodern eras, and therefore has something to say about modernity itself. We might easily perform the same examination of the history of hearing or touching. But seeing attracts my attention because it yields material artifacts—images and visual devices of one kind or another—that have engaged Catholics and Protestants over the centuries. Moreover, images and their uses have served as occasions for sharp debate, competition, and violence as well as devotional, liturgical, and even mystical experience.

## MODERNITY AND CHRISTIANITY

Modernity can be measured in many ways as a period of time when a number of conditions and assumptions prevailed as given truths among a dominant culture, in this case, Western European society and eventually its far-flung colonial projects and their post-colonial legacies. The approach that this book takes understands the following developments as the primary organizing effects of Euro-North American modernity: the broad relevance of the printing press for the production and dissemination of information; the consequent rise of literacy; the great expansion of middle classes; the attendant claim for an individual's right to read and believe according to the dictates of conscience; the gradual separation or buffering of church and state from one another; the cultivation of subjectivity as the domain of belief and individual identity, as conducted by the faculty of imagination and understood as the sovereign domain of individual liberty; and the facilitation of all of the above by the fluid medium of exchange of capitalism and the monetary markets that drove national development and colonial expansion. Moreover, I wish to argue that image and imagination contributed importantly to the modern history of Christianity by shaping practices of devotion, prayer, reading, evangelization, conceptions of nationhood, likenesses of Jesus, and

the circulation of images and objects as ways of structuring relationships among humans and with the divine. Imagination was not invented in the modern age of Western Europe, but it certainly rose to command new attention as a powerful faculty of human thought and feeling. And images of many kinds played a powerful role in stimulating imagination and putting it to work.

All of these aspects of Western modernity are implicated in the development over several centuries of broad changes in social relations. Individual, nation, commonwealth, and church all changed as the matrices of authority, as the media of modern identity. Who one was and how one's identity was constructed underwent considerable transformation. For modern religion to assume the legal as well as epistemological structure of "belief," it was necessary for it to be located within the head, that is, to be personalized and situated in the domain of private thought and sentiment. In fact, of course, religion was always more than that. Even as private sentiment, it was inextricably attached to the body hosting the sentiment. And images and acts of imagination were always more than cognitive modes of assent. Opinion shaped imagination powerfully by disciplining the body. Public punishment—burning, hanging, dunking, imprisoning, torturing—was itself a way of molding the body politic toward the public observance of particular confessions or rites. Print culture emerged as an even more powerful instrument for doing so, and adopted rhetoric and imagery as means of moving audiences toward the affirmation of certain views.

The target in print culture was the imagination—the faculty of thinking, feeling, and remembering in mental images and other sensory traces. Imagination allowed people to make themselves from within as well as to participate with groups who collectively imagined the world and the self. Visualization played a key role. The imagination is a remarkable medium for meditative practice in Ignatius Loyola's *Spiritual Exercises* (1548), which was quickly extended from clerical to lay use and resulted in intricately illustrated guides to prayer. That most modern of Protestant books, Bunyan's *Pilgrim's Progress* (1678), envisioned the Christian life as a long pilgrimage divided into a series of critical junctures that illustrators limned for countless editions of the book. Introspection, discernment, determination became the instruments of spiritual journeying not only for the spiritual elite of European society, as they had been for the cloistered before the modern era, but for everyone. Bunyan's book was the most owned and widely read book after the Bible in colonial North America. And the Jesuits took the *Spiritual Exercises* around the world with them, deploying its practice in retreats for religious and lay alike. In no small way, Catholics and Protestants helped teach the modern world how to imagine, how to read, and how to consume print.

## PLAN OF THE BOOK

Part I of this book sketches historical accounts of the imagery and visual practices of each tradition, beginning in the sixteenth century. I then scrutinize, in part II, the role of

images and imagination in sacred economies, the iconicity of words, the imagined community of Christian nationhood, the imagined likeness of Jesus, and the legacy of Christian visuality in the history of modern art. My contention is that external and internal seeing, vision and visual cognition, have shaped the modern history of Western Christianity in characteristic ways such that any account of the religion in either or both of its principal traditions must take into consideration the substance and effects of imaging and visual practice.

Although my treatment is not limited to the geography of Europe and North America, I focus on the careers of the two major strands of modern Western Christianity—Catholicism and Protestantism. I have kept the two together since they present a history of interacting with and mirroring one another in striking ways as they moved out from Europe to other parts of the world. The practice of separating Catholicism and Protestantism draws largely from the enmity they bore one another at the outset of the Protestant Reformation and the ensuing centuries of violent conflict that plagued Europe. Even long after the Peace of Westphalia in 1648, which brought an end to a protracted period of warfare, Protestants and Catholics maintained strong animosity. Although the two appear to have reconciled much of their antagonism in places such as North America and Western Europe during the twentieth century, the present competition between Catholicism and Pentecostalism in parts of South America shows that the two may still engage in rivalry.

As preeminent symbols of that enduring conflict, images have marked the intersection of debate and occasionally violence between the two parties. Ironically, when viewed from the vantage of dispassionate scholarship in the early twenty-first century, the imagery and visual practices of Catholicism and Protestantism can also be seen to bear family features; in some cases, they appear virtually identical. That should not be surprising, as Protestants have always borrowed from the iconographical stock of the Catholic visual tradition, and Catholics came to return the favor. Even while the two fought propaganda wars with imagery, their strategies and visual languages were widely shared. And their practices of devotion, instruction, memorization, commemoration, veneration, and communication are far more similar than the two traditions may have wished, at times, to acknowledge.

Still, there are striking differences between the two traditions, and I want to scrutinize these no less than their similarities. In the opening chapters, attention falls on how each tradition conceives and practices the mediation of the divine. It is not as if Catholics deal only in images and Protestants only in words. Both traditions have made abundant use of each medium. Indeed, I want to show that we cannot properly sever visual and verbal, picture and script from one another since they are intimately interwoven, though differently in each case and over time within each tradition. In the chapters that comprise the second part, I wish to argue that imaging pertains to several fundamental features of modern Christianity: to its practices of exchange that parse the sacred, to the Protestant use of words, to the imagination of nationhood, to the evocation of Jesus's personal

likeness, and even to modern art, whose relation to Christianity is ambivalent. All of these are visual ingredients in—and go far to characterize—the modern experience of Christianity.

I will show how images are part of economies or systems of exchange that characterize (however differently) each version of both traditions at various moments in their histories. As media of exchange among the divine and the human but also among humans themselves, images communicate intention, doctrine, ideological loyalty, contrition, longing, adoration, honor, and pleas for aid. Images are not simply representations of ideas or material correspondents of discourse. They communicate between devotees and saints, the church and the believer, the believer and other believers, the believer and the nonbeliever.

But communication, it will become clear, is more than message-delivery. It is closer to what we might mean by the word enactment. Images are forms of mediation, filling the spaces between bodies, places, things, saints, dreams, and nations. Images are the material, moral, and imaginative technologies without which these sometimes very abstract or immaterial realities would remain quite unreal. By mediating the relations that characterize a religion, images imagine the other, whether it is the devil, an infidel, a convert, a community or nation, or a deity. Among both Catholics and Protestants, images as forms of exchange and relatedness reach over the span separating individuals, to build what no individual can construct alone. Images deliver information, they touch and move, they intuit what cannot be seen, and they imagine communities and connections that complete the individual by securing his or her relation to a larger reality—Jesus, church, millennium, nation.

The history that I will examine from the sixteenth century to the present reveals how uses of images and practices of imagination mediated the relations that comprised the worlds of Christians, both Catholic and Protestant, in Europe, North America, and far beyond. These worlds were strongly distinguished from one another by virtue of religion, race, language, and history. Quite often images formed fault lines for competition and conflict between Catholics and Protestants, between missionaries and indigenous peoples. Thus, by refusing to venerate images, Protestants drew the charge from Catholics of denying honor to church tradition and to the saints, God's appointed assistants to believers. Protestants, in turn, rejected images as idols, as an affront to divine majesty. And both Catholic and Protestant missionaries urged those they proselytized in non-Christian settings to abandon the images of their religions as idols and the tools of demons.

Yet both versions of Christianity made use of images. Some Protestants were (and remain) fond of denying the fact, but images and visuality permeate Protestant thought, imagination, and practice. Protestants and Catholics have each made a point of overdetermining the role of images and their regulation precisely because these have been the features used to distinguish one tradition from the other in a long series of culture wars. The result has been partially distinct, but never completely separate, imaginaries. In fact,

in many ways, the sharp distinctions have blurred in the last century or so. But there remains a history in which images functioned differently in each tradition as media of exchange and as means of imagination.

As Protestants have long told their story, the Reformation reintroduced the primacy of the Word of God by rediscovering the authority of scripture and applying it as the sole authority in matters of faith. This was often taken to mean that Protestantism based itself on the true revelation of the divine in the words recorded in the Bible. Holy Writ was reliable and authoritative; images, liturgical and devotional paraphernalia, costume, ceremony, and ritualistic words were not. The *hoc est corpum meum* of the Latin mass was parodied as "hocus pocus," deceptive magic with no real spiritual authority, only the power to dupe the superstitious flock fooled by priestcraft.[17] The utterance of scripture by devout Protestants, on the other hand, was and remains charged with the power of the Holy Spirit to act. Scriptural words are speech-acts among many Protestants, and the Bible is a mechanical device for divination among those who select verses from it randomly as a way of discerning God's will for them. The Bible is a kind of material icon, an aperture through which God makes himself known and devotees petition their deity for all manner of aid. In view of how the Bible and its uses have been asserted by Protestants from the sixteenth century to the present, a leading interest of this study is the materiality of both images and words.

It is important to point out that I have in several chapters discussed the visual career of Christianity beyond the West, though often only enough to remind myself and the reader that this religion has moved far past its points of origin and traditional dominance. The study of Christianity in the South and East is well underway today and I hope my account provides the reader with numerous points of connection and interaction. But my discussions of Chinese, African, Indian, and Oceanic settings only scratch the surface. The history of Christianity is not a hermetically sealed narrative of internal development. I hope to show how dynamic this history is, even as it operates in remarkably conservative ways to preserve traditional arrangements of authority.

# WORD AND IMAGE

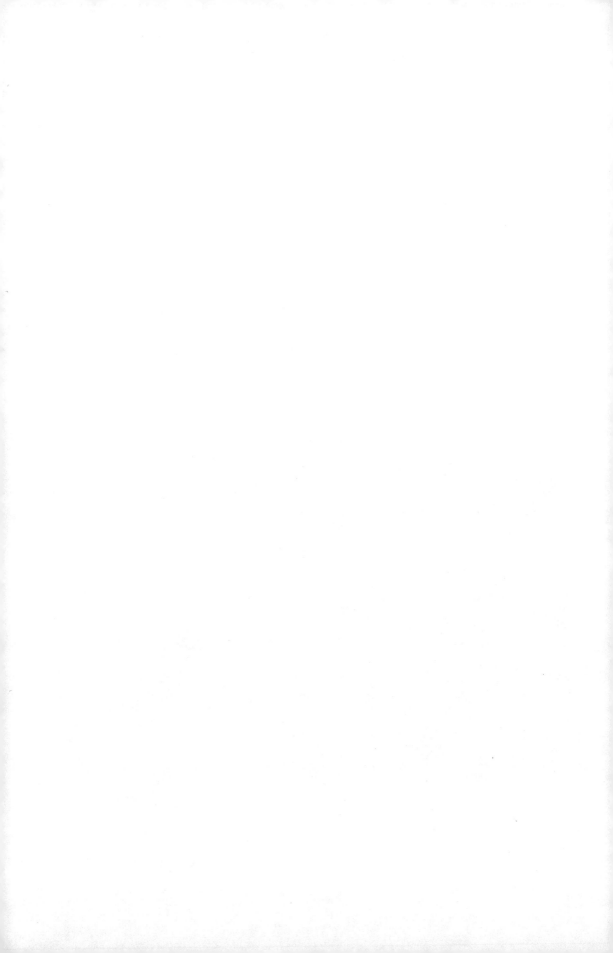

# 1

# THE SHAPE OF THE HOLY

Protestants and Catholics have long been obsessed with their origins. There is something powerful about claiming that one's faith descends directly from the life of Jesus. Holding to the truth thus means tracing one's practices and beliefs to the *true* beginning. Protestants have commonly imagined that their faith is grounded in an epochal return to Christianity's genesis after a long interlude of wandering and corruption. Roman Catholics have maintained that they never lost contact with the apostolic age, and have therefore preserved the church that Jesus founded, and then entrusted to Peter. The issue for both parties has been authority, or, in a more modern term, authenticity, though each has posed and answered the question of authority differently.

The Catholic tradition has been defined in many ways by asking *who* spoke for God, while Protestants from the outset focused instead on asking by what *means* God spoke. The Catholic answer is that the church fathers, the councils, and the continuous chain of popes speak as the united authority of the church. But that glosses over an ongoing conflict within the Catholic tradition that contributed importantly to the Reformation itself: a dominant strain of thought and practice asserts that authority resides in fathers and councils, yes, but that the preeminent servant of God, the vicar of Christ, remains the pope, who is invested with power by unbroken apostolic succession. The pope as the final authority on earth is infallible, as a nineteenth-century promulgation officially established. The Protestant tradition, by contrast, asserted that God spoke for himself, once and for all, in scripture, his Holy Word, which must be the unquestioned authority for all matters of faith. To be sure, this overlooks very rancorous, sometimes bloody

dissent among Protestants regarding the nature and authority of revelation: is it limited to the closed canon of the Bible or is it supplemented by prophetic inspiration, charismatic leadership, spiritual manifestation, or new revelatory writings?

Authority is force invested in a social mechanism for doing work. The sort of work that is performed depends on the mechanism and its purpose. Authority means that the individual or group or institution executing it compels obedience—because those subject to authority recognize the obligation to obedience or because they fear the consequences of disobedience, or both. They may also believe that the authority has it right. Authority organizes and maintains social configurations that obtain a kind of second-nature when their utility or the threat of punishment keeps them in place. Constancy breeds familiarity, which becomes an abiding sense of everyday life or normalcy. We learn something very important about Catholicism and Protestantism when we grasp how each of them understands religious authority to operate in human life. The major stream of Protestant thought and ecclesial practice insists that God calls the soul through the medium of scripture. A premium has therefore often been placed by Protestants on biblical literacy. Catholicism has long taught that God has established an apparatus for disseminating divine will and influence in the world. God operates through an elaborate bureaucracy of intermediaries that distribute divine agency. Emphasis has therefore commonly been placed on reverence for the institution and recognition of its authority and the propriety of obedience.

This difference plays out significantly in what sociologists call organizational dynamics. When Catholics say the word "church," they usually mean something different than the Protestant utterance of the word. Catholics often have in mind a vast and holy apparatus descending from heaven to earth and from the ancient world to the present. There have been and will be bad priests, heretical teachers, and power-hungry prelates, but the church abides because it is the way that God works in the world. Protestants may think more of God's people, who stretch from heroic beginnings through the dim present to the glorious future. If Catholics look upward and backward to see the church, Protestants often look ahead for the kingdom to come, pressed there by the intrepid example of the past and nagging uncertainty about the present. What this means for the material cultures of each tradition and the ways they practice their religion will occupy our attention here.

Of course, as soon as one accents the importance of obedience for Catholics, a host of qualifications come to mind. One thinks, for instance, of Brazilian and Haitian Catholicism, in which a substantial intermixture of spiritualist and African traditions challenges any notion of submission to official dogmatic purity. Or of American and European Catholics and their widespread disregard for church strictures on birth control, divorce, and church attendance. Obedience as ethos means neither purity of doctrine nor blank compliance with authority. As a marker of the faith, obedience has come to mean recognition of the institution at key ritual moments such as baptism, marriage, and death. And it means a history of reliance on its deeper sacred economies, which describe what Catholics do in everyday life to achieve comfort, health, and the favors of a merciful heaven.

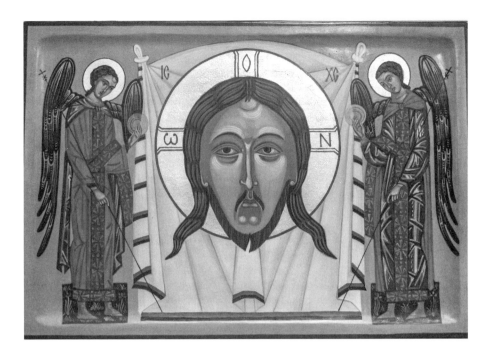

FIGURE 1

Basil Zymomrja, *Savior Acheiropoeta* (Not Made by Human Hands), 2003, egg tempera on wood panel. Photo by author.

Nor should we imagine that Protestant and Catholic are internally consistent or neatly distinguished from one another. There are Protestants who are virtually Catholic in their sense of tradition, liturgy, and sacramentality; and there are Catholics who are deeply Protestant in their sense of liberty of conscience and suspicion of institutions and clerical authority. Moreover, there is more than one version of each. Roman Catholicism is certainly the dominant and largest tradition of Catholicism, but is joined today by other versions.[1] And the lines are even blurrier when we consider the Eastern Catholic Churches that profess unity with the doctrines of Rome, but do not practice the Latin rite. Instead, they use liturgies drawn from Orthodox traditions, allow their priests to marry, and give an important place to icons like the one reproduced in figure 1, whose style is clearly Russian Orthodox. But I purchased it from a Ukrainian Catholic iconographer in Lviv, where a group of Catholic and Orthodox Christians were actively seeking to reestablish icons in churches in the 1990s, after nearly a half-century of Soviet rule during which icons had been banned. Icons play no formal role in the Latin rite, but they are vital for Eastern Catholic devotion and worship. If we are to recognize the breadth of Catholicism, we need to realize that its visual pieties are even larger than the familiar medieval altarpieces and Renaissance church frescoes that have done so much to shape the Western Christian imaginary. Although the focus of this book will be

on the Western heritage, we will not be confined geographically to Europe or North America.

This degree of latitude in defining Catholicism is important to bear in mind since it will help us to avoid essentializing it, and, by extension, the even more fractious tradition of Protestantism. Neither Protestantism nor Catholicism consist of a single, timeless essence. There is no pure "Protestantism" or "Catholicism." We can speak of Protestants and Catholics, but we are always speaking in generalizations, not single, irreducible principles. In each tradition, believers are shaped by history and by enduring loyalties expressed in artifacts and symbols that they may not clearly understand but that they find nevertheless important to enforce by forms of association, ritual utterances, and practices as varied as dressing, eating, praying, worshipping, marrying, and rearing children. As we shall see, Catholics and Protestants have relied on one another to define their own claims to authority. My aim in this chapter and the next is to examine their respective characteristics, follow them individually and interactively over the course of several centuries, and to consider the consequences of their various, differing sensibilities about word, image, revelation, body, and authority.

## THE SHAPE OF THE HOLY

The shape of the holy has preoccupied the Catholic tradition, as the record of its earliest documents attests. Replicating pre-Christian Roman society, early Catholicism structured authority as a vertical hierarchy of offices and as an unbroken temporal chain. A late second-century pope, Saint Zephyrinus, rehearsed the hierarchy: "The Apostles were made preachers of the Gospel to us by the Lord Jesus Christ; Jesus Christ was sent by God." When the apostles made converts, "they appointed bishops and deacons."[2] Appeals to the authority of Peter grow in the record over the next centuries as the pontiffs of the apostolic see asserted their primacy among bishops. They did so by citing Peter's martyrdom in Rome and Christ's words to Peter, interpreted as investing in him foundational authority over the church: "Thou art Peter, and upon this rock I will build my Church, and the gates of hell shall not prevail against it, and I will give unto thee the keys of the kingdom of heaven" (Matt. 16: 18–19).[3] In 431 the Council of Ephesus proclaimed: "It has been known to all generations that the holy and most blessed Peter, chief and head of the Apostles, the pillar of the faith, the foundation stone of the Catholic church, received the keys of the kingdom from our Lord Jesus Christ the Savior and Redeemer of the human race, and that the power of binding and loosing sins was given to him, who up to this moment and always lives in his successors, and judges."[4] From Peter to each successor is invested the power of the office to make decisions, to appoint bishops, to excommunicate, to rule the hierarchy from the pontiff's office to the parish priest and the religious in monasteries. Obedience is a key virtue in this vertical organization of power. Material continuity functions as an analog both of apostolic succession and of the hierarchy and chain that organize the institution and its passage through time. According to tradition,

Rome is where Peter died and where the bishops of Rome took his place at the head of the universal or Catholic church. The many martyrs buried in Rome yielded relics and cults centered there; St. Peter's Basilica, to take the most prominent example, was erected over the tomb of Peter. The growth of other churches, shrines, and relics made the city an important pilgrimage destination.

Of course, Catholicism is more than its formal structure of authority. It is also popular devotional practice, some of which operates far beyond the arc of papal authority and official recognition. Yet folk saints like Santa Muerte and unauthorized apparitions such as Our Lady of Medjugorje remain similar to official piety inasmuch as they offer sensory access to the power of a saint, through such means as pilgrimage and vow. Their very popularity serves to underscore the urgency of asserting control over tradition by means of official review and recognition by the hierarchy as the unrivaled avenue of authority, even if, in fact, the conduits of authority are far greater and more varied than the magisterium would like to allow. It is critical to understand that the engines that drive a great deal of Catholic piety are not located in the official rules of the church, but in the practices of the laity, where rules meet the realities of everyday life. Our Lady and the other saints have repeatedly appeared to peasants and children, in the distant backlands of local parishes and mountainsides. The response of shepherds, artisans, and townsfolk to such manifestations has shaped the holy at the level of everyday life. The hierarchy takes note only when hundreds and thousands of lay devotees make pilgrimages and recognize in the apparitions and deeds of heavenly visitors the work of the divine. The pattern is familiar: power invested in the ironclad bureaucracy responds to the charismatic power of pilgrims in the grain field, orchard, or desert. The story of Our Lady of Guadalupe models this process (see figure 2): Our Lady reveals herself to a peasant, Juan Diego, clothed in the flesh and costume of indigenous peoples, and the peasant is charged to bear the revelation to the archbishop of nearby Mexico City, and thereby to the official church. Once the cult is established by popular response, the church embraces it, steers it, and recognizes in it the powerful relationship binding the divine to the church and to the faithful. In the bronze group in figure 2, erected at the site of the original revelation on the Hill of Tepeyac—said to be an ancient site sacred to the Aztec deity, Tonantzin, a mother goddess—the fault lines are smoothed over, and the potential menace of a grassroots movement is successfully grafted onto the tradition. A long line of indigenous peoples submissively offer gifts, themselves, and their devotion to Mary, the mother of the Christian God. And yet Our Lady, enfleshed in brown skin and speaking in Nuhuatl, not Spanish, remains a potential icon of resistance and protest, no less than a symbol for appropriation by Mexican national military or the state. She is a site for the contestation of power, and that keeps her alive and relevant to the lives of many.[5]

The Catholic tradition maintains that it descends from a sacred origin and sustains the sacred in its performance of duties entrusted to its many offices and agents by virtue of their place in the hierarchy, as anchored in time to the chain of papal successors. In this regard, the shape of the holy for Catholicism is the configuration of authority in

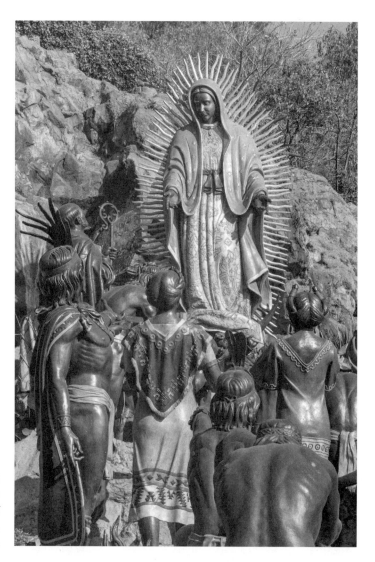

these institutional and temporal forms. Continuity is a premium. To change is to risk loss of connection with the past, which remains the font of authority and the material source of holiness. Moreover, a secure origin acts as an anchor for subsequent history and allows succeeding authorities to posit and curate a stable essence called "Catholicism." Of course this essence is in actuality a construction formed by time and the exertion of institutional power, and its maintenance is deeply dependent on the places and things that clothe the hierarchy of priests and prelates as the material culture of authority and put devotees in visceral connection to the majesty of the church. Catholic material culture is the means for accessing the power of the sacred in ecclesiastic ritual and in devotional life. Images, relics, altars, liturgical objects, vestments, rosaries, scapulars,

missals, architectural structures—all of these come from somewhere to deliver their power. They come, for one, from the past and are relied upon to maintain a connection to it. Further, these material forms come with the blessing and consecration of the hierarchy—the priest, bishop, archbishop, cardinal, or pope. Finally, the believer's officially endorsed access to the holy comes through material interaction with these artifacts. Using them, honoring them, is an interface with the celestial hierarchy that ends in God himself. Levels of intercession are not experienced as distance from the divine, but as the way in which the divine draws near to the soul. A good deal of Protestant theology and church practice rejected this conception, coding all forms of the Catholic hierarchy as confusions with its apex, and therefore as idolatrous.

At the heart of Catholic and Protestant difference was an abiding disagreement over authority as the shape of the holy. Protestants have typically believed they have authority in the Word of God, the Bible, which they can access independently of clergy and hierarchy. Catholic laity and even many religious in monastic settings have generally not relied on reading the Bible, which Protestants have considered indispensable, but have looked instead to the power of spiritual exercises, liturgy, Eucharist, penance, and devotion to saints to bring them to the source of the sacred. The power of the church is delivered through the things believers do, such as pilgrimage and penance, vows, and practices of reparation; the practices of belief; the objects, such as the rosary, they use to pray; and the images they use to pledge, promise, praise, and thank the saints who intercede for them and bestow favors by virtue of their friendship with God. Devotion to the saints, to Mary, and to Jesus is performed before images or with images in mind as a way of focusing attention and embodying attachment and dedication. To bow or genuflect, to kneel or flagellate oneself before an image is to generate a range and intensity of emotions that knit the devotee to the object of devotion. The body serves as a powerful matrix for the experience of penance, and visualization has long been an important means among Catholics for staging encounter with the sacred. But by "performed" and "staging" I do not mean to imply a lack of sincerity or a merely *external* exhibition of devotion. I want to stress the central role of the active, performative body in Catholic practice as part of the materiality of the holy in this tradition.[6]

In Catholic and Orthodox traditions alike, action toward an image is action toward its prototype. The Second Ecumenical Council of Nicea affirmed that "the honor of the image passes to the original," a view that was used in Orthodoxy to defend the veneration of icons.[7] Although the Carolingian court harshly rejected the Council's views on images, its judgments were not officially proclaimed or enacted, and the idea endorsed by Nicea is implicit if not explicit throughout Catholic history. The veneration of the images and relics of the saints was clearly endorsed by the church before the Reformation and was officially confirmed by the Council of Trent in response to the Reformation.[8] Trent made a point of affirming the second Nicene Council and insisting that honor shown to images "is referred to the prototypes which they represent, so that by means of the images, which we kiss and before which we bare the head and prostrate ourselves, we adore Christ, and

venerate the saints, whose likeness they bear."[9] To address the image of Jesus or Mary or another saint with one's pleas or petition was not to hold conversation with a piece of wood or a painted surface. The image was understood as a communicative relay that directed human speech, thought, and the sentiments conveyed by gesture and deportment to the celestial reality of the person to whom one spoke.

A dazzling painting by Flemish artist Jan Gossaert, produced between 1520 and 1525, captures in European Catholic terms what the Eastern councils and the Orthodox tradition asserted regarding the authority and stature of images. *Saint Luke Drawing the Madonna and Child* (plate 1) is a subject that became important during and following the Iconoclastic controversy in eighth and ninth-century Byzantium, when icons were banned by several emperors as idolatrous.[10] To show Luke, author of the longest and most detailed Gospel, creating an image of Jesus and his mother, and doing so with the supernatural aid of an angel, was intended to vindicate the practice of making icons and their authority. The Fourth Council of Constantinople (869–870), held thirty years after the end of the Iconoclastic period, boldly proclaimed the lofty stature of images of Jesus, and condemned as accursed any who failed to honor images of Mary, angels, prophets, martyrs, and saints. Most remarkable, however, was the elevation of the image to the stature of revealed biblical text as a source of teaching: "We decree that the sacred image of our lord Jesus Christ, the redeemer and savior of all people, should be venerated with honor equal to that given to the book of the holy gospels. For, just as through the written words which are contained in the book, we shall obtain salvation, so through the influence that colours in painting exercise on the imagination, all, both wise and simple, obtain benefit from what is before them; for as speech teaches and portrays through syllables, so too does painting by means of colours."[11] Since colors are the analog of syllables, image and text mirror one another, and merit the same honor. We see the idea asserted in Gossaert's image of Luke the author and painter. Stored inside the podium on which Luke draws an image of Our Lady and the Child is a clasped codex, no doubt the Bible. And just as the authors of Holy Writ were inspired as they wrote the scriptures, the angel intervenes to guide the draughtsman's hand.

The authority of the image could not find a grander expression than in Gossaert's painting. Luke has removed his shoes in honor of the holiness of the Virgin, who hovers in a radiant cloud that references the burning bush Moses encountered. We see Moses above, in a gray stone sculpture atop a well behind the angel. His presence is motivated by at least two allegorical references to the virginity of Mary. It was Origen who asserted that the burning bush was an apt metaphor for the virginity of Mary since the bush was aflame but was not consumed by the fire. And like Mary, Moses did the impossible in obedience to divine command, bringing water from rock by the touch of his staff (Exodus 17: 5–6). The scene in Gossaert's painting is set within an ornately decorated interior that may represent a church nave lined by an arcade that forms a series of niches, one of which encloses the fountain on which the statue of Moses sits, holding the tablets of the law. The radiant cloud encircling the Mother and Child reveals the cherub-borne Mother

of God, who is being crowned by two putti. Devotion to the Coronation of the Virgin was widespread in late medieval Europe and its worship was often invested in side altars dedicated to Our Lady. In such spaces, set off for pilgrims and other devotees, paintings and sculptures depicted her heavenly crowning. Gossaert situates Luke's artistic inspiration before such a niche, as the Gospel writer looks into the side chapel where she appears. The result is an image that Protestant iconoclasts at this very moment were busy smashing in Swiss and German villages and pilgrimage churches.

Crowning the Virgin immediately brings to mind two medieval hymns that foreground Mary's status as queen. One, the "Salve Regina," is attributed to the eleventh-century Benedictine monk Hermann of Reichnau. This hymn achieved and has maintained a prominent liturgical and devotional place in Catholic worship, appearing in the liturgical calendar before Advent. A second is the "Ave Regina Caelorum," which dates at least to the twelfth century, is chanted from the Feast of the Presentation of Jesus in the Temple to Wednesday of Holy Week. The text includes reference to angels *("Ave, Domina Angelorum")* and to the gate through which the light of the world shines. Both references might inform Gossaert's painting: the host of cherubim that keep Our Lady afloat act as an angelic throne, while the visionary blaze radiates from her into the dark interior. The "Salve Regina" also refers to angels *("Jubilate, Cherubim, / Exsultate, Seraphim!")*, but then addresses Our Lady in terms that seem quite relevant to Gossaert's image:

> *Eia, ergo, advocata nostra, illos tuos*
> *misericordes oculos ad nos converte;*
> *et Iesum, benedictum fructum ventris tui,*
> *nobis post hoc exsilium ostende.*

> Turn then, most gracious advocate,
> thine eyes of mercy toward us;
> and after this our exile,
> show unto us the blessed fruit of thy womb, Jesus.

In Gossaert's painting, Mary's eyes are turned downward as she attends to the Christ-child, and Luke's eyes are likewise trained on the image he is drawing with the angel's help. The painting thus enacts the moment of the hymn's plea for Mary to turn her gaze upon the viewer and to show the fruit of her womb. This showing *(ostende)* is a very significant matter for the understanding of Catholic imagery and its role in religious life because it sharply diverges from Protestant and iconoclastic views. As the Council of Constantinople decreed, the "imaginal energies of the colors" of icons are the equal of Holy Writ's syllables in their power to manifest truth, that is, to show what the Church teaches as revealed truth. Images bear truth as well as words and operate by showing or visually presenting it. Gossaert's image records a revelation, a showing, and affirms the power of images to capture that, though, like scripture, not without the intervening agency of heaven to secure its authenticity.

Closely related to the image's power to show the truth is the function of the emotions that images of Our Lady commanded, and produced, among Catholic faithful. As the "Salve Regina" instructs: "To thee do we cry, poor banished children of Eve; / to thee do we send up our sighs, / mourning and weeping in this valley of tears." The mother receives these heartfelt expressions of misery and sorrow and responds because she is a mother. And her response goes to the heart of Marian piety as well as to the core of Protestantism's rejection of the veneration of Mary. As the mother of Jesus, indeed, as "Mother of God," one of her oldest titles, she enjoys intimate access to and honor from him, making her the ideal advocate to intercede for sinners: *"Ora pro nobis sancta Dei Genitrix."* The "Ave Regina Caelorum" states the same request: *"Et pro nobis Christum exora"* (Plead with Christ [our souls to spare]). The coronation of the Virgin in heaven proclaimed her queenship and established her special rank there, to which belonged her role as mediatrix. She was understood to be empowered with dispensing graces or favors that were drawn from the treasury that accrued from Christ's righteousness and her own, as well as from the merits of saints. It is for this reason that the "Ave Regina Caelorum" was performed with indulgences and came to be an indulged prayer. As we will explore in greater detail in chapter 3, Mary is a central figure in Catholic sacred economy. Whereas Jesus generated the merits that sinners sought for forgiveness and aid, Mary was a principal mechanism for dispensing them through penance and indulgence. In light of this, the Protestant targeting of statues and images of Mary at pilgrimage churches—the places people went on missions to obtain her favor—is not hard to understand: by destroying these images, they hoped to disable the entire spiritual economy of intercession and the transfer of merit through Marian favor. What we learn from these images, and Gossaert's picture is a particularly beautiful example, is that interface with this economy was not grounded in texts, but in images linked to prayers. The cultural formation of the visual sense, that is, the forge of vision, imprinted the utterance and embodied performance of prayer on the act of seeing. Prayerful gazes engaged the image of Our Lady in a spiritual protocol of intercession that devotees hoped would end in the showing that the "Salve Regina" beseeches. Moses looks on, holding the diminutive tablets of the Law, the result of the "old" revelation on Sinai, which testifies and submits itself to the "new" dispensation taking shape visually before Luke.

Gossaert's picture reads like the guidelines on the veneration of images issued by the Council of Trent in 1563. The Council sought in its reforms both to affirm the veneration of images, relics, and the saints, and "to root out utterly any abuses that may have crept into these holy and saving practices . . . . All superstition must be removed from invocation of the saints, veneration of relics and use of sacred images."[12] Moreover, the Council sought to eliminate "base profit," "all sensual appeal," "drunken feasting" and "disorderly . . . exaggerated or riotous manner" inside churches that might ensue from the veneration of these same saints, relics, and images.[13] These three sacred elements were intricately interwoven in Catholic visual piety, and were often subject to what the Council considered an effervescent excess, particularly among the "unlettered." Regulating the

unruly physical body and the dangerous social body of the unlettered on occasions of ritual veneration was a key matter of Tridentine reform. The sensual appeal of images and rites posed challenges to control; these strictures of the Council were the first measure to mandate that sensuality be attenuated.

Far more powerful and invasive measures were already appearing within the church, but beyond the halls of the Council's deliberations. As we shall see, Catholic forms of spiritual renewal underway in the wake of the Reformation cultivated embodied, highly emotive practices of devotion and prayer.[14] Religious orders played an important role. For instance, the intense introspection undertaken by Ignatius Loyola's *Spiritual Exercises,* which appeared with papal endorsement in 1548, developed a meditative technique for channeling imagination toward its pious object, directing the sensuous energies of visualization toward the spiritual end of envisioning one's intimate connection to the suffering and redemptive activity of Jesus. But the Jesuits were hardly alone. A wave of new religious orders and renewals of older orders swept across Europe as a vital response both to the Reformation as well as to the widespread calls for spiritual reform within the Catholic church. Imaging, both inward and outward, contributed importantly to these forms of renewal.

## AUTHORITY, HIERARCHY, INTERCESSION: THE INTERFACE

But before we consider the impact of the new measures of visualization, it is necessary to examine the role of embodiment and its articulation in Catholic tradition. The human face is a form of communication unlike any other. We are wired to respond to faces interactively, using our own faces and our entire bodies to engage in a corporeal dialogue. The result is not a conversation of words, not a discourse, but an exchange of expressions and gestures that links bodies together in something more like a dance, a set of postures and movements that promise, anticipate, confirm, aver, deny, feign, and accept via the soundless engagement of looks, offers, aversions, and responses. And as a circumscribed field that we see and interact with, the face is likely the basis of the image as a system of human communication. A face, like the image of a face, looks back at us, allows us to watch it, leads us to expect something from it. Most importantly, a face is a surface that opens organically into a depth: to see a face is to enter the presence, the countenance of the person who lives within it. A face can be a frozen mask, a system of conventional signs, but the default is to experience a face as the living site where we hope to encounter one who shares our own life. Connecting with this other is what I mean by *interface.* Looking at a face is not in the first instance a semiological or symbolic process of abstract signification. It is not primarily a matter of reading a text as a set of signifiers. At first blush, to look upon another face, face to face, is to engage the presence of the other. It is to face something like oneself, even another version of oneself, and by consequence, to presume to know and anticipate what the face will do. Interacting in the medium of the face means, at least initially, to await affirmation or alienation. This is the raw affect of

interface. Meaning and the particular emotional interpretation of the face come later. Interface necessitates bodily connection, in which the face is not a sign of absent meaning, but the lived reality of it, the body or flesh whose salience is registered in our own flesh and face.[15]

Catholicism is a religion grounded in the belief that a community of friends has been put in place to help those who seek aid. God is a ruler who cannot be approached in himself because his holiness distances him from human presumption. But he reaches out to human beings by means of a system of intermediaries. Although human beings cannot look God in the face, they can seek out the faces of those whom he has appointed as his representatives—the saints, Mary, and, of course, Jesus. The intimacy of this yearning gaze is powerfully illustrated in Vincente Carducho's early seventeenth-century painting, *Stigmatization of St. Francis,* which shows the saint floating upward to see the crucified Jesus face to face (figure 3). In the distance we glimpse an attendant with the open book of the Gospels, which had served to launch Francis's vision of Christ, by being opened three times in the name of the Trinity. Rather than reading the text, Francis made use of it as a "divine oracle," a power object that unleashed visionary experience.[16] In high Baroque manner, Carducho portrays a tender and sensuous meeting as the two men gaze into one another's eyes. Jesus is crucified on the flaming wings of seraphim rather than borne "betwixt" them "while [the] twain hid His whole body," as Bonaventure, Francis's thirteenth-century biographer, described the vision.[17] Carducho seeks to stress the embodied character of the envisioned encounter, contrasting Francis's stiff gray robe with Christ's bare flesh. Francis is drawn upward by the force of mystical love, by what Bonaventure names the "seraphic glow of longing." Bonaventure relates that Francis afterward came to understand that the vision was a revelation, "that he was to be wholly transformed into the likeness of Christ Crucified, not by martyrdom, but by enkindling of heart. Accordingly, as the vision disappeared, it left in his heart a wondrous glow, but on his flesh also it imprinted a no less wondrous likeness of its tokens."[18] The trace of a visionary experience in the flesh of the mystic marks the subtle join of spiritual and material worlds. And the bracing eros of the vision appealed no less to the Baroque imagination of Carducho and his viewers.

But the mysteries of visionary union with Christ were reserved largely for the monastic few who were dedicated to lives of mortification and prayer. Jesus's role in lay Catholicism was often limited to the singular work of redemption that he undertook in his passion, death, and resurrection. It is certainly true that he engaged many important figures in the mystical traditions of Catholicism, including Francis, Henry Suso, and Catherine of Siena, but it was not until the early modern era, as we shall see, that his suffering and visual intimacy would become more important for popular devotions such as Jesuit spirituality and the Sacred Heart, though each of these began among cloistered spiritual adepts as part of a special religious vocation. Mary and the saints, precisely because they had extraordinary experiences of intimate connection to Jesus, commanded spiritual authority and had broad appeal among the laity; they have been much more

FIGURE 3

Vincente Carducho, *Stigmatization of Saint Francis*, early seventeenth century, oil on canvas. Courtesy of the Hospital de la Venerable Orden Tercera de San Francisco.

important than Jesus himself for the devotions of daily life because they are intermediaries who enable access to the infinite merits that Jesus poured into the heavenly treasury through his sacrificial death.

Saints are the departed who now enjoy bliss in heaven with Christ. They are chosen by God as his friends to do the important work of serving him by interceding on behalf of the living and by providing models of moral virtue and self-mortification. The saints are like images: "We honor the servants that honor may redound to the Lord, who said: 'Who receives you, receives me'" (Matt. 10:40).[19] The living can persuade saints to work on their behalf by offering masses in their honor, by prayer, by pilgrimage, by pledges, and by devotion directed to their images. Saints are inclined to help because they have proven their devotion to God and to humankind, both exhibiting virtues in this life and being divinely vindicated in the miracles worked by their relics or by their invocation. God honors them, so humanity should do likewise. The result is a sacred economy of exchange that distributes spiritual and material benefit among believers. The operation of this economy will be taken up in chapter 3, but it is important to say here that a saint's veneration and response are a constant means of sacred traffic that organizes everyday life. When a saint's patronage lags, it may be renewed, or it may be replaced by another saint or eventually by the translation of the saint's relics to another altar, where the saint has expressed some desire to go, or where need has bid an enterprising bishop or abbot to promote the saint's cause. The theft of relics by Crusaders and ecclesiastic entrepreneurs was a major part of the sacred economy of the cult of saints in the Middle Ages.[20] In this way, saints come into the presence of the community, materialized in their relics and visualized in the reliquaries, statues, and imagery that present them to their devotees.

A saint is the face or body of the one whom the believer wants ultimately to see, God. The saints look upon the face of God and, in the words of a bull issued by Pius IV following the Council of Trent, the saints are "reigning together with Christ [and] should be venerated and invoked." They "offer prayers to God for us."[21] Their presence before God empowers the images of their faces by connecting the supplicant with the prototype in heaven. And the church has long privileged images of Jesus as ultimately linked to his face. The Fourth Council of Constantinople decreed that "If anyone does not venerate the icon of Christ, the savior, let him not see his face when he comes in his father's glory to be glorified and to glorify his saints, but let him be cut off from his communion and splendor" and then went on to insist on the necessity of honoring the images of Mary, martyrs, and saints.[22] The priests, members of the church hierarchy, and monastics think of saints very much in terms of the liturgical calendar, the organized system of universal liturgy that joins the entire Catholic church in worship. Saints have their feast days and are remembered within the framework of the entire church year. The result is a communion of saints, an overarching community that structures sacred time so powerfully that it washes into the profane world and organizes it with bells, masses, and celebrations.

The church organizes worship according to the seasons of the liturgical calendar. But however much saints may participate in the liturgy of public worship, the laity is often inclined to think of saints more in terms of private devotion. The saints are engaged in daily veneration through prayer, rosary sessions, pledge, pilgrimage, meditation, and through occasional invocation for aid with a particular problem. There is certainly no inherent conflict between the two approaches, private devotion and liturgical worship. Over the centuries many Catholics regularly participated in formal worship, and before the modern era, liturgies were often in Latin, thus excluding active participation. Presence at mass did not require that laity understand the language of the liturgy. They knew the routine, the rhythm of the ritual. Presence meant being there and submitting oneself to the ritual's operation of grace. Participation did not mean cognitive understanding, but rather embodied response—chanted response in memorized Latin, standing, bowing, and kneeling on cue, praying, genuflecting, hearing the words of consecration, seeing the host elevated, receiving it, or not. Being there was not a mindless passivity, but neither was it the Puritan's careful notation of a preacher's sermon. It was an embodied form of presence, a participation in the event of the holy as performed by liturgical action.

The manner in which the church celebrates the saints and major feasts often involves processions, which take the cult statue or image on a tour of the surrounding neighborhood.[23] The processions, either before or after mass, organize the entire worshipping community into a long entourage that files into or out of the church with the image on a palanquin accompanied in succession by the priest, guest clergy or church officials, attendants, acolytes, sodality or confraternity members, and congregants. The entire company configures in its order a hierarchy that mirrors the structure of the parish, and the religious hierarchy of the church. The procession moves through the surrounding terrain, challenging the difference between sacred and profane space, finally blurring any distinction at all as the form of the procession dissolves into the streets. Processions enact the regal stature of the saint as spiritual nobility, simulating the august progression of the monarch or noble and the drama of their arrival and departure. Theatre or ceremony is an important part of Catholic ritual practice because, like standing before an image, it stages presence in a powerfully affective way. Obvious instances of this are the tradition of the Passion Play and the Via Dolorosa enacted during Holy Week.[24]

The affective means in such rituals is to address not only the intellect but also the body of the viewer-participant. The experience of presence is the result, and this turns generally on the presentation of something grand, mysterious, exalted, powerful, majestic, or transcendent, which imposes a relation of submission on the viewer, who complies as part of an embodied colloquy that will produce an abiding relationship, membership in a community, and the possibility of an answer to prayer. Presence has also long been a powerful part of private devotional Catholic life, in which the devotee experiences the image as a compelling presence, one that sometimes works miracles or shows wondrous signs, moving, speaking, or otherwise responding to the devotee.[25] But an image acts

most commonly in less spectacular ways merely by receiving the address of petitioners, who present themselves before the image, touching it, kissing it, fondly caressing it, speaking or praying intimately to the saint with whom they are likely to have a long relationship. By receiving their attention and responding with the obdurate gaze and material presence of the saint, the image performs as an anchor in daily life.

The cult of saints and the veneration of the relics of martyrs and saints operate in a Catholic cosmology in which the relation between the present world and the next is continuous. This contrasts markedly with the views espoused by many Protestants, who insist on a sharp break between the materiality of this world and the spiritual reality of the next. Recognizing the depth of this difference is helpful in coming to appreciate the character of materiality and presence that matter to many Catholics. So it is worth pausing to take a look at the Swiss reformer Ulrich Zwingli, who articulated a very clear view on this distinction and one that was rooted in his definition of faith. Faith, he contended, is "a matter of fact, not of knowledge or opinion or imagination. A man, therefore, feels faith within, in his heart; for it is born only when a man begins to despair of himself, and to see that he must trust in God alone. And it is perfected when a man wholly casts himself off and prostrates himself before the mercy of God alone."[26] This core state of faith, an inner state or disposition, is not the result of any external means, but of the individual's submission to God. So when Zwingli engaged Catholics and Lutherans in debate over the meaning of the sacraments, he dismissed their understanding of sacrament as an objective power. A sacrament, he concluded, "is nothing else than an initiatory ceremony or a pledging."[27] The Eucharist did not operate on the soul to regenerate the human being by forgiving transgressions or freeing the conscience from sin or producing knowledge of the sacrament's inner working of regeneration.

The Lord's supper and baptism, the two sacraments that Zwingli recognized, were public rites of initiation. Baptism is the social practice of naming the child with the charge "to fashion our lives according to the rule of Christ."[28] And the Lord's supper is a voluntary act by which "we give proof that we trust in the death of Christ, glad and thankful to be in that company which gives thanks to the Lord for the blessing of redemption." Zwingli steadfastly refused any idea of acts or objects infused with intrinsic power. Faith began and ended in the heart: "I unwaveringly believe that there is one and only one way to heaven, firmly believe that the Son of God is the infallible pledge of our salvation, and trust in Him so completely that that for the gaining of salvation I attribute no power to any elements of this world, that is, to things of sense."[29] Faith is "hope and trust in things quite remote from sense." So Zwingli insisted that to speak of the spiritual consumption of Christ's flesh in the sacrament of the altar was to speak nonsense, as "body and spirit are such essentially different things that whichever one you take, it cannot be the other."[30] When Jesus said "This is my body," Zwingli argued, he meant "This *signifies* my body."[31] The sacrament is therefore a sign or symbol of the testament.[32] Zwingli reasoned, with the definite instrumentation of a modern analytic philosopher of language, toward a staunch dualism in which faith is a disposition toward the next world, quite independent of bodily or

intellectual inducement: "In short, faith does not compel sense to confess that it perceives what it does not perceive, but it draws us to the invisible and fixes all our hope on that. For it dwelleth not amidst the sensible and bodily, and hath nothing in common therewith."[33] With this in mind, we grasp how Zwingli dismissed images as sensible things that could not know or teach of faith. Not only did he promote the removal and destruction of images that were worshipped, he also objected to the claim that images could teach anything about faith. Jesus, he argued, knew that "we turn to the things that are evident to sense, and He did not wish images to be made more impressive to us by the influence of teaching. For we do seem to owe something to those who teach us." But the proper source of Christian teaching, Zwingli insisted, is "the word of God externally, and by the Spirit internally."[34]

## COUNTERREFORMATION

A very different view was defended by the Catholic church, especially as articulated by the Council of Trent (1544–63), which condemned numerous claims advanced by the Protestants and spearheaded a Counterreformation that was taken up by artists employed by defenders of the faith in Italy, Spain, and elsewhere. Trent vindicated the place of images in churches, the cult of the saints, the veneration of relics, the Eucharist, and the use of indulgences—all issues Protestant reformers had targeted. It also boosted a theme that had been common in late medieval and Renaissance sacred art: the portrayal of saintly intercession, particularly in cases devoted to thanking saints for their aid in such disasters as plagues and the military siege of cities.[35] These images are typically spectacular, vertical compositions used on altars dedicated to the saint in question. Perhaps the most well-known image produced during the Counterreformation is El Greco's *Burial of Count Orgaz*, 1586 (plate 2). The subject is the sixteenth-century retelling of the fourteenth-century reburial of a nobleman, Don Gonzalo Ruis of Toledo (d. 1323), whose body was transported from the Augustinian monastery of St. Stephen to the Church of St. Thomas, also in Toledo. In the painting, the process is facilitated by the honored guests, Saints Augustine and Stephen, who appear richly dressed in gold embroidered robes at the lower center of the painting, grasping the deceased man. We have no trouble recognizing the domain of the living, formed by a line of black-clad and white-collared men standing behind the two saints, flanked by a priest in a transparent surplice on one side and by a Augustinian brother discussing the event with a Franciscan, on the other.

Yet the viewer's eye does not tarry long at this level, the sumptuous fabrics and gem-encrusted miter of the Bishop of Hippo notwithstanding. The entire picture conspires to draw the eye upward. We follow the ascending gazes of several figures to a glowing cloud that forms a natural barrier and conduit between heaven and earth. The cloud has opened up into a kind of celestial birth canal to receive the translucent shape of a child, the soul of the dead count, which is helped into the orifice by a winged angel. From there he will emerge into the august company of Our Lady and John the Baptist, Saint Peter, and the whole heavenly host of cloud-borne saints, martyrs, and glowing souls crowding

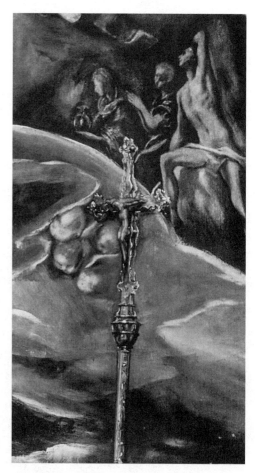

about the uppermost figure, the enthroned Christ, Lord of Heaven. The ascending hierarchy of terrestrial rank and angelic and saintly hosts joins with the plastic architecture of the cosmos to portray a universe in which heaven and earth are part of a single, organically unified fabric. The world of spirit is not cut off or ontologically separate from the world of materiality, but joined with the same literalness as the mysterious unity of Christ's body and blood in the bread and wine of the Eucharistic meal. Note, for instance, the crucifix on a long staff held by an officiating priest standing on the right (figure 4). Where the cross rises above the cloud that divides terrestrial from celestial spaces it turns transparent, an ethereal tracery of its concrete actuality. The division might be said to mark the distinction between substance and accident, yet the continuity of the two realms remains evident. This is not a Platonic vision of reality versus appearances, of being opposed to shadow. Heaven and earth are joined on a single continuum of being, and the saints live at one end, in the presence of Christ, while angels shuttle between the two domains with bodies composed of luminous substance.

Looking at this painting, one cannot miss its hierarchical organization of the cosmos and the key role that the saints play in populating a spiritual bureaucracy that connects the layperson and viewer to the apex of the universe's government. The saints occupy levels of a hierarchy that brings the soul to the very throne of the Almighty, whose gesture toward his mother and look at John signal his command over the entire mechanism of intercession. El Greco's painting grandly endorses the Council of Trent's bolstering of the cult of the saints in response to the attack of the Reformation. Mindful of the Protestant claim regarding the abuse of images, Trent directed bishops "to instruct the faithful carefully about the intercession of the saints, invocation of them, reverence for their relics and the legitimate use of them; they should teach them that the saints, reigning with Christ, offer their prayers to God for people; that it is a good and beneficial thing to invoke them and to have recourse to their prayers and helpful assistance to obtain blessings from God."[36] The Council of Trent addressed the misuse of images directly, telling bishops to teach laity that images of Jesus, Mary, and the saints should be displayed and venerated "not because some divinity or power is believed to lie in them as reason for the cult, or because anything is to be expected from them, or because confidence should be placed in images as was done by the pagans of old; but because the honor showed to them is referred to the original which they represent."[37] Their images act in devotion and intercession not by any intrinsic agency, but because they serve as a relay, transmitting veneration to the saints themselves. El Greco's painting shows that very procedure at work. The viewer's gaze enters the pictorial field of the figures only to be shunted upward. Although the allure of the painterly surface, particularly the fabrics and flesh tones, gives the eye pause, it lingers only briefly before moving restlessly onward, impelled by the very way surfaces dissolve into brushwork and by the composition's rising network of gazes, gestures, and movement. All things yearn upward in a universal circuit of energy, as Augustine put it in his *Confessions:* the heart is restless until it rests in God.[38] At the same time, the hierarchies of the celestial and terrestrial worlds conduct ontological traffic in both directions, upward and downward along the vibrating architecture of being. Like a cosmic diaphragm, the luminous nebula at the picture's midlevel aspirates a breath or spirit that sustains the cosmos.

El Greco's painting displays the ontology of Catholicism as a triumphal rejoinder to Protestant heresy. The difference is striking. Even though Catholicism and Protestantism are both versions of Christianity, and observe as such a dualist distinction between divine and mortal, spirit and matter, soul and body, their understandings of the relationship between this world and the next are different, and their conceptions of the connection between the materiality of the body and the soul are not the same. Although in Catholicism the body is understood to struggle against the destiny and longing of the soul, as a material reality the body is not ontologically separate from the spiritual realm, but rather serves as the existential seat of spirit. Spirit and matter intermingle and space itself is infused with presence. Because they have distinguished sharply between spirit and matter, Protestants have tended to differentiate between the here and the hereafter

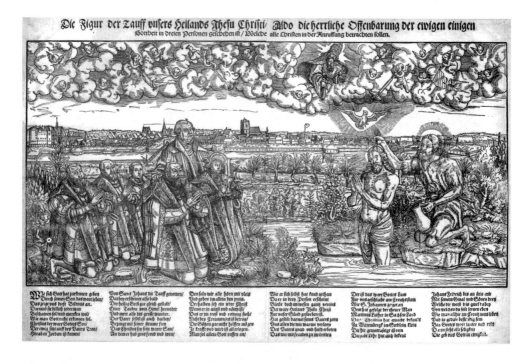

FIGURE 5

Jakob Lucius, *The Figure of the Baptism of Our Savior Jesus Christ, in which Took Place the Glorious Revelation of the Eternally United Godhead in Three Persons, which all Christians Should Prayerfully Ponder*, circa 1556, woodcut. © The Trustees of the British Museum.

*temporally:* thus, the kingdom of God is not yet come, but it will do so soon. Setting the time of this arrival has been a preoccupation among many Protestants. Catholics, by contrast, have articulated the relation of here and hereafter in *spatial* terms: the sacred is here in this relic, manifest in this miracle-working image, present on this altar, in the body and blood of the Eucharist under the appearance of bread and wine. Thus, at the level of theological discourse if not always in popular practice, images and sacred objects are often signs for Protestants, but forms of presence for Catholics.

A fruitful comparison of contemporary sixteenth-century Catholic and Protestant images makes clear the differing cosmologies articulated by images in the two visual cultures. We can set El Greco's painting beside a large print by the Wittenberg artist Jakob Lucius, *The Figure of the Baptism of Our Savior Jesus Christ*, from about 1556 (figure 5). The comparison turns on the moment of revelation as portrayed by each artist. In the print by Lucius we behold, above the broad landscape, the heavens emanating a radiant dove, the Holy Spirit, as John the Baptist kneels on the bank and pours water with his hand, gathered from the Jordan in a pitcher (a reproof of the Anabaptists who baptized by immersion). The heavens are contained within a writhing cloud, animated by the heavenly host, none of whom penetrate the distinct contour separating the celestial and terrestrial

domains. Only the effulgent dove descends, accompanied by the voice of the Almighty, who gestures downward as he announces the identity of his son. The event is beheld by Luther and his patron Johann Friedrich, his wife, and their three sons. The elector and his family hold their hands in prayerful contemplation of the revelatory moment, imitating Christ himself who submits to the Baptist in this consecration of his public ministry and the revelation of his participation in the Trinity.

Lucius limns a curious image. At first glance, it seems to say that Luther and his patron were present at the baptism of Jesus. But we quickly notice that the scene is not set in Palestine, but in contemporary Saxony. That is not the Jordan River, but the Elbe. The city in the background is ground zero for the German Reformation, Wittenberg.[39] At the center of the image is the City Church, which, as Joseph Leo Koerner has pointed out, "functioned like an episcopal see, where Lutheran pastors from throughout Europe were ordained, with the city's theology professors examining the applicants."[40] Thus, the scene celebrates the beginning of Christ's ministry as coinciding with the origin of the Protestant church in Germany. Luther and Johann Friedrich are not there in the simple spatial sense, but affirm the event prayerfully, faithfully across time. The past and present are type and antitype. Luther is the modern John the Baptist while Johann Friedrich and his family imitate Christ's submission to divine will and establish thereby the connection between heaven and earth. The two worlds are parallel, but do not touch. They only join in the person of Jesus, who is revealed here to be man and god. The image affirms the fundamental Reformation principle of returning to the source. As a latter-day John the Baptist, Luther anoints the elector's choice to support the Reformation as a purification of the church and a return to its origin. One might say that the image proclaims the inauguration of Jesus's *modern* public ministry. Produced just after Johann Friedrich's death in 1554, the print affirmed the Saxon nobleman's support for the Reformation in spite of his fate in the Schmalkaldic War, when he was imprisoned for several years by Charles V and stripped of his electoral title.

To be sure, Lucius's print and El Greco's painting are different genres of imagery. The first is a mass-produced historical allegory applied to political propaganda and the popular commemoration of Lutheran culture heroes. The second is an altar painting—propaganda, certainly, but no less part of an altar devoted to liturgical and devotional intercession. But both were politically engaged artifacts that manipulated time in order to shape religious consciousness. Both bend the rules of time and space to suit their purpose. El Greco placed a first-century martyr and a fourth-century bishop at the reburial of a fourteenth-century count as mystically witnessed by a gathering in the sixteenth-century. Lucius took comparable liberties. And both situated the present and the past on the cusp of the eternal. Yet the relationship of heaven to earth is different in each image. The Lutheran image beholds the heavenly world only through the act of faith, as a prayerful contemplation of an ancient miracle. El Greco, by contrast, sees the present opening organically into the eternal. The Catholic faith, his painting announces, is unified by its mystical communion of saints across and beyond time. Lucius's image operates in the

pictorial mechanics of political allegory, in which meaning is deciphered. The present mirrors the past, his print asserts: the Reformation is in harmony with the foundation of the true church of Jesus Christ.

Compare in this regard the roles of hands and of sound in each image. Lucius shows the hands of Johann Friedrich and family assembled in prayerful consideration of Christ's baptism. These latter day figures do not *see* Jesus wading in the Elbe; they contemplate his "figure." This more mediated relationship is announced in the image's title, "The Figure of the Baptism of Our Savior Jesus Christ."[41] The figure of speech is an "as if" in which *see* means *believe*. Rather than witnessing the ancient baptism, they *believe* that Christ's baptism impinges on their world in the figuration or allegorical translation of "as if." Further, we are told in the full title of the print that "all Christians should ponder [*betrachten*] in calling [on Jesus]" that the deity consists of three persons eternally in one. Believers are to consider, observe, or behold (the German verb may be rendered by each English word), the mystery of the Trinity as they behold the baptism of Christ as the revelation of the triune godhead. And so we see the noble family with their hands joined in prayer.

The entire woodcut integrates sight and sound. Luther and Johann Friedrich watch the revelation that is described in the Gospel of Mark. They see what they hear from above, though they seem quite unaware of the turbulent heavens above them and the divine action of God and the Holy Spirit. Yet in some sense what they see is the sound of the word of God booming from heaven, the very sound once transliterated into the Gospel of Mark and now transformed into image. One of the verses below the image refers to the "voice" *(Stimme)* of the Father who attests to his son, as the Gospel of Mark indicates (Mark 1:11). The next stanza reads:

> We all should hear him with zeal
> and prize him above all things.
> Therefore let every Christian see
> when he is in fear and need
> that he should seek comfort and salvation
> not with creatures, that is fraud
> the idols should not be called on
> their strength and value is a lie
> one should call on God alone.[42]

The intermingling of sound and sight couples seeing, hearing, and reading in the same way we see the painter Lukas Cranach the Elder do in a well-known image of Luther preaching (see figure 10).

This enfolding and relaying of sound, text, and image, the mechanism of meaning that Lutheran imagery had come to espouse, is not at all how El Greco's image works. The hands in his painting enact a literal gesticulation of beholding. The priest in the foreground, the knight between Stephen and Augustine, the Augustinian monk to the

left, and Saint John the Baptist above them all refer with their hands to a miracle before them, giving the embodied response, "Behold what is happening." For the Catholicism of the Counterreformation images do not *signify,* they *show.* And the eye does not interpret, but rather witnesses the material manifestation of divine action.

## VISUALIZATION IN IGNATIAN SPIRITUALITY

The Council of Trent, while undertaking some reforms aimed at curbing the abuse of church offices, focused much of its energy on responding to the schism in Northern Europe. The same decade that saw the first sessions of the Council also witnessed the formation of another arm of the Counterreformation, which would stretch from Rome, across Europe, and into the Americas and Asia. The Society of Jesus, or the Jesuit order, was organized by Ignatius Loyola (1491–1556) and authorized by Pope Paul III in 1540. Even before the order was founded, however, Ignatius had composed his most enduring work, the *Spiritual Exercises,* a remarkable manual for cultivating the spiritual discipline of self-examination as an intensive practice of visual introspection. The manual, organized into four "weeks" or sections, guided practitioners through a series of highly structured forms of visualization of moments in the life and passion of Jesus over the course of many days, with intervening experience of fasting, prayer, flagellation, canonical hours, mass, confession, and penance.

Most striking is the work's intensive, multi-sensory practice of visualization. The exercises are affective, deeply imaginative, rigorously introspective forms of guided meditation that take reader-participants from the fires of hell through the birth of Jesus to his Passion and Crucifixion and finally to the Resurrection. At each stage, practitioners are told to form a "composition," which consists of becoming able to "see the place."[43] The modus operandi is set out at the beginning of the first week: in "a visible contemplation or meditation, as, for instance, when one contemplates Christ our Lord, Who is visible, the composition will be to see with the sight of the imagination the corporeal place where the thing is found which I want to contemplate."[44] Ignatius was influenced by late medieval contemplative literature such as Thomas à Kempis' *Imitation of Christ,* in which affect played a primary role in identification with Jesus. Devotion and contemplation were not disembodied, but grounded in the faculties of feeling and imagination. Ignatius made abundant use of the imagination and the senses in the contemplation of hell, infamously celebrated in the graphic account of the Jesuit instruction of the youthful narrator of James Joyce's *Portrait of the Artist as a Young Man* (1916), in which the teacher dwells for pages on the agonies of those in hell. Likewise, the *Spiritual Exercises* direct the meditator "to see with the sight of the imagination the length, breadth, and depth of Hell," and to contemplate in every sense "the pain which the damned suffer." The diligent meditator is instructed: "to see with the sight of the imagination the great fires, and the souls as in bodies of fire . . . to hear with the ears wailings, howlings, cries, blasphemies against Christ our Lord and against all His Saints . . . to smell with the smell smoke,

sulphur, dregs, and putrid things . . . to taste with the taste bitter things, like tears, sadness, and the worm of conscience . . . to touch with the touch; that is to say, how the fires touch and burn the souls."[45] Ignatius cultivated a practice of contemplation that was robustly somatic, applying all faculties and senses to the immediate interior sensation of the object of contemplation, with the intention of dismantling distance and indifference. The aim is to "conquer the self" by learning to regulate it.[46] Visualization was a dismantling and reconstruction of the self in a discipline that would regulate its every feeling and thought. Ignatius championed the idea of spiritual calisthenics in which the spiritual interior, or soul, was analogous to the body. The *Exercises* seek to discipline thought, body, and imagination on the analogy of bodily exercise: "For as strolling, walking, and running are bodily exercises, so every way of preparing and disposing the soul to rid itself of all the disordered tendencies, and, after it is rid, to seek and find the Divine Will as to the management of one's life for the salvation of the soul, is called a Spiritual Exercise."[47]

In the third week of the *Exercises,* the practitioner is instructed to experience "grief, feeling, and confusion because for my sins the Lord is going to the Passion."[48] The path leads from the Last Supper to Gethsemane to the scourging of Christ and finally his crucifixion and burial. In effect, week three is a virtual experience of the Stations of the Cross, itself a recapitulation of the pilgrim's walk on the Via Dolorosa. Visualization is the fundamental medium of this virtuality, an imaginative projection of oneself into the scene that strips the meditator of dispassionate distance and replays the ancient contemplation of Christ's miseries and sorrows in the flesh of the shamed and guilt-stricken viewer. Not only did Ignatius condense centuries of spiritual practice into the *Spiritual Exercises,* he made the imagination a leading feature of contemplation for more than the cloistered elite, which had long engaged in dramatically visual forms of mystical experience. Ignatius applied a new psychological regimen to the practice of meditation among a far broader range of Catholics.

The *Spiritual Exercises* were fundamentally supportive of the Counterreformation, so much so that in 1548 Paul III issued a papal brief, *Pastoralis officii,* approving the *Exercises* and authorizing their use among the faithful.[49] Ignatius included at the end of *Spiritual Exercises* a list of rules to be observed in order "to have the true sentiment which we ought to have in the church militant."[50] The first of these is "to have our mind ready and prompt to obey, in all, the true Spouse of Christ our Lord, which is our holy Mother the Church Hierarchical." Ignatian spirituality regarded the mind as an elastic faculty that could learn to stretch itself into the shape of the holy as the Church understood it. This is evident in the absolute degree of obedience that Ignatius demanded, as the thirteenth rule makes bracingly clear: "We ought always to hold that the white which I see, is black, if the Hierarchical Church so decides it."[51] And to this blind obedience he added the Tridentine necessity of venerating the saints, their relics and images, and honoring the practices of the Stations of the Cross, pilgrimage, indulgences, and more.[52] Obedience was the core value because it was the pivot around which the mind could be shaped to serve the Church. And the visualization practiced and promoted by the *Exercises* demonstrated the

plasticity of subjectivity. The new medium for achieving the Church's aims was consciousness itself, shaped by the disciplinary rigors of Ignatian meditation: imagination was the new frontier. Where the Protestants discovered the value of mass-produced material imagery to shape public opinion as Evangelical propaganda, the Jesuits pioneered the power of internal imagery to form consciousness from within and instill a Catholic sensibility.

This trend was affirmed in 1593 by the appearance of a book densely illustrated with engravings by, among others, Anthony, Jerome, and Jan Wierix. The *Evangelicae historiae imagines,* or *Images from the Gospels,* had been written by Jerome Nadal (1507–80), aide to Ignatius, but not published during his lifetime. Nadal's work was intended as a pictorial guide to those using the *Spiritual Exercises.* Its task was to enable the intricate introspection that Ignatius taught as a powerful form of meditative prayer. Nadal undertook the tutoring of the imagination, recognizing how the brain works and can be best applied to devotional practice. Ignatius conceived of the imagination according to a long tradition of internal images that relied on place or spatial arrangement, especially by analogy to the manuscript page. This had been the way to train and exercise memory in the medieval world.[53] Ignatius moved from the memory of texts to engaging visual memory in an elaborate construction of place, regarding the production of mental imagery as a way to incite devotion and shape the mind into a vehicle of intense piety. Creating a sense of place in which memory unfolds was an ancient oratorical technique and one still practiced in Ignatius's day.[54] But he understood the imagination of place as a meditative technology that infused introspection with religious feeling. One did not merely remember the events of the Gospels, but constructed them in the mind as imaged sites whose process of visualization was interlarded with feeling and emotion. Imagination became a powerful creative act and introspection a searching inward practice that recoded neural networks to the shape and felt terrain of the individual's relation to what was imaged. The result was a reshaping of will and of the entire person.

The imagery of what came to be known as Nadal's *Illustrated Spiritual Exercises* is dedicated to the visual practice of Ignatian introspection, especially with respect to meditative prayer.[55] Consider figure 6, "On the Day of the Visitation," by Jerome Wierix, one of the opening plates of the book. Throughout the book, the engravings are composed around a central set of figures, very often positioned within an architectural milieu. Around this central placement appear vistas of events in the distance. Typically, these discrete scenes occur in windows, doorways, or apertures that open up onto the distance or position each scene as if it were a medallion floating above or behind the central configuration, as in figure 6. The page clusters a host of discrete moments from "the day of the Visitation," evoking thereby a temporal envelope in which the meditator's focus is fixed. Thus, just above Elizabeth and Mary in the foreground is a glimpse through the wall of Mary and Joseph traveling from Nazareth. Above this square image appears a circular frame encompassing the Annunciation. To either side of the central figures are vistas into the distance, where we see the birth of John the Baptist on the left, and on the

IN DIE VISITATIONIS.
Luc. i.

2
cxlix

A. *Nazareth, vbi repræsentatur Annunti- atio, poſt quam Virgo Mater ſtatuit Elisabetham inuisere.*
B. *Iter habet Maria feſtinanter cum Ioseph ad montana Iudeæ.*
C. *Domus Zachariæ in tribu Iuda in montibus.*
D. *Ad quam cum peruenißet Maria feſti- naut ad Elisabeth.*
E. *Sedula illi Anus occurrit, ſed eam tamen*

*prior ſalutat Maria.*
F. *Audita Matris Dei ſalutatione, ecce exultat in vtero Elisabeth Filius, & repletur Spiritu ſancto Mater, & prædicat Mariæ diuina encomia.*
G. *Zacharias & Ioseph laudant Deum.*
H. *Nascitur Ioannes.*
I. *Poſt eius ortum, redit Nazareth Maria Virgo Mater cum Ioseph.*

FIGURE 6
Jerome Wierix, *The Visitation*, in Jerome Nadal, *Evangelicae historiae imagines* (Antwerp: Plantin, 1593). Courtesy of Woodstock Theological Center Library, Georgetown University.

right Mary and Joseph going to the city of Judah in order to visit her relatives, Zechariah and Elizabeth (Luke 1:39). We know the identity of each of these scenes because each portion of the collage is labeled with a small letter that is keyed to a list of Latin captions below. The careful articulation of scenes in Wierix's engravings corresponds directly to the Ignatian "composition of place," what Ignatius also called "seeing the place," in the *Spiritual Exercises*, was the genesis of the meditative process. He defined this as follows: "the composition will be to see with the sight of the imagination the corporeal place where the thing is found which I want to contemplate."[56] The point of doing so was very clear: "to seek and find the Divine Will as to the management of one's life for the salvation of the soul."[57] In describing the aim of the first exercise, Ignatius wrote that the "first point will be to bring [into inner sight] the memory of the first sin" against God, "and

then to bring the intellect on the same, discussing it; then the will, wanting to recall and understand all this in order to make me more ashamed and confound me more."[58] The visual practice of introspective meditation was intended to integrate the human faculties, as Ignatius understood them, into a singular indictment of human guilt, to induce shame and to destabilize any sense of self-satisfaction. In other words, just as the mind constructed interior scenes, it did so to dismantle vanity and ego.

The engravings were intended to show meditators what their mental images should include and how the tableaux might be designed to incorporate it all. In figure 6 the process of visualization begins with place, the setting of the interior space defined by the architecture and labeled "C," that is, "the house of Zechariah of the tribe of Judah in the hill country," paraphrasing Luke 1:39. From there, the scenes register the biblical narrative. Against the background of these locative coordinates, the image features Mary meeting Elizabeth, the frontal figures, who perform the dramatic denouement of the narrative conveyed scenographically in a radial span behind them. The eye scans the array of visual episodes, darting from scene to scene to the central figures in order to assemble a coherent scheme or temporal sequence, combining image and text until the mind is satisfied that everything is identifiable and has found its place in a narrative that one already knows. By seeing the scenes of Christ's life painted within the imagination, viewers may come to recognize intimate existential implications and therefore overcome self-will and submit themselves to divine will. We see the humility of the Virgin Mother, the pious submission of Joseph, Zechariah's recognition and embrace of Joseph the paternal substitute who upheld Mary's honor, their selfless conformity to the will of God working through each episode of the sacred narrative, moving it along to its culmination in the crucifixion of Jesus. Seeing in such a way is not a passive witnessing, but an inwardly directed working on the self, an image-making that exercises a shaping effect on the self. Seeing is feeling. As a result of such a conception, imagination took on a new moral efficacy and duty.

The *Spiritual Exercises* were undertaken by clergy, religious, and laity alike. The success that the meditative practice experienced inspired new generations of Jesuits to produce meditation literature, much of which was illustrated by remarkable engravings.[59] One of the most popular such books was Jesuit Antoine Sucquet's *Via Vitae Aeternae*, or *The Way of Eternal Life*, which first appeared in 1620, but quickly went through several editions, and was translated into French in 1623; both the French and Latin versions contained illustrations by Boetius Bolswert (figure 7).[60] Sucquet's book was deeply informed by the *Spiritual Exercises*, and systematically deployed its visualist sensibility, providing an image for each of its twenty-four meditations.[61] The organizing metaphor for Sucquet, drawing from the *Spiritual Exercises* and Jesuit spirituality generally, was the discernment and choices that earthly pilgrims must make to fulfill the purpose of their lives, salvation. His book is a Jesuit *Pilgrim's Progress* seventy-five years before that Puritan masterpiece appeared. Celestial Jerusalem looms throughout the text and its visual apparatus. The figure with his back to the viewer in these engravings is "us," the

Christian reader/viewer who is engaged in the meditative work of discernment. The imagery offers a panorama that serves to map out the moral choices and spiritual discernments to be made by the meditator.[62]

Fundamental to Jesuit theology and spirituality was the idea of free will, the capacity and call for each person to submit to God's will. We see it at work in the image reproduced here (figure 7), where the Christian practitioner is shown at an easel, gazing on a landscape that recedes into the distance. The subject of the meditation is imitating the examples of the saints, and a line of them has assembled conveniently before the painter-soul, consisting of Our Lady, Saint Paul, Saint Anthony, and even Saint Ignatius himself, who was beatified in 1609 and canonized in 1622, and appears directly in front of the painter, holding the glowing monogram of the Society of Jesus. A winged personification of Virtue casts pagan "philosophers of old" in shadow and points the painter's attention

to the Christian saints. Saint Jerome is visible in the distance, at work in a cave lined with codices, and further back is a host of martyrs outside what is presumably the walls of Rome. Because the soul is free, and charged with the paramount responsibility of making a choice about the direction its life will take, all these Jesuit examples of the rhetorical operation of imagery, both external and interiorly visualized, were applied to the soul's persuasion, not coercion. To this was added the help of the saints and martyrs, their images and relics, and the writings and labor of the heroes of the faith. The imagery and the visualizations of the Ignatian *Exercises* and guide books like Sucquet's seek to map out the total view of life, the long path to Jerusalem glimpsed in the remote distances of Bolswert's engravings. As the preeminent religious order in the Church militant of the Counterreformation, dedicated to education and missionizing, the Jesuits took their visual practice far and wide, and taught the modern world how to imagine.

# 2

## THE VISIBLE WORD

It is often said that Protestantism has no place for images. In fact, Protestants have virtu-
ally always made use of images in one way or another. Yet the view persists that Protestant-
ism is aniconic. This probably depends on several things. One may be the tendency among
many Protestant groups to avoid imagery in worship settings, though rarely in the home,
school, or everyday life. Another reason is likely the episodes of iconoclastic riots in the
1520s in Germany and Switzerland, and in the Netherlands and England a few decades
later. Historians have often treated these ritualized forms of violence as convenient events
to locate the birth of the Reformation, a decisive break with the Catholic past symbolized
in a dramatic gesture of communal defiance. And a third reason for the myth of Protestant
aniconism is surely the theology of reformers such as Ulrich Zwingli and John Calvin,
who insisted that images were incapable of teaching Christian truth, for which the Bible
was the only reliable source. Zwingli taught that images could not serve in worship and
must be removed from churches. Even images that were not being worshipped ought to
be removed. In his *Commentary on True and False Religion* (1525), Zwingli argued that
"since sure danger of a decrease of faith threatens wherever images stand in the churches,
and imminent risk of their adoration and worship, they ought to be abolished in the
churches and wherever risk of their worship threatens."[1] "Do you not see," he asked his
interlocutor in another treatise, "that the highest, purest worship is to follow the will of
God? Images do not teach us this, or move us to do it; for they have never done anything,
nor are they doing anything now to move us to godly works. Listen to what they move us:
to a blind, lazy devotion."[2] True faith was free of images. Calvin (inaccurately) limned a

nonvisual first five centuries of the Christian church as the basis for rejecting images in Christian worship: "If we attach any weight to the authority of the ancient Church, let us remember, that for five hundred years, during which religion was in a more prosperous condition, and a purer doctrine flourished, Christian churches were completely free from visible representations."[3] In fact, the recovery of an age of prepapal Christianity, free from the corruptions of superstition, clerical intrigue, idols, and relics—the professed ideal that some Protestants still imagine to be their aim—would not be a recovery of an aniconic church, but one populated by catacombs, shrines, pilgrimage churches, and sanctuaries replete with frescos, mosaics, and sculptured figures.[4]

It is certainly true that there were notable episodes of destruction and organized removal of images from formerly Catholic churches in cities that served as the hotbed for the earliest years of the Reformation, and they have been well documented and care- fully studied by historians.[5] The Protestant anxiety about images is clearly registered in the cover illustration to a widely circulating pamphlet that calls for the end of images in churches in 1522 (figure 8). The tract was published by a former colleague of Martin Luther at Wittenberg University, Andreas Bodenstein, called Karlstadt, who argued that images in churches were a violation of the first commandment. He insisted that his contemporaries loved images more than one another, showing them honors that betray affection. Images, in Karlstadt's formulation, are "stuffed dummies" or fake human beings, and those who love them become as abominable as the idols they love.[6] People treat them as living beings, even as God, whom Karlstadt heard asking image-adorers: "You light candles before them, which you should do for me, if you wish to burn a light at all. You bring waxen offerings to them in the shape of your diseased legs, arms, eyes, head, feet, hands, cows, calves, oxen, sheep, house, property, fields, meadows, and the like, as if such images would give you healthy legs, arms, eyes, head, etc. or would pro- vide you with fields, meadows, houses, honor, goods, and possessions."[7] The rejection of images marked a fundamental shift for Protestants from what they considered a com- merce of purchasing divine favor to an evangelical conception of free grace. In the pas- sage above, Karlstadt alludes to the material economy that pilgrimage to shrines entailed in the offering of ex-voto effigies for the favor of divine healing. What he proposed in the removal of images was the termination of one sacred economy and the installation of another. Zwingli said the same in 1525.[8] In 1520 Luther called on German nobility to support a broad plan of reforms that would enact his sharp critique of the avarice of pilgrimage churches, the sale of ecclesial office, the payment of annual dues to Rome, the sale of indulgences to support crusades against the Turks, payment for private masses, and a host of other financial arrangements.[9] The alternative sacred economy consisted of the circulation of wealth in the form of sacred information: the good news of salvation by grace. This liberated people of their dependence on the intermediary device of images as a way of currying favor among the saints.

But the new sacred economy did not eliminate images. It repurposed them as forms of rhetoric, as visualized speech, as sacred information in order to serve several purposes

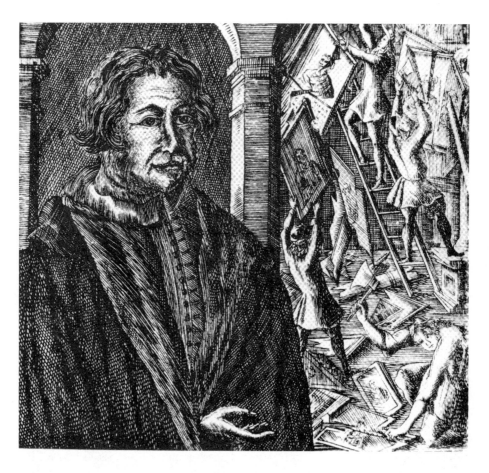

Cover of Andreas Bodenstein Karlstadt, *Von der Abthung der Bilder,* engraving, circa 1600. Courtesy of Snark / Art Resource, NY.

that were important to Protestants: propaganda, pedagogy, advertisement, evangelism, and public discourse. In fact, Karlstadt's essay did not advocate or urge destruction of imagery, only removal. Figure 8 envisions not what Karlstadt proposed, but rather what others had done and continued occasionally to incite and perform. Yet even if Karlstadt did not call for the demolition of images, the act of chopping up images of saints was a powerful symbolic expression of his own desire to break a persistent habit. He conceded at the end of his essay that he found it very difficult to put images out of his own heart:

> I ought not fear any images just as I ought not honor any. But (heaven help me!), my heart has been trained since my youth to give honor and respect to images and such a dreadful fear has been instilled in me of which I would gladly rid myself, but cannot. Thus I am afraid to burn a single idol . . . . Though . . . I know that images are incapable of anything

and that they lack life, blood, or spirit, fear holds me back and causes me to fear a painted devil, a shadow, and the slightest noise of a rustling leaf, and to flee that which I should seek out bravely.[10]

It is a telling confession because it suggests the value of symbolic violence as a kind of aversion therapy: in destroying or at least summarily removing images in a grand purgative act, Karlstadt may have believed that he would master his iconophobia by banishing the mechanism of desire that had organized his imagination for so long. Whatever the case, because images never actually vanished from Lutheran practice it seems compelling to conclude that the episodes of their removal and destruction, known as the Bildersturm (literally, "storm on images"), did not determine the Reformation as aniconic, but rather helped to inaugurate a new mission for images in a new economy of the sacred. Protestantism—and not just Lutheranism—by no means ended the visual culture of Catholicism; rather, it reappointed it. Protestants developed new uses for images that yielded productive visual legacies that remain in place today.

The Reformation was not a return to year zero, as many of its proponents have never tired of insisting. The ritualized violence of the *Bilderstürmer,* those who actually entered churches and smashed images, performed such an end for advocates by destroying the symbols of the old regime. With endings came new beginnings in the magic of ritual. Yet rather than the recovery of a pure, previsual early Christianity, the Reformation as a religious event is more accurately framed as the beginning of a shift from an older conception of Christendom to one that conceived of authority in different terms. Some historical background is necessary to frame the shift undertaken by Reformers.

Since the sixth and seventh centuries, the bishop of the see of Rome aspired to preeminence in Western or Latin Christianity, seeking to assert the symbolic capital of the Christian empire founded by Constantine in the fourth century. The West enjoyed less power after the empire's center shifted officially to the imperial capital of Constantinople in the eastern domain of the Roman Empire. The bishop of Rome entered into greater dependence on princes and regional leaders in Western Europe and by the eighth century anointed Charles the Great as the Holy Roman emperor to champion the continental conception of the Western church, which became synonymous in the European mind with Christendom proper, as the Iberian peninsula gave way to the steady advance of Islam. As Fortress Europe—from Sicily to Sweden and from Portugal to Lithuania—Latin Christendom anchored itself to its geographical boundaries as they took shape, to create an enduring sense of place. Though the Holy Roman Empire never counted for much in the way of actual military might in a Europe of warring duchies, kingdoms, and ambitious popes, as an ideal it corresponded to an imagined expression of shared identity that played out politically in the dynamics of elective monarchy. And though the Crusades—late medieval Europe's attempt to "recover" the Holy Land, vindicate the honor of Latin Christendom, and establish the primacy of the Roman pontiff—accomplished less to that end than the fall of Constantinople to the Ottoman Empire in

1453, they served to bolster Europe's abiding imagination of itself as opposed to the Muslim infidel, an idea that persists to this day.

Luther, Calvin, Zwingli, as well as Henry VIII, James VI, Elizabeth I, and others changed the older imagination of Christendom by augmenting the de facto sovereignty of the Holy Roman Empire's patchwork of duchies, principalities, and kingdoms. Most radical, in the long term, for political economy and religion in the modern era was the idea of the sovereignty of the nation-state. It took time for this idea to emerge. The Peace of Westphalia, ending long wars between Catholics and Protestants, occurred in 1648. Before that, the sovereignty of kings as protectors of true religion was the focal point of ongoing crisis and bloodshed.

The affirmation of the Protestant king was taken up in John Foxe's *Acts and Monuments*, better known as *The Book of Martyrs*, first published in 1563, but issued in new editions for many years after that. The visual scheme that opens book 9 of the 1570 edition juxtaposes an illustration of the removal of images above with the enthroned monarch and proper image of Protestant worship below (figure 9). As one kind of imagery is eliminated, per Karlstadt's suggestion, another is installed. The image portrays the ideal relation of monarch and pure religion, pictured beneath the expulsion of Catholics and the destruction of idols during the reign of Edward VI (1537–53), the teenage king whose short reign Protestantized the Church of England by purging the lingering Catholic framework of his father, Henry VIII.

The illustration appeared at the beginning of the ninth book in order to mark the turbulence of a very difficult period in English history, initiated by Henry VIII and extending to the reign of his daughter, Elizabeth I, who came to the throne in 1558. The image was intended to mark the end of the "popish" regime invested in the sacred economy of images, or "idols," and the dawn of what John Foxe hailed "the mild and halcyon days" of the reign of Edward VI, who reconfigured the relationship of church and state.[11] Located between Edward and Elizabeth, the few years of Mary's tempestuous and bloody rule saw the brief return of Catholicism, but Elizabeth's long tenure stabilized the political landscape by establishing an English Protestant church in a Religious Settlement (1558–59) that became the basis of the modern Church of England. Henry VIII had rejected the supremacy of the pope in matters of state and the king's conduct, but had not altered much else. Edward pushed toward a Protestant establishment with the counsel of his principal advisor and tutor, Thomas Cranmer, archbishop of Canterbury. Foxe compared Edward to Josiah, a biblical King of Judah.[12] The parallels were enumerated by Foxe: like Edward, Josiah came to the throne as a boy, and reformed the temple in Jerusalem when the book of the law, thought to be Deuteronomy, was discovered there (2 Kings 23). Josiah ordered all items used in the worship of Baal and other deities be removed from the temple and destroyed, and "deposed the idolatrous priests whom the kings of Judah had ordained to burn incense in the high places" (2 Kings 23: 5). The sacred economy of polytheistic worship was expunged by ritual violence to make room for the new order, the return of the old covenant.

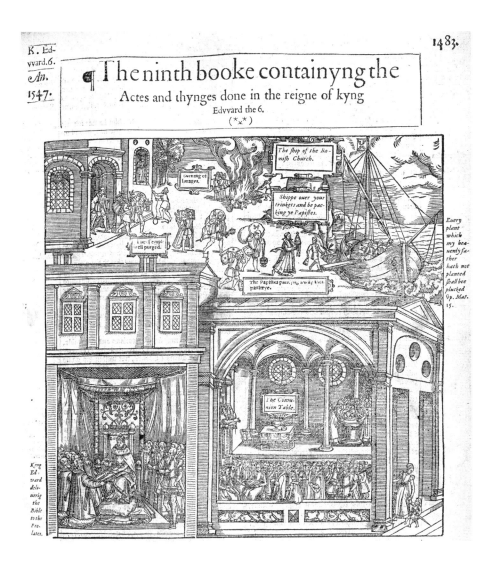

¶ The ninth booke containyng the
Actes and thynges done in the reigne of kyng
Edvvard the 6.
(★ₓ★)

FIGURE 9
"Actes and thynges done in the reigne of kyng Edvard the 6," in John Foxe, *Acts and Monuments*
(London: Printed by John Daye, 1570), book 9. By permission of the Folger Shakespeare Library.

The comparison justified Protestant reforms, casting England as the latter-day Judah
and Edward as divinely appointed for the special task of reforming church and throne:
as the biblical king had purged the temple and destroyed pagan altars,

> the like corruptions, dross, and deformities of popish idolatry (crept into the church of
> Christ of long time), this evangelical Josias king Edward, removed and purged out of the
> true temple of the Lord. Josias restored the true worship and service of God in Jerusalem,
> and destroyed the idolatrous priests! King Edward likewise, in England, abolishing

idolatrous masses and false invocation, reduced again religion to a right sincerity . . . . Moreover, in king Josias's days the holy Scripture and book of God's Word was utterly neglected and cast aside, which he most graciously repaired and restored again. And did not king Edward the like, with the selfsame book of God's blessed word, and with other wholesome books of Christian doctrine, which before were decayed and extinguished in his father's days, by sharp laws and severe punishments, here in England?[13]

The illustration used by John Foxe (figure 9) presents Edward as the latter-day Josiah, purifier of the Church, champion of Scripture, and kingly reformer of laws to support religious reformation.[14] We see the candelabra, vestments, paten, censors, and chalice being carried from the church entrance, a blazing fire consuming images, and "papists" boarding a ship to take them back to Rome. The engraving presents an English reformation patterned after Josiah's. With the removal of the items associated with Catholic liturgy and mass, the purged temple is restored to its proper use as the place for preaching the word of God, which we see in the scene in the lower right.

Josiah had ordered the temple to be renovated, which resulted in the discovery of the Deuteronomic scroll and the reforms that followed. Likewise, the young, unbearded Edward seated on his throne receives a large codex labeled "Biblia" with one hand and holds an upright sword with the other. He balances in his person the emblems of church and state as "supreme head" of the Church of England and sovereign monarch of the realm. As restorer of the true Church, Edward is shown enthroned in a chamber that sits beside the sanctuary, Josiah's repristinated temple, where someone, possibly Cranmer, preaches to an attentive, well-dressed audience in the foreground. Behind them are staged the symbols of the two sacraments that remained after the purge of Catholicism, which recognized seven sacraments. The two are baptism and communion, labeled in the print very noticeably as "The Common Table." The nomination was meant to distinguish very sharply the Protestant sacrament of Holy Communion from the Catholic Mass. Cranmer had labored to abolish the Catholic concept of real presence, the idea that the bread and wine of the Eucharistic meal were really the body and blood of Jesus and that the ritual consecration of the elements repeated the sacrifice of Jesus and enacted their transubstantiation into his body and blood.

Foxe's *Acts and Monuments* was an enormously successful publication, remaining a steady seller among Anglo-American Protestants for several centuries. The book passed through four editions in English during Foxe's own lifetime (d. 1587), and dozens more thereafter. From the first English edition, issued in 1563, the *Acts and Monuments* was illustrated with half and full-page engravings.[15] In sixteenth-century Germany the production of illustrated tracts, sermons, and broadsides promoting one issue of reform or another was even more robust. The setting for a great deal of Protestant imagery was illustrated print. This is because Protestants in England, Germany, and elsewhere were convinced of the power of information to shape public opinion. Images could enhance text in compelling ways, building on its emotional impact, sharpening its value as

propaganda, adding humor or bite to satire, illustrating abstract ideas, or enriching textual descriptions of spectacles, regal scenes, or individuals. And, as we have seen in each of the illustrations discussed here, images offer another powerful psychological opportunity: one can be razed and replaced by another.

Further, these images, as I've noted, each capture the shift from one economy to another. According to the Protestants, the Catholic side negotiated quid pro quo with saints and God, offering pledges or thanks in the form of the devotional veneration of images, lighting candles, offering incense, purchasing indulgences, or pilgrimage. Protestants replaced this economy with an ambitious traffic in sacred information. It was no longer what you offered or gave up that secured divine favor, but what you knew that counted. One did not buy God's attention, but learned to recognize one's place on the social map of the new Christendom. The vital importance of print derived from its role in disseminating knowledge of the social terrain, allowing readers or hearers or viewers to locate themselves. The sacrament of Communion was no longer an ontological exchange between the communicant and God, but a social exchange among the community of believers. The host was not a concretization of divine mystery, not a chance to adore divine substance and implore it for favors. Protestants continued to debate what it meant, but many were coming to see it as no more than a ritual of commemoration that strengthened the community of those gathered around the table. Access to the common table meant membership in the church, which meant social visibility and recognition.[16] But information was most essential for the salvation of the soul. Without it, individuals were uninformed of the law of God that condemned them and of the grace offered for their redemption. Preaching replaced the practices of confession, clerical office, indulgence, intercession, and penance as chief means of compensating the debt that transgression or sin accrued. Preaching the word meant hearing what God had to say. And in the Protestant sacred economy, only God dispensed goods in response to human need. Human beings were unable to purchase divine favor. Grace came at no price; it arrived only at God's instigation. But knowing this was the key to availing oneself of the gift.

For Lutherans this idea was set forth very clearly in an altarpiece painted by Lukas Cranach the Elder, the predella, or base image, of which shows Luther preaching to a congregation in Wittenberg (figure 10). Preacher and people occupy either side of a barren space—at least the viewer registers that it should be barren, all the while seeing, at the center, an image that makes visible the sound of the preacher's voice. We might call it a sonic emblem, a visual index of sound. This term signals an innovation, recognizing the way in which voice, text, and image join in Protestant sensory culture. The flattened, highly symmetrical character of the crucified figure in the center of the image recalls the tradition of emblem books, which gathered allegorical images or ideograms that represented abstract ideas. We could understand Cranach's figure as an emblem in that lineage. But his use of perspective to delineate the church interior, a kind of resonance chamber for Luther's voice, may have encouraged him to give the emblem more solidity:

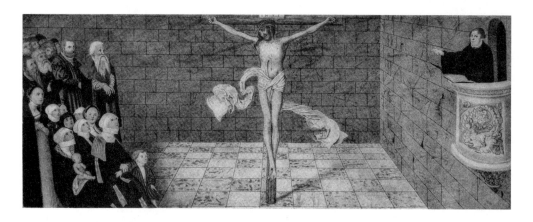

FIGURE 10
Lukas Cranach the Elder, *Luther Preaching*, predella of Wittenberg Altar, 1547. Courtesy of Foto Marburg / Art Resource, NY.

we see that the cross casts a shadow over the smooth flagstones. Yet we remain aware that the figure's presence is not literal, but discursive. The scene shows us what is happening, which is a sermon. Luther is preaching "Christ crucified," that is, he is announcing the gospel of salvation, achieved through the sacrificial work of Jesus on the cross. Luther's left hand rests on the open Bible, while his other hand points to the figure of Jesus. Text, gesture, speech, image, and listeners operate together in a single loop of communication. The people see what they hear and Luther speaks what they see. He touches what he reads and points to what he says. This imbrication of the senses is captured in the frame of a single image. The image seems to work against itself in order to achieve a new level of signification. The emptiness of the church interior is striking because it concentrates our attention on the space between speaker and hearers. Arcing across this stone-lined vault of air is the sound of the preacher's voice, whose airy reverberation animates the ruffled drapery afloat about Christ's waist. The new economy of the sacred could not find a better representation: Luther speaks God's word and in it brings his audience into direct contact with the deity's gift of salvation. The gaze they fix on the crucified figure indicates they have left behind the intercessory mechanism of devotion to the (now absent) saints, with its economy of exchange, for the new economy of the divine gift. There is only the deity himself to make intercession possible. The preacher's words reveal the very thing to which they refer, and the people hear the event of their salvation.[17] We might say that the image affirms the iconicity of scripture and preaching as the media of revelation and salvation. The new icons are words, but to see them at work, images become the new acolytes.

As a panel in an altarpiece, Cranach's image of Luther preaching the news of redemption is a fundamental rejection of the claim made by Karlstadt, Calvin, and Zwingli that images could teach nothing about religious truth. In this and many other works, many

made for use within the sanctuaries of Lutheran churches, Cranach and other artists developed a Protestant pedagogy of visual teaching.[18] Karlstadt had explicitly rejected the idea that images were the books of the illiterate, an idea famously proposed by Pope Gregory in an oft-cited letter of the sixth century. Ulrich Zwingli made the same point in 1525 and a decade later John Calvin followed him, as in many points, rejecting a long Catholic tradition that justified the use of images in the Church.[19] Luther, by contrast, had defended the idea, noting the irony that the iconoclasts quoted from his German translation of the Bible, which carried many woodcut illustrations. He then went on to wish that such imagery might be painted on walls "for the sake of memory and better understanding," even hoping that "the lords and the rich might let the entire Bible be painted on the inside and outside of their houses before everyone's eyes."[20] Cranach and his son, also an artist, devoted their active studio to the steady production of altarpiece commissions and broadside prints that took a strongly didactic approach to presenting a Lutheran conception of key biblical teachings such as condemnation and redemption. If one notes the rapt contemplation of Luther's audience in figure 10, it is clear that Cranach's image is redirecting the transfixed gaze with which late medieval people adored the Host to the new object of the spoken word, whose concreteness was anchored to the event of the Crucifixion as the basis of salvation.

## THE LOCATION OF IMAGES IN PROTESTANT LIFE

Although there are many Protestant groups for whom imagery in the sanctuary and as part of formal worship is rare if not unheard of, there are virtually no Protestants who have not made some use of images. We simply need to look in the right place to find them. The terrain of religious life is larger than the sanctuary of a church. While this is often the zone most highly charged and publicly scrutinized among Protestants, it is not necessarily the most important space. Home, tavern, municipal building, and schoolroom are often no less important for the practice and publication of the faith. For the practice of inculcating and socializing children, the home was arguably the most powerful site in Protestant life before the nineteenth century and the rise of public schools, because parents taught their children to pray, study scripture, and read and write. It is important to map the Protestant life-world in order to understand better what role visuality plays in it. I propose to do that in the remainder of this chapter. The process will be impressionistic, but the result will demonstrate that images pervaded Protestant life and offer rich ways of understanding a culture that is very fond of ignoring its visual culture.

We may find images and visual practices at work in several forms and places that collectively map out the Protestant life-world. First, I will use the term textuality to designate the various textual practices that deploy images among Protestants. These activities comprise virtually everything Protestants do as religious practice, such as teaching, preaching, proselytism, disputation, and devotional study. Textuality also relates directly to other uses of images among Protestants such as advertising and propaganda: all of these

rely on texts, and the Bible is never far from any of them. Second, as much as many Protestant groups are bothered by the idea of images in the worship setting, in fact they often find a place there. Third, if some Protestants have confessed anxiety about images in their worship spaces, few have ever objected to portraiture honoring those who voiced such concerns. Portraits exist of Calvin, Zwingli, and Karlstadt as well as a host of English and North American Puritans. Fourth, where textuality concentrates as a category on the role of images in discourse, teaching and learning form the dialectic of education, which turns on the teacher and student's engagement with one another in the medium of text and image. Images perform a powerful emotional function in education that deserves our attention.

Another indispensable domain of imagery in Protestantism is the domestic setting, where images assert themselves much more openly than in churches, assuming a fundamental role in moral formation, instruction, memorialization, decoration, and maintaining a mood or atmosphere of piety. Finally, Protestantism is often a highly proselytic religion, so when we look to the history of its missionary activities we find images applied to the problem of proselytism and, as a category of it, intercultural communication.

## TEXTUALITY

Let us begin with textuality, or the discursive character of many Protestant activities such as preaching, proselytism, propaganda, disputation, and devotional study.[21] Imagery has long served each of these since it fits so effectively into the texts that Protestants have widely deployed. Theologians and preachers since the sixteenth century have engaged in a passionate discursivity that organized reflection on human experience in terms of a framework of ideas extending from the purpose of history, the providential interpretation of events, the beauty of nature, the interrogation of one's feelings and emotions, and reflection on one's duties as child, spouse, parent, congregant, subject, and citizen. In every case, scripture was the principal resource for introspection and analysis, but Protestants have made assiduous use of devotional texts, biblical commentaries, catechisms, prayer books, published sermons, tracts, and such classic texts as Foxe's *Acts and Monuments* and Bunyan's *The Pilgrim's Progress*. What is striking about Protestant discourse, though hardly unique to it, is the intensive intertextuality at work in weaving a host of texts into a single, continuous fabric of discourse. Scripture was learned by heart and recited endlessly beginning in childhood, and was quoted and cited in texts of many different devotional and theological genres. This indefatigable intertextuality bolstered a relentless discourse that kept the "Word of God" in constant circulation. The print medium did not tarnish or dilute scriptural truth, but was held to deliver it in purity and potency. Historian David Hall has aptly described how this operated for sixteenth and seventeenth-century Anglo-Americans: "Elizabethans perceived Scripture as untouched and uncorrupted by the medium of print. To read or hear the Bible was to come directly into contact with the Holy Spirit. Scripture had no history, its pages knew no taint of

time. Its message was as new, its power as immediate, as when Christ had preached in Galilee."[22]

Inasmuch as images served this sense of immediacy in print, they avoided the disapprobation of the same Protestants who raged against idolatry. Even if a period of Calvinist iconophobia in the late sixteenth and first half of the seventeenth century constrained the flourishing of illustrated books in Britain, illustrated editions of Foxe's *Acts and Monuments* remained popular and in the last decades of the seventeenth century the arch Puritan text, *Pilgrim's Progress,* was illustrated and avidly consumed by conservative Protestant readers.[23] The illustration of Edward VI's reforms in Foxe's *Acts and Monuments* (see figure 9) championed the removal of images from churches and made a point of displaying their destruction, but that it could do so owed to the fact that its own image was ensconced within a polemical text studded with scripture citations and charged with the reformation of Christianity. Iconoclasm is almost never a repudiation of imagery per se, but rather a removal in order to make way for a new counterimage. Moreover, Protestants integrated image into text such that each might work in a variety of ways to secure the interpretation of the other. Sometimes images acquired a highly textual quality, as in the case of emblems.[24] On other occasions, texts assume an imagistic quality, as in the use of diagrams to summarize doctrine or theological teaching, which were employed in a major work by Puritan theologian William Perkins in 1600, or in the instance of acrostic poems, where text is graphically displayed on the page to create an image, such as the Gospel's account of the crucifixion of Jesus portrayed in the shape of crosses.[25] Textuality was the context for images, anchoring them to words not only to constrain their capacity to signify, but also to strengthen the capacity of text to attract readers and to enhance the assumption that text itself is iconic, or transparent to its spiritual content.[26]

## WORSHIP SETTING

The career of Lucas Cranach the Elder was fueled by the Reformation. He made altars for Lutheran congregations to the end of his life in 1547, and his son continued to make images thereafter. Painters in Northern Europe produced altar paintings over the next two hundred years, especially in Denmark and Sweden, where wealthy, state-sponsored churches in capitals and commercially important cities provided the funding and the prominent altars for doing so. It is quite true that altar paintings in Lutheran churches did not operate in the same way as their counterparts in Catholic worship settings. Prayer and liturgical action were not directed to the images of saints for the purpose of intercession. Instead, Protestant images in the sanctuary were more likely to consist of iconographical programs that made use of biblical figures to explicate central theological interpretations of scripture such as the fall of humankind, the Last Supper, the Ten Commandments, the prefiguration of Christ's sacrifice in such Old Testament events as the sacrifice of Isaac or the brass serpent, the Nativity of Jesus, or the Resurrection of Jesus.[27] In other words, the premium spaces within Protestant sanctuaries—the altar, but also and eventually more importantly,

the pulpit—were devoted to visual proclamation of the definitive doctrines of Protestantism. Another space for programmatic images dedicated to teaching doctrine in Protestant churches well into the seventeenth century were epitaphs, erected in honor of a deceased community member.[28] Funerary imagery, both inside the church and adorning grave markers outside of it, became an enduring form of commemorative pictorial oratory, admonishing and teaching the viewer as memento mori.

Whatever its exact location, Protestant sanctuary imagery typically showed what the preacher proclaimed, so the images generally provoked little or no resistance to being interpreted. They were there to reinforce the discourse and teaching of the clergy and the state-supported church. Cranach's predella showing Luther in the pulpit (see figure 10) is a striking case in point. The image performs what Lutheran preachers did and it endorses the heart of Protestant worship—hearing the Word of God. Cranach's picture is a direct assertion of the value of images in worship: they envision what the pastor says and the congregants hear.

PORTRAITURE

Altar paintings did not thrive in Protestant church art after the sixteenth century in most cases, in part because church design shifted over time to accommodate the greater importance accorded to sound—the preacher's voice, the organist's performance, the choir's liturgical chant, the congregation's hymn singing. But as I've said, images remained very much a part of the Protestant landscape. One genre of imagery that was important from the very beginning and never diminished in prevalence was portraiture. Portraits hang in libraries, seminaries, private homes, university halls, and in the narthex or nave of churches. But they circulate far more widely in books as author portraits and frontispiece, on pamphlet covers (as figure 8 did), as broadsides, and as folios pasted to walls and doors. Why have portraits been so popular among Protestants? The answer begins with an indication of who is portrayed. The leading reformers (Luther, Calvin, Zwingli, William Tyndale, John Knox, and important precursors such as Jan Hus and John Wycliffe) dominate the pictorial record, although there are many images of famous preachers and theologians, such as Philipp Melanchthon and Heinrich Bullinger, who carried on the work of the charismatic fountainheads.[29]

The most common use of portraits is to revere great men. We might call their purpose totemic since an honorific portrait of its key reformer could represent an entire branch of Protestantism. In effect, these images specify the intellectual and ecclesiastic genealogies whereby Protestants tended to distinguish themselves from one another. The totemic portrait operates as a prototype from which sects, church bodies, and denominations ultimately issued. As totems, they were not intercessory saints, nor were their images icons. A totem in this case presents the venerable ancestor who founded the clan's lineage and whose image helps distinguish the group from other clans. And yet, totems can become something more. Because they are dear to followers of the reformers,

these images are powerful objects to manipulate among opponents. When we see por-traits of Luther marred by detractors, stained with paint or poked with a stylus, his fea-tures redrawn or caricatured, the insult to his person is also one to his tribe, to his theo-logical descendants. To deface the totem is to dishonor the clan.[30]

Portraits also celebrated heroes of the faith for their spiritual virtues, their memorable character, and their decisive actions. Foxe's *Acts and Monuments* limned many such por-traits in literary form and inserted in successive editions a large number of engravings that portrayed the sufferings but also the nobility of Protestant martyrs (the edition of 1570 included 149 engravings).[31] The demise of Thomas Cranmer, archbishop of Can-terbury and privy counselor to Edward VI, at the hand of Queen Mary is a fascinating example of Foxe's use of a boldly visualist rhetoric. His text refers to the humiliated Cranmer under arrest, presented in St. Mary's Church, Oxford, to hear a funeral sermon on the day of his execution by flames as a heretic. Foxe invokes the medieval practice of portraying Jesus as the Man of Sorrows, beaten and scourged before being taken to the cross for execution. "The lamentable case and sight of that man gave a sorrowful specta-cle to all Christian eyes that beheld him," wrote Foxe. "A man might have seen the living image of perfect sorrow in him expressed."[32] Yet Foxe records Cranmer's resolution in this moment of high pathos not to recant before he was taken to burn. We read that he calmly prepared himself to die. Once again, the scene is vividly imagistic in Foxe's prose. He limns a grave and moving portrait of the condemned man:

> His feet were bare; likewise his head . . . . His beard was long and thick, covering his face with marvelous gravity. Such a countenance of gravity moved the hearts both of his friends and of his enemies . . . . And when the wood was kindled, and the fire began to burn near him, stretching out his arm, he put his right hand into the flame, which he held so stead-fast and immovable (saving that once with the same hand he wiped his face), that all men might see his hand burned before his body was touched. His body did abide the burning with such steadfastness, that he seemed to move no more than the stake to which he was bound; his eyes were lifted up to heaven . . . and using often the words of Stephen, "Lord Jesus, receive my spirit," in the greatness of the flame, he gave up the ghost.[33]

Foxe literally references the death of Stephen, the first martyr of the Christian move-ment recorded in the Book of Acts (6:8–7:60), who, like Cranmer, was arrested, engaged in a long disputation with learned religious figures, tried before an antagonistic counsel of religious authorities, and condemned to death. Like Stephen, but also like Jesus on the cross, Cranmer died with a calm spirit and offered up his soul peacefully to God. But Foxe fixed on the pathos of Cranmer's brave taunting of the flame in which he held his hand. The image is so compelling that it was a scene repeatedly selected for illustration (figure 11). We see the Spanish friar John in the foreground, who had vainly attempted to coerce Cranmer into rehearsing profession of faith in Rome and to bend him to the purpose of Queen Mary's project of reversing the Reformation in England. Cranmer

❡The burning of the Archbiſhop of Cant. D.Tho.Cranmer, in the Towndich at Oxford, with his
hand firſt thruſt into the fire, wherewith he ſubſcribed before.

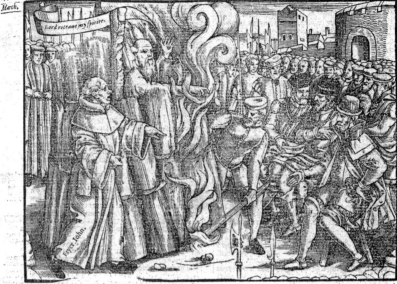

FIGURE 11

"Death of Thomas Cranmer," in John Foxe, *Acts and Monuments* (London: Printed by John Daye, 1570), book 8. By permission of the Folger Shakespeare Library.

himself stands calmly among the thick piles of kindling as the crowd watches, transfixed and troubled.

Depictions like this were less likely to arouse the suspicion of even the most iconoclastic Protestants because they attended to historical fact presented as an action, and to an account that served the Protestant interest (indeed the book's illustrations inspired intense resentment from an English Jesuit[34]). In fact, Evenden and Freeman point out that "Elizabethan authorities expressly ordered that [Foxe's] book be displayed so that it could be consulted by the servants of the senior clergy," and that the book was placed in numerous parish churches.[35]

Strictly speaking, of course, the image of Cranmer is not a portrait per se, but a historical scene. Even Calvin made a point of affirming the place of historical images as "of some use for instruction and admonition," as long as they do not envision the invisible and are not worshipped, clarifying that "the only things . . . which ought to be painted or sculptured, are things which can be presented to the eye." This excluded the majesty of God, "which is far beyond the reach of any eye." Calvin distinguished two classes of visual representation, "the historical, which give a representation to events, and pictorial, which merely exhibit bodily shapes and figures."[36] The latter were those that had in his

view been inappropriately exhibited in churches. Calvin concluded that neither form of image belongs in a church since "the moment images appear in churches, idolatry has as it were raised its banner."[37] But if the portrayal of human forms led easily to idolatry, events, by contrast, narrate time and consist of moments of great significance. Still, not all images in Foxe's book are narrative. Ruth Samson Luborsky has used the term "icon-like" to characterize smaller images in the *Book of Martyrs* that focus closely on the burning bodies of individual martyrs.[38] To use this term risks confusion when applied to an author who endorsed iconoclasm. But she is surely correct to note the difference between close-up depictions of individuals and large, narrative scenes. Foxe and his publisher, John Day, applied the devotional image of Catholic piety, made widely known in illustrated devotional books on the Passion of Christ, to a Protestant portrait-totem achieved by combining prose description of the person with visual narration of action. The point of passion images was not intercessional prayer, for which icons would have served the direct purpose, but rather empathic identification with the suffering of Jesus. The rhetorical structuring of the images invited a deeply felt response, a projection or absorption of the viewer's imaginative faculties in order to be moved by the portrayal of suffering. They sought the same result as the narrative images in the book: the subjects of the smaller images, like the events in the larger ones, acted as models of virtue whose cause was just and whose work helped found the church. The difference was the emotional appeal of a close-up, which removes distance and detailed reading in favor of graphic impact.

Perhaps because of Calvin's anxiety about the readiness of the pictorial figure to be abused in churches as idols, Foxe never employs a portrait in the fully conventional sense to portray any of the martyrs or heroes of the faith. What the book's illustrations do display is the destruction of living icons by Catholics, the inverse of Protestant iconoclasm. *Acts and Monuments* is a Protestant celebration of the personal iconicity of the martyrs. The illustration program shows the deeds that made martyrs, whether close up or more panoramically. Foxe conjures close-up portraits in textual form, carefully describing the facial expressions and demeanor of Cranmer, as we've seen, but these are momentary snapshots in words rather than obdurate visual icons. His literary portraits supplement the images of historical events to hail the totemic authority of Protestant martyrs as the true icons of faith. Rather than invoke their intercession, the composite portraiture renders visible the personal actions of sacred exemplars, moving the viewer to horror, sorrow, and indignation.

This affective form of portraiture was useful for describing the tribulations of Protestant England's martyrs, which served to confirm the authority of the Church of England. Foxe drew a parallel between early church martyrs and those of the latter-day English Reformation in order to convey the legitimacy of the Reformation project as a recovery of the apostolic age. As a contemporary analogue of Saint Stephen, a heroic martyr like Cranmer helped the Church of England argue the claim for its apostolicity. Catholics disputed this vigorously and would continue to do so for centuries. Presenting portraits

of the venerable new martyrs in action, especially in the action of being destroyed, was Foxe's idea for inaugurating the Reformation. It made visible another version of the ritualized violence of iconoclasm, in this instance one practiced by Rome, which was put to the service of forming a visual sensibility among Protestants.

EDUCATION

Protestants knew that the generation of emotion was an effective rhetorical device, and that images were good at eliciting feelings and associating them with texts and memories. Images therefore had a noteworthy contribution to make to education and moral formation. Protestant educators produced the first illustrated schoolbooks for children, such as the *Orbis Sensualisum Pictus* (The Visible World in Pictures) by the Moravian educator and author Johann Amos Comenius (1592–1670), the first edition of which appeared in Latin in 1658. *The New England Primer* appeared in 1699 and served generations of North American Protestants as an explicitly Protestant illustrated text. In the early national period in the United States, several publishers applied themselves to producing illustrated devotional and educational materials for children. The American Tract Society (ATS), founded in 1825, was one of the most productive benevolent societies in America. Modeling themselves after the Religious Tract Society founded in London in 1799, the ATS widely reproduced British material. One of the most popular authors of evangelical tracts among British and American readers was the Anglican pastor Legh Richmond, whose several tracts were repeatedly put into circulation by the ATS. His work, often focusing on children, is among the best examples of popular Protestant writing that relied upon the emotional connections it cultivated with readers.

In 1797 the young Reverend Richmond (1772–1827), freshly graduated from Cambridge with a master's degree in divinity, arrived in Brading, a village on the Isle of Wight, some twenty miles off the southern coast of England, where he took up duties as a pastor. Before long, he convened a class in religious instruction for local children, where he met Jane Squibb, a twelve-year-old girl. Just over a year later, Jane developed tuberculosis and died from the disease in 1799. A few years later, Richmond left Brading for a parish near London and in 1809 wrote what became one of the most widely read Protestant tracts of the nineteenth century, *The Young Cottager,* which was about little Jane. Richmond's narrative portrays the girl as innocent, humble, and meek, calmly suffering the abuse of neighbors for her piety, and declining peacefully in Christian confidence of the afterlife. Remarkably sensitive, articulate, and devout, young Jane confirmed to the pastor her evangelical faith when he first went to see her and pleaded for his help in encouraging her family not to drink, swear, and quarrel.[39] Richmond's account urged sympathetic readers to imagine a poor girl who deserved their pity.

As Richmond related it, on summer evenings in Brading, children from around the village gathered at his home for religious instruction. In addition to catechisms, hymns, and scripture passages, the pastor was fond of using the material texts of the local world

to exercise the children's skill at recitation. Beside his yard was the church graveyard, which bore inscriptions more affecting than those written on pages. "I had not far to look," he recalled, "for subjects of warning and exhortation suitable to my little flock of lambs that I was feeding."[40] As a way of sparking evangelical awakening in the children, Richmond resorted to the emotional technology of contemplating death, which had been made fashionable in pastoral verse by Thomas Gray's "An Elegy Written in a Country Churchyard" (1751). Richmond deployed the children to ponder for themselves how, in Gray's verse, "The paths of glory lead but to the grave." He wanted the children to find an image of themselves in what they saw: "I could point to the heaving sods that marked the different graves and separated them from each other and tell my pupils that, young as they were, none of them were too young to die; and that probably more than half of the bodies which were buried there were those of little children. I hence took occasion to speak of the nature and value of a soul, and to ask them where they expected their souls to go when they departed hence and were no more seen upon earth."[41] Richmond asked the children to examine the gravestones and commit to memory the words inscribed on them. Alexander Anderson, wood engraver and graphics producer for the American Tract Society, selected this scene for an illustration to adorn the Society's first edition of Richmond's tract (figure 12). We see two girls in the foreground, one of whom may be Jane, engaged in memorizing the epitaph inscribed on the elaborate tombstone, which, the narrative tells us, she duly recited for the clergyman. The motif of children at grave-stones became a trope in illustrated evangelical literature. Images like this served as part of a moral technology to elicit feelings of dread and fear in the sobering reflection of one's mortality. But fear and dread were not the only emotional sensations that evangelical visual piety generated. Sorrow, pity, sympathy, longing, and tenderness were also keyed to a range of images that appeared in devotional literature and instructional materials, in which learning and feeling were intimately intertwined, seeding memory with faith in the form of emotionally charged imagery.[42]

## DOMESTIC SETTING

Historically, a great deal of instruction among Protestants has occurred in the home.[43] Luther and other reformers stressed the importance of domestic religious life and it is arguable that the home exceeds the church sanctuary as, practically speaking, the most important religious space in Protestant life. Although he opposed the presence of reli-gious images in churches, Zwingli came to allow depictions of Jesus in the home.[44] Learning in the home has always been about more than memorizing scripture passages and reciting catechisms, though this performance of knowledge has been a foundation of transmitting literacy in Protestant faith from one generation to the next. Protestants widely have understood "belief" to consist of such propositional knowledge and assent. But that is not all that belief is. It is also the material, embodied practices of memory, of learning, of social formation, of family membership, and of the habitus of domestic life

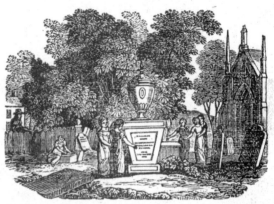

NO. 79.

THE

# YOUNG COTTAGER.

An Authentic Narrative.

BY REV. LEGH RICHMOND,

Author of " The Dairyman's Daughter," &c.

I took pleasure in seeing the little ones thus dispersed in the church-yard, each committing to memory a few verses written in commemoration of the departed.—*Page 3.*

PUBLISHED BY THE

AMERICAN TRACT SOCIETY,

FIGURE 12

Alexander Anderson, engraver, cover of Reverend Legh Richmond, *The Young Cottager,* no. 79 (American Tract Society, New York, circa 1826). Photo by author.

that shape a person's awareness of self and household as a foundation of communal life beyond the home. Learning to believe is learning to feel, to manage the body, to present the self in various social theatres, to behave as part of the social body to which individuals belong—white, black, male, female, young, old, working class, professional. The home is a matrix in which people are first and most enduringly formed as members of a religious community.

The organic, shaping character of domestic piety is immediately clear in a hand-tinted lithograph issued by Nathaniel Currier sometime between 1838 and 1856 (plate 3). A mother tenderly teaches her young child how to pray. The caption conveys the imperative tone of the instruction: "Pray 'God Bless Papa and Mama.'" But the instruction is not left disembodied and verbal. The mother embraces the child and with each hand directs its arms inward so that the child's hands may join in the gesture of prayer. She gazes steadily and affectionately into the child's eyes, whose gaze returns hers in an intimate bodily

discourse that frames prayer as a affective state. The image was rendered as an engraving for use in 1859 in Rev. Samuel Phillips's advice book, *The Christian Home,* where the image was retitled "Maternal Influence" and located at the beginning of a chapter called "Home Influence." According to Phillips, the Christian home exerted an influence "stronger than death." It was "a law to our hearts, and binds us with a spell which neither time nor change can break."[45] Phillips attributed the spellbinding power of home influence to the character-molding effect of parenting: "The parents assimilate their children to themselves to such an extent that we can judge the former by the latter." What's more, he considered the effect of the mother to be paramount.[46] The imaging or mimetic effect of maternal influence is shown in the illustration as a somatic effect: the mother's arms encircle the child to configure prayer as a bodily deportment. The force cohering the home was what Phillips called "home-sympathy" and he meant by it the "primary power of the heart by which all the affections of one member are extended to all the other members."[47] It is "the law of oneness in the family, weaving together, like warp and woof, the existence of the members, and locking each heart into one great home-heart . . . . By it we are not only bound to our kindred, but to our friends, our nation, our race."[48] The home was therefore the springboard to the larger world, and the principal source of this binding power within the family was mother, wife, and sister. The enclosed, almost womb-like space that contains the maternal affection in Currier's image and in the illustration in Phillips's book presents the tender embrace of mother and child not as the denial of the larger world, but as the origin of its moral operation. Phillips warmly endorsed the Protestant cult of motherhood that emerged in antebellum America as the home became less and less the site of livelihood and more and more the private domain of family life and child-rearing, the domain of the Christian mother.[49]

## PROSELYTISM AND INTERCULTURAL COMMUNICATION

Yet another prominent site in which images find a place in Protestant life is proselytism, the act of presenting the religion to potential converts with the intention to persuade them. Since at least the seventeenth century, Protestant evangelism has been both domestic and international, unfolding in everyday life at home and at the intercultural seam of missionary work. One of the most widely used visual manuals for missionary communication in the nineteenth and early twentieth centuries was Johannes Gossner's *Das Herz des Menschen* (The Heart of Man), first published in 1812 in Berlin, and thereafter in the United States (1822) and around the world in far-flung mission settings (figure 13). In fact, Gossner, said to be a convert to Lutheranism from Catholicism, repurposed a much older text, a Catholic emblem book first published in French and issued in German translation in Wurzburg in 1732, entitled *Geistlicher Sittenspiegel* (Spiritual Mirror of Morality), and reproduced the engravings.[50] The French source emerged from a long tradition of Jesuit emblem books of the sort we examined in the previous chapter. One of the most reproduced illustrated texts in this tradition, *Cor Jesu amanti sacrum,* was

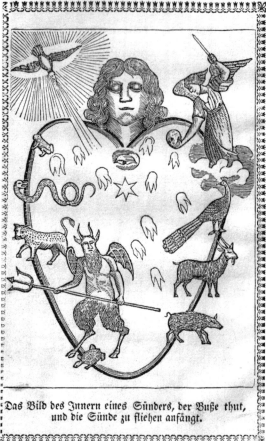

Das Bild des Innern eines Sünders, der Buße thut, und die Sünde zu fliehen anfängt.

FIGURE 13

Anonymous, *The Image of the Inside of a Sinner who is contrite, and sin begins to flee*, in Johannes Gossner, *Das Herz des Menschen: Ein Tempel Gottes, oder die Werkstätte des Teufels* (Harrisburg, PA: Theo. F. Scheffer, ca. 1870), 14. Photo by author.

produced by the Flemish illustrator Antoine Wierix around 1595. In about 1628, Alberto Ronco derived nearly all of his illustrations for his Italian text, *Fortezza reale del curore humano* (Royal Fortress of the Human Heart) from Wierix's imagery; in Ronco's work we find a plate (figure 14), which clearly resides in the genealogy of images leading to Gossner's book.

Ronco's booklet provided a dozen images and brief meditations as directions to his soul to contemplate images of the path of the boy Christ's action on the soul, from awakening (which Wierix portrayed as the boy knocking on the closed door of the heart) to a meditation on the piercing of the child Jesus and the believer's heart by the arrow of his love. In Ronco's image here (figure 14) we see the young Christ sweeping out the heart, purging it of vices symbolized as vipers and small beasts, in order to make room for himself to dwell there. In the dense, layered metaphors of Baroque emblems, the petals of the heart droop from the indwelling evil, but will revive once Jesus is enthroned within. In the Gossner image, rather than the sweetness of the infant Jesus we see an

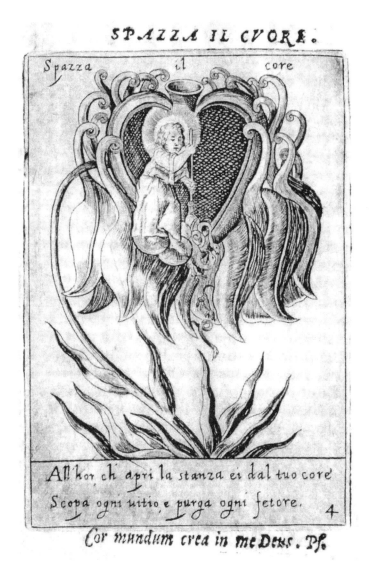

SPAZZA IL CVORE.

Spazza     il     core

All hor ch'apri la stanza ei dal tuo core'
Scopa ogni uitio, e purga ogni fetore.     4

Cor mundum crea in me Deus. Pf.

FIGURE 14

Third meditation, "Sweep the Heart," in
Alberto Ronco, *Fortezza reale del cuore
humano* (Modena: Cassian, 1628), 28.
Based on Antoine Wierix, *Cor Jesu amanti
sacrum,* circa 1595. Courtesy of University
of Illinois, Urbana-Champaign, Rare
Book & Manuscript Library.

armed angel and the radiant dove entering the heart to expel not only the vices, but Satan
himself. Satan makes no appearance in the Catholic imagery by Wierix or its appropria-
tion by Ronco. The visual program focuses on the sweetness of the loving Christ child,
whereas the visual discourse in Gossner's Lutheran imagery is of exorcism and sanctifi-
cation. Where Ronco and Wierix treat divine testing of the soul's dedication to God,
Gossner traces backsliding, the return of Satan to the soul, and the psychomachia that
culminates in the death of the godless man whose soul is awaited by fiery demons, in
contrast to the scene of the pious man, whose infant soul is welcomed by God to heaven.
The Baroque conceit of Ronco's child Jesus as a young Eros (shown in the last plate

holding a Valentine's heart pierced by an arrow) offered nothing useful to the sober Protestant mapping of conversion and the course of piety toward death. Yet both authors sought to envision the imagined life of the interior, using images to understand the soul as a dynamic path to be charted. For Gossner, the human situation was best characterized as a moral theatre of good versus evil, played out within the interior of the soul. The face atop each heart in his booklet, he pointed out, "is at the same time a sign-board that displays the inner man, in which one may recognize whose spiritual child he is." And then he instructed the reader to look at each image and "ponder inside of yourself to learn in which circumstance you are: whether Christ or Satan rules in you, whether you are of the kingdom of God or the Devil."[51]

The arch trope of interiority prevailed in the Protestant Gossner, though it owed a great deal to the Jesuit tradition. Yet there is something this-worldly and practical in Gossner's visual trajectory, where relapse, final judgment, and the agency of evil framed the life of the soul. This quality was preserved when his booklet traveled to India, Africa, and East Asia with European missionaries. Wherever missionaries set to work, Gossner's booklet was quickly translated into indigenous languages as an aid to evangelism. The images were altered in their details to accommodate local knowledge. The bestiary shifted to indigenous symbols of vices and virtues, and the image of Satan derived from the Greco-Roman Pan was modified in order to undertake the demonization of the local non-Christian religion.

Images serve as forms of communication by mapping one culture over another, often by dressing the proselytized people in the costume, gesture, and iconographic scenery of the proselytizing culture. The process is a negotiation of sorts, or better, an accommodation that intermingles elements of each culture. A painting of the nativity of Jesus by an unnamed Chinese artist was published in the Anglican mission's organization, the Society for the Propagation of the Gospel (SPG) in 1938, and portrays the event unmistakably in the traditional manner of European painting since the Renaissance (figure 15). Three magi present their gifts to the infant enthroned on his mother's lap while Joseph stands quietly to the side and Mary is flanked on the other side by an angel. A shepherd stands reverently to the right and two camels and their attendants wait behind the central group. Mary is seated on the manger and straw is spread beneath her. This scene and set of characters is very familiar from Western devotional painting since the fifteenth century. But the Chinese artist has situated the event in a composition that draws not only from Renaissance art but also from Chinese screen painting. The scene floats on a flat ground and is starkly vertical, which the artist stresses by an elaborate, wafting cloud of incense that appears to rise from the censer that the angel at Mary's side holds in the child's honor. The meandering cloud of incense might have morphed into dragons in traditional Chinese painting, as occurs in paintings of the *Nine Dragons*, a famous thirteenth-century hand scroll from the Song Dynasty.[52] The dragon was a traditional symbol of the Chinese emperor, the Son of Heaven. So the suggestion of the curving, dragon-like forms rising above the infant Jesus, incarnate Christian deity, also a "son of heaven," may

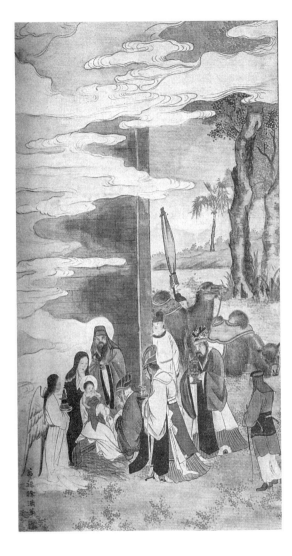

FIGURE 15
Tsui Hung-I, *The Nativity,* from *The Life of Christ by Chinese Artists* (London: The Society for the Propagation of the Gospel, 1938), 17. Photo by author.

represent an appropriation of Chinese iconography to the Christian context of this picture. And yet the artist was restrained from showing a dragon too literally, since doing so would risk both confusing Jesus with the Emperor, and invoking the Western Christian lexicon of the dragon as feature of the Anti-Christ in Protestant imagery since the Reformation, in the apocalyptic scenario that had long dominated Protestant eschatology. Other features of the image, however, safely anchor the image to Chinese referents. The magi, for example, wear traditional Chinese robes and headgear to signal their status. The race of each of the figures is clearly Chinese, not European. And the landscape is also native to Chinese viewers of the image. The negotiation of European Christianity and Chinese culture yields an integration of artistic traditions, traditional symbols, racial identity, and biblical narrative.

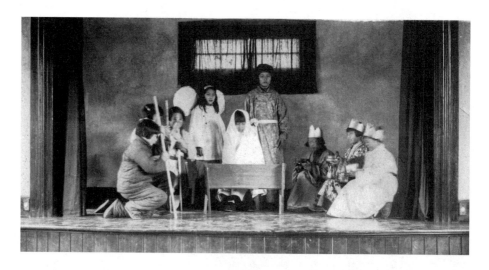

FIGURE 16

Ernest Forster, *Children's Christmas Pageant at St. Paul's Church, Nanjing, China, 1938*, photograph.
Courtesy of Special Collections, Yale Divinity School Library.

We can see the way in which a painting like this reaches into the lives of a proselytized community in a photograph (figure 16) by Ernest Forster, an American Episcopal missionary, taken in December 1938 when he was visiting St. Paul's Anglican Church, which was founded in 1913 and built in 1922–23, and was the first church in Nanjing, China. The children strike a familiar pose about the wooden manger in which the Christ child lays. The Three Wise Men form one side, while three shepherds form the other. A winged angel and a towering Joseph stand to either side of the seated Mary. The scene is a kind of tableau vivant created on a shallow proscenium stage before rows of seating in the church. The arrangement is similar to the contemporary painting, although the costuming is less grandiose. Nevertheless, the children and their audience were engaged in an embodied internalization of cultural motifs. These motifs—today called "memes"— are structures, often conveyed by visual media, that inform body deportment, dress, gesture, and expression in the process of embedding a new religion in a cultural milieu in which it remains novel and alien until it takes root, that is, until it finds an indigenous set of circumstances that look, sound, and taste Chinese (in this case). Europeans and North Americans have been apt to forget how deeply racialized and historicized Christianity is in their world because they have thoroughly indigenized it within the circumstances of race, gender, authority, class, and ethnicity that organize the history of European civilization. Missionaries encounter this in a visceral way when they are surrounded by a culture that is not their own and struggle to find points of access or connection where the process of communication can find purchase. Images mediate this process, though any evaluation of their role, success, or failure will necessarily depend on the position of those conducting the evaluation. The history of visual culture in intercultural

contact is fraught with disagreements over the complexities and risks of translation. But whatever misgivings Protestants may have had about images since the Reformation, they have commonly made use of visual media in missionary work around the world.

What does this survey of Protestant visual imagery and visual practice suggest? First, as different as Protestants like to think they are from Catholics, the evidence shows they have made careful use of Catholic imagery again and again. Second, Protestants have used images principally far beyond the worship setting. So have Catholics, but as we shall see in the next chapter, in very different ways. It is also clear from the overview provided here that images operate for Protestants in tandem with texts, charged with the dissemination of information. Whereas Catholics, as noted in the last chapter, have intertwined seeing with uttered prayer, Protestants commonly embed images in texts. In the Protestant forge of vision, seeing images has also meant seeing words, or perhaps the better word is *code*. As coded devices, images convey messages. This has allowed images to perform in the currents of everyday Protestant life. We might say that images form a kind of currency in the double sense of the word: conveying news and acting as the medium for the traffic of such goods as information and social relations. Images work within what I will call the Protestant economy of the sacred, which needs to be placed within the larger history of rival economies in order to be properly understood. That is the task to which we now turn.

# THE TRAFFIC OF IMAGES

# 3

# RELIGION AS SACRED ECONOMY

In the previous two chapters we had occasion to refer in several instances to the different sacred economies of Catholicism and Protestantism, without however exploring in any detail what this might mean. We now are in the position to do so, with the aim that each tradition may be described in terms of spiritual transactions conducted in material forms of exchange.

A productive way of understanding the host of material, social, and performative features that comprise a religion is to see them engaged within patterns of exchange. A religion, in this way of thinking, can be studied both socially and materially as a set of relationships that are negotiated in a sacred economy. This kind of economy regulates relations between humans and divine or spiritual powers by means of the terms of exchange. Life is unpredictable, riddled by randomness, menaced by powers and events beyond human control. Economies manage the scarcity of goods and reduce the impact of unwanted ills by securing what people lack and distributing it through systems of rational exchange. Economies create and maintain value. This idea has occupied the attention of religion scholars for some time. Emile Durkheim, for instance, summarized a good deal of nineteenth-century scholarship on sacrifice as a core practice of religion, capturing what I have in mind: "a mutually reinforcing exchange of goods or deeds between the deity and his worshippers."[1]

Durkheim was deeply influenced by Henri Hubert and Marcel Mauss's important book, *Sacrifice: Its Nature and Functions* (1898), in which sacrifice is characterized as "establishing a means of communication between the sacred and the profane worlds

through the mediation of a victim, that is, of a thing that in the course of the ceremony is destroyed."[2] This definition turns on the idea of the gift, whatever is offered to the god either as tribute or as an offering to invite the deity's favorable response. Hubert and Mauss go on to generalize that "there is perhaps no sacrifice that has not some *contractual* element."[3] The terms they use to describe sacrifice—contract, redemption, penalty, gift—all imply the operation of an economy. And we may look beyond the sacrificial gift in order to discern a range of media that host exchange between human beings, on the one hand, and gods, ancestors, and spirits, on the other. Systems of exchange commonly consist of the mediating function of things—images, objects, goods, money, clothing, food—deployed in practices such as pilgrimage, petitions, vowing, fasting, gifting, alms and charity, forms of penance, and devotional exercises.

My thesis is twofold and simply stated: that images and other things, deployed in various practices, operate as the medium of the exchange that constitutes the sacred; and that the history of religion is a history of such economies rivaling one another. The economies in question take many forms: gift economy, bartering, even monetary systems of exchange. What Marcel Mauss famously argued of the gift economy may be applied to any form of giving: the presentation of gifts entails obligations and reciprocations, and therefore exerts a structuring of human relations—with the divine, with ancestors, and with one's peers.[4] His work and much since, especially in anthropology, provides the opportunity to show how images and their uses have participated in practices of exchange that construct and maintain the social reality of religions. Examining it reveals the substance of visual culture, the visual means of constructing and maintaining a group's shared reality.

The concept of sacrifice that informs Christianity draws from the archetypal event of the near-sacrifice of Isaac by Abraham, as related in Genesis 22:1–19. The episode inspired countless representations in the history of sacred imagery, one of which, by Master Bertram, demonstrates very clearly the economic nature of the sacrifice as a transaction between human and deity (plate 4). Abraham and his wife, Sarah, had reached old age without child, suffering humiliation and the grave prospect of the substitution of a slave's child, Ishmael, as their own heir. Finally, however, God gives them a child, Isaac, only to challenge Abraham with the task of giving him back in an act of sacrifice as a "burnt offering" (22:2). On the way to the place God had instructed Abraham to travel to in order to make the offering, Isaac asks his father about the lamb they intend to sacrifice. Abraham's grim answer portends something he does not yet understand: "God will provide himself the lamb for a burnt offering, my son" (22:8). The concept of sacrificial substitution has not yet occurred to him. The focus of the test is the measurement of Abraham's resolve. Will he do what God has asked, even if it means losing the very thing he values most and has long suffered to receive? Abraham demonstrates that he will indeed do so, and only an angel's last-minute intervention stays his sword in Bertram's image. The angel holds the blade in one hand and points to a ram "caught in a thicket by his horns" (22:13) with the other, deftly trading the death of Isaac for the slaughter of the sacrificial animal.

For both Jewish and Christian exegetical traditions, the iconic story taught that one life may replace another in the economy of sacrifice. In ancient Judaism, the lifeblood of certain animals was offered in formal rituals to pay the debt of sin, to appease God and achieve atonement, to offer thanks, and to achieve purification (Leviticus 1–7). For Christians, the story of Abraham and Isaac has long been regarded as a typology of Jesus's sacrifice, in which Jesus is the lamb offered by God to take the place of humanity (Hebrews 11:17–20). Bertram clearly wanted to regard the Old Testament event as a prefiguration of the sacrificial death of Jesus in the New Testament: Isaac rests on a smoothly hewn stone altar that is absent in the Genesis account. The coordination was likely understood to enforce a key distinction among medieval Christians: the stone altar was a symbol of the old covenant surpassed by the new. The new covenant is alluded to in the panel by the ram that hangs from the tree; as Galatians 3:13 put it, "Christ redeemed us from the curse of the law, having become a curse for us—for it is written, 'Cursed be every one who hangs on a tree.'" For Christians, the key substitution at work in redemption was the exchange of Jesus's death on the cross for Jewish ritual law as the means of expiation of sin.

A human party offers the deity the sacrifice because it is a debt owed to God. And it is an act that will result in receiving something in return. The sacrifice mediates the exchange. Its loss to the offering party is gain to the party receiving the offering, since it takes the place of whatever separates the two parties. The aim of the exchange is to reestablish what is considered a proper relationship, in which God is always the party that will accept one thing for another. The terse accomplishment of Master Bertram's panel is its elementary articulation of the relationship as a mediating substitution. Abraham's sacrifice was not his child, but the submission of his will to keep the gift God gave him and therefore to act in obedience to God's command. In return for this obedience, God enables the substitution of the ram for the boy. With this substitution in place, Abraham returns home to expel Ishmael and his mother as no longer acceptable.

The idea of religion as an economy of exchange is challenged by Georges Bataille when he asserts that the religious sacrifice is an expenditure, a destruction or annihilation of what is offered to the deity: "Sacrifice is the antithesis of production, which is accomplished with a view to the future; it is consumption that is concerned only with the moment. This is the sense in which it is gift and relinquishment, but what is given cannot be an object of preservation for the receiver: the gift of an offering makes it pass precisely into the world of abrupt consumption."[5] Others have stressed that sacrifice is the very opposite of economic, since there is no set of equivalences that governs any given exchange, no quid pro quo in which the offering may be understood to be exchanged for an equal.[6] And yet, as Hubert and Mauss concisely put it, the destruction of the sacrificial victim is a mediation, "a means of communication." Exchange should not be confused with transmutation. One thing replaces another, not by virtue of alchemy, but within the practical realm of need. The result is a negotiated relation between two parties. This chapter will show that such communication is fundamentally economic

inasmuch as religious systems of petition, gifting, divination, sacrifice, penance, and devotion commonly calculate the price of divine action. Sacrifice means the loss of something useful for the sake of offering it to a god, saint, or ancestor. If it were not utterly, irredeemably lost to the petitioner, as Bataille stresses, it would not exert the requisite effect on the group.[7]

Different gods want different things. When they seek animal flesh or human lives, calculating the effect of the offering is easier since the expense of the offering comes with a clear value attached. But when gods have no inherent use for gold, money, or blood, the meaning of the sacrifice shifts. What the Christian divinity wants is devotion, adoration, adherence, loyalty, and this is offered to him in the loss that a sacrifice costs the faithful. So there is an exchange and it does constitute a kind of economy, though not a commercial form. When the faithful willfully endure loss in order to show their dedication to their deity, they are ranking the god above the prevailing value system that organizes the exchange of goods among human beings. This is not anti-economic or noneconomic, however, since it structures an ongoing relationship between human and divine. It maintains a relation to a reality beyond material wealth. The procedure of maintaining this relationship is what I understand as a sacred economy. I want to distinguish but not to isolate the sacred economy from the commercial economy, on which it remains parasitically dependent inasmuch as the price of anything one sacrifices possesses a value determined by the commercial economy. But since modern Christians for the most part don't sacrifice animals, their offerings to saints and to their god consist of goods that are not destroyed, but are usually put to use by churches.[8] This only underscores the economic value of the Christian sacrifice of wealth, time, or goods such as gold, cloth, or imagery. Christian sacrifice means loss in one sense, but it also means a return: what one gives may be displayed as a testament to one's charity. Even Jesus comes back from death, a burnt sacrifice that returns to God as God himself, a gift the giver gets back, with interest.

## THE TREASURY AND ITS COIN: INTERCESSION, INDULGENCES, RELICS

Penance and devotion were two of the most prevalent ways in which medieval Christians negotiated with the church and the saints to acquire remission of sins, on the one hand, and such benefits as healing, fertility, marriage, or success in business, on the other. Penance was an institution controlled by the hierarchy; devotion was both officially regulated and a private practice. Within the public setting of formal worship, liturgy, altars, shrines, and masses celebrated the lives of the saints and invoked their aid. But interface with the saint also occurred in personal devotion through prayer, visual veneration, processions, and pilgrimage, domains that ranged from private to public, vernacular to official and hieratic. Relations with saints pivoted on paying homage to them and invoking their aid. When they received respect, they might reciprocate with favors; the cycle was maintained when people made pilgrimage on the basis of a vow or pledge to repay

a saint for a favor. The most powerful saints were those enshrined in major pilgrimage churches in Rome (St. Peter's Basilica), Jerusalem (Church of the Holy Sepulchre), Canterbury (Cathedral), and Santiago de Compostella (Cathedral of St. James). Pledges and ex voto payment made in these pilgrimages and in more local settings for grace delivered form a very old and still active feature of Catholic sacred economy.

Penance was a sacramental rite rooted in the clergy's office of confession and exercised by bishops in the later Middles Ages in the form of indulgences, or pardons. Indulgences did not exist before the eleventh century, but as one scholar has pointed out, the characterization of forgiveness or pardon in economic terms is ancient; it is found in biblical accounts of redemption and is traceable from the early Christian period to the later Middle Ages in a variety of sources and media.[9] Thus, Robert Shaffern concludes, "by the turn of the twelfth century, Scripture, the liturgy, homilies, and religious drama had for centuries regularly and consistently portrayed in the metaphors of ransom, price, chattel slavery, and precious metals the means by which God had chosen to reconcile a fallen humanity to himself."[10] Between the eleventh and the fourteenth centuries, church hierarchies defined, authorized, and refined the use of indulgences, which came into widespread use. That period was inaugurated in the eleventh century when bishops began to apply indulgences or pardons as a juridical operation, an exercise of authority that descended on them by right of apostolic succession. Before the eleventh century, Shaffern points out, the penitential power of remitting penalties for sin was executed by bishops when they pledged the church's intercession on behalf of the penitent.[11] The indulgence had the advantage of declaring the punishment diminished or canceled by virtue of the power invested by Jesus himself in the authority of the church. Sin produces guilt and requires punishment. Penance removes guilt; indulgences satisfy the debt to be paid by punishment. The benefit of the indulgence was to remit the punishment for a past sin, or in the case of plenary indulgences, punishment for all sins committed up to the remission provided by the indulgence. If the debt of punishment was not paid during this life, it would be satisfied after death in purgatory, when the corrupted soul is painfully purged of sin in order to enter the presence of God. But this punishment could be shortened by indulgence.

The idea of the indulgence was closely linked to the notion of the treasury of merits accrued by Jesus's sacrificial act of crucifixion and by the good deeds of Mary and the saints. In his 1343 bull *Unigenitus,* Clement VI assured the faithful that "concerning the consumption or the diminution of this [treasury] there should be no fear at any time, because of the infinite merits of Christ . . . as well as for the reason that the more are brought to justification by its application, the greater is the increase of the merits themselves." The treasury was established by Christ and its operation entrusted to Saint Peter, "the keeper of the keys of heaven and his successors, his vicars on earth."[12] God forgives sins, but the church has the power to remit their temporal punishment. In a parallel economy, Mary came to be regarded as the "treasurer" and administrator of divine graces.[13]

The metaphor of finance and expenditure, if it is in fact a metaphor, so thoroughly pervades Catholic thought and practice that it is explicitly used in catechetical materials produced by the church. An officially endorsed guide on indulgences published in 1955 described the action of the indulgence as the pope's absolution of temporal punishment of penitents, "by virtue of the power of the keys . . . paying their debt by drawing from the spiritual treasury of the Church."[14] The indulgence was effectively a check drawn on the account of the treasury and issued to those who undertook a specified act with a contrite heart. The action might be reciting an indulgenced prayer; making a pilgrimage; attending mass at a particular church on certain feast days; participating in an indulgenced activity such as building bridges, hospitals, or churches; going on a crusade; or eventually, purchasing an indulgence with coin from indulgence sellers.

Images and objects could also be indulgenced. The first image to receive this honor was the Veil of Veronica, housed in the Lateran Palace in Rome. In 1216 Innocent III issued what has been claimed to be the first recorded indulgence attached to an image. By reciting a prayer authored by Innocent in honor of the Veil of Veronica, one would receive ten days' indulgence for each repetition.[15] The practice of indulgence connected to images and objects became more and more common, particularly as the Crusades supplied old and new churches with relics and icons for their altars, and bishops and abbots sought to attract pilgrims. An often-repeated subject for indulgenced images was the Mass of Saint Gregory, which gratified the late medieval interest in beholding the suffering of Jesus as a form of visual piety that conveyed the benefits of the Mass (figure 17). We see the instruments of Christ's passion displayed on the wall behind the altar in Israhel van Meckenem's late fifteenth-century portrayal of the Mass of Saint Gregory. Other versions of the scene were indulgenced, sometimes heavily, offering devotees as much as 430 years deliverance from purgatory for reciting the Lord's Prayer before the image. Given the pressures of vying bishops, the need to attract pilgrims, and the desire of popes to inspire popular devotion, inflation crept into the valuation of indulgences.

No doubt because of the tendency of inflation in this magnitude to create a secondary and very commercial market in indulgences, the church took steps to insulate the sacred economy of the indulgence from contamination by the secular marketplace. This was particularly important when the indulgence pertained to an object such as a rosary or medal, which circulates as a commodity. The *Raccolta*, an official publication of all indulgenced prayers, novenas, utterances or ejaculations, and pious actions (numbering 491 in 1910) stipulates the conditions under which indulgenced objects may circulate and be exchanged, in order to protect their sacrality or potency in delivering benefit:

> Blessed objects can only be used by the person for whom they were originally blessed, or if blessed for distribution, can be passed on by that person to others; but they can go no further. They cannot be given away, or lent with the intention of transferring the indulgences attached to them. If they be so dealt with, the indulgences are lost, and the objects return to their original unblessed condition. They cannot be sold or exchanged. And if a

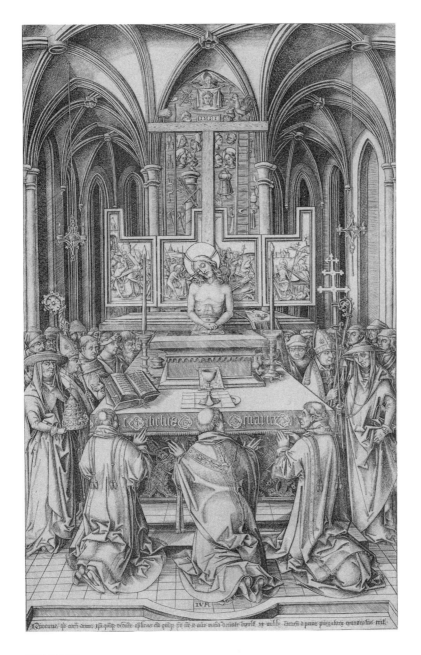

FIGURE 17

Israhel van Meckenem, *The Mass of Saint Gregory*, 1490, engraving. Courtesy of RMN-Grand Palais / Art Resource, NY.

person undertakes to get such objects blessed for others, he must be careful, if he wishes to receive payment for them, either to obtain the money before getting them blessed, or at least a precise commission to buy them, sufficient to determine the ownership of the goods.[16]

Because the sacred can pass from one item to another by contact, containing the fluid nature of the sacred requires regulation. The *Raccolta* stipulates that indulgences may be acquired by those who possess "blessed objects which have touched the holy places and sacred relics of the Holy Land" and "to similar objects blessed by the Pope or a priest with the requisite faculties," but only under certain conditions.

> i. The blessed object must be carried about on the person, or kept in the bedroom, or other suitable place and reverently used for the prescribed devotions.
> ii. It must not be made of fragile material.
> iii. Pictures, whether printed or painted, are not admissible, and images must be of saints canonized or inscribed in approved martyrologies.[17]

Each condition addresses an issue of circulation. The first point restricts circulation to the individual; the second addresses the material medium of the object; and the third restricts images of saints to those officially recognized and proscribes printed and painted pictures, limiting images to crucifixes, medallions, medals, statuettes, and other durable forms. According to one commentary, durability is the chief issue: "the article must be made of solid material, namely, such as cannot easily be broken, defaced, destroyed, used up."[18]

Indulgenced prayers to Jesus, Mary, holy angels, and the saints might easily be linked to imagery of them. The *Raccolta* lists several.[19] Several prayers are directed to the Sacred Heart of Mary, and might very well have been uttered by the owner of a French medal reproduced here (figure 18). The importance of durability is made clear by the significant wear the medal shows on the face and chest of Mary. The *Raccolta* lists an indulgenced ejaculation, "Sweet Heart of Mary, be my salvation," which elicits three hundred days of pardon. The owner of this medal may have regularly availed him or herself of that powerful speech-act combined with a reverent rubbing of the medal's image. Durability avoids the problem of fragility compromising devotion, but it also creates the problem of resale and a market in durable goods. So the church sought to further regulate the sacred economy by stipulating that a blessed object may be part of a commercial transaction only under circumstances that preserve its capacity to bear a blessing to a particular person. Entering the open market cancels its value, perhaps because the church wishes to limit sacredness to the action of blessing or consecration. If the blessing were able to enter general exchange, the benefit of certainty, of knowing that the object was bona fide, that it actually bore the blessing attributed to it, would be imperiled. Such circulation would also produce a secondhand pool of spiritual goods that would operate beyond the control of the church.

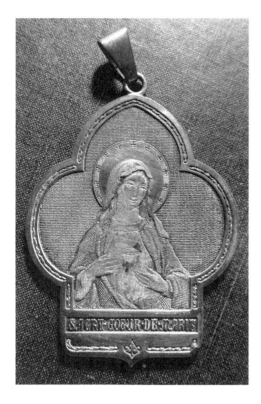

FIGURE 18

Sacred Heart of Mary, brass medal, early
twentieth century, France. Photo by author.

A similar anxiety afflicted the late medieval world regarding relics. Their proliferation
during the period of the Crusades, which were undertaken in part to acquire the relics
of saints and martyrs in the Holy Land, led to an international market in relics avidly
sought after by abbots and bishops to grace the altars and shrines of cathedrals and pil-
grimage churches. Among the worst in this regard was the Fourth Crusade, which went
woefully off script when it descended on Constantinople instead of Muslim-held territory
in Palestine. Alarmed at the depreciating effects of the market in relics, the Fourth Lat-
eran Council, called by Innocent III in 1215 to deal in part with the consequences of the
Fourth Crusade, stipulated that "ancient relics shall not be displayed outside a reliquary
or be put up for sale."[20] This requirement enhanced the rarity and therefore the sacred-
ness of relics, removing them from sight and from market. But though it restricted com-
merce in relics, the ruling did not decommoditize them. Instead, the acquisition of relics
came to rely on gift or theft, or on the black market. The council also regulated the pub-
lic veneration of newly discovered relics by requiring that these items be "approved by
the authority of the Roman pontiff." Both measures indebted any acquisition and ven-
eration of relics to the papacy, whose control of the relic market had been significantly
undermined by the influx of relics from Constantinople. (When dukes, abbots, and bish-
ops installed relics acquired through crusades in monasteries and pilgrimage churches,
they became less dependent on papal indulgences to attract devotees.) And the council

effectively ordered abbots and bishops to test the veracity of the pious discourse that surrounded relics and directed their veneration: "Prelates, moreover, should not in future allow those who come to their churches, in order to venerate, to be deceived by lying stories or false documents, as has commonly happened in many places on account of the desire for profit."[21] Limiting exchange was crucial to safeguarding the capacity of a sacred economy to deliver certainty—the surety of value, that is, the certainty of getting what one paid for. It was a crisis in the loss of certainty in the sacred economy of indulgences and relics that helped to spark the Reformation.

## REFORMATION AND THE PROTESTANT GIFT ECONOMY

In his 1515 *Instructio summaria*, Archbishop Albert of Mainz set out the procedure for selling indulgences, referring to their capacity for remitting some of the punishment of those in purgatory "because of offense done to the divine majesty."[22] It was this phrase that John Calvin later used in his unremitting attack on images in the 1559 edition of *Institutes of the Christian Religion*. Images, he insisted, were thought to convey worship to the portrayed saints and thence onward to God but succeeded only in insulting divine majesty.[23] Rather than compensating for offense, as an indulgence on the divine treasury of mercy, idolatrous images only compounded the debt. In Calvin's view, "idols" were therefore a kind of negative icon. As he put it, "whatever is bestowed upon idols is so much robbed from [God]."[24]

Visual evidence for the rerouting of iconic reference comes in a well-known Protestant *Spottbild*, or image designed to ridicule, the *Seven-Headed Papal Beast* on an altar made of a money chest (figure 19). Robert Scribner perceptively noted that this image is a "reworking of familiar devotional imagery," in particular the image of the Mass of Saint Gregory, which circulated widely in print form during the later Middle Ages (see figure 17).[25] In the *Seven-Headed Papal Beast* the implements of Christ's passion are also displayed about the diabolic altar, intended to indict their coerced contribution to the idolatrous altar whose magic was to transubstantiate the clink of coins into the commodity of redemption.

In this image, the papal coat of arms that authorized the sale and efficacy of indulgences hangs on flags on either side of the central, tiara-bearing head of the pope. The instruments used to scourge Jesus hang as relics on the cross. The money chest, whose use in the collection of indulgences had been stipulated in the archbishop's *Instructio*, serves as a profane altar, counterpart to the sacred economy of forgiveness that the Evangelical party sought to establish as the true altar. Already by 1517, in the seventy-ninth of his ninety-five theses, Luther himself had identified the papal insignia displayed at the sale of indulgences as the emblem of a blasphemous misunderstanding: "To say that the cross emblazoned with the papal coat of arms, and set up by the indulgence-preachers, is equal in worth to the cross of Christ is blasphemy."[26] In his *Smalcald Articles*, 1537, an attack on the papacy intended to state the position of the alliance of Lutheran princes, Luther

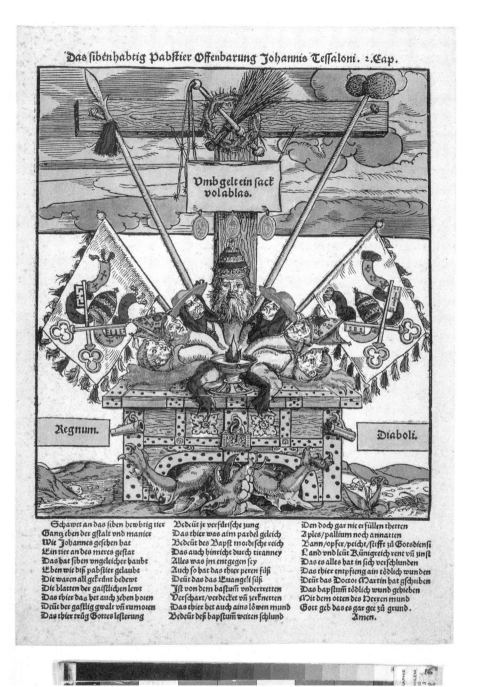

FIGURE 19

Anonymous, *The Seven-Headed Papal Beast*, circa 1530, hand-colored woodcut. Courtesy of BPK, Berlin / Kupferstichkabinett / Jörg P. Anders, photographer / Art Resource, NY.

referred to the Catholic Mass as a "dragon's tail . . . [that] has begotten a numerous vermin-brood of manifold idolatries."[27] This print accordingly identifies the pope as the Antichrist and an instrument of Satan, whose dragon form appears beneath the treasury box/altar. The central head perched above the altar echoes Luther's denunciation of the pope as Antichrist and as a "head [*Haupt*] . . . raised up by the devil."[28] Luther and this print took aim directly at the authority of the pope in the late medieval Catholic sacred economy because it was the pope, according to Luther, who "will not permit Christians to be saved without his power."[29] Luther also denounced the invocation of the saints as one of the abuses of the Antichrist, regarding it as an idolatrous act that robbed Christ of honor.[30]

Inverting iconography, as the *Seven-Headed Papal Beast* does by turning the Mass of Gregory on its head, reversed the effects of the original images: what had been an image instilling adoration of the body of Christ and spiritual lamentation of the instruments of his suffering and death becomes an image that inspires repulsion toward the monstrous body of the pope. Valorization becomes vilification, celebration turns into defamation. The effect of inversion relies on the currency of a valued motif in order to generate a subversive response. The *Seven-Headed Papal Beast* pushes Luther's warning against confusing the cross of Christ with the cross of the papal indulgences to an extreme by polarizing pope and Christ, investing the pope within an apocalyptic schema as the demonic beast, even suggesting that the final prototype of this papist anti-icon was Satan himself, writhing below. This print was, for the Lutheran party, a "true image" of the reign of Satan, an apocalyptic vision that shifted the gaze of the faithful from the other-worldly domain of saints to the present and imminent realities of the end times. Thus, the role of images shifts from dispensing grace via veneration of the saints, to shaping public opinion, teaching the new doctrine, and vilifying the papacy by acting as a coun-tericon, a familiar image recoded to ridicule the practice it had formerly enabled. In effect, this was an image substituted for those that Protestants destroyed in Catholic churches.

Ironically, the bracing certainty boldly proclaimed by the visual assault on the *Seven-headed Papal Beast* was rooted in Martin Luther's experience of existential doubt. He was gripped by a visceral belief in an angry deity that demanded satisfaction no human could achieve. And he was unconvinced that the sacred economy of late medieval Catholicism was of any avail in mitigating the debt and punishment that condemned humanity. Pen-ance, indulgence, and saintly intercession failed to supply the certainty that he longed for. So he searched for an alternative. He found it in his reading of Saint Paul, who, in his letter to the Romans, 1:17, stated that the gospel, or good news, revealed the right-eousness of God "through faith for faith." And that faith was not the work of the human being, Luther understood, but a divine gift: "There [in Romans] I began to understand that the righteousness of God is that by which the righteous lives by a gift of God, namely by faith."[31] One could do nothing to achieve the gift of redemption oneself or to earn it. Sin offended God and merited only damnation as punishment. The demands of the law were so difficult to satisfy that no human could achieve righteousness by lawful conduct.

Luther believed that he had discovered in Paul's epistle to the Romans and other New Testament documents attributed to Paul what amounted to an alternative sacred economy—one based on the unilateral gift. In this scheme of redemption, the debt owed God for sin was too great for human beings to pay, so God absorbed the debt by paying for it entirely himself, in the sacrifice of Jesus. God's act of grace, achieved in Christ's death and resurrection, purchased humankind from damnation.

But this schema presents a problem, since the logic of the gift, as Marcel Mauss persuasively argued, is that it comes with the obligation to reciprocate. Yet Luther strenuously rejected the idea of what he called "works-righteousness." Humans could do nothing to earn salvation. Angry as he was at human sin, God could not expect payment for the gift of salvation because that would destroy its nature as a gift, the unilateral movement of divine love. Yet Protestantism may nonetheless be understood as a sacred gift economy of the sort described by Mauss. This becomes clear when we realize that the response to the divine gift of forgiveness for the debt of sin, and the attendant need for punishment to satisfy the insult to divine honor, are necessary not to pay God back for his mercy, but to *pay forward,* that is, to respond to divine grace by doing God's will and expanding his kingdom on earth. Luther explained this in a brief essay of 1522. Faith and the gospel work together to bring Christ's benefits to the believer, he explained: "If you believe that [Christ] benefits and helps you, then you really have [faith]. Then Christ is yours, presented to you as a gift. After that it is necessary that you turn this into an example and deal with your neighbor in the very same way, be given also to him as a gift and an example."[32] Works did not redeem the already redeemed, but served God and the church. The saints were no longer those in heaven who were petitioned through their images and relics to expend the capital of their accumulated merits on the satisfaction of penalties for sins. The saints were now defined as the entire community of the redeemed who work in common for the benefit of the church, that is, for one another and the cause of God's kingdom.

## COUNTERREFORMATION AND BEYOND: THE QUEST FOR CERTAINTY IN AN UNCERTAIN WORLD

Luther did not grasp, or did not choose to accept, the Roman Catholic view that the certainty he sought was available in the church itself. Certainty, in that view, was invested in an economy that offered satisfaction and regarded itself as infallible. The church existed to mediate humanity and deity in just the way that priests performed the Mass, standing between the altar and the people. The priest, and by extension, the hierarchy culminating in the pope, the supreme pontiff, the vicar of Christ on earth, were put in place by Christ himself to administer the sacraments, dispense indulgences, and conduct prayer and devotion in order to render forgiveness and the encouragement to God's people. This is how Roman Catholicism officially understands God to work in daily life. The laity have often tended to rely equally if not more on devotion to the saints and the Blessed Virgin.

The church responded to Luther and other Protestants with the Council of Trent's reaffirmation of the validity of indulgences and the protocols of penance, an intercession of the saints, and the importance of venerating images. The Council clearly asserted that "the power of granting indulgences was given by Christ to the church, and this divinely given power has been in use from the most ancient times."[33] Yet the Council openly recognized that indulgences were misapplied, and so urged moderation in granting them, proclaiming "that all base gain for securing indulgences, which has been the source of abundant abuses among the Christian people, should be totally abolished." What that would mean in practice the Council left unsaid because it concluded by enjoining bishops to examine abuses in their dioceses and report them so that the pope could determine the appropriate action, such that "the gift of sacred indulgences may be dispensed to all the faithful piously, holily, and without corruption."[34] The view of Trent, in other words, was to bolster the operation of the sacred economy by insulating it from commercial forms of exchange with appropriate review and reform, rather than to change its fundamental principles.

Something about the very design of the sacred economy served by indulgences breeds insecurity. The quest to amass pardons from purgatory was fueled (before the 1960s) by indicating the accrued numbers of days and years according to books like the *Raccolta* and other guides issued to promote the practice of indulgences as a stimulus to piety. Yet when one secured a surplus of pardons, the motive for engaging in pious actions might diminish, resulting in less action. To counter this, the system had to devalue the efficacy of penance and increase the number of indulgenced prayers and actions. Thus, a 1910 edition of the *Raccolta* listed 491 items carrying indulgences. By 1937, the list had been increased to 772.[35] A host of ejaculations produced significant value in pardons. For example, the ejaculation to the Sacred Heart, "All for Thee, most Sacred Heart of Jesus," provided benefit of three hundred days. Kissing a medal of the Child Jesus and uttering the invocation, "Holy Child Jesus, bless us" produced fifty days, but carried a plenary indulgence when uttered *in articulo mortis,* in time of death.[36] The *Raccolta* itself conceded the inflationary loss of penance over time:

> Punishment, like a shadow, follows all sin, whether mortal or venial, and it is not usually remitted to the full when forgiveness is obtained.
>
> Eternal punishment, incurred by mortal sin, is always remitted with the guilt, but *some* temporal punishment generally remains due to the justice of God . . . .
>
> The *guilt,* then, of sin is one thing, the *punishment* another. The guilt is remitted when a man truly repents, either with our without the Sacrament of Penance; but though the punishment, or a portion of it, *may* be remitted with the guilt, some usually remains, as a debt of satisfaction, to be paid in this world or the next. This truth is clearly indicated in the sacramental penances which always accompany Absolution. These penances have, in course of time, under pressure of external circumstances, lost much of the severity which characterized them in earlier ages, but they still testify to the principle that after forgiveness satisfaction remains due. The comparative lightness of modern sacramental penances

ought to suggest that they alone are not sufficient to satisfy the justice of God, and that they should be supplemented either by other penances, self-inflicted or patiently accepted at the hand of God, or by some equivalent . . . . The equivalent is to be found in Indulgences.[37]

As a result, the effect of certainty is compromised. An early twentieth-century guide on indulgences recognized this, but sought to assure Catholics of moral, if not absolute certainty. Can one know with certainty that he gains an indulgence? One popular guide to official teaching and sanctioned use of indulgences taught that "we cannot, indeed, be *absolutely* certain that we gain the indulgences for which we place the prescribed good works, but we can have *moral* certainty, i.e., certainty supported by reason and having a high degree of probability. If we do our best to fulfill the conditions we may simply take it for granted that we gain the indulgences granted by Holy Church."[38] Catholics could find themselves in a situation ironically similar to what Calvinists faced, with their gnawing uncertainty about salvation owing to the vexing implications of double predestination. Since God had preordained each person's eternal destiny, and human beings might never know for sure their fate in this life, can there be there any sense of confidence for those who seek salvation?

Catholics and Calvinists responded to their respective situations differently, though both found it important to stress human depravity. But Catholics saw in the embrace of a self-effacing humiliation a penitential action that was worth something in the calculus of satisfaction. By dismantling the self before God, the devotee celebrated the converse glory of the saints, as this portion of a prayer for Our Lady's Assumption, yielding an indulgence of three hundred days, put it: "Pardon, O Lord, we beseech Thee, the sins of thy servants; that we, who of our own actions know not how to please Thee, may be saved by the intercession of the Mother of thy Son, our Lord."[39]

## PAYING BACK: REPARATIONS AND THE PENITENTIAL ECONOMY

Popular piety in Catholicism has also relied on the steady imbrication of new devotions within the old patterns of the sacred economy, as a way of renewing the faith and reiterating its economic practice and the value of its spiritual capital. This form of lateral proliferation balances novelty with continuity, seeking to bolster the sacred economy by iterating its fundamental principles. For example, devotion to the modern apparitions of Our Lady of La Salette, Lourdes, and Fatima are linked to the payment of reparations for sin against Jesus.[40] Mary benevolently intercedes by appearing on earth to bid a renewal of piety in order to stave off Christ's anger. Pilgrimage to the shrines as well as veneration of images and the performance of novenas and other prayers to these apparitions of Our Lady all generate spiritual capital.

The practice of reparations in modern Marian devotion owes something to an earlier modern devotion to Jesus that also became intimately associated with devotion to the

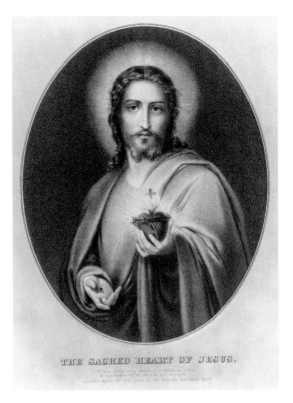

THE SACRED HEART OF JESUS.

heart of Mary. In 1675, Margaret Mary Alacoque reported that Jesus showed her his
Sacred Heart as she was contemplating the sacramental host during the period dedicated
to the Feast of the Blessed Sacrament. As he presented his heart to her, Jesus said,
"Behold this heart, which has loved men so much, that it has spared nothing, even to
exhausting and consuming itself, in order to testify to them its love; and in return I
receive from the greater number nothing but ingratitude by reason of their irreverence
and sacrileges, and by the coldness and contempt which they show me in this sacrament
of love."[41] Jesus then asked Alacoque that a feast of honor be established after the Octave
of Corpus Christi, which occurs near the Feast of the Blessed Sacrament, which would
make reparation to his heart and would "make amends for the indignities which it has
received during the time it has been exposed on the altars." Alacoque's devotion recast
the sacramental host as the heart and built itself upon the late medieval adoration of the
host and Corpus Christi, making the Sacred Heart a new version of the old visual piety.
What devotees saw in the devotion's imagery was the display of the body of Christ, reen-
acted as a revelation presented to the individual (figure 20). Jesus removes the heart from
his body, originally an intimate act performed as a gesture of love for his beloved, Mar-
garet Mary. But as the devotion was spread far and wide by Jesuit promoters, the image
became Christ sharing his body with the entire church, and therefore a reassertion of

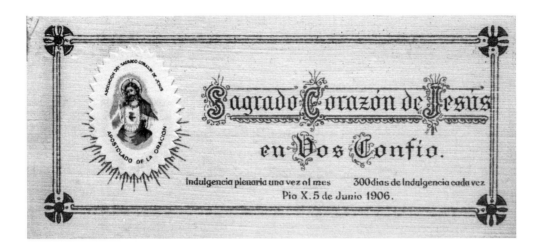

FIGURE 21

Sacred Heart of Jesus, Catholic Teachers and School Teachers Federation, Paschal Communion indulgence holy card, dated June 13, 1943. Photo by author.

Eucharistic piety, which both Alacoque and her Jesuit supporters were dedicated to renewing.

Devotion to the Sacred Heart was a way of paying reparations to Jesus for offenses done to him by Catholics who neglected frequent communion and, according to Margaret Mary's spiritual director, the Jesuit Father John Croiset, by "furious heretics" such as Protestants who denied the Catholic understanding of the Eucharist.[42] After Alacoque's lifetime, Jesuits expanded their appeal to this devotion by tirelessly promoting the Sacred Heart, using their extensive school system and practices of spiritual direction. Alacoque herself had conveyed the many promises of blessings and benefits that would follow from devotion to the Sacred Heart, and Croiset and the devotion's promoters proclaimed them.[43] The *Raccolta* points out that in most cases the pardons generated by indulgenced prayers can be transferred to others, either living or dead. Spiritual capital is not limited to material conditions, though it is regulated by the church. Pius X issued numerous indulgenced prayers on behalf of the Sacred Heart, including one, in 1906, that secured three hundred days from purgatory when recited once each day.[44] The monetary character of this capital could even be conveyed in holy cards issued on the occasion of masses dedicated to the Sacred Heart, such as figure 21, which is the size of small bill (4 by 1 3/4 inches) and reiterates the promise of Pius X, assuring the devout holder an indulgence of three hundred days (figure 21). It was a promissory note issued on the occasion of an educational federation's celebration of mass in 1943. The text, "Sacred Heart of Jesus I trust in you," bears comparison to the inscription on American coinage since the 1860s and on currency since 1957, "In God we trust," and to that on Nicaraguan coinage since 1912, "EN DIOS CONFIAMOS." The proclamation underscores the idea that capital

requires belief in the promise of value circulated by the paper note. Credo, credit, and credibility are the glue that holds profane and sacred economies together.

## DEVALUING THE ECONOMY OF INDULGENCES

A reformist attitude toward indulgences took shape following the Second Vatican Council (1962–65), which charted a Christocentric path and sought to moderate the antagonism of the Church's relationship to modernity. On January 1, 1967, Pope Paul VI promulgated the apostolic constitution, *Indulgentiarum Doctrina*.[45] The document endorsed the doctrines of purgatory, indulgences, the role of the treasury of the Church, and the necessity of the payment of reparations for sins, affirming longstanding teachings with the following summary: "In an indulgence in fact, the Church, making use of its power as minister of the Redemption of Christ, not only prays but by an authoritative intervention dispenses to the faithful suitably disposed the treasury of satisfaction which Christ and the saints won for the remission of temporal punishment."[46] Though captive to the metaphor of the "treasury," Paul VI was at pains to distinguish spiritual from material capital. "The 'treasury of the Church,'" he felt it important to point out, "should certainly not be imagined as the sum total of material goods accumulated in the course of the centuries, but [as] the infinite and inexhaustible value [that] the expiation and the merits of Christ Our Lord have before God, offered as they were so that all of mankind could be set free from sin and attain communion with the Father."[47] Mary is mentioned only once in the constitution and the saints not at all, a dramatic shift away from twentieth-century Marian devotion.[48] The First Vatican Council (1869–70), summoned by Pius IX, flatly reaffirmed the Tridentine view on indulgences and did so in the same breath that it endorsed veneration of images of Jesus and Mary, the existence of purgatory, and honor due to saints and their relics.[49] Vatican II did not mention indulgences at all, leaving it for Paul VI to address his constitution to the problem that abuses of indulgences caused in the sacred economy: "Unfortunately, the practice of indulgences has at times been improperly used either through 'untimely and superfluous indulgences' by which the power of the keys was humiliated and penitential satisfaction weakened, or through the collection of 'illicit profits' by which indulgences were blasphemously defamed."[50] Paul VI eroded the material base of indulgences by severing the relationship between the performance of an action and any object or place to which the action was formerly attached.[51] Plenary indulgences were no longer possible for devotions that used "an object of piety (crucifix, cross, rosary, scapular or medal) properly blessed by any priest," though the benefit of a "partial indulgence" remained. The only exception to this rule was that if this object of piety were blessed by the supreme pontiff or any bishop, "the faithful who use it devoutly can also acquire a plenary indulgence on the feast of the holy Apostles Peter and Paul, provided they also make a profession of faith using any legitimate formula."[52] Paul VI also decided to end the practice of quantifying the number of days and years attained in temporal indulgences, in effect, disabling the arithmetical

accounting of the economy. The pope himself appears to acknowledge that reining in inflation was clearly at issue, stating that "for indeed the greater the proliferation (of indulgences) the less is the attention given them; what is offered in abundance is not greatly appreciated."[53]

But in the year 2000, John Paul II chose the occasion of proclaiming the Great Jubilee year of the end of the second millennium, to be celebrated by pilgrimage to Rome by Catholics from around the world, to reassert the value and centrality of indulgences. Calling indulgences a "distinctive sign" of the faith comparable to pilgrimage, John Paul II announced in the bull *Incarnationis Mysterium* that "the indulgence discloses the fullness of the Father's mercy" and that, as a component of the sacrament of penance, the indulgence is God's means of diffusing mercy to the world.[54] A new edition of the *Manual of Indulgences* appeared in 1999, in anticipation of John Paul II's bull, and offered an expanded number of grants and norms directing the issuance of indulgences. Its official authors, the Apostolic Penitentiary, stressed that this fourth edition had not changed the "principles governing indulgences" but did revise several norms regulating the production.[55] The 1999 manual also added a fourth general grant of indulgence, for "the Christian faithful who, in the particular circumstances of daily life, voluntarily give explicit witness to their faith before others."[56] This grant effectively expanded the number of occasions for indulgence.

But the seesaw pattern of promoting and curtailing indulgences continues. When in 2013, the recently elected Pope Francis announced that those who followed the pontiff's tweets from Catholic World Youth Day would receive an indulgence, the archbishop who headed the pontifical council for social communication was quick to point out that "You can't obtain indulgences like getting a coffee from a vending machine."[57] To receive the benefit, it was necessary to engage in prayer, an effort that the prelate thought sufficiently demanding as to set it apart from the convenience of purchasing a cup of coffee.

In addition to the crisis of value owing to inflation, the medieval treasury of Catholicism also encountered hazard in the form of profanation of the holy, in the case of relics. Both problems have persisted over the centuries since then. Thus, the number of relics available for sale on eBay, the Internet auction site, can reach into the hundreds on any day, at prices from a few dollars to several hundred. This commodification of relics not only thrusts them into the marketplace, but also endows them with proprietorial status. As a result, the penitential economy is undermined, because the conditions of contrition and the control of the church over the dispensing of the sacred are replaced by the conditions of purchase and private ownership. If there is power in the object, if it is ontologically connected to its origins, this relationship is compromised by the conditions of commercial acquisition.

At least this is the insistence of one organization, the Apostolate for Holy Relics, organized by a Catholic layman in the United States, which urges that, "according to Christian law and practice, no person or group may 'own' a holy relic. Rather, a person or group in possession of a relic is its temporary guardian, charged with safeguarding it

until such time as custody of the relic is passed along to another individual or group who will then assume responsibility for its guardianship."[58] The website laments the decline in the veneration of relics, in particular the tendency among parishes, religious orders, and family estates to "dispose of these objects and thereby be relieved of their duties as guardians." Sacred objects pose this problem: in most cases, they cannot simply be thrown out. The Apostolate for Holy Relics understands its mission to include collecting these unwanted items by establishing "a permanent site which will serve both as a museum for the display of the collection, and a religious shrine and place of pilgrimage." The idea merges two different sorts of space—the modern idea of the museum and the traditional notion of shrine and pilgrimage site. But the merger suits the intervention it seeks to conduct because the museum is a esteemed form of gathering objects whose value is considered intrinsic, for the purpose of a secular form of veneration that bears marked characteristics of preserving and magnifying the sacred or aesthetically significant value of objects. The museum secures the value of the relic by removing it from the marketplace and placing it on display for reverent viewing. However, in order to preserve itself from the profanation of entering the market to purchase relics for sale, the Apostolate expressly states that it will only receive donated artifacts. "Out of respect for differing viewpoints regarding the wisdom of 'rescuing' relics by means of purchase, the organization will not use its own funds . . . for the purpose of acquiring items offered for sale. However, should individuals offer to donate items which they have 'rescued' to the organization as gifts, such gifts will be accepted and corresponding tax deductions will be given." The Apostolate intends specifically to target those who place relics for sale on the Internet in order "to invite them to donate the items being auctioned."[59] The aim is to move the relic from the category of commodity to what Annette Weiner called an "inalienable possession," that is, objects that remain the property of heaven, regulated by the church even while individuals hold them.[60] The relic belongs to the saint who gave his or her life for the church, and it must therefore be passed from one generation to the next.

A gift economy suits the preservation of the sacred while a monetary one threatens to profane it. Marcel Mauss argued that gifts conveyed an inherent spirit from one party to another.[61] As we will see in the case of the prosperity gospel, money need not always be considered a profane force interfering with this transmission of spirit, but may be regarded as a sign of divine favor. But to those Catholics for whom the sacred relic may not be converted into exchange value because it is ontologically fixed to the body of Jesus, Mary, and the saints, the intermediary of money destroys the relationship between giver and receiver by substituting itself for the spirit-bearing gift. A relic is a powerful case in point since it is a body part that belonged (or still belongs) to the saint. Therefore removing this artifact from market exchange as an act of "rescuing" it, and holding it in custody or guardianship rather than owning it, conveys the animation of the item and its connection to the rescuer, the guardian, the saint, the community of believers, and ultimately to God. This web of relations, the Apostolate would contend, is the proper matrix

for regarding the relic as sacred since this network enables the recognition of something greater than a bone or bit of matter.[62]

## THE PURITAN ECONOMY OF TIME

Reformed Protestants also thought of the relationship with God in the overtly economic terms of spending and wasting. But for them the precious commodity was time. Time was a finite resource to be prudently invested in order to plot one's way through life toward the Celestial Jerusalem. To be sure, one did not earn salvation, but rather invested the gift of redemption in the business of passing through life toward its heavenly end. In his catechetical "First Principles of the Oracles of God," composed in 1655 for his congregation in Cambridge, Massachusetts, the Reverend Thomas Shepard answered the question "What is redemption?" with the terse prose of the typical catechism: "The satisfaction made, or the price paid, to the justice of God for the life and deliverance of man out of the captivity of sin, Satan, and death, by a Redeemer, according to the covenant made between him and the Father."[63] Christ paid the price of human transgression, demanded by God's insulted honor, for the encroachment on his sovereignty and the besmirching of his majesty committed by the disobedience of the first parents, Adam and Eve. Human beings were not equal to the demand because they were incapable of the perfection and infinite redress that it required. Not so God himself, in the form of the second person of the Trinity. Jesus's sacrifice fully and exclusively compensated humanity's debt to God.

And yet, there must be a human portion—not in effecting salvation nor in removing the vestiges of sin described by Catholic tradition concerning penance and indulgences, but in striving to respond to Christ's call. In his sermon aboard the *Arabella*, preached in 1630 as the dissenting Puritan band made its way to found the Massachusetts Bay Colony, John Winthrop stressed the cohesive or lateral binding that grace exerted, because all capital spiritual and material remained God's. Providence, he argued, assigned people to different social degrees of wealth and poverty so

> that every man might have need of other, and from they might be all knitt more nearly together in the Bond of brotherly affection: from hence it appears plainely that noe man is made more honourable than another or more wealthy etc., out of any perticuler and singuler respect to himselfe, but for the glory of his Creator and the Common good of the Creature, Man. Therefore God still reserves the propperty of these guifts to himselfe, as Ezek: 16.17. he there calls wealthe his gold and his silver, etc. Prov: 3.9 he claims their service as his due, honour the Lord with thy riches, etc.[64]

Shepard, for his part, distinguished between justification (entirely the work of Christ) and sanctification, which is "imperfect, being begun in this life," but not completed. He defined the latter as a "benefit" or fruit of justification, and as something that required time, the rest of one's life. Sanctification was the slow process by which "the sons of God

are renewed in the whole man, unto the image of their heavenly Father in Christ Jesus, by mortification, or their daily dying to sin by virtue of Christ's death; and by vivification, their daily rising to newness of life, by Christ's resurrection."[65] The consequence of this daily dying and rising is "a continual war and combat" in the human being between the power of God and the power of Satan.

This ongoing psychomachia, or struggle for the soul, shifted Puritan consciousness to the theatre of the psyche, accounting for the voluminous biographical and autobiographical writing that became both a personal therapy and a steadfast devotional exercise. Self-scrutiny was exacerbated by the necessity that one never knew for a fact if one's soul was included among the elect. Looking for signs of progress on the path was the procedure that aimed at rendering the anxiety manageable. The temporal register admirably suited the quest for progress. Sanctification was a slow work that led toward the recovery of the image of God in the soul, an image that was never to be fully achieved in this life, but one that introspection impelled the devout to seek through ongoing discernment.

Puritan spirituality is often regarded as inimical toward visuality, but in fact it pivoted on acts of seeing understood in the register of time. Puritans in Europe and America alike both made use of images in this search and their imagery consistently reflects the dimension of temporality. Whether it was carved gravestones marking the end of a life's span, funerary imagery illustrating sermons and tracts that urged the reader/viewer to remember death (Memento mori!), or the many illustrated editions of Bunyan's The Pilgrim's Progress depicting the road to heaven, one finds time marked by images throughout Puritan life. The theological impetus for such concern may have originated in apocalyptic thought. At the direction of the Puritan parliament in 1642, the 1627 Latin text of Cambridge theologian Joseph Mede's Clavis Apocalyptica was translated and published two years later as Key to Revelation. Included with it was a diagram titled "Apocalyptick Scheme" (figure 22).[66] The diagram and the book it illustrated provided an interpretation of the book of Revelation that prophetically plotted the course of time to the present age and looked for the possibility of the end not far off. Mede calculated this by aligning prophetic utterances, visions, symbols, and numbers with historical events, situating the past in relation to the present age. The purpose of the diagram in Figure 22 was to assemble into a single scheme the events described in the fifth and following chapters of Revelation, where a seven-sealed scroll held by God is opened by Christ, culminating in the opening of the seventh seal, the end of the world.[67]

Plotting time as the course of the soul toward the Heavenly Jerusalem allowed the Puritan imagination to trace the soul's response to grace and to organize its efforts into a moral progression toward the eventual accomplishment of divine work on the soul. Bunyan's Pilgrim's Progress charted this long, arduous trek through life in a narrative that became for generations of Protestants a map of the spiritual life. Bunyan understood the sacred economy of the quest as distinct from the commercial economy of world, as the story of Christian and his companion, Faithful, in the town of Vanity makes clear. Having left the Wilderness, Christian and Faithful are compelled to enter the town called Vanity, since the road to the Celestial City passes through the place. There they encounter Vanity-Fair, a

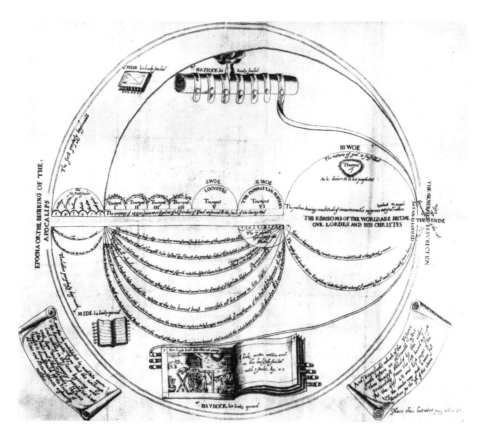

FIGURE 22

"Apocalyptick Scheme," in Joseph Mede, *Key of the Revelation*, trans. Richard More (London: R.B., 1643). Photo by author.

marketplace for the commerce of everything humans crave: trades, titles, preferments, honors, kingdoms, lusts, pleasures, whores, wives, husbands, children, souls, and lives.[68] The two pilgrims pose a spectacle to the townspeople, clothed as they are "with such kind of Raiment, as was diverse from the Raiment of any that traded in that fair." The result is "a great gazing upon them." The crowd becomes hostile to the newcomers when they take no interest in the market's wares; when asked what they would buy, the two replied, "We buy the Truth."[69] The rejection of the commercial market for the sacred economy of the spiritual quest lands the pilgrims before the town magistrate, where they are indicted and tried for disturbing trade and for contempt of the laws of the prince. Faithful speaks bravely in court, upholding his dedication to the law of God, for which he is condemned, then executed. Christian escapes and continues his journey.

As the spectacle of their righteous garments, which both signal their status as seekers of divine truth and single them out for the public gaze, images mark the pathway of creating the Christian self, the task of stewardship that will end in the life one presents to God,

who will judge the wisdom and good effect of the initial outlay of capital that was given the individual, according to the common Protestant interpretation of the biblical parable of the talents (Matt. 25:14–29). Calvin himself cautioned against confusing the continuing gift of God's grace with human merit and read the parable of Matthew 25 (verse 29: "For to everyone who has more will be given, and he will have abundance; but from him who has not, even what he has will be taken away") as evidence that God rewards, but not that humans merit the "gratuitous gift of God." Yet he saw God as a generous investor:

> It must not be said that the legitimate use of the first grace is rewarded by subsequent measures of grace, as if man rendered the grace of God effectual by his own industry, nor must it be thought that there is any such remuneration as to make it cease to be the gratuitous gift of God. I admit, then, that believers may expect as a blessing from God, that the better the use they make of previous, the larger the supplies they will receive of future grace; but I say that even this use is of the Lord, and that this remuneration is bestowed freely of mere good-will.[70]

Just as in the history of Catholicism the spiritual treasury generated an anxiety about spiritual and material wealth, Protestants also struggled with the meaning of prosperity. If, for Bunyan, commerce with the world could only come at expense of the proper sacred economy of purchasing truth, other Puritans invested commerce within an economy of providence. For them, material wealth was not only a temptation to mammon, but also a sign of divine favor. The practice of discerning God's providential will in the course of events was a kind of Puritan divination that occupied a great deal of public discourse in colonial America. When things went well, when food production flourished, and healthy markets brought goods to consumers and exported goods to foreign buyers, providence was read in terms of God's bountifulness. As the colonies prospered, anxieties regarding prosperity rose and continued to nag the Puritan conscience even as wealth and commercial success were seen as evidence of God's pleasure.

Edward Johnson published an account of the wonders of providence in New England in 1654, in which he extolled the generous work of God in blessing the British colonies. The Lord "hath of late altered the very course of the Heavens in the season of the weather, that all kind of graine grows much better then heretofore; Insomuch that Marchandizing being stopped at present, they begin question what to do with their Corne."[71] The surplus of grain was accompanied by additional divine interventions such as God's commanding "the Fruits to spring out of the Earth, when none were." Johnson enthusiastically reported that in 1642 cattle prices in England dropped precipitously, thus increasing the supply to the colonies, resulting in greater wealth upon resale there. For Johnson all these events were only evidence of God's intentions for the New World and he urged his readers "to take notice of the wonderful providence of the most high God toward these his new-planted Churches, such as was never heard of, since that Jacobs sons ceased to be a people, that in ten or twelve years planting, there should be such wonderful alteration, a Nation to be born in a day, a Commonwealth orderly brought forth from a few Fugitives."[72]

Mark Valeri has explored how this attitude developed among American Puritans over the course of the seventeenth century. For example, in 1695 Boston merchant Samuel Sewall and Puritan divine Cotton Mather sat at table engaged in long conversation on providential readings of the rise of Britain's Protestant empire and the health of commerce. Rather than resorting to jeremiad, Valeri points out, Mather "offered merchants a moral law that chastened their inner affections without compelling conformity to previous puritan rules for economic exchange."[73] Earlier Puritan standards had "obliged merchants to give their allegiance primarily to the religious community, which guided them on social practice."[74] While Mather insisted on the propriety of moral restraints binding the conscience of the merchant, by the time of his conversation with Sewall at the end of the century, the colonies were no longer in danger of the social or economic collapse that might warrant the stringent strictures of an earlier day. Puritanism was friendly toward commerce, at least in those cases when it was understood to play a role in the divine theatre of providence for the church and its national expression, the commonwealth.

Plotting time as the primary medium for spiritual development continued as a fundamental Protestant sensibility into the nineteenth century. Evidence of this is the image in plate 5, which was a popular print motif in England and the United States and can be found in many different forms.[75] Today the image looks more like a board game than anything else, and indeed, the Puritan text became the basis for a game in the nineteenth century, as we learn in Louisa May Alcott's important novel, *Little Women* (1868–69). That entire novel can be read as a recoding of *Pilgrim's Progress*: three children, led by their intrepid mother, find their way through life. Their father is away at war, just as in part 2 of *Pilgrim's Progress,* Christiana's husband, Christian, has left this world for the next, leaving the mother and her children to fend for themselves. The image of the March sisters' playful trek as latter-day pilgrims recalls illustrations from Bunyan's book (see figure 33). Several chapters are named after key moments in Bunyan's book, and the novel's opening chapter, "Playing Pilgrims," describes how the three girls "used to play Pilgrim's Progress," when they would "travel through the house from the cellar, which was the City of Destruction, up, up, to the house-top, where [they] had all the lovely things [they] could collect to make a Celestial City."[76] Alcott's novel certainly documents the important shift from Puritan sobriety to modern Protestant leisure, yet the idea of the pilgrim's journey remained a strong metaphor of moral formation, applied in the nineteenth century to the maturation of children. The playful character of plate 5 is likewise transitional, but remained a moral technology that was designed to attract a child's attention, making moral formation entertaining.

## PAYING FORWARD: LATERAL RECIPROCATION IN THE GIFT ECONOMY

Swiss reformer Ulrich Zwingli urged in a major treatise of 1525 that rather than producing and worshipping images, Christians should heed the voice of faith, which declared

"that all the moneys you spend for the honor of the Lord ought to be converted to the use of the poor."[77] As noted in chapter 2, other reformers of the time had made the same critique of Catholic sacred economy. The advice recommends transforming one economy of the sacred into another, alerting us to an arch principal of the Protestant conception of the gift. Zwingli would have the late medieval practice of petitioning saints through their images for favors, exchanging devotion for assistance in a form of barter or quid pro quo, replaced by charitable donation or gifting to the poor. Instead of spending wealth to acquire God's assistance, Zwingli urged that the Christian respond to the gift of grace by making a gift of his or her own to another. The idea is not to pay back, but to pay forward as a form of response to God's mercy.

Calvinists, and especially Puritans, pressed the discourse in the direction of reflection on the practice of leading a holy life. In their writings we find the emergence of a new Puritan sacred economy, the creation of a tradition with a long legacy, particularly in Great Britain and the United States. The holy life is, this economy proposes, the pursuit of one's calling as a participant in God's plan and kingdom. The sanctified life is not what one owes God for salvation, but rather the proper response to God's inaugural act of grace, which leads, Calvin stated, to additional grace, favors or blessings poured out in the plan of divine providence. Authentic faith produces a holy life as part of the unfolding kingdom of the Lord. The Calvinist economy pivots on divine investment in the elect. The duty to seek and do God's will amounted to what might be called a lateral reciprocation. One did not pay God back for salvation, but responded to the gift accordingly, in effect, paying forward.

For early nineteenth-century Protestants in the United States, who had become convinced that the spirit of God was moving them to engage in public revivals of religion, this meant responding to God's call by spreading the news to others. God rewarded the efforts of revivalist preaching and tract distribution by pouring his spirit onto the church in America. His servants did not merit or earn this latter-day Pentecost, but were instruments in its service. New forms of preaching, publication, and communication became the means or media for promoting revival. The traffic in print had grown over the course of the eighteenth century until it exploded in the antebellum period, when transportation via canal and rail, steam-powered printing, pulp paper production, and the postal system became the providential means of conducting an even larger round of revivalism known as the Second Great Awakening (1800–40). God was once again blessing the nation with prosperity for the sake of his millennial plans.

A battery of voluntary associations and benevolent societies such as the American Tract Society, the American Bible Society, and the American Sunday School Union regarded the principal method for advancing God's kingdom in the American nation as the distribution of pious print—tracts, Bibles, reprints of classical devotional works such as Bunyan's *Pilgrim's Progress*, schoolbooks, primers, almanacs, and children's literature. Millions of copies of these items were handed out for free or sold at reasonable prices. As images that illustrated these items show, the tract distribution enterprise was precisely the form of

**NO. 104.**

# Anecdotes,

ILLUSTRATING THE BENEFICIAL EFFECTS

OF

## RELIGIOUS TRACTS.

*See page 27.*

Perhaps nothing is so well calculated to illustrate the beneficial tendency of Religious Tracts, as the simple detail of well authenticated instances in which, under the blessing of God, they have been the means of leading to newness of life, by exciting in those to whom they have been presented, a concern for their immortal interests.

The Committee of the American Tract Society are in possession of many facts of the most pleasing and satisfactory nature, from which those contained in the following pages have been selected.

FIGURE 23

Alexander Anderson, engraver, "The Distribution of Tracts," cover illustration of *Anecdotes Illustrating the Beneficial Effects of Religious Tracts*, no. 104 (New York: American Tract Society, circa 1826). Photo: author.

lateral response to God's gift of mercy that Zwingli had in mind (figure 23). Quite often, as in this example, the iconography shows that the tract or gift is handed from a middle-class to a working-class person, suggesting that the act of distribution was part of belonging to the social body of bourgeois Christians, or was what members of that class did to purchase their status. Images and their uses in classrooms, homes, and the public circulation of texts such as tracts and other illustrated publications contributed to the broadly shared Protestant economy of the sacred in Britain and North America. They reinforced the lateral reciprocation of the gift of redemption by visualizing the practices of Christian discipline—the strictures, norms, and actions that make for good religion, pure souls, and a proper civil order. Images such as figure 23, widely used in antebellum primers and tracts in the United States, capture the lateral movement of gift-giving: the kind or benevolent act that, at least to the giver, edifies both him or herself and the receiver, though surely unsymmetrically. The receiver is not rescued from poverty or the plight of the laboring class and the giver does not surrender, but rather confirms his superior, bourgeois status. The giver donates information and receives elevated status in return. In figure 23,

the tract distributer is a well-dressed gentleman in a top hat, who offers the Good News to the shorter man, a farmer dressed to station, his humble hat contrasting with the shiny headgear of the gentleman. In return, the farmer gives the distributor the opportunity to receive confirmation of his bourgeois status as a good Christian, the one who condescends to extend the secret of his success and stature: God's grace and continuing favor.

Colporteurs, or print peddlers, were the actual distributers of the largest share of tracts and pious literature. This fact contrasts with the symbolic representation of gifting often shown in illustrations, which were rather messages to an internal audience, showing the self-defining activity of the middle class. The gift was symbolic capital that accrued to the benefit of those who contributed financially to the benevolent societies but in most cases did not themselves distribute the products. The Protestant gift of sacred information in the form of inexpensive copies of the Bible and tracts was valorized by Protestant depictions of Catholic opposition to the gift's circulation (figure 24). The scene portrays what amounts to an instance of Catholic iconoclasm: not the destruction of images, but of Bibles, those distributed by Evangelicals to Catholic residents in the hope of converting them. Although the event was overdramatized by the image, it did reflect the fact that several successive popes had from 1816 to 1864 explicitly condemned the operation of Protestant Bible societies, claiming that the distribution of Bibles in vernacular languages did more harm than good.[78] By destroying the Protestant Bibles (inexpensive editions of the King James or Authorized Version), the priests undermined the sacred economy of Protestant print as gift in order to reassert the priority of Catholic sacramentalism and the penitential economy of their faith. In fact, nothing quite like the depiction occurred, but as debates over the role of the Bible in American public schools heated up and Catholics began to press the legal issues of state-endorsed religion, American nativists used images like figure 24 to advance their cause.[79]

## THE GOSPEL OF PROSPERITY

The tendency to read fortuitous events such as a good harvest, increase in production, or booming national economy as providential expressions of divine favor, was complemented during the colonial era by the perennial jeremiad unloosed from pulpits on occasions of public distress or disaster. But by the nineteenth century, an ethos of individualism had come to color how American Protestants read the parable of the talents (Matt. 25). Many saw the generosity of God as part of a divine reward system. In a famous sermon that Russell Conwell was said to have delivered more than six thousand times between 1873 and 1924, the Baptist preacher claimed that gaining wealth encouraged the development of temperance, anxiety for a good name, and industriousness—the signal marks of good character in a Christian man. Addressing himself to men, Conwell berated effeminate "dudes" and praised the rigors of self-made millionaires such as Alexander T. Stewart, John D. Rockefeller, Andrew Carnegie, and John Jacob Astor.[80] Wealth was evidence of good Christian character. "The foundation of godliness and the foundation

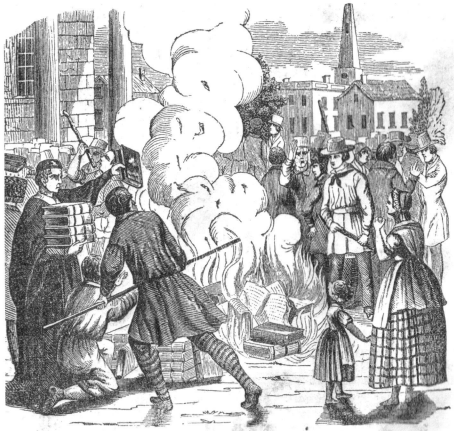

Burning of Bibles, by Romish Priests, at Champlain, N. Y. (*See page,* 613.

FIGURE 24

"Burning of Bibles by Romish Priests, at Champlain, New York, October 1842," in John Dowling, *History of Romanism: From the Earliest Corruptions of Christianity to the Present Time* (New York: E. Walker, 1853), 441. Photo by author.

principle of success in business," Conwell assured his many listeners, "are both the same precisely."[81] Moreover, poverty was the product of one's own shortcomings and God's punishment for one's sins. Acquiring wealth, though not loving money, he insisted, was the "duty" of the Christian, the result of honest living, and the performance of good conduct.[82] "To make money honestly," Conwell baldly proclaimed, "is to preach the gospel."[83] Practicing capitalism was now the proper response to the gift of redemption. Wealth manifested God's favor; prosperity was proof of good character, or membership in the desirable social body. But for both Conwell and Andrew Carnegie, the Protestant task was not to accumulate wealth, but to apply it to moral purpose. Conwell could strongly endorse becoming wealthy because, as he put it, "Think, if you only had money, what you

could do for your wife, your child, and for your home and your city."[84] In his *Autobiography*, the multimillionaire Presbyterian Carnegie defined the "Gospel of Wealth" as "ceasing to struggle for more wealth" and turning instead to the proper administration of what he had accumulated, that is, giving it away by investing it wisely in social infrastructure.[85]

The twentieth century saw the rise of evangelists who used radio, television, and print media on an unprecedented scale to engage very large audiences in direct appeals for donations. These figures—Jim and Tammy Baker, Pat Robertson, Kenneth Copeland, Kenneth Hagin, Benny Hin, and Creflo Dollar, Jr. among many others—created a version of Evangelical Protestantism that measured its success in terms of growth—growth of audience, ministries, media market, miracles, and donations—and developed a message of prosperity that suited the metric of growth. The spokespeople for this new version of the sacred economy strongly affirm the goodness of prosperity as the life of abundance that God wanted for all his faithful. "There are certain laws governing prosperity revealed in God's word," wrote Kenneth Copeland, Pentecostal minister and television evangelist, in a 1974 book, *The Laws of Prosperity*. "Faith causes them to function. They will work when they are put to work, and they will stop working when the force of faith is stopped."[86] Reading this, one may think of contemporary economic thought championed by Ronald Reagan and staunchly supported by conservative Protestants. Reagan's economic advisor, Milton Friedman, an academic and strong advocate of neoliberal economic policy, argued for recognizing fundamental principles of the marketplace as self-regulating and able, if left alone, to proliferate wealth and promote political freedoms by doing so.[87]

Yet one must exercise care in making facile comparisons. Copeland grounded financial success not in material laws of capital, but in the spiritual bounty of God, a bank without limits. He distinguished spiritual systems of wealth from the worldly financial system. It is difficult to imagine Friedman acquiescing when Copeland counseled his listeners and readers to opt out of the credit system. In Copeland's view, the world's financial system was "the biggest problem on earth . . . . we find that the world has a system of finance which is complex and very poor in its operation. It continually rocks back and forth between the two extremes of depression and inflation. However, when you are functioning in God's system of finance, life can be very simple. Don't borrow from anyone—get it from God. The problem with borrowing is that it is controlled by the world's system."[88] Friedman's answer to recession and inflation was supply-side economics: the stabilizing effect of monetary policy that restricted or encouraged investment by raising or lowering interest rates. Copeland harnessed his hopes to a higher bank than the Federal Reserve or the International Monetary Fund. "When you let Him be your Source of supply, you can live independently from the world's system."[89] This worked, he maintained, because God commanded an infinite reserve of spiritual capital that operated on a principle of giving: "God's system is really unique. He takes a person who is absolutely destitute, provides the seed to start his giving, then gives him the hundredfold return on what he gives. Only God could manage or afford a financial operation like that!"[90]

Copeland developed an account that ironically reminds one in certain respects much more of the medieval Catholic spiritual treasury and the system of indulgences than of neoliberal economics. God invests his wealth in a hierarchical system of relations in which one party hands down to the next the favor or gift that flows through the entire system, drawing on the endless resource of God's prosperity to distribute spiritual wealth and material prosperity throughout the body of Christ. Faith opens a channel through which God's riches flow to the faithful. Copeland outlined the path of the distribution in a way that recalls the vertical structure that connected the medieval worldview by means of a descending chain or hierarchy:

> An example of this channel can be seen in the Book of Revelation. God gave His revelation to Jesus, who signified it to His servant John by His angel; the angel gave it to John; John was to give it to the churches; and they, in turn, would give it to the body of Christ who would feed it to the world. A constant channel, a constant flowing—the flow of love . . . the flow of power . . . the flow of money . . . the flow of food . . . the flow of everything you need![91]

But this flow depends on the act of faith that gives in order to receive. The system itself enacts the principle described by Mauss regarding the obligation to reciprocate. Copeland elaborates: "Give, and after a while it will come back to you again . . . . The key is to give continually. As you are walking in the Word and God's prosperity is being produced in your life, you will reach a point when your bread is coming back to you on every wave!"[92] In contrast to the idea that investors take a chance, that luck plays a role in financial success, Copeland insisted that spiritual laws give no place to chance: "Luck has nothing to do with it."[93] God operates by laws revealed in the Bible. This means that by learning those laws, one can prosper. And the key law is that by giving, one shall receive. Like Conwell and Carnegie, Copeland maintained that prosperity required giving away wealth. Keeping it was not conducive to the system of giving and receiving. Whatever one gives, the return will be one hundredfold. So the more one gives, the more one receives. Believers thus find their place within the apparatus of distribution, the flow of divine wealth, that Copeland outlined. The result is an increase of prosperity: "As you give, it will be returned to you faster than you can keep giving it away!"[94] Such an economy would be a Ponzi scheme if there were not an infinite source of wealth emanating from God.

The system operates almost as an apparatus, according to particular laws, and is activated by the individual's action of faith: "Your faith is in direct relation to the level of the Word in you. Get your Word-level up so that you can believe spiritually, mentally, physically, financially, and socially."[95] Copeland's theory depends fundamentally on Biblicism, the Fundamentalist view of the Bible as the printed revelation of divine reality. "God and His Word are one. When you are in the presence of the Word of God you are in the presence of God Himself."[96] This notion is crucial for Copeland and others because it empowers the faithful reader of scripture with mechanical control over the laws emanating from

God or the Bible: "God has laid out His innermost thoughts and desires, His perfect will, in the form of a contract and placed them in the Bible. They are available to set us free from Satan's authority, by the Spirit of God in the name of Jesus."[97] Copeland's stark contrast between Word and world, spirit and natural reality, invests in the Bible a word or name magic whose use accesses divine power.

Within this sacred economy, the Bible qua sacred text replaces images of saints or rosaries in practices of comfort, petition, and divination: "Nothing thrills me more than to know that if I wake up in the middle of the night with some problem, all that I have to do is reach for my Bible. This is the manifestation of the power of God. It will work every time for anybody who will use it. When you realize that this manifestation of God is available all the time and begin to walk in the light of it, you will become prosperous."[98] Having faith means having access to God's power to provide prosperity. "When the Word says you are healed, *you are healed!* It doesn't matter what your body says about it. If you will believe this and operate accordingly, then the Covenant you have with God—His Word—will become the absolute truth in your situation, and your physical body will come into agreement with the Word."[99] Faith makes the material world conform to the spiritual conviction of prosperity.

If the prosperity gospel's economy recalls something of the medieval account, Copeland made a point of attributing poverty as a Christian ideal to Catholic monasticism.[100] In contrast to the monastic's vow of poverty, impoverishment is not, in Copeland's view, something God wants for his people. Therefore, looking successful and healthy signals that one has received the gift from God and behaved properly within the sacred economy by spending it on others. The gold standard in the visual culture of this economy is the appearance of the pastor himself (along with his loving spouse), fashioned as a cult celebrity whose market value is sustained by the management of his image on television, video, Internet, billboards, and book covers (figure 25). The image of the man of God is a fundamental feature of advertising and public appearances. Pastors tend strongly to be well-dressed (designer suits), finely appointed (silk handkerchief, expensive jewelry), and conservatively groomed (short hair, minimal facial hair). In visual terms, they are their message: success coded in bearing, demeanor, and presentation.

Sociologist Asonzeh F. K. Ukah has examined the important role that roadside billboards advertising Pentecostal personalities and events in Nigeria have played in recent years in "the marketing of charisma."[101] The many billboards as well as handbills, banners, and magazine testimonials that he studies foreground the preacher and underscore the theme of abundance—in power, health, prosperity, miracles, blessing, and in liberation from poverty, financial troubles, and witchcraft. As a charismatic figure properly manicured, the pastor is a visual model of the good life. Figure 25 is a characteristic example of a roadside sign in Nigeria, from fall 2012, to promote a weeklong campaign on the theme "Unlimited Height." Conducted by Pastor Tola Olukilede, who appears with his wife, Wumi, on the sign, the event was presented by "The People of Power, Purpose, and Prosperity" to advertise the anniversary celebration of the ministry, which

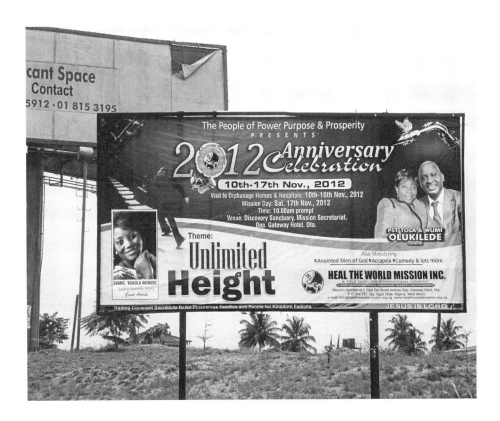

FIGURE 25
Roadside billboard promoting Pentecostal gathering, Nigeria, 2012. Courtesy of Asonzeh F. K. Ukah.

was founded by Olukilede in 2000. In their Internet presence, the couple underscore the purpose of the ministry, which is "to raise couples worldwide to prove the power and glory of God in partnership as God originally ordained marriage to be."[102] Visually, the billboard promises a good show, a program that will be entertaining, uplifting, and inspiring. Prosperity seems closely associated with American style. A businessman runs hurriedly up a series of floating stairs, and a bold red, white, and blue color scheme seems to tout "American-style" prosperity. It may be worth noting that the name of Pastor Olukilede's ministry, "Heal the World Mission Inc," recalls the name of Michael Jackson's Heal the World Foundation, a charitable organization founded in 1992 and ended in 2002. Olukilede's project makes no reference to Jackson or America, and probably has nothing to do with either. But the billboard operates visually at the level of suggestion and association, and its message of prosperity relies on associated perceptions. If the sign links a sense of success with the event, it has done its work. And the allusion to American prosperity is apt since Olukilede's Pentecostalism turns on the exchange of money for spiritual benefits. The tagline at the bottom of the billboard signals this: "Trading Covenant Secrets to Raise Prosperous Families and People for Kingdom

Exploits." The "trading" involved refers to participants paying money for the blessings and encouragement offered by the program. In these terms, healing the world means financially empowering those who seek Olukilede's inspiration.[103] Although the Nigerian state installed a regulatory commission on broadcasting in 2004, Pentecostal sacred economy before then had actually come to resemble Milton Friedman's neoliberal vision of minimally regulated markets. If occasional reformers such as Martin Luther and Pope Paul VI have insisted on distinguishing the sacred from the profane economy, Tola Olukilede and many others in Africa, the United States, and far beyond see no reason to do so.

# 4

# THE AGENCY OF WORDS

Ask many Protestants what their religion is about and you are likely to hear something about "God's word": doing God's word, hearing God's word, studying God's word, sharing God's word, living God's word. To be sure, Evangelicals are more inclined to speak this way than are members of the Anglican community or the Quakers. But reading the Bible, reading devotional texts that reflect on the Bible, listening to the Bible read aloud in worship, committing sacred writ to memory, and reciting or declaiming it on important occasions are practices that can be found across the spectrum of Protestant groups. That is in part because, for Protestants, the sound and pronunciation of scriptural texts is a modulation of spiritual reality. Speaking the word of God articulates more than sound. It conveys power and spirit. Spoken, read, or written, the word is a vital medium for Protestants because it gives sound or visual presence to the voice of God.

Many Protestants are fond of rubricated or red-letter Bibles, which print in red all words attributed to the direct discourse of Jesus. Doing so may allow readers to feel more directly the presence of the speaker, particularly when they read or hear aloud the red-lettered words. The inventor of the device, Louis Klopsch, wrote in the preface to *The Red Letter Bible,* which first appeared in 1899: "Modern Christianity is striving zealously to draw nearer to the great Founder of the Faith. Setting aside mere human doctrines and theories regarding Him, it presses close to the Divine Presence, to gather from His own lips the definition of His mission to the world and His own revelation of the Father."[1] But why would speaking bring one closer to God than would seeing images of the sacred? The answer lies in what we noted in chapter 2 regarding Protestant textuality: the iconicity or transparency of words.

In response to the Reformation's rejection of devotional images and of the cult of the saints, Catholic polemicists Hieronymous Emser and Johannes Eck each invoked Basil, John of Damascus, and the Second Nicene Council in their respective pamphlets, both issued in 1522.[2] Images, Basil had declared, direct whatever the devout utter by way of request or praise straight to the saint himself or herself. The Council of Trent followed suit, reaffirming the 750-year-old doctrine that images of saints should be venerated for their ability to convey all praise and petitions to their celestial prototypes.[3] Protestants insisted, to the contrary, that images were of no avail, that only the word of God delivered the saving grace that enabled faith. Intercourse with heaven was limited to receiving the word and responding to its power of grace with prayer and good works. The word of God exerted power in its own right. Rather than compelling people to abandon the Catholic mass, Luther asserted that God's "word should do the work alone, without our work. Why? Because it is not in my power to fashion the hearts of men as the potter moulds the clay, and to do with them as I please . . . . We must first win the hearts of the people. And that is done when I teach only the Word of God . . . [which] would sink into the heart and perform its work."[4] Luther countered Karlstadt's iconophobia by "attacking the attack on images because I first tore [images] from the heart by means of God's Word and made them meaningless and despicable, which was happening before Dr. Karlstadt even dreamt of assailing images. For when they are removed from the heart, they can do no evil before the eyes."[5]

For the Protestant tradition, the word of God, scripture, as conveyed by human discourses of preaching and teaching—but also in ejaculations and invocations associated with healing, exorcism, rituals of baptism and communion, and prayer—is the privileged avenue for transmitting the power of the spirit of God to work in the soul, or heart, as Luther called it, as well as in other theaters of action. One finds this medium commonly in use among Protestants and others around the world today; its emphasis is particularly strong in West Africa, where religious messages and scriptural passages appear on bumper stickers and car windows, broadcasting messages that evangelize other drivers, testify to the owner's faith, link the driver with a particular social group, and, not uncommonly for Charismatic Protestants, pronounce publicly the divine blessing the owner expects by faith to receive (figure 26).[6] In figure 26, the scripture verse Exodus 14:14 appears in the rear window of a van in Ghana, prompting anyone unfamiliar with it to look up the text, which is a direct address from God to Moses, but reads, in this context, as a personal message to the reader: "The Lord will fight for you, and you have only to be still." In the setting of Charismatic Protestantism, where spiritual warfare is a compelling theme, the owner of the van would likely expect the message to be gratefully received.

The display of printed, embroidered, and painted scripture passages is a venerable Protestant practice that is centuries old. Broadsides, hand-stitched samplers, text panels, lithographed house blessings, and printed mottoes have commonly been displayed by Protestants in their homes, schools, churches, mission fields, and places of work.[7] Such

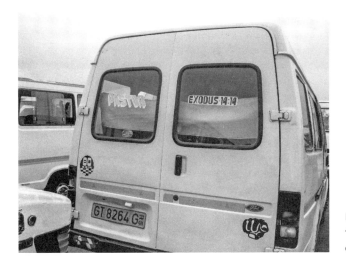

FIGURE 26
"Exodus 14:14," bumper sticker, Ghana, 2013.
Courtesy of Jeff Korum.

texts have integrated seeing and reading, space and memory, to give words material presence in daily life. Another instance of language as a conductor of spiritual power in the present day was articulated in a short sermon on miracles by the televangelist, Pat Robertson, who began the sermon by saying that the power to invoke miracles requires that one have faith. Robertson proceeded to explain that by faith one enters the presence of God, beholds his glory, and in a state of being born again, is able to communicate directly with the spirit of God, which is then channeled into the world in the medium of speech.[8] "Now here's how it works," he continued:

> The principle of power comes from this. It comes from God, who is the eternal mind. God speaks to his Spirit. The Spirit speaks to your spirit. Your spirit speaks to your mind. Your mind speaks to your mouth. Your mouth speaks to the created universe around you. So you speak to devils. You speak to disease. You speak to poverty. You speak to famine. You speak to storms. You speak in the name of the Lord. But it comes by having the Word of God energized in your mouth. Because you've been in His presence and you've beheld His glory. You've listened to His voice. And you're speaking the word that He says.

Robertson described a chain of transmission that conducts the power of God's spirit from the pure thought of the divine mind to the phenomenal world along a pathway of speech. Words are the medium of power, spoken to demonic powers and to any condition or circumstance of affliction. Words form a kind of network of translations through which the power of God passes without being lost or diminished.

From Luther to Robertson, we see that the Protestant experience of divine power is invested in speech. But the speech of God's word needs a matrix to be heard—air, spaces, bodies, images, texts, pages, printing presses—the material networks that Robertson's explanation begins to unpack. The history of Protestant print culture since the Reformation

bears a vital history, one worth scrutiny: this is the history of the enchantment of words as things, as social agencies, as forces that move through bodies and images and books and objects, from the mind of God to the heart of human beings and back again. This is the history of Protestant mediation. Sorting out the complex interweaving of features that comprises this history is the task of this chapter.

An entire apparatus of social circumstances, historical tendencies, and ideological formations have combined over a long period to make sacred print what it is to Evangelical Protestants: a social force doing the work of God at a particular moment in human history. For Evangelicals, the Bible is an object or a medium that acts. It reveals, shows, demonstrates, proves, approves, reproves, denounces, proclaims. The Bible and its shorter iterations such as tracts, psalters, and gospels constitute one book by one author who actively touched the world through the medium of the book's words. Bibles and tracts are reputed to preach and convert by themselves, even without evangelists or ministers to declaim or interpret them. We are perhaps inclined to miss the fact that such printed works are what anthropologists call "power objects." But when the Bible or a portion of it reproduced in a tract or sermon is said to speak to, convince, or convert someone, scholars need to hear the depth of the claim: a cultural object is said to act on behalf of an animating spirit, a deity who interfaces with human affairs and shapes the world of events through interaction with this print artifact.

The authority of Holy Writ is the subject of the frontispiece of a 1741 edition of Luther's translation of the Bible that featured Hebrew and Greek on the facing pages of each testament (figure 27). At the top of the page, light radiates from a triangle containing three Hebrew *yods,* the letter that begins both the tetragrammaton's abbreviation (YHWH) of God's name, Yahweh, and the Hebrew spelling of Jesus's name; the symbol of three *yods* was a common convention used by artists and illustrators to refer to the members of the Trinity.[9] The use of the Hebrew character is significant since it refers not only to the name of God, but to his speech, the original form of the divine word spoken both at creation and with Moses, and the language from which the German translation of the Old Testament was made. The light rays then pass through portrait medallions of the biblical authors in several groups: six Old Testament figures, from Moses to Solomon on the top level; followed by the four major prophets (Isaiah, Jeremiah, Ezekiel, and Daniel); twelve minor prophets; the four evangelists; and the four authors of the New Testament epistles. Below them, a group of German Reformers appears around a table: they are Martin Luther's translation team at Wittenberg, gathered before biblical codices in various languages.[10] In addition to assuring the reliable rendering of God's Hebrew into Luther's German, the image is a robust affirmation of the latterday technology of the printed codex. The biblical authors wrote their texts on rolled papyrus or vellum, not in codex form. Yet in figure 27, the biblical authors each appear in their medallions with their respective codices because these correspond to the biblical codex that the modern translators busily manufacture at their worktable below. The visual continuity of the medium underscores the continuity of the content it conveys.

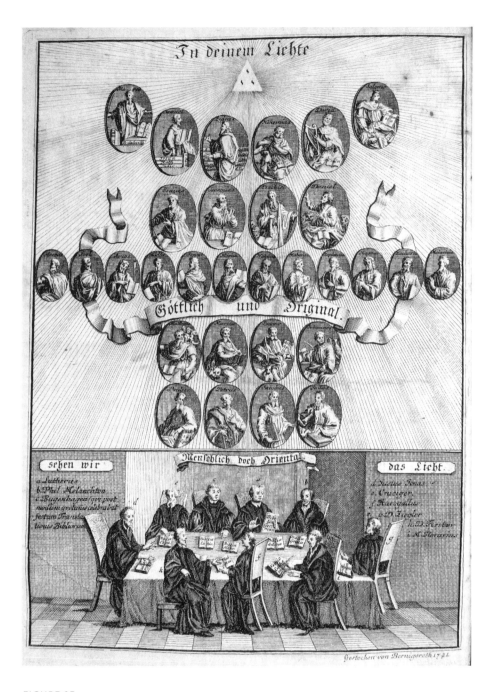

FIGURE 27

J. M. Bernigerroth, engraver, *In Your Light We See Light,* frontispiece of *Evangelische Deutsche Original-Bibel* (Züllichau: Verleugnung des Waysenhauses, by Gottlob Benjamin Fromman, 1741). Photo by author.

The motif of Reformers around the table is almost certainly borrowed from a mid-seventeenth-century Dutch print that circulated widely, which shows an even larger group, including biblical translators as well as preachers and theologians, gathered about Luther, before whom burns a single candle.[11] But whereas that image was intended to hail the Reformation and its ongoing diffusion (the pope is shown vainly trying to blow out the candle), figure 27 addresses a more particular issue: the authority of the Bible as a faithful transmission of God's word. The banderoles interpose text from within Psalm 36 (verse 10 in Luther's translation; verse 9 in the Revised Standard Version) to read:

In your light
divine and original
we see / humanly but eastward / the light.

The light from the triangular symbol of the Trinity streams through each author, making them into what might be called Protestant icons, that is, images transparent to the divine word, which is deposited in the texts spread on the table before the Reformers, whose work it is to translate them in order to assemble the German Bible. Yet for Lutherans, it was Luther who was the primary agent of the process of translation. A preface to the edition, written by a superintendent of Saxon clergy, also quotes Psalm 36:10 and may have provided the theme for the engraving. The clergyman opens his preface by situating Luther in a key position in the divine motif of light: "The ascent from on high, which so powerfully drove out the darkness, performs many great wonders through the *light of his truth*. Luther, chosen by God to be a great beacon for the church and for this reason illuminated, served as a burning and effulgent light."[12] The image does not conceal the human means of producing a modern Bible in the vernacular, but wishes to argue for its fidelity by pairing the biblical authors above with their modern, scholarly counterparts below. They are human, but they look to the light streaming from above and visible in the original scriptural text. The engraving's scheme affirms the reality of the Bible's individual authors, but regards this as no loss of divine authority and truth. Indeed, applying the Psalm text to the work of the Reformers would suggest that they, the modern biblical scholars, relied on divine light to discern the truth borne by the historical mediation of translator and editor to produce the Luther Bible.[13]

For modern Fundamentalists however, the Bible, in particular the King James version, is not a collection composed of work by unified ancient authors but a uniquely authoritative, single-authored text. The postcard reproduced here captures this conception by showing the volume itself, rather than its translators and authors, as illuminated or light-emitting (figure 28). Where the previous image shows the authors infused by the divine light of inspiration, this image ascribes a power to the book itself, and privileges it above all other translations as singularly authoritative by asserting its historical priority. Although the image does not convey the historical complexity that the 1741 image acknowledges, it certainly affirms Luther's idea that the word of God acts. Where

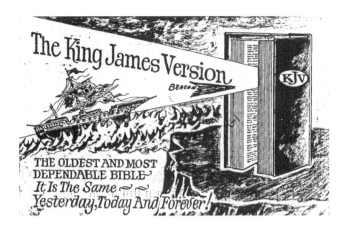

FIGURE 28

Postcard promoting King James version of the Bible, mid-twentieth century. Photo by author.

Tridentine Catholics would have prayed to a saint for intercession on the imperiled ship's behalf, the Protestant ideal is to regard the word of God as a life-saving beacon.

But how do we proceed from the Reformation to the twentieth-century Fundamentalist view described by this postcard or by Pat Robertson's sermon of miracles? The intervening global history of print culture that can help us understand the transition. The span of five centuries is occupied by a vast network of print production, circulation, and reception that enhanced the agency of print, making Bibles and tracts into power objects. The question to pose throughout is one that decenters inquiry from the conventional matter of decoding writing to a scrutiny of the power of sacred print as a thing that acts: how is it that paper comes to talk? In order to understand how Protestant print works among and on its believers, one must discern the history of its politics, its social organization, its deployment in global colonialism, its technology, its theological and ritual setting, and its deployment in revivalism and the encounter of rival religions. Each of these conditions helped shape a series of causal factors and ideological formations that in turn influenced the uses and forms of print. I will sketch the emergence of these conditions and their engagement in the Evangelical enterprise in the eighteenth and nineteenth century, in a story that turns on the Protestant understanding of the power of print as a social agent. I will argue that without a sense of this experience, we will not have a robust understanding of the sacred economy of Evangelicalism circa 1800, which is to say, its social career as one important contributor to the formation of modernity around the world .

## THE SOUND OF PAPER TALKING

John Calvin opened his monumental systematic theology with the argument that the existence of a deity is apparent to human beings by virtue of the very experience of human ignorance, frailty, and need. Human depravity itself teaches people that God exists and is the only source of goodness.[14] Even the rampant and universal practice of idolatry

shows that humans recognize the existence of a deity, which Calvin treated not as a rational induction in humans, but a "natural instinct."[15] Yet God is also apparent in nature, and in more than a merely symbolic manner. Calvin the iconophobe could speak in remarkably visualist terms about the revelation of God in nature. Not only does God "deposit in our minds that seed of religion" that Calvin called instinctive, the deity also makes "manifest his perfections in the whole structure of the universe, and daily place[s] himself in our view, that we cannot open our eyes without being compelled to behold him. His essence, indeed, is incomprehensible, utterly transcending all human thought; but on each of his works his glory is engraven in characters so bright, so distinct, and so illustrious, that none, however dull and illiterate, can plead ignorance as their excuse."[16] Beholding this glory is not a matter of cultural decoding. It is effulgent, radiating from the heavens. Bright as God's works are, however, Calvin contended that human stupidity is too great for human beings to derive benefit from merely beholding the natural world. "Every individual mind being a kind of labyrinth, it is not wonderful, not only that each nation has adopted a variety of fictions, but that almost every man has had his own god."[17] Driven by vanity, selfishness, fear, and ignorance, human minds replace the real God with endless deities. Human imagination replaces God with one more suited to the misperceptions and contorting needs of the individual: "For no sooner do we, from a survey of the world, obtain some slight knowledge of Deity, than we pass by the true God, and set up in his stead the dream and phantom of our own brain."[18] This is the "forge of idols" that Calvin reviles later in the same book.

Calvin framed his enterprise in this way in order to foreground human depravity, which the natural revelation of God underscored. He diagnosed something fundamental to the human mind as falling short and plunging humankind into corruption. The brain was a fickle thing, given to be buffeted by the passions, by an unruly immoral nature, and by the deceptions of imagination, a faculty in service to selfishness and pride. God's plan was to select a special people and enclose them in a rigid structure that fortified the glory naturally revealed: "For, seeing how the minds of men were carried to and fro, and found no certain resting-place, [God] chose the Jews for a peculiar people, and then hedged them in that they might not, like others, go astray."[19] Law and providence organized Jewish life to set it apart, bridling the human mind in order to sustain divine revelation and therefore divine presence as apprehensible. Calvin then asserted that God used the same means to "retain [all humankind] in his knowledge," namely, providing scripture, which is nothing less than God opening "his own sacred mouth": in scripture, God "manifests himself."[20] Calvin concluded, therefore, that God had foreseen "the inefficiency of his image imprinted on the fair form of the universe" and therefore "has given the assistance of his Word." With this, Calvin raised the new media hierarchy of the Protestant sacred economy: "While it becomes man seriously to employ his eyes in considering the works of God, since a place has been assigned him in this most glorious theatre that he may be a spectator of them, his special duty is to give ear to the word that he may the better profit." It is the word of God, God's own utterance seamlessly recorded

in Scripture, that offers what Calvin called "a genuine contemplation of God."[21] Those who long to see God, must instead hear him, which means they must read him: "We must go, I say, to the Word, where the character of God, drawn from his works, is described accurately and to the life."

The Bible thus is the definitive, stable, unshakable revelation of God, what Calvin characterized as the thread that guides our way through that other labyrinth, "the brightness of the Divine countenance."[22] Humans are like God, are his image. And Calvin insisted that to study the one meant to study the other.[23] But seeing is hopeless in the confusing labyrinth of human nature, no less than in that of the divine. The divine labyrinth is too bright; the human labyrinth too dark. The scriptures are the key to unlocking the maze and finding one's way out, to capturing a truly revelatory glimpse of the divine face.

Why words and not images? Because images are the medium of human thought as well as of divine activity. The human mind and God himself both generate images of themselves, but these are dissimilar: the human mind, under the faculty of imagination, produces images that replace the thing they claim to represent. Not only are images fake, they are simulacra, eclipsing what they pretend to portray. Words, by contrast, elude the register of visibility, which is limited by extreme brightness or darkness. Word meant sound in the first instance, but what it really meant is sacred writ, the covenant of divine authorship, a new and fully efficacious revelation that completes the inefficiency of the first, visual, revelation, which is limited by human failure. Words establish a contract in a medium that Calvin considered more stable than images because discursive reason trumps imagination. One could argue with reason in the court of scholarly discourse, and theological disquisition could determine truth by adequate interpretation, while images operate in a different, nondialectical register. Scripture does not gain its authority from the judgment of the church, according to Calvin, but "bears upon the face of it as clear evidence of its truth, as white and black do of their color, sweet and bitter of their taste."[24] The proof is in the pudding because the pudding contains the very thing that proved the scripture's authenticity: "The highest proof of Scripture is uniformly taken from the character of him whose word it is." Words are icons, the medium that conveys the very truth to which it refers. Hearing thus becomes a kind of seeing, perhaps because reading the word of God is optical: "If we look at it with clear eyes and unbiased judgment, it will forthwith present itself with a divine majesty which will subdue our presumptuous opposition, and force us to do it homage."[25]

But how does one know? The surest proof is the "secret testimony of the Spirit." For Calvin the real medium was the spirit, intermixed with the breath of ancient prophets and apostles: "The same Spirit, therefore, who spoke by the mouth of the prophets, must penetrate our hearts, in order to convince us that they faithfully delivered the message with which they are divinely entrusted." Those taught inwardly by the Holy Spirit know "that Scripture, carrying its own evidence along with it, deigns not to submit to proofs and arguments, but owes the full conviction with which we ought to receive it to the testimony of the Spirit."[26] Words are the privileged medium for Calvin, and for Protestants generally,

because they are the medium of original revelation in which the divine spirit intermingled with the utterance of prophetic discourse without undergoing translation into another medium, and therefore remain there at work in the written records of that discourse. Any image, by contrast, is a human rendition of a previous medium, its message transformed by the matrix of imagination. Words keep the Spirit of God pure. He dwells there, uncorrupted by human imagination. One does not require proof that a given text is truly divine scripture if the spirit has moved the believer in faith to apprehend the text as such. We have, Calvin wrote, "a thorough conviction that in holding it [the Scriptures], we hold unassailable truth . . . *because we feel a divine energy living and breathing in it—an energy by which we are drawn and animated to obey it.*"[27]

What does all this mean for Protestant experience? Put simply, the words of the Bible are, in this conception, infused with divine presence. One speaks them, reads them, writes them, sings them, chants them, studies them, and paints them in order to tap their power. For Calvin, spiritual illumination assured the Christian beyond the limits of human reason that "the Scriptures are from God." The sense of the scriptural word's authenticity was as certain "as if we beheld the divine image visibly impressed on it."[28] The true icon of God for Calvin was the word of God. The faithful did not need images or things because they had the reliable equivalent in the words that God spoke. Calvin therefore dismissed the Catholic tradition's emphasis on relics of Jesus as a material basis for devotion to the savior: "Instead of discerning Jesus Christ in his Word, his Sacraments, and his Spiritual Graces, the world has, according to its custom, amused itself with his clothes, shirts, and sheets."[29] Calvin contended that Jesus was no longer a material presence, but a spiritual reality. Spirit and matter were as different as past and present, Old Testament and New, earth and heaven. Relics as material traces could not reveal spiritual power and authority. Therefore, "all that is carnal in Jesus Christ must be forgotten and put aside." Christians should instead "direct our whole affections to seek and possess him according to the spirit."[30] Because this spirit rested in the words of Holy Writ, they were the only proper revelation of Jesus.

Luther parted company with other reformers on the carnality of Jesus, especially in his understanding of the rite of Holy Communion, but he grounded the written scriptures in the spoken utterances of Jesus and the apostles.[31] He urged his contemporaries not to reduce the gospel to a set of inscribed rules, but to think of it as spoken good news: "The gospel should really not be something written, but a spoken word which brought forth Scriptures, as Christ and the apostles have done. This is why Christ himself did not write anything but only spoke. He called his teaching not Scripture but gospel, meaning good news or a proclamation that is spread not by pen but by word of mouth."[32] Luther clearly stressed gospel as a mode of address, but he did so by tying speech and writing to one another, as Cranach's painting of him preaching suggests (see figure 10). We can see the power of Christ's speech put to textual work in another Lutheran print, this one by Hans Sebald Behem from 1525 called *The Fall of the Papacy* (figure 29). Stationed in the upper left, Jesus breathes out his word, which transforms into arrows carrying Bible verses,

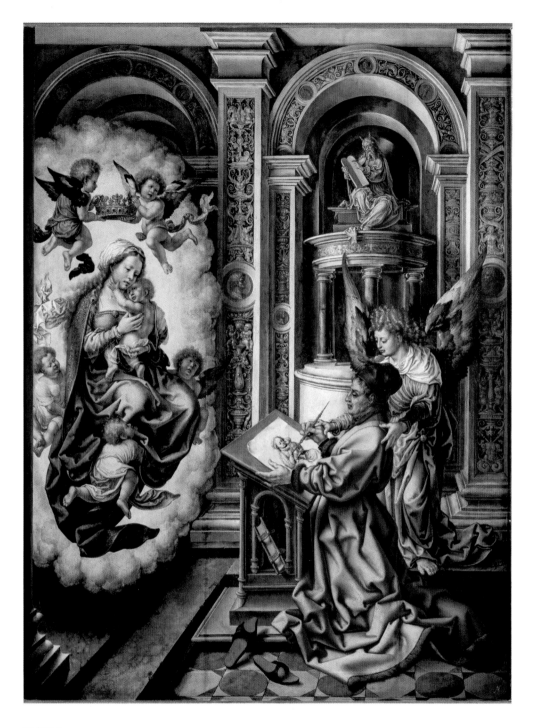

PLATE 1

Jan Gossaert, *Saint Luke Drawing the Virgin and Child,* 1520–25, oil on oakwood. Courtesy of Erich Lessing / Art Resource, NY.

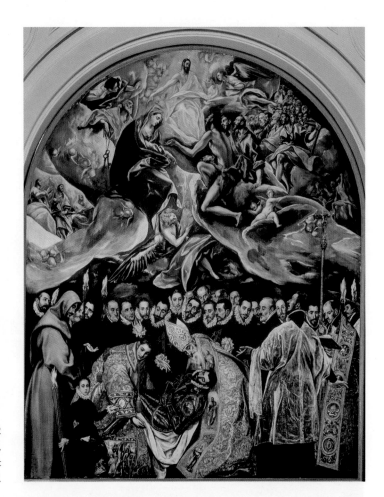

PLATE 2
El Greco, *Burial of Count Orgaz*, 1586–88,
oil on canvas. Courtesy of Scala / Art
Resource, NY.

PLATE 3

Nathaniel Currier, *Pray "God Bless Papa and Mama,"* circa 1838–56, hand-tinted lithograph. Courtesy of Billy Graham Center.

PLATE 4

Master Bertram, *Sacrifice of Isaac,* panel from the Grabow Altarpiece, St. Petri Church, Hamburg, 1379–1383, oil tempera on wood. Courtesy of BPK, Berlin / Hamburger Kunsthalle / Elke Walford/ Art Resource, NY.

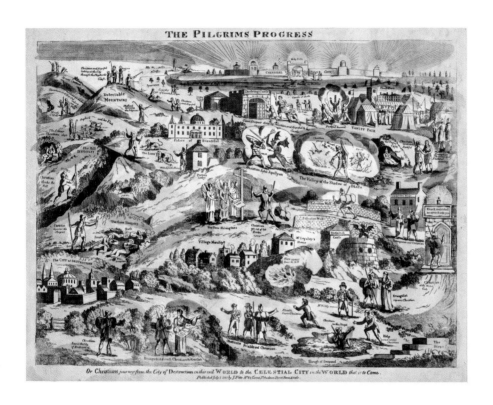

PLATE 5

*The Pilgrim's Progress, Or Christians journey from the City of Destruction in this evil World to the Celestial City in the World that is to Come,* broadside (London: J. Pitts, 1813). © The Trustees of the British Museum.

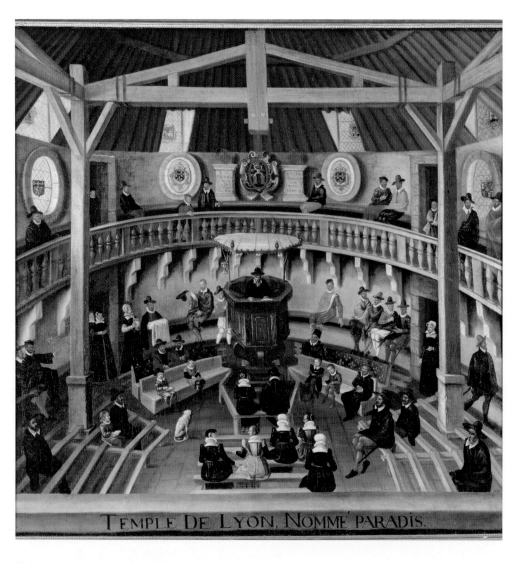

TEMPLE DE LYON, NOMMÉ PARADIS.

PLATE 6

Jean Périssin, *Sermon in the Reformed Church in Lyon, called "The Paradise,"* 1564, oil on canvas. Courtesy of Erich Lessing / Art Resource, NY.

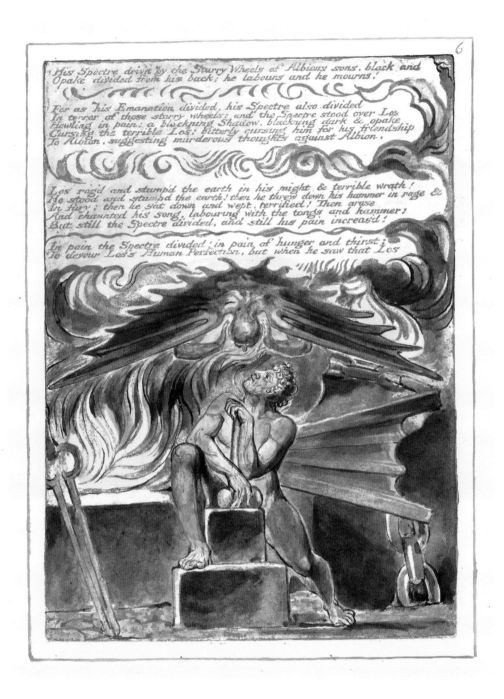

His Spectre driv'n by the Starry Wheels of Albions sons. black and
Opake divided from his back; he labours and he mourns!

For as his Emanation divided, his Spectre also divided
In terror at those starry wheels; and the Spectre stood over Los
Howling in pain; a blackning Shadow, blackning dark & opake
Cursing the terrible Los; bitterly cursing him for his friendship
To Albion, suggesting murderous thoughts against Albion.

Los rag'd and stamp'd the earth in his might & terrible wrath!
He stood and stamp'd the earth! then he threw down his hammer in rage &
In fury; then he sat down and wept, terrified! Then arose
And chaunted his song, labouring with the tongs and hammer;
But still the Spectre divided, and still his pain increas'd!

In pain the Spectre divided; in pain of hunger and thirst;
To devour Los's Human Perfection, but when he saw that Los

**PLATE 7**
William Blake, "His Spectre driv'n . . . " plate 6 from *Jerusalem*, 1804–22, relief etching. Courtesy of Yale Center for British Art, Paul Mellon Collection.

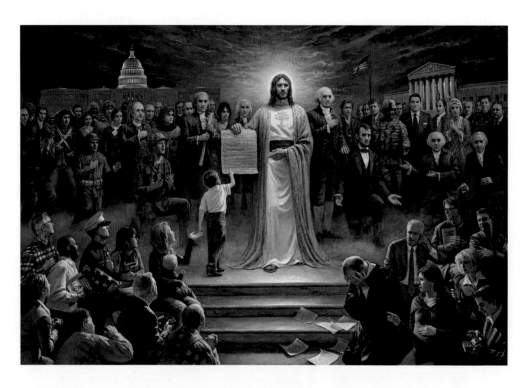

PLATE 8

Jon McNaughton, *One Nation under God*, 2009, oil on canvas. Courtesy of the artist.

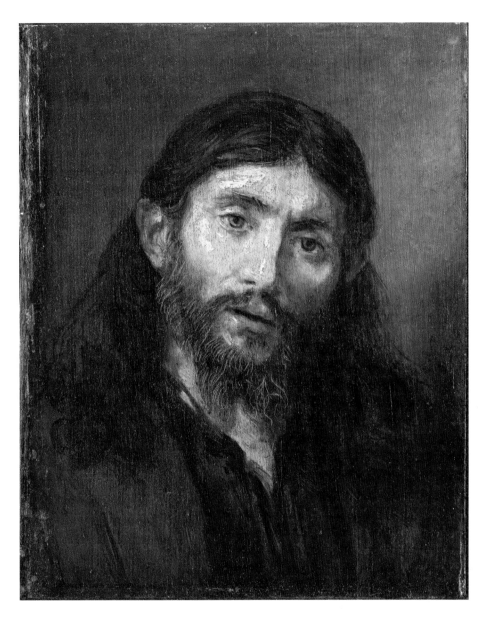

PLATE 9

Rembrandt van Rijn, *Head of Christ,* circa 1648–52, oil on oak panel. © Harvard Art Museum / Art Resource, NY.

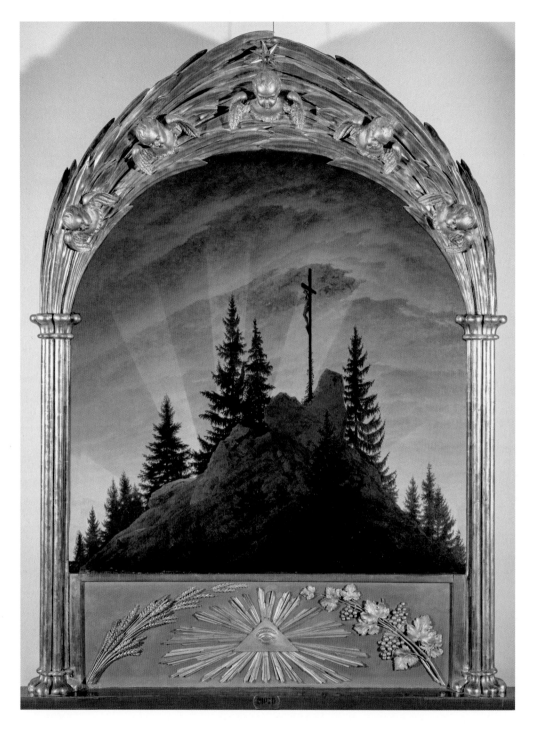

PLATE 10

Caspar David Friedrich, *Cross in the Mountains*, 1807–8, oil on canvas. Courtesy of Erich Lessing / Art Resource, NY.

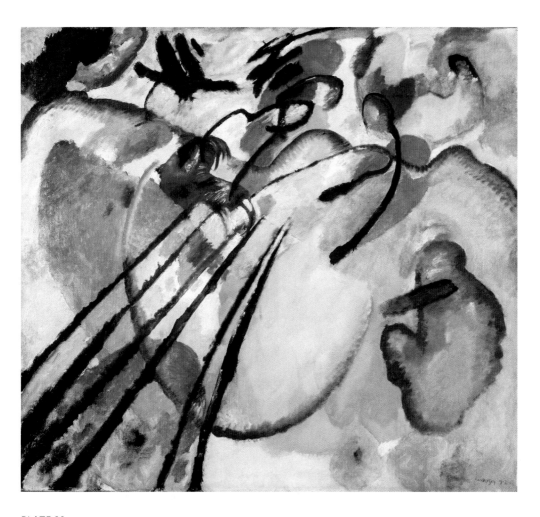

PLATE 11

Wassily Kandinsky, *Improvisation 26 (Rowing)*, 1912, oil on canvas. Courtesy of Munich, Städtische Galerie, Lenbachaus, Germany.

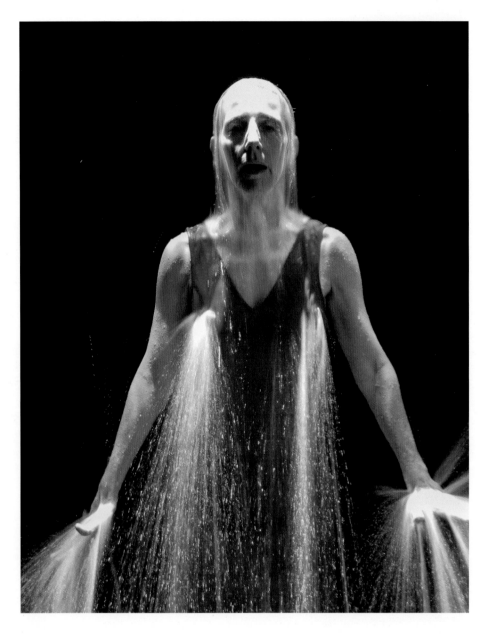

PLATE 12

Bill Viola, *Ocean without a Shore*, 2007, production still, high definition video triptych, two 65" plasma screens, one 103" screen mounted vertically, six loudspeakers (three pairs, stereo sound). Room dimensions variable. Performer: Weba Garretson. Photo by Kira Perov.

FIGURE 29

Hans Sebald Beham, *The Papal Throne torn down with ropes by the Protestant corporations*, circa 1544, woodcut. Courtesy of Staatsbibliothek zu Berlin, Stiftung Preussischer Kulturbesitz, Berlin, Germany / Art Resource, NY.

directed at the Catholic party. The papal force falters beneath the barrage of scriptural missiles. Most of the verse-arrows cite biblical passages referring to the Antichrist, and so find their target in the pope, the object of Protestant scorn, identified as the apocalyptic force of evil. Luther is visible in the far left, holding a cross and leading the party labeled "Christendom." A preacher in the front of this group gestures sermonically with a pointing finger, suggesting that the missiles Christ launches were activated by the Lutheran party preaching the word against the Antichrist. At the center of the image stands a prince, identified by R. W. Scribner as Charles V, the Holy Roman Emperor, who vainly supports the falling pope with the help of a kneeling bishop at his side.[33] Missiles of the word abound, battering the Catholic hierarchy, the princes, and the crumbling church.

Protestants by no means invented this focus on the word. Christian speech-acts such as the consecration of holy water, the Eucharist, baptism, marriage, exorcism, and all manner of incantatory word magic were widely practiced long before the sixteenth century. Protestantism directed its valorization of the word qua scripture against the sacred economy of late medieval Catholicism in order to develop an alternative economy of the sacred, as I have described it in the previous chapter. Moreover, Protestants have used

images in tandem with scripture in a variety of ways. For instance, Protestant churches in sixteenth-century Germany, France, Switzerland, and other northern countries made use of mottoes, plaques, and epitaphs to visually present scriptural passages. Images were avoided in Calvinist churches, but plaques enumerating the Ten Commandments and other scriptural texts were not uncommon.[34] A painting by Jean Périssin of the interior of the short-lived Huguenot church in Lyon, France, the Temple de Paradis, completed in 1564 and destroyed three years later, includes two classical pedestals on the upper tier that bear the abbreviated French text of Jesus's two summaries of the law recorded in Matthew 22:37 and 39: "You will love the Lord your God with all your heart, all your soul, and all your mind," and "You will love your neighbor as yourself" (plate 6).[35] Commenting on the Two Tables of the Law, Calvin points out that Jesus "summed up the whole Law in two heads" in the Matthew text. The painting clearly shows the two verses presented on a pair of stone tables, to make a reference to the stone tablets of Mosaic law and to follow Calvin's explicit teaching regarding the necessity of both the divine and the human aspects of the law: "God thus divided his Law into two parts, containing a complete rule of righteousness that he might assign the first place to the duties of religion which relate especially to His worship, and the second to the duties of charity which have respect to man."[36]

The interior space of the temple shows the impact of Protestantism on architecture. A paradigm of clarity, simplicity, and order, the church interior reveals what the Reformed community of Lyon wished to convey to the city about their movement. The interior was a material communication of respectability, propriety, and stability in a moment of civil unrest and armed Reformed zeal that even elicited Calvin's reproach. Huguenots throughout France needed buildings to house their growing numbers, but also to convey the clear signal that they pursued a new dedication to the *"Parole de Dieu"* and that they were not a subversive sect. They had written to the king of France, in 1561, insisting on their loyalty to the crown as subjects and rejecting claims that they were seditious and heretical. They requested the king's permission to assemble "to hear the pure preaching of the gospel from the mouths of ministers whom God has sent us in order to teach us, so that by these means we might be instructed more and more in the knowledge of our duty to God as well as to Your Majesty, and so that we might gather to beseech God incessantly for the preservation of Your Majesty, and for the repose of the entire kingdom." To this end, and that complaints about their "secret assemblies" might be put to rest, Louis de Bourbon Condé, speaking for the scattered congregations of the Huguenots, asked the king to grant them temples "or other public places, built or to build at our expense" since their "great multitude" could not be housed in private homes.[37] The open, ordered, and clear space pictured in the painting of 1564 was also designed to convey the orderly, civil, and genteel nature of their gatherings.

Organized for auditory advantages, the church was built in the round, designed as a large drum or cylinder in which seating radiated in arcs from the pulpit. The space no longer foregrounds surfaces for sculptures, paintings, or devotional imagery, nor

for the adoration of the host—there is not even an altar. This is a spaced dedicated to the sound of words. Sight lines are opened up and converge on the speaker in the pulpit. Speaking is the source of power in this interior, and it is striking that the nobility sit close to the speaker in what appear to be much more comfortable pews. The display of their station is visual, but the spatial proximity that anchored status was to sound. This serves to remind us that speaking, hearing, seeing, and touching were not appreciated as isolated sensory modes, but enfolded into one another in order to structure the life-world.

The only imagery appearing in the interior are heraldic emblems and coats of arms, set in wall medallions and in the upper story windows. The city's municipal coat of arms appears in the brightest window illuminating the interior, seen in the upper left. To either side of scripture-bearing tablets above the pulpit are two windows composed of what appears to be the French royal coat of arms, bearing fleurs-de-lis on a blue shield, surmounted by a gold crown. Their purpose was to declare the patriotism of Lyon's leading Protestant families, who included Huguenot burgers who had assumed control of the city in a brief moment of Reformed success. Their genteel status is evident in the finely dressed citizens who appear in the sanctuary. The best seating, to either side of the pulpit on the main floor, seems to be reserved for highly stationed families, and features a blue tapestry with golden fleurs-de-lis, referring both to the Lyonnais and the royal coats of arms. Above the pulpit, flanking a central coat of arms, appear two classical tablets inscribed with the scripture passages we have already examined. These inscriptions visually limn *"la pureté de la Parole de Dieu"* cited in Condé's petition to the king as the reason why the Huguenots had suffered "extreme calamities."[38]

The people in the painting perform what the 1561 petition to the king requests: they listen to a minister preach the pure gospel.[39] In 1567 the church was destroyed during the second wave of religious civil war, undertaken by Catholics who resented the terms of the Edict of Amboise (1563), which had endorsed freedom of conscience in religious worship, suggesting a Catholic act of iconoclasm that underscores the political nature of ritual destruction.

## TOWARD A MODERN PROTESTANT CHRISTENDOM

The conflict involving monarchy and the republican sentiments of Protestants alluded to in Périssin's painting remained in place into the nineteenth century. In eighteenth-century England, Dissenting Protestants (largely Presbyterians, Independents or Congregationalists, and Particular or Calvinist Baptists) were as likely as Catholics to be the target of the Established (that is, Anglican) Church. This tension produced by the end of the century a new strategy among Dissenters. Committed to a Reformed view, the Dissenters conceived of a web of interrelated forces that would change modern Christianity: union, print media, missions and revivalism, discernment of providence, and the reconception of Western Christendom within an emerging global print network. The Protestant

experience of sacred words as things, as agents exerting power, was configured and enabled by the reticulation of these conditions.

PAPER WARS AND POLITICS: ESTABLISHMENT VERSUS DISSENT

In conscious distinction to the hierarchical structure of the episcopacy of the Church of England, Dissenting Baptists and Independents had long practiced a congregational polity, which worked extremely well for a piety grounded in individual volition and discernment of vocation, for the experimental religion of the Puritan tradition, and for dissent from the establishment. The liability of this polity, on the other hand, was its capacity for spawning further dissent, which happened along a number of fault lines: to take just two examples, the hyper-Calvinist emphasis on divine sovereignty and predestination collided with its bitter opponent, Arminianism; and the Evangelical emphasis on experiential religion guided by a more or less literalist reading of the Bible was opposed by the Socinian or Unitarian insistence on rationality in biblical interpretation.

The paper wars that arose among these impassioned adversaries tutored a generation of Calvinist ministers born around 1750, all of whom had arrived in the pulpit just as the followers of Wesley and Whitefield raged over free will and divine sovereignty and as former Congregationalist clergyman Joseph Priestley publicly articulated his Unitarianism in a series of tracts, books, and sermons. One publication answered another for nearly two decades of sometimes urbane but often acrimonious debate, in what became rhetorically styled as a field of honor in which each side ritualistically expended the contents of its weaponry of print, creating a public sphere of dueling discourses. The controversies over Arminianism and Unitarianism began to die down just as the long struggle for civil liberty among Dissenters heated up once again in the late 1780s, when Evangelical and Unitarian Dissenters joined with Whigs in Parliament to seek the repeal of the Corporation and Test Acts, which had for over a century kept conscientious Dissenters and Catholics alike out of many public offices as well as banned them from admission to Oxford or Cambridge unless they consented to receive the Eucharist according to the Anglican rite.[40]

Opposing the repeal were the occupants of the Bishops Bench in Parliament, whose most outspoken member by 1790 was Samuel Horsley, bishop of Rochester and St. Asaph. Horsley had every intention of preserving the Establishment and took special delight in smearing Dissenters and especially Methodists with the odium of French infidelity, Masonic conspiracy, and revolutionary insurrection.[41] Horsley's underlying concern was the threat posed by the success of vernacular, itinerant preaching. Long smarting from the abuse of George Whitefield, whose popular homiletic style had gathered thousands of auditors out of doors when Established clergy had locked him out of their churches, the Established hierarchy was prepared to take a hard stand against the Dissenters, whom they viewed as arch rivals in the struggle for the soul of the British people. Most offensive to Horsley was the Dissenters' use of extemporaneous preaching,

in stark contrast to the carefully written discourses of Established clergy, which were read from the pulpit, to, it is important to add, dwindling numbers of congregants, particularly in the countryside, where the Evangelical preaching style and itinerant incursions successfully competed for listeners. The Evangelical proliferation of Sunday schools and village preaching stations and the rising flood of Evangelical print aimed at vernacular readership posed a clear and real menace to the Establishment. Checking this was the primary agenda in the fight to maintain the Corporation and Test Acts.

That all of this was unfolding in the moment of revolutionary France only intensified matters for both sides. Among the Dissenters, conservatives and progressives alike, many looked to Paris in 1789 as a rebirth of the hope signaled by the American Revolution. The Anglican Church, by contrast, saw the humiliation of the monarchy as utterly repugnant and sought only to tighten their hold on tradition as their institution defined it, arguing indefatigably for the necessity of the Establishment as bulwark for king and constitution. In the view of Horsley, Tory leader Lord Frederick North, and, with a bit more subtlety, Prime Minister William Pitt the Younger, the Dissenters simply could not be trusted.[42] Horsley repeatedly claimed that the Dissenters would seek to establish themselves the moment they were allowed to occupy the privileged positions denied them by the Test Acts. It was their kind, he insisted, who had executed a British king in the last century and it was their kind who had burned London in the riots of 1780. And, Horsley boldly asserted in his "Charge of 1790" to the clergy of his diocese, it was naïve country Methodists who were being made the dupes of French agents and unwittingly spreading political disorder in England, from the rural scatter of what Horsley contemptuously called Methodist "conventicles."[43]

The response among conservative Dissenters was to erect a big tent for conservative Calvinists to occupy, under the public title of "Evangelical." The immediate impetus for this shift in strategy was the failure to achieve complete civil liberty in repeated attempts to repeal the Test Acts—first in 1787; again in 1789, when it came only 20 votes from succeeding in the House of Commons; and 1790, when it failed by 189 votes after much more vigorous opposition from the Bishops Bench.[44] With the third successive failure, some conservative Dissenters decided to concentrate their hopes for Britain's spiritual renewal on evangelical measures. In 1793, twenty-four Dissenting ministers formed the editorial board of a new journal called *The Evangelical Magazine* (figure 30). This publication came in very short order to serve as the clearinghouse for cooperation among Independents (Congregationalists), Presbyterians, Particular Baptists, Calvinist Methodists, and conservative Calvinist clergy in the Church of England in the cause of spreading the gospel. The magazine avoided political commentary, though some of its editors had very strong political sentiments. One of the leaders of the group, David Bogue, published a four-volume *History of Dissenters* between 1808 and 1812, in which he and his young coauthor, James Bennett, gave much space to the history of the Dissenters' attempts to secure civil liberty, and repeatedly expressed disgust at Samuel Horsley and his party of heavy-handed "High Churchmen."[45]

FIGURE 30

Cover of *Evangelical Magazine*, 1805.
Photo by author.

At the same time that the battle against the Established church was being redirected into a project of Evangelical union invested in expanding print networks, Dissenters defended themselves from another quarter—the attack from freethinkers such as Tom Paine and Ethan Allen. In a sermon delivered in England in 1796 and immediately printed in the United States, Baptist preacher and *Evangelical Magazine* editor Andrew Fuller lamented that Paine's *Age of Reason* (1794) had exerted "great influence . . . upon men's minds."[46] Fuller reputed the charges of irrationalism and superstition ascribed by Paine and Allen to biblical writers by insisting that "God, in all his works, has proceeded by system: there is a beautiful connexion and harmony in every thing which he has wrought . . . [and so] it may be expected that the scriptures, being a transcript of his mind,

should contain a system."[47] Fuller offered a defense of the Bible's systematicity in order to bring Evangelicalism into the paper wars of public discourse where it could compete successfully with any philosophy, rational analysis, or cultural critique. This meant *textualizing* the Bible: like nature, the Bible as a text was comparable to "one grand piece of machinery, each part of which has a dependence on the other, and altogether from one glorious whole."[48] The result helped adapt the orality of Evangelicalism to a voluminously expanding print culture. In effect, Fuller crafted an important bridge between what he called "the oracles of God" and a textually grounded understanding of the Bible as exhibiting "systematical knowledge" or "systematical principles." This rooted a faith traditionally centered in preaching even deeper into written discourse and the enterprise of print culture, and thereby intensified the power of printed words to do work previously performed orally.[49]

## EVANGELICAL UNION: THE COMMON WORK OF PRINT

*Evangelical Magazine* promoted several causes that were central to the expanding print culture of British Evangelicalism in the 1790s. First was the London Missionary Society (LMS), initially proposed in a letter by David Bogue that was printed in the magazine in 1794. When the LMS was formed the next year, thirteen of its twenty-five inaugural directors were also on the editorial board of the *Evangelical Magazine*. Bogue was among the speakers at the first meeting of the Society in 1795, where he proclaimed: "This is a new thing in the Christian church . . . here are Episcopalians, Methodists, Presbyterians, and Independents, all united in one society, all joining to form its laws, to regulate its institutions, and manage its various concerns. Behold us here assembled with one accord to attend the funeral of *bigotry*."[50] He meant to herald an overcoming of sectarian strife in the unity of good will among Evangelicals from many sects, but also surely he intended a swipe at the partisan interests of the Church of England, whose Evangelical clergymen he welcomed to the collaborative venture. In any case, the magazine became the posting board for the LMS. The magazine added a regular feature called "Religious Intelligence" in which it broadcasted the latest news of LMS activities, published correspondence to and from the Society's leadership, and carried the ever popular reports and journals of missionaries from such exotic places as the South Pacific islands (the Society's first try at creating a foreign mission in 1796).[51] *Evangelical Magazine* also became the medium for official correspondence between the LMS and such far-flung organizations as the Moravians on the Continent and Evangelicals throughout Europe and North America. Letters reprinted in the magazine regularly updated readers about the status of Evangelical revival and missions around the world, feeding a journalistic curiosity and fueling the millennial expectations of Evangelicals. As a posting board, the magazine served to create a kind of monitor on world events that possibly contained, encoded within them, just the sort of prophetic correlations that Evangelical ministers were fond of deciphering as harbingers of the millennium's arrival.

In addition to celebrating the LMS, the editors of *Evangelical Magazine* promoted the practice of village preaching, that is, of preachers taking time away from their ordinary congregational posts to offer services to rural villages that had no local church, established or otherwise. Some of the magazine's founding editors served as itinerant preachers, organized the village preaching effort, articulated and defended its aims, and produced dozens of printed sermons for use by ministers and lay preachers.[52] The magazine also supported the formation of Sunday schools and circulated in its pages plans for establishing such schools. To support this effort as well as general evangelization, the magazine also urged its readers to form tract societies that might partner with a formally organized association, the Religious Tract Society (RTS), to provide tracts, pamphlets, and books for use in the classroom and home, and in public evangelization. Formed in 1799, the RTS offered in its first tract an address on the value and use of tracts, authored by none other than David Bogue. In this short and readable treatise, Bogue stressed the power of the ephemeral agency of print. He defined the religious tract as "a select portion of divine truth, designed and adapted to make the reader wise unto salvation."[53] Tracts were sacred truth conveniently packaged for mass production and dissemination, the latter both in the conventional and in the metaphoric senses: Bogue and his colleagues believed that tracts could be cast wide like seeds to plant the Gospel where it might grow into conviction and conversion and lead eventually to evangelical new birth. Evangelicals placed enormous hope and expectations in tracts as a primary agency of spreading the word.

## UNION, MILLENNIUM, PROVIDENCE

In the final decades of the eighteenth century in Great Britain, print media came to shape an international discourse that Evangelicals experienced as a medium of signs, what the directors of the LMS called "blessed symptoms that the spirit of God is moving upon the face of the troubled waters" of a turbulent Europe besieged by the high infidelity of the French Revolution and its aftermath.[54] The directors were deeply encouraged by mass print as a form of communication because it seemed to convey the benevolent acts of providence. Correspondence among widely spread Evangelicals and the constant stream of notices advertising international efforts in mission and revival were indications of a spiritual movement in which they took part, what they believed was a new dispensation that might hearken the millennial age. Evangelicals formed a media network, a global, diffused church, whose center was not composed of bricks and mortar, but of the printing press and publishing committee. Writing and reading were devotional exercises of communication and testimony of the new Christendom circa 1800.

Union meant a new age of Christian cooperation in the face of the global task. A report to the LMS in 1799 clearly articulated the ideal and its import: "The union among all real Christians, without distinction, which forms the distinguishing feature of your plan, attracts their peculiar admiration, and encourages the pleasing hope, that we shall soon approximate more universally towards each other, assume, as the body of Christ, greater

visibility, and hold more general intercourse, for the purposes of promoting his spiritual kingdom."[55] This report conveys the ecclesiology, evangelism, and millennialism of the Evangelical union. The membership of the LMS and related societies such as the RTS was seeking to realize an Evangelical Christendom as the "real" church, and saw contemporary political events as symptomatic of providential opportunity. A German clergyman conveyed to the RTS in a letter of 1801 what the communication network meant to him: "To be sure, there is nothing which can afford nobler pleasure to a Christian mind than to be united with other vital Christians, and to be convinced that there really exists an invisible church of Christ, planted in the midst of the visible, and to enjoy a share in the communion of the saints on earth."[56] It was not a new Reformation they sought, but a revitalized Christendom spread around the world. Print media were to play a key role in realizing this Evangelical Christendom because print—not sacrament or liturgy or traditional institutions—was the chief manifestation of the body of Christ, in the emerging visibility of the church as a global reality. The strategy was to build a canopy of print around the world to contain the real church, to make visible the true Christendom. The mediated body of Christ did not seek to separate itself or dominate the state, but to grow into greater influence and extent in order to hasten the second return of Christ.

## ORALITY AND PRINT: THE INSTRUMENTATION OF SPEECH

David Bogue emphasized the power and convenience of the tract medium. It avoided the limits of face-to-face oral culture to deliver the same message, and could do so irrespective of the limits of time and place. Print had something that orality did not. As Bogue said of the tract: "It would require some time to deliver its contents, and they might slip out of the memory, and could not afterwards be recalled. But it is given away in an instant; it may be perused and reperused at pleasure; and the truth may thus flow through a great variety of channels, and profit even many years hence."[57] Unlike the sermon, print was not limited to real-time effects. Stories soon circulated about the ability of tracts to plant the word without any contribution from a preacher. As bits of paper left along the way in everyday life, where they could be found by chance and read by those who had not encountered Evangelical truth, tracts assumed a providential stature: what might appear as happenstance to humans was in fact the operation of a higher agency making use of prosaic events.

Tracts also possessed very practical advantages, according to Bogue. They exerted a welcome social control that ought, he argued, to be applauded by Evangelicalism's cultural despisers: "In the present state of society," Bogue proclaimed, "when wickedness stalks abroad in every form with a brazen front, to take away from the mass of vice, though but a small portion, and to add to the sum of virtue but a single grain, will, by the philosopher and the moralist, be neither overlooked nor despised."[58] The tract, in other words, was the Evangelical answer to the Establishment's putative bolstering of British political institutions. If the Established church would secure Britain from above, the Evangelicals would do it from below. According to Bogue, tracts suppressed vice by virtue of their cheapness: because they

were very inexpensive, tracts could compete very well in the commercial marketplace with profane literature. For this reason, the RTS followed the example of the tracts of Hannah More's Cheap Repository by including wood engravings on the covers of many tracts (see figure 35). The RTS also engaged in aggressive competition. The minutes of the publication committee of the RTS demonstrate the organization's careful attention to the forces of the market, in their efforts to undersell secular competitors by offering hawkers special discounts on religious tracts. An annual report of the RTS noted very clearly the intention behind lowering the cost of tracts for street hawkers, even to the point of suffering an annual loss of four hundred pounds in 1815: "It is hoped gradually and ultimately to suppress more effectually, the foolish and licentious ballads and papers which are displayed on walls, or otherwise offered for sale in various parts of the metropolis and of the country."[59] Bogue assured his readers that customers would be led from reading tracts to further evangelical literature, indicating that tracts were but the front end of an entire regimen of evangelical salesmanship. He urged distributors and writers of tracts to prefer or produce tracts that presented "pure truth" clearly and plainly stated, and were striking and entertaining, that is, capable of grasping the reader's attention and holding it.[60] In a sermon, "The Diffusion of Truth," preached in 1800 before a meeting of the RTS, Bogue compared speech and writing as equally authorized forms of communication; writing, he argued "can plead in its favour divine example and command. Man has a hand to write, as well as a tongue to speak; and God has employed the pen of the ready writer, as well as the tongue of the learned, to convey a word in season to him that is weary."[61] If there were any doubt about the authority of text, Bogue proclaimed that "God himself becomes the author of a short Religious Tract: with his own hands he wrote the Ten Commandments of the law." Tracts were, therefore, in Bogue's words, "a method of God's own appointment."[62]

By making speakers into writers, tract authorship was able to overcome the insufficient number of preachers. A tract operated in the place of a speaker: many of the hundreds of tracts eventually produced by the RTS addressed the reader in the first person. In the United States, where the RTS served as the template for the American Tract Society (ATS) and a large number of other tract-producing and distributing organizations, Evangelicals were counseled to produce tracts that spoke directly to the reader without high-blown language or sermonic condescension. In both Britain and America, tract distributors were urged to keep on hand a variety of different tracts that could be suited to the needs of individuals. The RTS and the ATS produced dozens of different categories of tracts—for infidels, drunkards, swearers, backsliders, errant servants, errant children, errant husbands, vain wives, dutiful mothers, Catholics, pensioners, managers, merchants, sailors, soldiers, and even those most in need of sacred truth, divinity professors.

The power of print culture as Evangelicals understood it was its translation of the oral culture of the preached word, with all the limitations of face-to-face, real-time social worlds, into the far more flexible medium of sacred information. Mass print could be inserted into the byways of every social milieu and disseminated over time and space without forfeiting the advantages of orality. Print captured the spiritual presence that

FIGURE 31

Elisha Gallaudet, *Rev. Mr. George Whitefield*, 1774, engraving. Courtesy of Library of Congress.

animated speech and that was at the heart of scripture. Tracts remediated this presence, without, many Evangelicals believed, losing any of its charisma or aura. But this last question had to be worked out very deliberately, since preaching had been the privileged medium for Evangelicals. Indeed, since Whitefield and Wesley, the preferred mode of homiletic address among most English Dissenters was extemporaneous speaking. This is apparent in one of the countless engraved iterations of Nathaniel Hone's painting of George Whitefield (figure 31). The engraving reproduced here shows the famous preacher in a lofty oratorical moment, arms raised high. The Bible rests in the pulpit before him, but the image is about the speaker, about the speech of his dramatic gesture, wig, and piercing gaze (the artist has corrected Whitefield's crossed eyes). Scriptural truth is performed and performative. The spirit moves in the commanding speech of the orator, but voice here is part of an efficacious packaging. The bodily presence of the speaker linked

eye and ear in a single moment of absorption, as one contemporary commented: "Every accent of his voice spoke to the ear, every feature of his face, every motion of his hands, and every gesture spoke to the eye; so that the most dissipated and thoughtless found their attention involuntarily fixed."[63] Evangelicals were moved by such oratory because its interpersonal directness and spiritual immediacy conveyed the urgency and deeply felt dedication that comported with "religion of the heart." Moreover, this mode of discourse remediated their understanding of the Bible as writ transposing prophetic utterance, as spiritual discourse grounded in divine revelation. No less important, speaking extempore engaged lay listeners much more effectively than formal, written disquisitions read from the pulpit. The stodgy delivery of some Anglican clergy who read their sermons from prepared texts failed to inspire audiences in the way that the Evangelical improvisational style could.

The task for print producers, therefore, was to pattern the new mode of discourse in tracts on the archetype of Evangelical oral culture. The result, at least in the ideology of Evangelical print culture, was a seamless join that made print capable of delivering Evangelical truth. Contrary to the widely accepted dogma of Walter Benjamin, aura loses nothing in mass production, indeed, is even enhanced by it.[64] The proponents of religious tracts were fond of calling them "little messengers" and a variety of other endearing, animating terms that underscore the power of print to preach.[65] Bogue urged writers of tracts to use stylistic means that would encourage readers to project themselves empathetically into the text: "Where narrative can be made the medium of conveying truth, it is eagerly to be embraced, as it not only engages the attention, but also assists the memory, and makes a deeper impression on the heart. Dialogue is another way of rendering a tract entertaining. The conversation draws the reader insensibly along. He is generally one of the speakers introduced: he finds his own sentiments and reasonings attacked and defended: he feels every argument that is adduced, and the subject fixes itself strongly and deeply in his mind."[66] Readers were to find a close fit between the tract's evocation of circumstances and their own. The RTS was so enamored of the power of this match as the means of affecting readers that it regularly reproduced anecdotes, eventually several volumes of them, as demonstrations of the reception of their tracts. Reception was enfolded into production as these letters from readers were issued as tracts themselves. In one characteristic account from 1808, a woman is given a tract written as a dialogue between a minister and a parishioner, which, according to the report, becomes a dialogue between herself and the minister and ends in her conversion. According to the anecdote, the entire process unfolded without the assistance of another actual human being, consisting only of the reader's inward consumption of the tract.[67] The reader inserted herself into the dialogue and was transformed by it. The tract exercised the power to convert her. Just as Evangelicals commonly abhorred the power of the novel to lull the reader into dissipation, a wasting of will and energy in foolish, fanciful musing, they celebrated the power of pious print to bolster the will and rouse the conscience.[68] Texts had the power to help or hinder the cause of faith.

The experience of *ecclesia* that British Evangelicals at the end of the eighteenth century sought to nurture in the ecumenical unity of para-church organizations like the LMS, the RTS, and the *Evangelical Magazine* relied fundamentally on print culture, that is, on a culture of reading, writing, and publication that brought its participants into an extended *communitas* by means of the circulation of texts. The print networks undertaken among Evangelicals were believed able to produce action at a distance. The cover of the *Evangelical Magazine* preached this intention (see figure 30): an allegorical figure standing in for the magazine, its editors, and its readers presents profits from the enterprise's income to the veiled widow and children of Dissenting clergymen, an ongoing charitable effort that was documented to the last pence in the pages of the magazine each year. The message was simple: by subscribing to the magazine, readers contributed charity to widows and orphans whom they would never meet. The print network was more than a means of distributing information. It was a way of doing Christian good. More than communication, it was a formation of Evangelical community.

We learn something important about the stress that Evangelicals placed on print and unity by comparing the LMS and the RTS with one important source of their inspiration, the Moravian Brethren or Unitas Fratrum. In 1801, a brief account of the current state of Moravian missions around the world was printed in London. Its description of the role of writing among the Moravians in regard to missions is telling when compared with that among the British Evangelicals: "All Missionaries keep up a constant correspondence with this department, and also transmit to them copies of their Diaries and Journals. A Secretary is appointed to make extracts from them, of which manuscript copies are sent and read to all the congregations and Missions. By this a spirit of brotherly love and sympathy, and a near interest in the concerns of every Mission is preserved through out the whole Church, and constant prayers and supplications are offered up unto the Lord for the prosperity of his kingdom and the spreading of the Gospel."[69] This practice of correspondence and circulation was intended to emulate the early Church's use of epistles. Why did the Moravians prefer manuscript to print? Perhaps it preserved a sense of immediate communication that they associated with the apostolic church. The Moravian identification with the primitive apostolic church encouraged an ecclesiology that the British in turn extrapolated for their own print culture and ecumenical associations. In both cases, the idea was that epistolary texts circulating among a network of congregations conveyed the unity-forming power of the apostolic church, provoking sympathy and cooperation, igniting concern and compassion, and providing the means for imagining the church as a far-flung, organically expanding life, a human register of the work of the Holy Spirit. Manuscript preserved the personal dimension. But British Dissenters, who were fond of comparing their efforts to those of the apostolic or early church, attempted a mass-culture version of the same. And they took the Unitas Fratrum as a model of unity to be emulated, though selectively. London was to be the Herrnhut of the new

Evangelical *communitas*. Or on a broader historical scale, London was to be neither Rome nor Canterbury, but something more like Jerusalem—the launching point of a new Evangelical order that would configure Evangelicals everywhere in a bond characterized by purity and cooperation.

The Evangelical conception of this rebirth of the apostolic age becomes clear in Samuel Greatheed's work in Bedfordshire, where, in 1797, he organized an effort at union among diverse Protestant groups. In a sermon, Greatheed, who was both a founding editor of the *Evangelical Magazine* and an original director of the LMS, portrayed unity as the primary feature of an apostolic revival and looked to the Unitas Fratrum as inspiration for its possibility. The project's plan stipulated that its "primary design is to restore the universal Church of Christ to some measure of its primitive harmony and unity; and thereby to remedy the positive and obvious evils, which have been produced by discord among Christians."[70] Evangelicals were exuberantly confident about the prospects of achieving the primitive harmony of the apostolic age. In fact, some felt they might outdo the apostles in missionary zeal. In his sermon before the first meeting of the LMS in 1795, Bogue wondered if, to meet the millennial calendar calculated by many of his colleagues, which placed the dawn of the millennium within their own lifetime, "the religion of Jesus must have more rapid success than it has ever had, since it was first preached in the world; more rapid success than it had under the ministry of the apostles themselves."[71] Bogue seemed to imply that the answer to critics of foreign missions, who asked, "Are we better than our fathers?" was "Yes."

BEYOND EUROPE: IDOLATRY AND THE POWER OF PRINT

One of the most active agents at work on the experience of print in the colonial era was the non-Western mission enterprise of European and American Protestants. Missionaries and the enormous literature they and their sponsoring organizations generated often defined their purpose in terms of the encounter with idolatry, which became caught up in an extended network of representations, spaces, efforts, and institutions.[72] The ideological work of the idol, or rather, of writing about images dubbed "idols," is difficult to overestimate precisely because it is so deeply embedded in strata of contexts and uses. By enjoining idolatry, modern Protestants imagined themselves in the mantle of Hebrew prophets castigating ancient Israel's neighbors and foes. Just as the rejection of idol worship had been deployed to delineate Israel as God's chosen people, so did its extirpation by Western missionaries was intended to clarify the civilizing mission of modern Christianity in Africa, Asia, and the South Pacific. The battle was between word and idol. Images—both captured idols and printed illustrations in mission literature—served a fundamental role in the fight because the death of idols meant the life and victory of God's word, the Bible. Protestants challenged idols as dead matter, as things with no soul, no speech, no senses to enable interaction—as the opposite of scripture as divine agency. Ironically, they sought to destroy these objects and to replace them with animated objects

of their own: books and tracts that spoke God's word, paper that talked. One animism was exchanged for another, under cover of the presumption that words don't talk on paper, they signify. But we've seen that Calvinist theology itself was predicated on the animating power of God's word set down in the words of scripture, an Evangelical animism that scholars have often ignored. Protestants animated their words within what came to be a global print network that deftly linked a missionary's encounter with idolatry to daily life in London or Boston such that the end of idolatry over "there" was the victory of Christianity "here." Print linked the kingdom of God everywhere. To celebrate the gospel, the "Good News," it was necessary to get the news of its triumphs abroad, which returned to the British or American Evangelical as the marvelous working out of Providence.

My thesis is simply stated: killing images made paper come to life. Breaking images was an ancient ritualistic act, one with visceral connections. To break a habit means to free oneself from its grip. Violence of some sort, literal or symbolic, exerts control over the force that once controlled the habitué. For Protestants, those who venerated images were under the control of Satan or ignorance, that is, of moral or intellectual darkness. Knowledge was the key to spiritual liberation. The missionary's effort to illuminate the state of heathen ignorance made use of a variety of means. For those convinced that ignorance was best matched with information, such as Adoniram Judson in Burma or William Carey in Calcutta, the preferred strategy was literacy, argumentation, and the printed text. Other missionaries sought to invalidate indigenous beliefs by the use of scientific devices. One Baptist missionary among the Burmese recalled that her husband had attempted to subvert a Buddhist priest's legalistic insistence on the importance of avoiding the inadvertent killing of even an insect by placing a drop of water full of living creatures on the lens of a microscope to show that such avoidance was quite impossible.[73]

But for those less patient, or less committed to a pedagogy of proof or falsification, iconoclasm offered what they imagined would be a quicker, more decisive solution. The violation of cult images, which took a variety of forms, as we shall see, was intended to break the hold of such images on the imagination, to break the habit of dependence on them by reversing the relation of power. The idea was that what can be destroyed may not exert power over one. A British account from about 1816–17, republished for American Baptist consumption, related an incident involving a recent Chinese convert to Christianity in Java. The Chinese man was found in the garden of his home "beating to pieces with a hammer that idol he had recently worshipped as a god. On asking him what he was about, the awakened Asiatic exclaimed—'I am destroying that idol which I falsely believed in, lest it may again tempt me to sin; if I threw it away, somebody might fall down before it as I have done. I will worship the only true God, who dwelleth in Heaven. I know that I dare not return to my own country, but God can see and bless me as well at Java as in China.'"[74] Whatever the veracity of the account may be, the story taught the lesson of iconoclasm in Protestant conversion: only by the physical violation of the image would the convert be freed of temptation and rescued from the life-world of idolatry, in this case, the man's former home in China. Iconoclasm promised an abrupt and irreversible transformation, a

FIGURE 32

"The Idol Aesculapius: Scene in a Chinese Temple," cover of *Missionary Sketches*, no. 137 (October 1852). Photo by author.

radical departure from the culture of the unchristian and rebirth into the culture of Christianity—just the sort of conversion that Calvinist Evangelicals were looking for.

No less familiar a trope in nineteenth-century mission literature was the head-to-head encounter between Bible-toting missionary and an idol-worshipping priest at his shrine or altar. Figure 32 offers an example. Here we see the London Missionary Society evangelist and Bible translator Walter Medhurst engaged in debate around 1850 with a Taoist priest, in a temple said to be near the western gate of Shanghai. Medhurst spoke Mandarin, helped produce early translations of the Bible into Chinese, and founded the LMS Press in Shanghai. His reputation as a pugnacious man of the book is clearly portrayed in the illustration, which depicts him holding bibles tucked beneath one arm, extending the other in commanding oratory. According to a letter of 1852 by one his colleagues, who described his debate with the priest, and which Figure 32 was created to illustrate, Medhurst entered the temple, which was beside an apothecary's shop, for the purpose of aggressive evangelism. His technique was to bait the locals with questions and then attack their responses by citing and refuting their own sacred texts. On "one cold morning in January," we read, Medhurst accosted his interlocutors by dismissing the temple's "idol of Aesculapius" as "a mere piece of wood, destitute of all the senses: why apply to it to cure disease?"[75] The name of the Greek healing deity was used by the missionaries to name a Chinese healing figure. Visitors to the temple went next to the apothecary to purchase medicines for illnesses determined by divination. "Your money is thrown away," Medhurst insisted to one devotee, "and all this burning incense, and asking

information and aid from the idol is sin against God." When the priest objected to the missionary distributing Bibles by citing the *Kan Ying Pien (Book of Rewards and Punishments)*, a popular Taoist text, Medhurst responded by quoting it and arguing about its application to the worship of idols.[76] At each attempt to secure the sovereignty of his own religion by showing its parallel to Christianity, book for book, god for god, the priest met ridicule and abrupt refutation from the missionary. This technique of evangelism turned on challenging the cultural authority of the priest in order to demonstrate to laity that an alternative model of healing and religion existed, one grounded in a book the missionary was delighted to distribute among them at no charge. The tactic of Protestant missionaries throughout Asia was to textualize indigenous religion, focusing discourse with adversaries and potential converts on their own texts in order to refute them. The resulting "textual imperialism," as it has been called, favored the strong textual disposition of Medhurst's Calvinist Protestantism by organizing encounters in terms of creedal assertion and syllogistic argumentation.[77]

LMS literature offers fewer instances than one might expect of LMS missionaries in Asia directly undertaking the physical destruction of images. Although there is no shortage of evidence that missionaries assailed actual images with invective and sermons, preaching in front of them and publicly predicting their fall, and that they did bless their destruction, less space is given to description of LMS evangelists themselves smashing idols. Instead, as David Shaw King has documented, the process of conversion turned on the ritual and very public repudiation of cult imagery by converts, especially those of high rank, who would burn or hack the objects to pieces.[78] But it was also common for missionaries to gather discarded images or to purchase them as curiosities for themselves or for London, where a museum had been formed to display "trophies of Christianity."[79] In other cases, particularly in the South Pacific islands, missionaries received images from new converts. All these stances toward idols—acquiring them, displaying them, analyzing their meanings, and sending them back home for the curious to examine— constitute forms of capture that defused the power of such images, and constituted what may be called "soft iconoclasm."

But this is not to ignore instances of missionaries orchestrating the outright destruction of images. In 1817, Joseph Kam, LMS missionary on the Indonesian island of Amobyna, gave the following account of his role in an entire community's ritual act of iconoclasm:

> When I lately arrived at a large Negery, or Village, the name of which is Lileboi, north-west from Amboyna, upward of 800 persons, in order to convince me of the reality of their faith in the only true and living God, brought all their idols before me, and acknowledged their foolishness. I advised them to pack them all up in a large box (into which they formerly used to be put for their night's rest), and to place a heavy load of stones upon them, and to drown them in the depth of the sea, in my presence. They all agreed to follow my advice: a boat was made ready for the purpose; and with a great shout, they were carried out of the

Negery, and launched into the bosom of the deep. After this business was over, we sang the first four verses of the 136th Psalm. This is the fruit of the Gospel of Christ.[80]

The psychology of the ritualistic act that Kam urged the community of converts to perform was quite shrewd: by sinking the idols in a boat made for the purpose, the gods were drowned, killed en masse by the village gathered together for the purpose of a collective act of transformation. The selection of the first verses of Psalm 136 reinforced the intention behind Kam's instructions for the rite of iconoclasm. Its second verse reads: "O give thanks to the God of gods, for his steadfast love endures forever." The act of launching the boatload of older gods into the sea, where they sank to the bottom and drowned was intended to assert their inferiority to the God of the Bible. Conversion in this schema did not mean, at least not immediately, demythologizing the indigenous deities as errors of thought or delusions enforced by fear. Instead, the strategy was to convince the people of their gods' submission to the Christian deity. It was an approach adapted to the situation of many indigenous peoples. And conversion was an event conducted publicly and collectively. The entire community participated because the gods being replaced were community gods, constituting the social structure of the village's life. To replace them was a traumatic event, one that had to address the community as a group and to offer a direct substitute. Iconoclasm was not a destruction of gods who were empty or nonexistent, but of gods who were no longer powerful. The way to remove them was to execute them at the hand of the new and more powerful deity.

This nuanced engagement with the cultures they encountered was not a subtlety that the directors of the LMS held up for public scrutiny back home. In their annual report for 1820, they summarized the "entire abolition of idolatry" as motivated by "the influence of Christianity." Of greater interest to readers in London was the bloody revolt being carried out on Indonesian islands in 1817 against the Dutch colonial authority.[81] But Kam's understanding of iconoclasm was shared by many missionaries at work in island cultures in the South Pacific and was put into practice there much more commonly than among Indian and Chinese religionists encountered by Western missionaries. Widespread destruction of temples and cult figures in the islands of the South Pacific took place from 1815 to 1830—in the Tahitian Islands (1815), the Georgian and Society Islands, the Hawaiian Islands (1819), and the Cook Islands (1830).[82] At Tahiti, rival groups fought over the issue of dominance and split along lines of adherence to the traditional deities, under the leadership of a chief named Papara, and adherence to the new religion of Christianity, under the celebrated leadership of Pomare, the king of Tahiti. When Papara was killed in battle, Pomare ordered that his followers not be harmed. As a result, the missionary account relates, the party of "idolators" relented and "unanimously declared that they would trust the gods no longer; that they [the gods] had deceived them, and sought their ruin; that henceforward they would cast them away entirely, and embrace this new religion, which is so distinguished by its mildness, goodness, and forbearance."[83]

The result was the destruction of cult images and of the *marae,* or sacred grounds, where the images had lived. In these instances, the destruction of images was conducted by the indigenous population, not by Western missionaries, whose position was often precarious when they were present. An important role was frequently played by native converts from other islands, who instructed converts and prompted the destruction of images. But image destruction was nothing new to Polynesian culture. The cult images of an enemy party had always been a highly symbolic target in rivalries and wars. To destroy a foe's images was to claim power over him or her. Christian iconoclasm mapped itself over pre-Christian forms of visual violence, and did so with an eye trained carefully on the dynamics of images as powerful objects.

As missionaries in the South Pacific collected images of fallen gods, they announced the need for books and proclaimed the necessity that converts learn to read. Evangelicals replaced indigenous gods with a profusion of paper. Johann Supper, working in Batavia, distributed Chinese-language scriptures and reported that some Chinese inhabitants who read them "were induced to tear down from the walls of their houses those painted paper idols to which they had been accustomed to pay religious honours."[84] The act recalls the RTS campaign in London to replace secular paper bills posted in public establishments and in private homes with handbills it printed and provided to hawkers at reduced rates.[85] It also brings to mind the image limned in an annual report of the RTS, of a tract distributor handing out tracts among a group of card players, whose game is disrupted by their examination of the text. Poised with tracts in one hand and cards in the other, the players eventually capitulate, the tracts, we are told, having proved "victorious."[86] The work of tracts to rouse or strike the conscience, arrest cursing and drinking, and reprove vice and folly was hailed in stories recounted again and again in missionary society literature. Tracts were acclaimed as "silent, yet powerful monitors," "silent messengers of Grace," and "silent preachers of righteousness." They were "channels of communicating Divine Truth" and they fought head to head "to counteract the pernicious tendency of ballads, and other licentious and foolish publications."[87]

Though missionaries sometimes despaired at the thought that there were so few workers to gather in the harvest, they consoled themselves with the power of tracts to make the most of chance as the mask used by Providence. Unable to reach the twenty thousand Chinese living inland on Borneo, whose coast he visited briefly in 1819, LMS missionary John Slater sent in his stead "some Tracts and Catechisms; and hope that the seed sown will be as bread cast upon the waters, to be found after many days."[88] The reference was to Ecclesiastes 11:1, and was meant to convey that the diligence of the missionary who invested the tracts would return a profit even though, as William Milne, LMS missionary to China, reminded his readers back home, "to plough and sow are the labour of this age; to reap abundantly, that of future times."[89] His agrarian trope was not so picturesque as to conceal the Protestant economy it surely endorsed. The return on missionary investment sometimes seemed hopelessly slow, but the economy at work was finally anchored in divine bounty. Tempted by despair when he considered the

intransigence of Hindu castes to join in fellowship, another LMS missionary, Wilhelm Ringeltaube, reminded himself that the Lord alone was able "to open the book of Providence closed with seven seals."[90]

The missionary was not without books that he could open, and in which he took much comfort. On days when his labor seemed futile, Ringeltaube retreated to letters and missionary publications, devouring them with devotion. The books and letters offered the soothing presence of their authors: "Father Van der Kemp's Diary always has a most blessed effect on my mind," he recorded in his journal. "When those around grieve me, my distant friends and brethren, through a kind of Providence often experienced, come to console me."[91] The material presence of Evangelical print answered in some respect to the emotional attachments that others formed to cult images. Paper bore the breath of God and the warm presence of a far-flung community of saints.

# 5

# CHRISTIANITY AND NATIONHOOD

In his epic poem *Jerusalem: The Emanation of the Giant Albion* (1804–22), William Blake envisioned a complex and many-layered allegory of primeval humanity and the struggles that animate human nature, all taking place on the shores of the Thames. The story concerns the fate of Albion, the ancient name for England and the name of primordial man whose sleep produces deep rifts in his being that play out against one another, whose reintegration will reverse the fall of humanity. A primary figure in the cast of titanic forces is Los, the representation of inspiration and creativity, and the figure of the artist's imagination (plate 7). Los longs to reunite reason and imagination in order to awaken the slumbering and divided Albion and to destroy the false truth of religious orthodoxy, which has lost sight of the real nature of the human situation.

The image of Los at his forge conveys the centrality of the imagination as a faculty of revelation for Blake and signals the modern discovery of it as a positive rather than deceptive operation of the mind. Crafting the purpose and scope of the imagination was one of the principal tasks of the forge of vision during the modern era, since seeing owes as much to internal imaging as it does to external perception. Imagination came to be regarded in the course of the seventeenth and eighteenth centuries as a very useful mental faculty. As such it became part of Christian thought and practice, as the next two chapters will explore. Already in Blake's poem and in this image from it we can sense something profound at work. The poem is many things, but one of them is an elaborate emblem of England's travail as a symbol for the human condition. Albion was both the ideal of humanity and everything that was wrong with it. The image of Los reproduced

here makes visible the intrepid struggle of the artist to pursue his imaginative ideal in the face of oppressive religious authority—in Blake's case, the force of religious orthodoxy. And it is evidence of nationhood as a primary object of imagination.

In this chapter and the next I would like to understand two powerful ways in which imagination—of nationhood and of the founder of the religion—has shaped modern Christianity.[1] Often reviled for its perverse effects, imagination has not received its due in religious studies, especially in the study of Christianity. This misses an enormous opportunity to understand more about religious practice and the context in which modern religions have taken shape. With the rise of the modern individual and state, the interiority practiced in the Ignatian *Spiritual Exercises* and in the Protestant conception of the "religion of the heart" became a fundamental idiom for the imaginative practice of envisioning self, group, and polity in relation to one another. Without these interwoven forms of imagination, it is difficult to see modern Christianity at work since they interact to map the believer's sense of personal and collective belonging. Identity for moderns is an imagined participation in narrative and nationhood, a status one acquires principally through acts of imagination.

Imagining nationhood was very much a part of the colonialism of early modern and modern Europe. And religion had everything to do with this, since a nation was very often understood in terms of a single religion. Protestantism stood for England, the Netherlands, and the United States. The *Kulturkampf* that formed the emergence of Germany as a nation in the nineteenth century was fought over the battle line separating Catholic and Protestant allegiance. Catholicism stood for France, Spain, and Portugal. In the colonies, "heathenism" initially stood for everything that was not Christian, Jewish, or Muslim—or monotheistic. But eventually, as national consciousness arose and colonizers learned more about their domains and needed intellectual and cultural tools to organize and dominate them, religious constructions such as "Hinduism" emerged.[2] Buddhism came to stand for Sri Lanka, Burma, and Thailand. Religion was a powerful way that colonizing nations understood themselves and their subject nations. A nation was envisioned as singular, uniform body and a single religion was its soul.[3] In this regard, by imagination I mean the mental act or faculty of visualizing something that one does not and perhaps cannot see. Imagination could therefore help believers to visualize something like a nation or the lost appearance of Jesus. It is an act of seeing that claims to know. Moreover, imagination serves as a medium that allows large and scattered groups of people to come together despite their distance from and unfamiliarity with one another. The need to see, to possess, to know, the need to belong easily trump the risk of misrepresentation.

## IMAGINATION

The Reformation and the rise of the nation-state, which slowly reapportioned the hodgepodge territories of the Holy Roman Empire into a shrinking number of polities, provided

new geographical and political as well as religious circumstances for Europeans to imagine their relationships to one another. We have seen that images in Catholic spiritual guidebooks, in allegories like Bunyan's, in emblems such as those deployed by Johannes Gossner, and in texts used by Protestant missionaries were helpful in charting the spiritual path of conversion and sanctification. In all of these settings, the image of the heart was a primary metaphor for the interior state of the soul and tracing its vicissitudes. Showing the interior, imagining its process, was understood as an unfolding biography, a process that occurred in stages. Images served a primary role in imagining what was happening within. The interior came to be the locus of religion.

But as we have seen, imagination has a troubled history in Protestant thought, especially in the Reformed tradition. Calvin developed a strong critique of the imagination as a human tendency to distort God, by substituting human conceptions for the divine as revealed by scripture and the Holy Spirit. In his discussion of the Second Commandment, which he interpreted as strictly proscribing images of God or Jesus, Calvin insisted that "the human mind, stuffed as it is with presumptuous rashness, dares to imagine a god suited to its own capacity; as it labours under dullness, nay, is sunk in the grossest ignorance, it substitutes vanity and an empty phantom in the place of God."[4] The American Puritan minister Thomas Shepard (1605–49) denounced "man's headstrong presumption," the way in which people "content themselves with a faith of their own forging and framing." People "think they hold fast Jesus Christ in the hand of faith, and so perish by catching at their own catch, and hanging on their own fancy and shadow."[5] For the Calvinist Shepard, imagination was no more than human self-deception, a vain preference for self-forged shadow or image rather than divine reality. But as a medium for introspection among Evangelicals, the imagination gradually became a resource in the spiritual quest for contrition and rebirth. Knowledge of and interaction with the soul or heart depended on imagination—whether that was accessed by literature, imagery, prayer, or other material practices such as pilgrimage or scriptural study. One of the most important images to signal this shift among Protestants was the first illustration in Bunyan's *The Pilgrim's Progress* (first published in 1678), where the author himself is shown asleep, dreaming his narrative (figure 33).

Bunyan's allegory opens with the scene illustrated on this title page: "As I walked through the wilderness of the world, I lighted on a certain place where there was a Denn: And I laid me down in that place to sleep. And as I slept I dreamed."[6] He invokes in these lines the opening of Dante's *Inferno:* "At one point midway on our path in life, / I came around and found myself now searching / through a dark wood."[7] Both authors situate themselves out of the ordinary in the very midst of life. Lost in confusion and spiritual travail, each man resorts to literary imagination to envision a path—a sinuous, difficult, epic journey that will lead to the grand vision that pulls him forward. Bunyan helped Protestants to recognize the power of imagination by using it to narrate the way of the soul. Indeed, in the eponymous figure of "Christian," shown just behind the dreaming author in figure 33, Bunyan demonstrated how imagination was an indispensable faculty for Evangelical introspection.

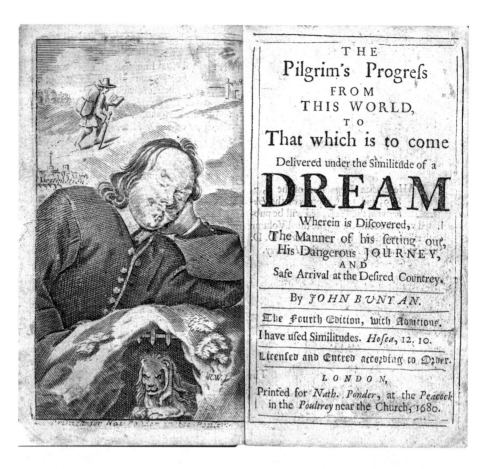

FIGURE 33

Frontispiece and title page of John Bunyan, *Pilgrim's Progress* (London: Nathaniel Ponder, 1680), showing Bunyan dreaming. By permission of the Folger Shakespeare Library.

The trope of the dream was very useful for Bunyan. Note how large the word "dream" appears on the title page, as if to assure the reader of the text's artistic license. As a medium, the dream was understood as visual, a flutter of images, the chimerical but inwardly optical stuff of thought. Its prominent place here implied a new evaluation of epistemology, a shift from regarding the imagination as fancy, phantasy, sensuous indulgence, inherently deceptive and untrustworthy, a means of misrepresentation, to imagination as a figuration of truth. Introspection was not a strictly rational procedure, a logical deduction of convictions, but a discernment consisting of analogies and figures. Consciousness was movement from state to state, episode to episode, scene to scene. Self-awareness, or introspection, arose through a complex relation as a way of locating oneself on a long journey. All of the elements—author, protagonist, and reader, beginning and end—form an imagined matrix in which to locate one's self.

In the course of the seventeenth century, imagination became a spiritual practice for Protestants. That it could do so owes to the Ignatian tradition that made visualization part of introspection or spiritual discernment. And Bunyan was clearly indebted to the spiritual road trip of Dante's *Divine Comedy,* as one instance of the broader tradition of the "dream vision" in late medieval literature.[8] But the shift also drew from the seventeenth-century tendency to regard imagination as part of the machinery of cognition. Thomas Hobbes included imagination among ideas, notice, conception, and knowledge as belonging to "the faculty, or power, by which we are capable . . . of knowing or conceiving."[9] More famously, in his *Elements of Law,* he asserted that imagination is "conception remaining, and by little and little decaying from and after the act of sense."[10] And Milton, in *Paradise Lost* (1667), described the utterances of Lucifer in the sleeping Eve's dreams as

> . . . imaginations, aery shapes,
> which reason joining or disjoining, frames
> all what we affirm or what deny, and call
> our knowledge or opinion.[11]

The self, for Bunyan, is inherently in motion, driven by the desire for salvation—by Christian's opening question, "What shall I do to be saved?" Christian cannot stop or dwell at any point lest he lose himself to the world. Fixture is death; mobility is hope, a foretaste of the ultimate transcendence that is redemption. An Evangelist appears in the midst of Christian's confusion and unrolls a parchment to reveal the engine of Bunyan's narrative: "Fly from the Wrath to come."[12] Christian then runs from his wife and children, stopping his ears in order to mute their pleas for his return. The desperate quest on which he embarks in this flight is for eternal life, for himself, the salvation of his soul, which Bunyan understood as a tearing away from the cares of the world, even those of one's own family. Driven by the heavy burden of sin that he totes on his back, Christian leaves them and his community of neighbors behind. They occupy the City of Destruction and do not share his painful consciousness of the burden of sin, which sharpens his anticipation of the bliss of the Celestial City. When he resists all attempts to compel him to come back, Christian and another fellow whom he has momentarily persuaded to accompany him are abandoned by a neighbor named Obstinate, who says, "I will go back to my place . . . I will be no Companion of such mis-led fantastical Fellows."[13] Obstinate berates their enthusiasm for redemption as "fantastical," a chimera of feverish imagination.

But Christian reveals a different view of the faculty when his traveling companion asks for more information about what awaits them. "I can better conceive of them with my Mind, then speak of them with my Tongue: But since you are desirous to know, I will read of them in my Book."[14] Scholars have compared the passage with another in *Paradise Lost,* in which the Archangel Raphael ponders Adam's request to tell him the

mysteries of time before time, the prehistory of the present world. Raphael wonders how best to "unfold the secrets of another world," but concludes that

> what surmounts the reach
> of human sense, I shall delineate so,
> by lik'ning spiritual to corporeal forms,
> as may best express them,

He then wonders if the analogy of the two domains is really so unsuitable:

> though what if earth
> be but the shadow of heav'n, and things therein
> each to other like, more than on earth is thought?[15]

Both Bunyan and Milton consider imaging able to capture an otherwise elusive relation. Movement in this likening or analogizing is key. When Christian meets a former traveler to the Celestial City now locked in an iron cage, he learns it is despair, the antithesis of this hopeful movement, that imprisons him. The entire book is structured as a series of passages from one node to the next, propelled by means of analogy that images feelings such as shame, despair, hope, trust, pride, and fear. The result is a narrative that organizes feelings into a landscape through which Christian journeys toward his final deliverance. The succession of scene after scene demonstrates that serial imagery is an ideal medium for introspection because it captures the temporality of the movement from ignorance to knowledge, condemnation to redemption. The revelation is experienced as the formation of a tempered self.

The emergence of interiority that helped define the spiritual path of the pilgrim-soul in the Protestant imaginary is paralleled by that of the lover of Christ in the Catholic baroque imaginary, where imagination was a means of empathy and intimacy with Christ. Jesuits were attracted for a variety of reasons to the Sacred Heart devotion that emerged in late-seventeenth-century France: for one, it fit their emphasis on visualization, which recognized the heart as the organ of interiority. An image from Ronco's *Royal Fortress of the Human Heart* portrays Christ at work in the heart, having entered and purged it of vices (figure 34). Jesus then paints the heart's interior with beautiful images, virtues that destroy the gall of vice that had possessed the heart.[16] Goodness is portrayed in the soul by means of spiritual influence, and the resulting images are models for moral conduct. In the preface to his book, Ronco indicated that the rulers of the human heart are the intellect (the king) and will (the queen).[17] The Christian welcomes Jesus to the fortress and allows him to take up residence there, where he refines, cleans, paints, teaches, illuminates, and reigns. Ronco's book, like Antoine Wierix's *Cor Jesu amanti sacrum* and the anonymously written *Geistlicher Sittenspiegel*, is not an allegory of the soul's mystical union with Christ, but rather a practical, moral guide to the several stages

DIPINGE IL CVORE.

Dipinge                    il core

Quasi diuin Pittor l'imagin belle
Dipinge egli nel Cor strugge le felle

Beati Mundo corde quoniam Deum videbunt.

FIGURE 34
Seventh meditation, "Paint the Heart,"
in Alberto Ronco, *Fortezza reale del cuore
humano* (Modena: Cassian, 1628), 54.
Courtesy of University of Illinois,
Urbana-Champaign, Rare Book &
Manuscript Library.

of submitting the soul to its spiritual master. As such, it marks a popular portrayal of the
soul in visual terms and suited the broad interest in shaping devotional life using forms
of visual media.

Catholicism and Protestantism were each developing a treatment of the heart as the
dominant emblem of the soul, a shift which injected Christianity with a material referent
for devotional practice and nurtured the intensified sense of interiority that slowly came
to characterize early modern Christianity at a time when the body painfully marked one's
membership in the Catholic or Protestant party. The tribulations of Christian and his
traveling companion, Faithful, in Bunyan's book allegorize the suffering of the true
Christian. After their arrest in Vanity-Fair, the two are tried and found guilty of civil

disorder. Faithful is denounced as a heretic, then scourged, stoned, lacerated, and burned at the stake, although Christian eludes the punishment by divine aid.

The trial and execution of Faithful is composed and illustrated in *Pilgrim's Progress* in a way that explicitly recalls the description and depiction of the fiery deaths of countless Protestant martyrs in Foxe's *Acts and Monuments*. "Heart religion" meant much more than intellectual assent to theological principles. It was the embodied faith of ardent commitment that might be put to the test of martyrdom, or, more likely, the ridicule and emotional suffering endured by Christian on his long pilgrimage, or by the Catholic heart-soul suffering the lacerations and arrows of providence. For Evangelicals, "heart religion" came to mean the experiential or, to use their term, "experimental" search for contrition and spiritual graces that would somatically mark God's work on the soul.

Hannah More (1745–1833) was an Evangelical in the Church of England, an abolitionist and author who joined with Beilby Porteus, bishop of London, to produce the Cheap Repository, a series of very popular religious tracts in the 1790s. In her widely read tracts and essays, More described Evangelical Christianity as a thorough transformation of the human being, touching all aspects of the person and transfiguring emotional and cognitive life. Simply put, she wrote in *Practical Piety*, a volume published in 1811, "heart" meant the entire person:

> The change in the human heart, which the Scriptures declare to be necessary, they represent to be not so much an old principle improved, as a new one created; not educed out of the former character, but infused into the new one . . .
>
> The sacred writings frequently point out the analogy between natural and spiritual things. The same spirit which in the creation of the world moved upon the face of the waters, operates on the human character to produce a new heart and a new life. By this operation the affections and faculties of the man receive a new impulse—his dark understanding is illuminated, his rebellious will is subdued, his irregular desires are rectified; his judgment is informed, his imagination is chastised, his inclinations are sanctified; his hopes and fears are directed to their true and adequate end . . . . The lower faculties are pressed into the new service. The senses have a higher direction. The whole internal frame and constitution receive a nobler bent.[18]

Yet as deep and as thorough as this infusion seems to be, it did not, More insisted, erase the old character. The faculties and the flesh remained, the human heart was as inclined to evil as ever. More described the countervailing need for what others called introspection but she called "introversion," and placed under the more general heading of "Self-Examination." She considered the need for self-examination to be habitual, an ongoing, regular practice of self-scrutiny that might regulate the will of the flesh to conform to its sinful inclinations. "We have appetites to control, imaginations to restrain, tempers to regulate, passions to subdue, and how can this internal work be effected, how can our thoughts be kept within due bounds . . . how can 'the little state of man' be preserved

from continual insurrection . . . if this faculty of inspecting be not kept in regular exercise?" The rhetorical framework in which self-examination is visualized continued to describe a politics of introspection: "This inward eye, this power of introversion, is given us for a continual watch upon the soul. On an unremitted vigilance over its interior motions, those fruitful seeds of action, those prolific principles of vice and virtue, will depend both the formation and the growth of our moral and religious character. A superficial glance is not enough for a thing so deep, an unsteady view will not suffice for a thing so wavering, nor a casual look for a thing so deceitful as the human heart."[19] If imagination remained a suspect faculty for some, including More, the language and instrument of self-examination—the medium of the heart's life and regulation—was nevertheless visual.

More's visualization of the psychological politics of self-control is striking, for she articulated it in terms that resonated within the social framework of British Christianity. The concern for social control is never far from More's portrayal of humble, industrious peasants who respect the gentry and prefer hard work, frugality, and piety to social unrest and the French Revolution. Her various personae encouraged the working class to read the Bible and tracts; one, a Mrs. Jones, a Sunday School activist, informs a recalcitrant farm owner that knowledge of the Bible "and its practical influence on the heart, is the best security you can have, both for the industry and obedience of your servants."[20] As the recommended tracts were also authored by Hannah More, it is easy to understand why she felt they had this effect. In what was perhaps her most famous tract, *The Shepherd of Salisbury Plain* (1795), Mr. Johnson, "a very worthy charitable gentleman," is riding across the plain when he encounters a lonely shepherd whose colorfully patched coat bespeaks his poverty but "equally proved the exceeding neatness, industry, and good management of his wife."[21] The distinction in social station between the two interlocutors could not have been more sharply drawn. Mr. Johnson discerns that the shepherd is without "any kind of learning but what he had got from the Bible" which he puts to use in the conversation reluctantly since "it better becomes me to listen to such a gentleman as you seem to be, than to talk in my poor way."[22] The spirit of the encounter is visually conveyed in the tract's cover illustration (figure 35), where the unequal rank is announced in the unmistakable differences between the peasant on foot and the mounted gentleman and their clothing. (For an American tract's portrayal of class difference and tract distribution, see figure 23). For More, the narrative of Christian fiction envisioned British Christianity as it was properly constituted: pious gentility and pious peasantry both at home in the rustic beauty of the English countryside, sharing a religion that buffers but also clearly reinforces their class differences while helping them to imagine a common purpose and national identity. Condescending gentility and self-effacing peasantry (we never learn the shepherd's name) were the complementary social units of English social order. If peasants needed to know their place, so did gentlemen, whose problem was not poverty but infidelity and dissipation. Mr. Johnson represents the proper English gentleman and he is the vehicle for the reader's presence

Cheap Repository.

# THE SHEPHERD

OF

## SALISBURY PLAIN.

IN TWO PARTS.

SOLD BY J. EVANS AND Co.
Printers to the Cheap Repository for Moral and Religious Tracts,)
No. 41 and 42, Long-Lane, West-Smithfield, and
HATCHARD, No. 190, Piccadilly, London. By S. HAZARD,
Bath; and by all Booksellers, Newsmen, and Hawkers,
in Town and Country.

Great Allowance will be made to Shopkeepers and Hawkers.

PRICE TWO PENCE.
Entered at Stationers Hall.

FIGURE 35
Cover illustration of Hannah More, *The Shepherd of Salisbury Plain*, Cheap Repository for Moral and Religious Tracts (West-Smithfield: J. Evans & Co.; London: J. Hatchard; and Bath: S. Hazard, 1795). Photo by author.

in the story. His is the eye the reader assumes in the inspection of the shepherd and his family.

One day Mr. Johnson decides it would be "neither unpleasant nor unprofitable to observe how a man who carried such an appearance of piety spent his Sunday," so he pays a visit to the shepherd's cottage. But as he approaches it, Mr. Johnson

wished to take the family by surprise; and walking gently up to the house he stood awhile to listen. The door being half open, he saw the Shepherd (who looked so respectable in his

Sunday-coat that he should hardly have known him), his wife, and their numerous young family, drawing round their little table, which was covered with a clean though very coarse cloth. There stood on it a large dish of potatoes, a brown pitcher, and a piece of coarse loaf. The wife and children stood in silent attention, while the Shepherd with uplifted hands and eyes, devoutly begged the blessing of Heaven on their homely fare.[23]

In this act of genteel espionage, the reader is made privy to a portrait of humble country life as a model of the Christian virtues of frugality, contentment, filial duty, and domestic piety. The gaze that Mr. Johnson constructs is clearly one that presumes the privilege of station. The peasant who placed himself at the door of a country mansion and presumed to spy on his or her betters would not be likely receive so charitable a treatment. More deploys the voyeur as a conceit to deliver a bona fide snapshot of the authentic life of pious peasants, but it is a snapshot that only the genteel viewer could take.

Yet More had at least two audiences in mind for her tract. The point was not simply to preach to peasants, but also inversely to present them to the genteel class as models of self-restraint. In fact, the scene of the furtive Mr. Johnson engrossed in quiet inspection of the family fits very well within the visual scheme that we have already seen at work in *Practical Piety*. The Christian, More wrote, will uncover in the relentless practice of introversion the idols that were the heart's manufacture: "The faithful searcher into his own heart, that 'chamber of imagery,' feels himself in the situation of the prophet [Ezekiel], who being conducted from one idol to another, the spirit, at sight of each, repeatedly exclaims, 'here is another abomination!'"[24] Calvin's forge of idols remains in force. The pious heart or interior of the self is a temple swept clean of idols, purged by an iconoclastic procedure of self-examination that sees in order to eliminate what the self might display to boast its value. All virtue, More contended, "is founded in self-denial, self-denial in self-knowledge, and self-knowledge in self-examination."[25]

In the place of self-love, the Christian seeker hoped eventually to see spiritual virtues installed by God, moving the soul toward greater and greater perfection. But this meant that the entire spiritual life was a restless motion, never fixed or stable. The same anxiety that was the driving force animating Bunyan's pilgrim would relentlessly purge the heart of the idols that gather there. "No one," More argued, "can be allowed to rest in a low degree and plead his exemption from aiming no higher. No one can be secure in any state of piety below that state which would not have been enjoined on all, had not all been entitled to the means of attaining it. Those who keep their pattern in their eye, though they may fail of the highest attainments, will not be satisfied with such as are low."[26] In the visual register of Christian introspection, a filmography that can capture the restive trajectory of spiritual progress, advancement is prompted by virtue of design. Endemic to the medium of self-knowledge, progress is a duty, an inner compulsion. "Let us strive every day for some superiority to the preceding day, something that shall distinctly mark the passing scene with progress; something that shall inspire an humble hope that we are rather less unfit for heaven to-day, than we were yesterday . . . . The Christian, like

the painter, does not draw his lines at random, he has a model to imitate, as well as an outline to fill. Every touch confirms him more and more to the great original."[27]

In More's extended metaphor of visuality the holiness of God operated as the engine of Christianity, and imagination was the means of discerning its work. By subduing the self through introspection, the Christian replaced the idols of vice with the vision of God's holiness, a dazzling spectacle that induced self-forgetting. When in scripture the "saints of old" are seized by the praise of God, she said, "they display a sublime oblivion of themselves, they forget every thing but God. Their own wants dwindle to a point. Their own concerns, nay the universe itself, shrink into nothing. They seem absorbed in the effulgence of Deity, lost in the radiant beams of infinite glory."[28] These images carry the soul out of itself, push it beyond its idols toward the face of the divine. With the retooling of imagination, the forge of vision had become an Evangelical work. Introspection was the heated internal search for the idols of sin and the radiance of the divine.

## NATIONHOOD

More framed her concern regarding the application of Protestant morality and religious faith among all classes of Britons within a commitment to recovering national well-being. The legacy of the French Revolution was the immediate occasion for her concern, but her interest in the social and political relevance of a revival of faith ultimately unfolded within the British tradition of the Christian nation-state. Religion was not simply a personal matter for More or her contemporaries. It was also national. Religion went to the core of the nation's character. This of course can be traced to Henry VIII and an age when the king embodied the nation. To throw off the shackles of Rome and proclaim the king the protector of the Church of England meant to liberate the polity of the nation from foreign rule and to align true religion with a people. Britons were quickly encouraged to regard themselves as the new Israel, an idea that is at least implicit in the portrayals we have discussed of Edward VI as the latter-day Josiah, rediscovering and reestablishing true religion. Thomas Hobbes promoted the idea of the people composing the body politic of the king, who in turn is their head, the head of state, containing the people within his person, balancing both secular and sacred power in his reign (figure 36).[29] The medieval European ideology of the king's two bodies, famously studied by Ernest Kantorowicz, identified the king's natural and political bodies as interrelated and the basis for the unity of his body and the kingdom he ruled. In the words of a sixteenth-century report to Queen Elizabeth, the king "has not a Body natural distinct and divided by itself from the Office and Dignity Royal, but a Body natural and a Body politic together indivisible; and these two Bodies are incorporated in one Person, and make one Body and not divers, that is the Body corporate in the Body natural, *et de contra* the Body natural in the Body corporate."[30]

The king's unification of corporate and personal identity is famously visualized in the frontispiece to Thomas Hobbes's *Leviathan* (1651), which depicts the monarch as the

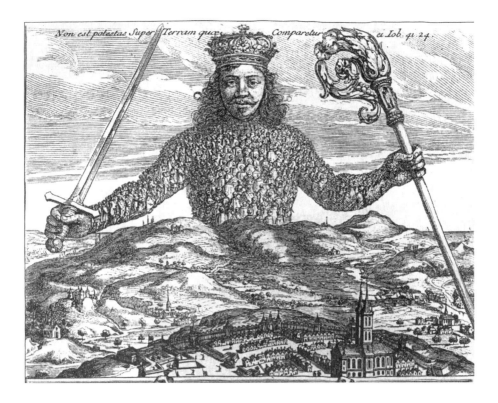

FIGURE 36

Abraham Bosse, engraver, "Leviathan," 1651, frontispiece to Thomas Hobbes, *Leviathan, or The Matter, Forme, and Power of A Commonwealth Ecclesiasticall and Civil* (London: Andrew Crooke, 1651). Photo by author.

head of the body politic, the corporate body of the commonwealth, holding a sword in one hand and an ecclesiastical staff in the other (see figure 36). According to Hobbes, the commonwealth only works when it appoints "one man or assembly of men to bear their person."[31] This is conveyed in the engraving by the gaze of the members of the host of people: each of them looks to the head of the king. Horst Bredekamp has argued that this visual convergence was in fact understood by Hobbes as a force that constituted the body politic and stature of the king.[32] Kings were made by natural force or by agreement among those who become the king's subjects. In either case, the act of looking exerted force and was therefore the emblem of the king's sovereignty. As Hobbes put it, "the miserable condition of war" follows from the natural inclination of humankind "when there is no visible power to keep them in awe, and tie them by fear of punishment to the performance of their covenants" and the observation of laws.[33] Awe, like fear, signals the power of submission induced by the visible presence of authority. But that very authority, Hobbes contends, results from "a real unity" of the members of a realm "in one and the same person, made by covenant of every man with every man." More than consent, the

people's conferring "all power and strength" to one ruler produces what Hobbes called "that great LEVIATHAN, or rather (to speak more reverently) of that *Mortal God* to which we owe, under the *Immortal God,* our peace and defence."[34] The mortal God is fashioned by humans via the visual traffic of awe. This definition pivots on an analogy linking personal and collective personhood. The body politic corresponds to the individual body or person of the monarch. The monarch decides for the subjects just as the individual decides for his or her body's parts, which are unified in each individual by means of will. This conception ranked monarchy above republic, disparaged democracy, and centered nationhood in the person of the king—and did not survive the seventeenth century in England. Yet the frontispiece to Hobbes's book and the idea it conveyed marks an important point in the history of national imagination, for even the popularly elected president of a modern republic comes to assume in his or her person an aura of the nation. In a mystical way, the leader of a commonwealth personifies it, and therefore allows its people to imagine their collective reality as a nation. For this reason, the piety of the leader has been important to British and American national imaginaries. The American president and the British monarch as protector of the Church of England are high priests in civil religions that are understood to secure national unity.

The literature on the history, origins, and constitution of the nation and nationalism is very large. Suffice to say here that I understand the nation to be a modern invention, emerging in the sixteenth and seventeenth centuries in Europe as a form of political imagination and social organization shaped by ethnicity, geography, language, commerce, and conceptions of monarchy that made use of religion to challenge older arrangements of power.[35] Imagination, as Benedict Anderson argued, made modern media into powerful instruments for manufacturing extended yet cohering communities of thought and feeling that reinforced the footprints of nations along lines of increasingly uniform language use.[36] But of course the formation of the nation-state was about more than language. The concentration of capital in historically established and geographically defined provinces with dominant ethnic identities reinforcing linguistic and religious majorities, intensified by competition for colonies and markets, and enabled by humanist republicanism and, in Protestant settings, by recognition of secular authority and national sovereignty over the primacy of the pope or imperial ruler—all of these combined to create the opportunity for new forms of political power and organization to emerge. The far flung network of global colonialism took the practice of the nation-state and nationalism around the world, planting it in the colonized populations that eventually freed themselves of their occupying states and joined the global marketplace to craft their own national polities. This is, of course, only one scenario for reading global history over the last several centuries. But my interest in national imagination is not in principle limited to the Eurocentric model, though for the global spread of Catholic and Protestant influence and the rise of the Western geopolitics of modernity, it remains my focus here.

By Hannah More's day, the rise of the middle class had already begun to replace an often impoverished nobility as the locus of national identity. It was More's own stratum and she took pleasure in endorsing the middle classes as the hope of Britain. For this reason she was alarmed by the allure of French taste among the British bourgeoisie, whose commerce, travel and wealth took them to France and allowed them to keep houses there, where they were "more than ever assimilated to French manners." The result was not encouraging. "It is to be feared," she wrote in 1819, "that with French habits, French principles may be imported . . . . We are losing our national character. The deterioration is by many thought already visible."[37] The hope, she maintained, was Britain's Protestant faith and a long list of items that touched on everything important to More: the rejection of French influence and bad literature, the return of the middle classes to "their ancient sobriety and domestic habits," the resumption of the "ancient rectitude, the sound sense, and the native modesty which have long been the characteristics of the British people," prison reform, care for the poor, the abolition of the slave trade, the return of British universities to "moral discipline and strict religion," Bible reading, Sabbath keeping, family prayer—only when these triumphed would England "not only excel her present self, but be continually advancing in the scale of Christian perfection."[38] The relationship between true religion and the English nation was special. More had no doubt that "the Christian religion, grafted on the substantial stock of the genuine British character, and watered by the dews of heaven, may bring forth the noblest productions of which this lower world is capable."[39] In contrast to France, in England, "Christianity presents herself to us neither dishonoured, degraded, nor disfigured. Here she is set before us in all her original purity; we see her in her whole consistent character, in all her fair and just proportions, as she came from the hands of her Divine Author."[40]

## NATIONAL IMAGINATION IN FRANCE AND AMERICA

But this idea was hardly limited to the English imagination. Margaret Mary Alacoque, for example, had framed devotion to the Sacred Heart of Jesus in the theological narrative of reparations to be paid for neglect of the Eucharistic body, but also with the motif of a divine lover spurned by his national paramour. France was God's chosen people, the new Israel, and Jesus divulged his longing for the nation through his chosen servant, Margaret Mary.[41] Near the end of her life she described the political desire of the Sacred Heart for royal recognition at the court as a reversal of Jesus's suffering and humiliation. Jesus wanted justice and designated the Sacred Heart as the focal object of national devotion so that he might receive it:

He desires, then, it seems to me, to enter with pomp and splendor into the palaces of princes and kings. He wants to be honored there as much as He was outraged, contemned,

and humiliated in His Passion, and to receive as much pleasure at seeing the great ones of the earth abased and humiliated before Him as He felt bitterness at seeing Himself spurned at their feet. Here are the words I heard with regard to our king [Louis XIV]: "Make known to the eldest son of My Sacred Heart that, as his temporal birth was obtained by devotion to my Holy Infancy, so will he obtain his birth into grace and eternal glory by consecrating himself to My adorable Heart. It wants to triumph over his and, through him, over the hearts of the great ones of the earth. It wants to reign in his palace, be painted on his standards, and engraved on his arms, so that they may be victorious over his enemies. It wants to bring low these proud and stubborn heads and make him triumphant over all the enemies of holy Church."[42]

It is a remarkable passage for its blatant expression of ambition. The economy of reparations is fitted over the national apparatus of France as the most Christian nation, the ever insecure kingdom of Christendom that had long pitted its national pride and interest against the rival Holy Roman Emperor as favored ally of Rome. Alacoque would make of Louis XIV another Constantine, who had affixed the emblem of Christ to his battle standards in order to achieve victory over his rival and establish Christianity as the religion of the Roman state. Alacoque called on the king of France to become the instrument of Jesus, reversing the centripetal force of the Reformation and European national politics that was already creating autonomous nation-states and eroding the power of the Roman pontiff. According to Alacoque, Jesus wanted to enter many palaces, not only that of the French king, in pomp and splendor. But the honor that Louis was called to bestow on the Sacred Heart would be the first step. Alacoque offered France this special recognition, but her letter continued to say that the Society of Jesus, through the intervention of her spiritual confessor, Father de la Columbière, would enjoy the blessings and graces of devotion to the Sacred Heart. And indeed, the Jesuits were the international force behind the long struggle to secure the spread of the devotion, its papal recognition, and Alacoque's eventual canonization. The Jesuits had long fought against the Jansenists and their commitment to a Gallican understanding of French Catholicism.[43] Embedded in Alacoque's words to the French monarch was a negotiation that at once privileged France and subjugated it to Rome in accord with Jesuit ultramontanism. Proponents of the Sacred Heart opposed the French Revolution and cheered the restoration of the monarchy in the nineteenth century. They renewed the push for the monarchy to embrace devotion to the Sacred Heart as means of making good on a national vow that eventually was fulfilled in the construction of the Sacré-Coeur de Montmartre in Paris.[44] Building the church was undertaken as a national act of penance, reparation for national failure, most immediately associated with the humiliating loss to Germany in 1870, but going back to the violence of the Revolution. The rapprochement of humbled nation and triumphant but gracious savior was visualized in an endless number of allegorical images such as figure 37, where we see France on her knees, eyes averted in shame, presenting a model of the Sacré-Coeur to Jesus, who condescends to accept the vow and reconcile himself to

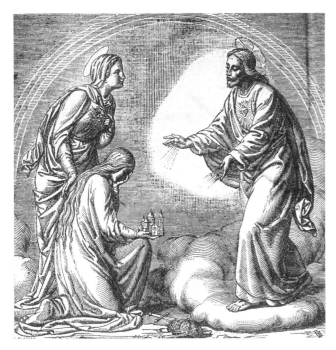

FIGURE 37

"Most Sacred Heart of Jesus with Gallia penitent and devoted," *Messager du Sacré-Coeur* 39 (January 1881): 2. Photo by author.

his favored daughter. France had strayed, but now as penitent Magdalene, prodigal son, or errant Israel—the biblical metaphors for national penance and redemption were manifold—the hope for regeneration was taken up in a sacred economy of reparation and pledge.

The imagination of Christian nationhood took a different form in the United States owing to greater British influence and to the dominant Protestant tradition. Protestant groups who migrated to the New World in the early seventeenth century understood the migration and formation of community settlements such as the Massachusetts Bay Colony in terms of a collective purpose blessed by divine providence. John Winthrop's famous 1630 sermon, "A Modell of Christian Charity," was delivered to frame the endeavor as a quest for a social body in which, as he put it, "the care of the publique must oversway all private respects."[45] "Wee must be knitt together in this worke," Winthrop declared, "as one man."[46] The mutual consent of the company was based on "a special overruleing providence" and an extraordinary agreement among Christian churches "to seek out a place of Cohabitation and Consortship under a due forme of Government both civill and ecclesiasticall."[47] This form of government was not what Hobbes had praised, but it clearly intermingled church and state. Its model, however, was not that of the parliament, monarchy, and Church of England, but the theocracy of ancient Israel. Winthrop used the rich rhetorical register of the prophetic tradition of the Hebrew Bible to configure the relationship between the Puritan company and their God.[48] The sermon established a parallel between the group's task and the biblical Exodus, a trope that would

remain in place by figuring the colony, and later the nation that followed, as a new Israel. The endeavor would be blessed, Winthrop assured his listeners, with an unusual outpouring of spiritual blessings and divine presence. The new Israel would enjoy a new dispensation of grace, a growth of religion that Jonathan Edwards associated one hundred years later with the wave of revivalism spreading through the colonies, leading him to claim that the millennial age would dawn in America.[49]

The idea of a special mission in which the remnant of the true church, sets out in a world hostile to it, breaking away from the reign of worldliness to seek the distant promise of the heavenly Zion, was of course the master trope of the second part of Bunyan's allegorical epic. Part 2 corrected the individualism of Christian's lonely trek in Part 1 by narrating, under the trope of Christiana, his wife, and the band of their children, the collective quest of the body of true believers for redemption. Christiana and her company are introduced by the Interpreter, Bunyan's allegory of the Holy Spirit, to his "man-servant," named Great-Heart, whose "business is to perswade sinners to Repentance" (figure 38).[50] A tradition of commentary identifies Great-Heart as Bunyan the minister and, by extension, all Dissenting ministers, leaders of their flocks, who were concerned to guard, but also to instill proper discipline within their congregations.[51] Great-Heart is bade by the Holy Spirit to take sword, helmet, and shield with which to protect and conduct the congregation to their next destination. The second part of *Pilgrim's Progress* becomes the adventures of the intrepid minister and his faithful flock.

The significance of Great-Heart's arms bears consideration as part of the Protestant imagination of the Christian polis. The Puritans, who avidly read Bunyan, wielded weaponry and executed a king; they were subjected to imprisonment, persecution, and execution. What does Great-Heart's sword mean for the pilgrimage of the true church? He first draws his sword when the band approaches two lions, who had represented civil and ecclesiastical powers in Part 1, when they tried and executed Faithful as a heretic. In Part 2, the Pilgrims encounter the lions that are guarding a highway. When the Pilgrims seek to enter the road, they are accosted by Grim or Bloody-Man, a member of a race of giants, we read (and possibly a reference to the Leviathan of Hobbes). Grim represents the civil and ecclesiastical powers oppressing the Dissenters, the very powers that had imprisoned Bunyan himself. The sword that might have seemed allegorical performs in a hideously literal way: Great-Heart hews Grim into pieces and smashes his helmeted head before dispatching him.

The portrayal of violence, punishment, and execution in Bunyan's allegory seems to disentangle itself from metaphor and limn actual or anticipated retribution. The illustration of Great-Heart that appeared in numerous editions beginning in 1684, when Part 2 appeared, and was emulated by subsequent engravers many times, shows him at the head of the small company, large sword over his shoulder, with three figures hanging from a gibbet on the hilltop beyond them. They are Simple, Sloth, and Presumption, whom Christian had encountered. When Christiana learns who they are, she refuses to lament their fate and coldly dismisses them: "They have but what they deserve, and I

FIGURE 38
"Great-Heart with Christiana and children," in John Bunyan, *Pilgrim's Progress*, part 2 (Boston: Joseph Bumstead, 1800), 164. Photo by author.

think it is well that they hang so near the High-way, that others may see and take warning." Mercy, her traveling companion, agrees: "Let them hang, and their Names Rot, and their Crimes live for ever against them."[52]

Violence serves in *Pilgrim's Progress* as a necessary means for separating oneself from the corrupting city of the world in order to make the pilgrimage to Zion. No champion of tolerance, Bunyan put in the mouth of none other than Ignorance the pacific sentiment of relativism: "Be content to follow the Religion of your country, and I will follow the Religion of mine." It was what Native Americans would tell Puritan colonists and it was the basis for negotiating territorial sovereignty in the peace treaties of Augsburg (1555) and Westphalia (1648) following the interminable religious conflicts: *cuius regio, eius religio*. But for Bunyan, and for the citizens of Puritan settlements in Massachusetts, violence against those infidels who threatened the community was a necessary means of preserving the community and maintaining its covenant with God. The illustration of Great-Heart leading Mercy, Christiana, and her four sons implied something powerful about the sovereignty of "mutual consent" that Winthrop identified as the political basis of his group's migration to North America. Violence is not only a physical act but also a

powerful form of imagination, able to draw the boundaries of those who envision its use by identifying authority, in the form of the bodies protected by violence and those damaged or destroyed by its use. The evocation of violence in literature, song, art, film, and folklore as well as in pious narrative likely constitutes the most prevalent role of violence in a national life. Imagining the destruction of "the bad guys" reinforces the broadly shared sense of a nation's boundaries and moral rationale. Protestantism came to the New World with a clear preconception about group cohesion and the symbolic as well as actual role of violence in maintaining that cohesion. After all, the new Israel had patterned itself after the old one, whose God endorsed the sort of violence that Great-Heart practiced against the church's foes, and which had been practiced on the church by monarch and state. Belief in the power of righteous and redemptive violence never left the American imaginary.

The tradition of Puritanism was arguably a living tradition in British America until the mid-eighteenth century. The Revolutionary War changed the key in which Puritanism was regarded, however. With the gradual ratification of the Bill of Rights, the disestablishment of religion became part of the culture of the new nation-state. But many Protestants, especially those of Calvinist descent, looked to the Puritan past as the proper ancestry of something many of them felt was now threatened by the separation of church and state: the Protestant ethos of the Christian nation. Rising immigration of Catholics in the 1830s and 1840s only exacerbated their anxiety. Evangelicals and other Protestants mobilized efforts at proselytism, tract and Bible distribution, the formation of Sunday schools, and promotion of the use of the King James Bible in public schools. Voluntary organizations such as the ATS and the American Sunday School Union produced primers, almanacs, and children's literature to support the instruction of children along Protestant lines. Narratives of the nation's origin commonly stressed the Puritan founders of colonies in New England.

Although the observation of Thanksgiving, established as a national practice in the midst of the Civil War by President Lincoln, included no reference to the Pilgrims or Puritans, the state-sanctioned act of ritual thanksgiving dated to the days of Puritan governments. The trope of the "Pilgrim Fathers" can be traced at least as early as the 1790s, and became the title of a best-selling history by British author William Henry Bartlett in 1853: *The Pilgrim Fathers; or, The Founders of New England in the Reign of James the First.* After the Civil War, as immigration once again flourished and was opened to immigrants from far more varied backgrounds than Irish and German Catholics and European Protestants who had arrived in earlier periods, the public iconography of Thanksgiving fixed increasingly on seventeenth-century Puritan life and slowly came to include Pilgrims, a separatist sect of Puritanism. One of the most popular and widely reproduced paintings of the early colonial Puritans was George Henry Boughton's 1867 canvas, *Pilgrims Going to Church* (figure 39). Boughton had read Bartlett's narrative and even copied out several passages of it, which may document his inspiration for the picture.[53] Bartlett's text stressed the precarious state of affairs among the early settlers on lonely trails in the

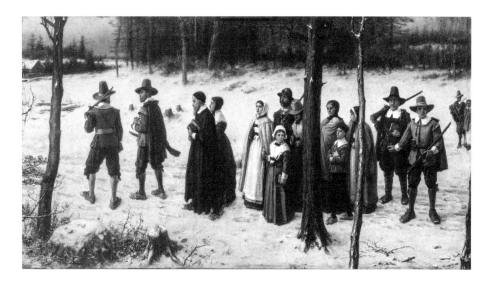

FIGURE 39

George Henry Boughton, *Pilgrims Going to Church*, 1867, oil on canvas. Collection of the New York Historical Society.

forest wilderness, "armed to protect themselves from the Indians and wild beasts," as they made their way to church. Bartlett mentioned a wedding party en route to the church, but Boughton portrayed instead a small company with armed men at front and rear enclosing the privileged company of the pastor and his wife and female family members. Life was rustic and risky in those days, the painting implies, but Puritan piety and chivalry prevailed (Boughton's original title made no reference to Pilgrims, only to Puritans). In the beautiful but dangerous countryside, the group bands together to secure civilization in the wild. The world that Victorian viewers of the image inhabited, it intimates, was the result of the Puritan effort at Christian community. Just as Christiana and her band of Christians had been led by armed force in the person of Great-Heart, so Boughton's band of Puritans risks life and limb in the pursuit of the holiness that was the very reason for their errand in the wilderness. In effect, Boughton updated the seventeenth-century illustration of Great-Heart and Christiana, giving Americans an appealing way of imagining their joint enterprise at a moment of dual national crisis: civil strife and division, on the one hand, and massive immigration and demographic change, on the other. The world founded by the Puritans was crumbling, and in places like Boston, now a dominantly Catholic urban center, even disappearing. The mythos of Thanksgiving, ritualized by Lincoln and visualized in the corpus of Boughton's many paintings of Puritan life in the early seventeenth century, offered an alternative narrative of national origins and purpose. Perhaps many admirers of Boughton's picture wanted to imagine a Christian nation's beginning as something that might be reclaimed, or at least used as a steady mooring in the troubled waters of the present.

But not everyone was convinced by the Protestant propaganda lauding the Puritan Thanksgiving as the originating moment of the nation. As early as 1842, a year in which tensions between Protestants and Catholics in the United States were boiling over (see figure 24), the Philodemic Society of Georgetown College, a collegiate debate society, sponsored the first commemoration of "the Landing of the Pilgrims of Maryland" with an oration by local Catholic author and activist William George Read (1800–46). "Why are we so late," the speaker asked the gathering at St. Mary's City on the western shore of the Chesapeake Bay in the spring of 1842, "in the proud ceremonial of this day?"

> Why so far behind our brethren of Massachusetts, in testifying veneration for the founders of a time-honored community? Why is the rock of Plymouth classic ground, consecrated by annual outpourings of the mind and heart of cis-atlantic Attica, while old St. Mary's and St. Inigo's, the primal seats of civil and religious liberty, are known but to an occasional wanderer? What has made the Mayflower, the Argo of American story, while the Ark and the Dove, that bore the mysteries of Religion, and the olive branch of peace, to a benighted people who as yet knew the pale face only by his wrongs, have perished uncelebrated and unsung, till their very names have faded from the knowledge of more than half our people. I will not enforce the humiliating answer.[54]

The New England Puritans commanded more cultural capital than the Catholic party aboard the *Ark* and the *Dove,* which landed in 1634 on an island off the coast of what would soon become the colony of Maryland, where the second baron of Baltimore and his brother founded St. Mary's City. A small engraving on the cover of the oration pictured the scene of the arrival of Father White, a Jesuit priest who was among the *Ark*'s company (figure 40). We see the *Ark* anchored in the Potomac and the small company gathered about the cross that the priest had raised in honor of the day.[55] William Read, in his speech, not only recounted the story of Father White's arrival, but framed it within the plans of George Calvert, first baron of Baltimore, for founding the colony of Maryland, and within the long history of Catholic conversion of "pagans" to Christianity. Calvert's sons brought to the New World ideas later used by the founders of the nation, ideas which, Read pointed out, Calvert had found in Catholic teachings much older than John Locke, Thomas Paine, or Thomas Jefferson, "the principles of civil liberty, diffused throughout the works of the most approved divines of those and yet earlier ages."[56] Read cited Thomas Aquinas as endorsing the equality of human beings, the justification for overthrowing a tyrannical government, and the confessor of Charles V as espousing the idea of political authority derived from "the people."[57] He held up "the unprecedented legislative declaration of religious liberty" as the "crowning glory of the Calverts and of Maryland."[58] In 1840 the Catholic Tract Society of Baltimore issued its first tract, the *Address of the*

FIGURE 40
"Pilgrims of Maryland," cover
illustration of *Address of the
Editorial Committee of the Catholic
Tract Society of Baltimore* (Balti-
more: Catholic Tract Society, circa
1839). Courtesy of Library
Company of Philadelphia.

*Editorial Committee,* and placed on the cover the same engraving used two years later on the cover of Read's *Oration.* The *Address* explained that the image portrayed "the example of those holy and patriotic men who first unfurled the banner of civil and religious liberty," which deserved to be remembered because "the spirit which glowed in their hearts is the spirit of our religion and of our government."[59] The idea that American ideals of liberty were grounded in Catholic thought and example would continue to figure in Catholic social thought and scholarship well into the twentieth century.[60]

The celebration of civil liberty as a soundly Catholic heritage was a point that Read was moved to argue in the face of Protestant Nativists in the United States, who claimed and would continue to assert that Catholic immigrants could not make good citizens in a democratic republic since they recognized a supreme and autocratic authority in the Roman pontiff. To counter this claim, Read unleashed a rhetorical fusillade against a host of Protestant patriarchs in the Northeast and in Anglican Virginia:

Tell me not of the liberal principles of Roger Williams, under whose rule of near half a century at Providence, the Rhode Island ordinance excluded the Catholic from the franchise of his own asylum from Puritan persecution! Tell me not of the charity of Penn, who could rebuke his officers for toleration of the Catholic worship! . . . while Winthrop was recording his discontent at the "open setting up of Mass" in Maryland; and the Law-established Church, in Virginia, was wielding the scourge of universal proscription, the Catholic of Maryland alone was found, to open wide his door to the sufferer of every persuasion.[61]

Read pointed proudly to the Maryland Toleration Act of 1649, passed by the second baron of Baltimore, which ensured freedom of religion to any Trinitarian Christian. Referring obliquely to the law's intolerance of Jews and Unitarians, Read conceded that the act "was but the opening of the glorious day we have been permitted to see."[62] But in doing so he cleverly stressed that Catholicism was part of a historical progression toward increasing civil liberty in America. In the midst of nineteenth-century Protestant anti-Catholicism, Read urged his audience to recognize a useable Catholic past to challenge Protestant hegemony's claims to a Protestant nation. A countervailing national narrative would make room for Catholic founders, pilgrims of another tradition, and ones who contributed to the formation of the nation in ways that contradicted latter-day attacks from Protestant Nativists.

The battleground for this clash soon became the public schools, since the schools were seen as democracy's necessary means of civilizing and moralizing citizens. The disestablishment of religion and the rise of immigration combined to intensify the anxieties caused by democracy. Education was considered the best way of inculcating a necessary influence. And the Bible was among instructional texts widely in use in the opening decades of the nineteenth century. But Catholics soon challenged this, pointing out that the King James Bible was a Protestant rendition.[63] In 1841 Archbishop John Hughes addressed a gathering of angry Catholic parents in New York City on the matter of the public school use of the Protestant Bible and even of anti-Catholic tracts. He stipulated that Catholics were not asking for sectarian schools or for public money to support them. "We do not ask for the introduction of religious teachings in any public school," he proclaimed, "but we contend that if such religious influences be brought to bear on the business of education, it shall be, so far as our children are concerned, in accordance with the religious belief of their parents and families."[64] Nativists were alarmed at the spread of Catholic schools and by the prospect of public monies spent on the Roman faith. In the end, it made more sense to a growing number of jurists to remove the Bible from the public schools altogether.

In fact, Bibles had been dropping out of public education since the antebellum period, well before the much-discussed controversy in Cincinnati from 1869–72, which ended with the removal of Bibles, although a few states and school districts continued to mandate Bible reading well into the twentieth century.[65] In its place, a contemporary and more uniform movement began to claim the public schoolroom as the space for a civic

piety dedicated to making American citizens, targeting its efforts on the sacralization of the American flag. In the final decades of the nineteenth century, flag piety become the focus of veterans organizations such as the Grand Army of the Republic (GAR), the Daughters of the American Revolution (DAR), the Sons of Veterans, and Protestant clergy who advocated the display of the flag in and on churches. On September 30, 1889, for example, the Central Illinois Conference of the Methodist Episcopal Church adopted the resolution to "recommend that the American flag be placed in our churches and Sunday-schools as an emblem of our Christian civilization."[66] Many church bodies followed suit, leading to the common sight of American flags in sanctuaries to the present day. In the long wake of the Civil War, the oratorical pyrotechnics mounted as veterans and patriots intensified flag piety. Newton Bateman, Illinois superintendent of public instruction and longtime friend of Abraham Lincoln, maintained that "the true American patriot is ever a worshipper. The starry symbol of his country's sovereignty is to him radiant with a diviner glory than that which meets his mortal vision . . . . Where that ensign floats, on the sea or on the land, it is to him the very political shekinah of his love and faith, luminous with the presence of that God who conducted our fathers across the sea and through the fires of the revolution to the Pisgah heights of civil and religious liberty."[67] The intermingling of flag and faith grew so fervent that the loss of the Bible from the public schools was forgotten by those who felt the totem of the flag was a stronger device for fusing the immigrant nation into a militant uniformity.[68] Accordingly, the DAR and the GAR undertook the sacralizing of the flag as a civilizing ritual to be deployed in public schools as a way of making citizens. Manuals appeared in the 1880s and 1890s to guide school officials and teachers in the administration of flag display and veneration, and state legislatures quickly codified anti-desecration laws.[69] Imagining nationhood became a powerful ritual for shaping students, and also for shaping new citizens. We see it at work in photographs of school children from the 1890s, standing as a single body in a powerful corporate act of recitation and bodily attention (figure 41). The Pledge of Allegiance, written in 1892, was modified in 1923 in order to capture the pledger's imagination and eliminate any ambivalence about the referent of the ritual utterance. The words "to the flag of the United States of America" were added to the opening phrase "I pledge allegiance" since advocates felt the original lack of signification might allow new citizens to hold in their mind allegiance to their former nations.[70] Imagining the proper nation at the moment of sacred oath was considered crucial in the minting of new citizens, whose loyalties were to be bound by the ritual. Imagination was a powerful act, intermingling soul and nation in an utterance. In order to clarify the object of commitment, flags were prominently displayed in the ceremony and citizens were typically made to stand in attention, recalling the formal recitation of the Pledge of Allegiance performed each morning in schoolrooms.

During the nineteenth century the Vatican preferred that the Catholic Church around the world avoid close ties to the emergence of nationalism and the ascent of democracy as the political culture of modernity. Owen Chadwick has succinctly summarized the

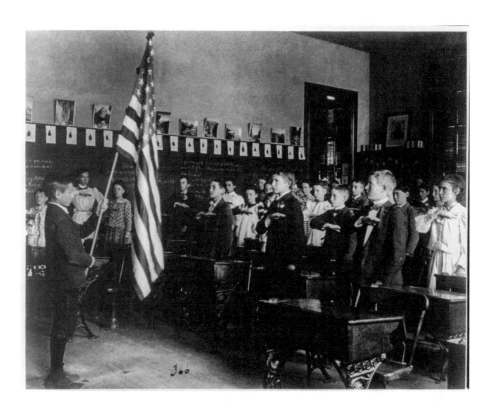

FIGURE 41

Frances Benjamin Johnston, *Schoolchildren Reciting the Pledge of Allegiance to the Flag*, Washington, DC, 1899. Courtesy of Library of Congress.

view of Pius IX in 1848: "The Pope wanted Italy to be free of foreigners, and to prosper, but saw that a fully constitutional government was not compatible with the temporal sovereignty of the pope."[71] Buffeted by reaction to his refusal to endorse a war of liberation against Austria, Pius IX fled Rome. In 1849, the revolutionary government of the republic of Rome stripped the pope of temporal power and declared that Catholicism was no longer the state religion. When Pius IX returned to Rome in the following year, Garibaldi and Mazzini having fled the peninsula, "a once liberal-minded pope," as Chadwick put it, "became a resolute conservative."[72] Pius IX joined many other popes before and after him in targeting modernity and liberalism as challenges to the sovereignty of faith and the authority of the Church. Driven by the alarming violence and institutional upheaval across Europe as a long series of political revolutions helped form secular nation-states, or states in which the traditional position of the church was limited or even eliminated, Pius IX issued the "Syllabus of Errors" (1864), which catalogued "the particular errors of our age." Among these were the claims that "the entire government of the public schools in which the youth of any Christian state is instructed . . . can and should be assigned to the civil authority" and "the best state of civil society demands that

the peoples' schools . . . should be exempted from all authority, control, and power of the Church."[73] On matters of government, the papacy aimed directly at the legacy of the Reformation on national sovereignty, rejecting the view that "kings and princes are not only exempt from the jurisdiction of the Church, but they also are superior to the Church in deciding questions of jurisdiction." In a statement with direct relevance to American national history and constitutional law, the syllabus opposed the idea that "the Church is to be separated from the state, and the state from the Church."[74]

Pius IX had issued the syllabus on the Feast of the Immaculate Conception, a date that recalled his formal proclamation in 1847 of Our Lady of the Immaculate Conception as the patroness of the United States. That proclamation endorsed the 1792 placement by the bishop of Baltimore, John Carroll, of the United States in the protection of the Blessed Virgin under the name of the Immaculate Conception. As Jay Dolan has suggested, two models of Catholicism competed in nineteenth-century America: what he calls "republican Catholicism," which was shaped by Enlightenment thought and advocated an indigenous national church, and Tridentine Catholicism, which insisted on a strong papacy and "stressed the authority of the hierarchy and the subordinate role of the laity. The medieval monarchy, not the modern republic, was its model of government." The latter won in what Dolan calls "the Romanization of the Church."[75]

An image captures U.S. Catholicism's configuration of authority and nationhood at the time of the first Vatican Council, 1869–70. Issued in German and English, *The Eternal Rock of the Roman Catholic Church* (figure 42) was created by August Hoen, an established lithographer in Baltimore, and published in 1872 by F. Schummer & Co., also of Baltimore. Pius IX had convened the council to affirm the church's stand on doctrinal issues in the face of spreading revolutions and the advance of political agendas that supported nationalism, secular states, and scientific and philosophical materialism. No less important, in an age of crisis for authority, the council also endorsed the doctrine of papal infallibility. The Schummer lithograph reads like a billboard affirmation of the reactionary nature of the council and the pope who planned it. The submission of kings and princes to the power of the church, the authority of the pope based on apostolic succession and the original decree of Jesus, the centrality of the ecclesiastic institution in matters of faith—all are visually registered in the lithograph. On the far right, Constantine, the first Christian emperor of Rome, hails the apparition of the cross, which enabled his victory over a pagan rival, and commends it—with its Latin inscription, "Conquer under this sign"—to his fellow "heroes of the true faith," Charles V and Henry II. On the far left, Jesus hands Peter the key to his kingdom, announcing that he will build his church on this rock, in text running up the contour of the central mountain and into the image of St. Peter's basilica on its summit. Behind Peter appears the long line of subsequent occupants of the throne of Peter, vanishing in the distance behind the rock. In the two upper panels, the Blessed Virgin receives the Annunciation and is crowned by the Trinity. Across the front of the elevated altar space appears an iconostasis or screen of images that separates the viewer from the mysteries of the altar and proclaims the central moments of Jesus's life: his birth, entry into Jerusalem,

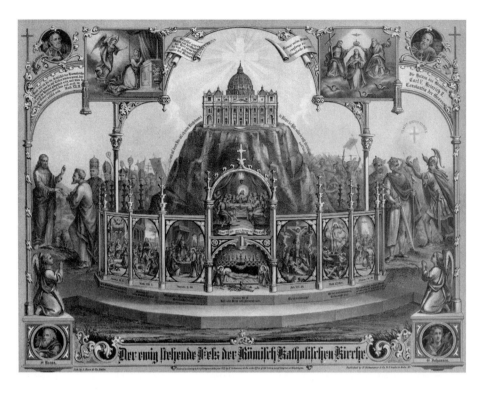

FIGURE 42

August Hoen, *Der ewig stehende Fels der Römisch Katholischen Kirche* (The Eternal Rock of the Roman Catholic Church), lithograph (Baltimore: F. Schummer and Co., 1872). Courtesy of Library of Congress.

the Last Supper, his trial, crucifixion, the lamentation of angels over the dead Christ, burial, Resurrection, and Pentecost. Consistent with what Jay Dolan has described as the "siege mentality" of the Romanized Catholic Church in America throughout the nineteenth century, the image suggests that the church is a fortress protected by faithful rulers and the unbroken line of papal authority going back to Christ. The centrality of the magisterium and clerical authority could not be clearer.[76]

While Pius IX and some of his successors opposed the modern conception of the sovereign nation, with its clear distinction between church and state, many American Catholics were able to imagine a happier relationship between American democracy and the church. Though republican Catholicism was a thing of the early national past, there were Catholic intellectuals like William George Read who saw religious liberty as a Catholic heritage and could see Catholicism as belonging to the American landscape of cultural ideals. A visual example of this stance is Fr. Raphael Pfisterer's mural, *Mary Immaculate, Patroness of the United States*, painted in the Church of St. Francis Xavier in Buffalo, New York in 1920 (figure 43).[77]

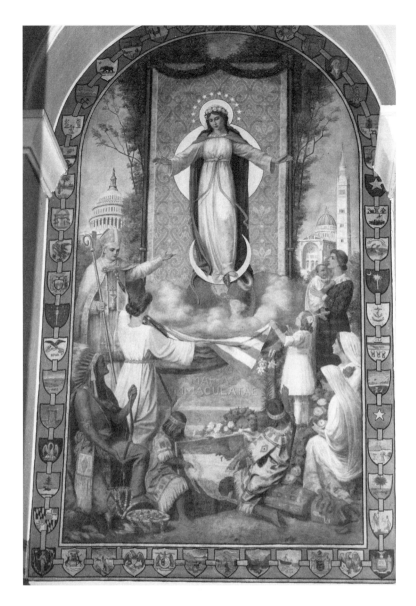

FIGURE 43

Father Raphael Pfisterer, OSB, *Mary Immaculate, Patroness of North America,* in St. Francis Xavier Church, Buffalo, NY, 1920. Courtesy of Buffalo Religious Arts Center, Buffalo.

To either side of Our Lady appears, on the left, the Capitol building, and on the right, the future National Shrine of the Immaculate Conception, whose tower slightly exceeds in height the cupola of the Capitol's dome. It was an imagined juxtaposition, since the shrine is in fact several miles from the Capitol. Yet their proximity and symmetry in the image, arrayed beneath each benedictional hand of Our Lady, clearly indicates both their sympathy and their parity. A pope affirms the Virgin and a gathering of Native Americans at her feet acknowledge the protection of Our Lady. The imagery is historically resonant. The presence of Native Americans recalls the theme, sounded by Read and others in the nineteenth century, of the benevolence of the first Catholics in America toward the native inhabitants.[78] The reproduction of Pfisterer's image in a brochure promoting the National Shrine of the Immaculate Conception in 1920 suited the vision of the diversity of the Catholic faith espoused by the shrine's planners.[79] Whereas contemporary Protestants admired in Boughton's painting the drama of armed Puritans poised for attack from hostile "savages" (see figure 39), devotees of the Immaculate Conception celebrated the docility of Native Americans. With the American flag spread below her, Mary's presence also echoes the founding of the colony of Maryland in honor of the Feast of the Annunciation. In that context, the flanking church and government buildings might even be taken to refer to the Maryland Toleration Act of 1649, which mandated freedom of religion for all Trinitarian Christians, a configuration of church and state that Calvert, sponsor of the first settlers in Maryland, wished to install there to prevent the episodes of persecution that plagued Catholic and Protestant alike in sixteenth and seventeenth-century England. The image suggests that benevolent establishment of Catholicism on American soil, distinguishing it from the aggressive Romanism of the Schummer lithograph (see figure 42). The faith is not, Pfisterer's image argues, inimical toward democracy. Nation and Mother of God bear a special relationship: the cloud of her glory is gathered up in the American flag below her. Emblems of the forty-eight states surround the scene. The implication is that the cohesive force bringing the nation together is Mary. The nation, represented by the gathered people, but especially by the flag that is used to receive her glory, is like a vessel in which her grace is contained.

The idea of nationhood as a modern vessel, a medium of revelation fashioned to contain a new dispensation of an ancient truth, also shaped Black nationalism among Christians and Muslims in the twentieth century. Imagining a diasporic nation of wayward sons and daughters of Africa, cast to the winds by the long industry of the slave trade, became a powerful way out of centuries of enslavement, enslaved mentality, and social inferiority for many Blacks in the Western hemisphere. Whether it consisted of creating a separate and sovereign state, liberating Africa from colonial rule and mentality, or transforming one's consciousness from a state of racial inferiority to a celebration of international Black culture and history, Blacks in the Caribbean and the United States, from W. E. B. DuBois and Marcus Garvey to Elijah Muhammad, encouraged generations to think beyond their citizenship in a dominant white nation.[80] For Black nationalists, the logic of nationhood proposed an irreducible polity, able to actualize the inherent

liberties and possibilities of a people racially defined. Religiously, nationhood was the medium of divine intention or providence, the communal form for experiencing covenant or promise between a race and a deity. Modeled on the Hebrew Bible's conception of Israel's relation to Yahweh, Black nationalism, whether Christian or Muslim, understood race and religion as the indispensable ingredients of national identity and political self-determination. "The Negro," wrote Marcus Garvey in his "Appeal to the Conscience of the Black Race to See Itself" (1923), "needs a nation and a country of his own, where he can best show evidence of his own ability in the art of human progress. Scattered as an unmixed and unrecognized part of alien nations and civilizations is but to demonstrate his imbecility, and points him out as an unworthy derelict, fit neither for the society of Greek, Jew nor Gentile."[81] To this end, Garvey founded the Universal Negro Improvement Association (UNIA) in 1914, dedicating it, as he wrote a few years later in his newspaper, *The Negro World*, "to champion Negro nationhood by redemption of Africa."[82] Included in the organization's aims was the desire "to promote a conscientious Christian worship among the native tribes of Africa."[83] Dedicated to working "for our racial salvation," the UNIA was a fraternal organization that aimed at practicing the American ideal of self-reliance. In his "Appeal," Garvey embraced a Social Darwinism, boldly declaring that "the best of a race does not live on the patronage and philanthropy of others, but makes an effort to do for itself. The best of the great white race doesn't fawn before and beg black, brown or yellow men; they go out, create for self and thus demonstrate the fitness of the race to survive."[84] Garvey employed the religious trope of "racial salvation" in service to a secular rhetoric, suggesting that races around the world formed a competitive social system in which nationhood was the principal measure of progress. Without a discrete nation, Blacks could not better themselves and show their improvement. Yet Garvey also understood nation in the religious terms of salvation. Rather than requiring all Blacks to return to Africa, the UNIA regarded Africa as a topos, a cultural ideal to which people might return imaginatively, on spiritual pilgrimage, recognizing thereby their lost unity. Nationhood was therefore the means of envisioning a social redemption of the race. To imagine belonging to a Black nation was the critical visual move toward realizing it.

The relationship of religion and American political ideals continues to be variously construed. One religious group that has defined itself by grounding its religious ideology in American geography and nationhood is the Mormons, or Latter-day Saints (LDS), whose founder, Joseph Smith, believed them to be God's chosen people. Neither Catholic nor Protestant, but in their own understanding quite Christian, the Mormons have charted a national story that redeploys the Bible in a national imagination that aligns the future of God's people with an ancient past. In this history, Jesus came to preach to a wayward tribe of Israel in North America, then warfare resulted in the transcription of sacred scriptures, which were buried and revealed to Smith in the 1820s. It is not difficult to recognize a powerful connection between American nationhood and the Latter-day Saints, especially as configured around the person of Jesus in a fascinating painting by

the contemporary LDS artist Jon McNaughton (plate 8). *One Nation Under God* is a picture fraught with doctrine and a sense of urgency, in what amounts to a homiletic occasion. Jesus stands at the center of a large gathering of Americans from past and present, holding the American Constitution. McNaughton states on his website that the Constitution was "inspired" by God, and the title of his painting endorses the claim dear to many that the United States is a Christian nation, a nation "under God."[85]

In this painting, Jesus's white tunic bears the golden silhouette of what the artist identifies as the "Tree of Life," whose seven branches signify the seven dispensations of time, an official teaching of the Latter-day Saints.[86] His golden robe recalls the gilt statuary of the Angel Moroni, who perches on the steeples of many LDS temples around the world. Moroni, ancient Nephite prophet, was the son of Mormon and final author of the Book of Mormon. Before dying, he hid the sacred texts, recorded on golden plates, and returned as an angel centuries later to reveal their location to Smith. In McNaughton's painting, Jesus displays the U.S. Constitution in order to remind Americans about its divine inspiration and the sacred nature of their nation, which the artist adamantly believes that Americans have forgotten. McNaughton's painting may also function as a restaging of Christianity's Last Judgment, showing the end of history on American soil? Mormonism was framed by its founder as an eschatological faith, arising at the end of time to complete God's dispensational plans. The painting's apocalyptic sorting of righteous and wicked to either side of the postresurrection Jesus (the nail mark is visible on the back of his hand) suggests the Last Judgment. Yet there is no hint of apocalyptic destruction. Rather, the image is a warning. The picture intones its message in the tradition of the American jeremiad: the nation must repented its sins and return to God's providential plan for his chosen people, the new Israel.[87] McNaughton uses the motif of the Last Judgment and the scenography of a history painting to suggest that Jesus is vindicating the Constitution as well as affirming American history's saints and martyrs. He condemns liberals—the professors, judges, lawyers, journalists, and Hollywood producers who hijacked America (all carefully identified and explained at the artist's website)—and he extols those who have struggled to keep the faith: the schoolteachers, farmers, hardworking immigrants, mothers, doctors, and soldiers. It is they who recognize Christ's hand in and on the Constitution. But the damned are not persuaded. Only the judge clasps his face in remorse, having cast aside the stack of papers, which represent, McNaughton's text explains, decisions that eroded the Constitution's original intent by according increased power to the Supreme Court and an "activist" judiciary.

McNaughton's painting echoes the conservative politics of many Evangelicals in the United States who regret the loss of what they consider the nation's originally Christian ethos. But ethos is a vague word. On the one hand, there is nothing in the Constitution to suggest that it was intended to promote Christianity or belief in God, though most of its signers believed in one. On the other hand, the *separation* of church and state is neither a simple nor an accurate description of the long relationship between the two in American history. The fact that "under God" remains on American money and in the

Pledge of Allegiance (inserted during the 1950s, in Cold War opposition to "godless Communism"), that American presidents typically take the Oath of Office with one hand on the Bible and end their speeches by calling on God to bless America, and that sessions of Congress open with prayer by a Jewish or Christian chaplain, are all evidence that religion remains a fundamental ingredient in the national imaginary, and will continue to do so, however problematic and contested it may appear to many Americans. Nationhood and Christendom do not easily disentangle.

# 6

# THE LIKENESS OF JESUS

The argument of this book has been that modern Christianity, sometimes reduced to an intellectual state of mind or volition, can be described in terms of visual practices that unfold on, outside of, and within the body. For instance, we saw a picture of Saint Francis in chapter 1 conforming the gesture of his body to that of the crucified Jesus (see figure 3); in chapter 3, images that the faithful exchange and display; and in chapter 5, images that nurture a concept of the nation as a religious dispensation that joins a people in a common purpose. In this chapter we will consider images that join the imagination to physical images, as people envision the appearance of Jesus. Viewers imagine the Jesus they know even though they have never seen the man himself.

Judging from the endless number and variation of devotional portraits of Jesus, one of the most familiar acts of imagination among Christians over the last two centuries has been to picture the appearance of their savior. Images such as figure 44 are so ordinary in the age of mass-production and the ubiquitous format of the portrait that it seems unremarkable to see Jesus pictured in this way. But it is worth estranging the practice in order to recover how extraordinary it is. Jesus, it is safe to say, never sat for a portrait. And no one within nearly two hundred and fifty years of his lifetime ever seems to have presumed to draw or paint his actual likeness. Not even a literary description of him survives, although there is a late medieval tradition still in circulation that offers a contemporary literary account of the appearance of Jesus; figure 45 is a late nineteenth-century French example. The text purports to be a description of Jesus's face by an eyewitness, one Publius Lentulus, governor of Judea, writing to the Roman Senate.[1] Although there

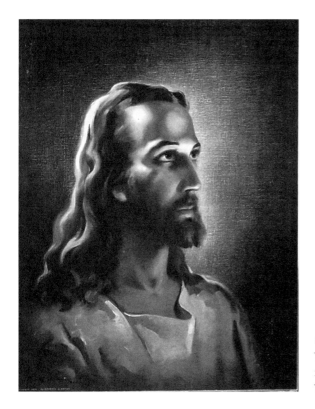

FIGURE 44
Warner Sallman, *Head of Christ*,
1940, oil on canvas. Courtesy of
Warner Press.

is no record of such a man and the letter itself dates to the fourteenth-century, when
portraits of Jesus had become part of European visual piety, the artifact remains fascinat-
ing for putting into circulation a description that matches the preceding tradition of
portraits of Jesus.[2] In Figure 45 we see an artist's rendition of the description. The French
text actually departs from the older tradition of the letter by stating "I send you this por-
trait . . ." But which portrait? The textual description or the image of Jesus floating above
the text? The reader is not told, which allows word and image to intermingle in a power-
ful act of mutual validation. And this is how the letter had long been visualized—as text
and image in tandem. The text must be true because it describes the image; the image
must be true because it resembles the text.

   In fact, of course, we have no idea what Jesus looked like. Yet there is no shortage of
images that millions of people instantly recognize. Why do Figures 44 and 45 look like
Jesus? We might easily set beside them dozens of other images made in very different
times and places, put to use among people who believed dramatically different things
about the identity and purpose of Jesus of Nazareth, yet we would find that many viewers,
Christian or not, American or European or not, would recognize the person as Jesus.
How is that so? There must be some mental operation, some process of imagination, at
work that relies on imagery both mental and material to cue recognition.

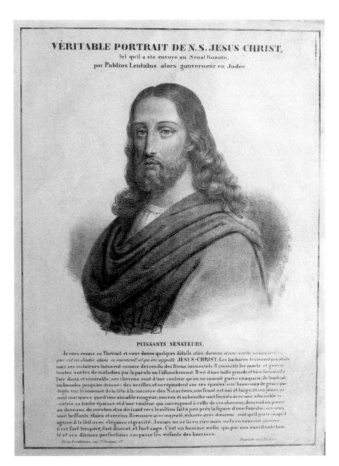

VÉRITABLE PORTRAIT DE N.S. JESUS CHRIST,
tel qu'il a été envoyé au Sénat Romain,
par Publius Lentulus, alors gouverneur en Judée.

PUISSANTS SÉNATEURS,

Je vous envoie ce Portrait et vous donne quelques détails *d'un homme d'une vertu singulière*, *qui est en Judée dans ce moment et qu'on appelle* JESUS-CHRIST; Les barbares le croient prophète mais ses sectateurs l'adorent comme descendu des Dieux immortels Il ressuscite les morts et guérit toutes sortes de maladies par la parole ou l'attouchement. Il est d'une taille grande et bien formée, il a l'air doux et vénérable; ses cheveux sont d'une couleur qu'on ne saurait guère comparer, ils tombent en boucles jusqu'au dessous des oreilles et se répandent sur ses épaules avec beaucoup de grâce, partagés sur le sommet de la tête à la manière des Nazaréens; son front est uni et large et ses joues ne sont marquées que d'une aimable rougeur, son nez et sa bouche sont formés avec une admirable symétrie, sa barbe épaisse et d'une couleur qui correspond à celle de ses cheveux, descend un pouce au dessous du menton et se divisant vers le milieu fait à peu près la figure d'une fourche, ses yeux sont brillants clairs et sereins. Il censure avec majesté, exhorte avec douceur : soit qu'il parle ou qu'il agisse il le fait avec élégance et gravité. Jamais on ne l'a vu rire mais on l'a vu souvent pleurer, il est fort tempéré, fort discret, et fort sage. C'est un homme enfin qui par son excellente bonté et ses divines perfections surpasse les enfants des hommes.

FIGURE 45
Unknown, *True Portrait of Our Lord Jesus Christ,*
late nineteenth century, lithograph (Paris:
Lordereau, Rue St. Jacques). Photo by author.

A historical approach to the problem seems in order, since one answer to the question of how people "recognize" Jesus is that they have seen his picture before. There is in fact a bulging archive of such images, stretching back many centuries and forming a long chain of portraiture. In some sense, of course, what else could recognition imply? The question then becomes, what are people recognizing—Jesus or a long lineage of portraits of him? We may begin with a simple but relevant fact: images of Jesus tend strongly to bear a family resemblance. Since no one who ever saw him recorded his likeness, it must be the case that images of Jesus share what has come over time to be regarded as his features. In other words, a set of characteristics—a long face, large eyes, somber expression, shoulder-length hair parted in the center, short, slightly forked beard, and a broad, uncovered forehead—have congealed into an abiding formula for representing the face of Jesus.

Yet this explanation is not entirely satisfactory. Many other people have become recognizable in enduring iconography—Saints Peter and Paul, for example, or Saint Francis—but these images do not sustain the exuberance and passion of likeness that

people insist on in the case of Jesus. Fidelity to an established formula seems to matter in a distinctive way when it comes to the likeness of some cultural figures. For Americans, for instance, the portrayal of figures such as George Washington and Abraham Lincoln has undergone a broad cultural vetting that settled on characteristic costume, hairstyle, body gesture, and facial appearance. Departing from the standard invites a negative response, or mere confusion regarding identity. Every schoolchild knows what George Washington looked like. The image that fails to deliver the canonical type will not be recognized or, if it is recognized, will meet with objection and possibly dissatisfaction. Such likenesses belong to cultural literacies and national imaginaries. For this reason they are able to operate as popular icons in mass communication, socialization, and entertainment. Understanding more about this will help us grasp how religious believers distinguish between what *really* looks like Jesus and what is no more than an artist's conception of his appearance—and why they won't hesitate to assert with confidence that an image fails to resemble him. This confidence is remarkable. In such images, people see a face that is more than a face. It is Jesus, someone they have never seen yet feel they know intimately. They see someone whom they believe, trust, adore. They see their salvation, they see their comfort, they see the face that launched two thousand years of faith. They see the man they have always known and loved, because they see the face of the soul that spoke the wisdom that they believe, the person who felt and experienced the moral genius that has guided their lives. Clearly something is at work in their vision that is about more than eyes. The visibility of Jesus—his appearance, his recognition, the gravity, allure, and power of his face—depends fundamentally on history, on sociality, and on the intricacies of visuality, which includes imagination as well as images and visual practices.

One way to think of imagination is as the mental invention of images that are purely fantasized. But imagination as a faculty of daily use is not sealed off from sensory experience. It is a form of mental activity that works very closely with sensation. While the province of neuroscience is to probe the circuitry and operation of brain transmissions and electrobiochemical interactions among neurons, the historian and scholar of visual culture may contribute to the understanding of visuality by scrutinizing the subtle relations that physical images enter into with internal imagery as it occurs in visualization and memory. For it is well known that people intermingle the two domains of imagery, substituting photographs for memories they could not otherwise possibly possess, or seeing in a vision the very picture of Jesus that they have hanging on their bedroom wall. Physical imagery may be a kind of scaffolding over which people drape and form mental images, and mental images may be a shorthand that comes to stand in the place of the actual images that people seek to remember. The two domains bear a symbiotic relationship with one another. Neither is fully autonomous, neither complete without the other. We do not live inside of our heads, but in a constant colloquy among feeling, memory, and cognition, on the one hand, and the world of objects, other people, and environments, on the other. Whereas cultures, especially religious cultures like Christianity, might wish to interiorize consciousness, sealing the human

person off from the outer world as if within a cloistered, fortified inner world, the biological and social reality is that human flesh is a porous boundary that does as much to coordinate and integrate "inner" and "outer" as to segregate the two. One of the powerful things that a religion does is to configure the fleshly delineation of the two domains, coding emotion, sensation, feeling, fantasy, imagination, intuition, intellection, and bodily functions and behavior (defecation, eating, bathing, sexuality) in such a way that they reinforce integration or segregation, as the case may be.

I would like to define imagination generally as the mental and bodily practice of thinking and feeling in sensations such as imagery, sound, or touch, in order to grasp or envision what one literally may not behold. Imagination uses sensation to transcend it, to fill in the gaps, to provide what is missing or is not otherwise accessible, to glimpse what one fears or desires, or to envision what is only partially, or not at all, visible. The sensations put to use are coderivative, coming from outside the body as well as from within it. As a manipulation of images, imagination is therefore an integration of mental and physical imagery that allows us to see what is unknown, unseen, past, absent, or never directly experienced. But I want to stress that I do not limit imagination to images and vision. Obviously, musicians who compose scores hear tones in their minds. Dancers feel their bodies move within their minds. Moreover, embodiment is a process in which all forms of sensation intermingle. We rely on seeing the person who is speaking to us because it strengthens our ability to hear by confirming additional information, namely, that the individual is speaking to me, that he is, or is not, angry, frustrated, happy, accusative et cetera. Human communication and understanding rely on the integration of sensations. This means that seeing, hearing, and smelling are not absolute forms of sensation, operating in isolation, but are enfolded in one another as well as in other aspects of human embodiment such as posture, gesture, dress, or gender ideals. Yet for the purpose of this study, it is important to say that my interest lies in the visual operations of imagination.

## THE NATURE OF LIKENESS

Several years ago an anthropologist friend and I stopped by the visitors center of the LDS (Mormon) temple in Westwood, California. We were welcomed by a full-size reproduction of Bertel Thorvaldsen's monumental 1838 statue of Jesus, situated within a sunset panorama. The statue was a replica in resin of the Danish sculptor's marble *Christus*, which stands above the central altar of the Church of Our Lady (Vor Frue Kirke) in Copenhagen (figure 46). A recorded voice in the visitor's center was activated as we approached. It was impossible not to recognize the figure. His face bore the physiognomic formula to which I have already referred: a solemn expression, a slender, symmetrical face, broad forehead, short, forked beard, shoulder-length hair split in the middle. And if that weren't enough, the figure spoke in a majestic voice in response to our presence. The monumental size of the sculpture was surprising, and its placement within a cloudy apse unfamiliar. And his

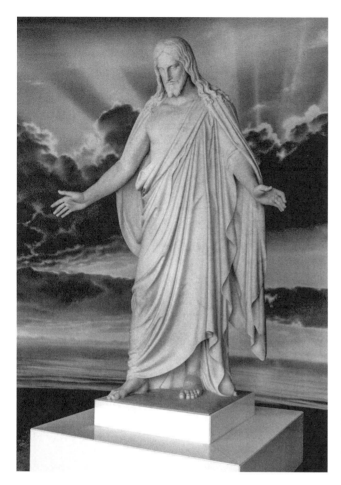

FIGURE 46
Replica of Bertel Thorvaldsen's *Christus*, 1821–33,
in the visitors center, Los Angeles California LDS
Temple. Courtesy of COR / Intellectual Property,
Church of the Latter-Day Saints. Photo by Allen
Roberts.

amplified voice was something we'd never encountered. But these features could not overcome the greater weight of the recognizable appearance. There was no doubt who this was. Likeness is always a compelling ratio between conformity to expectation and divergence from it. There was enough strangeness in the ensemble to make it a little weird and quite memorable, but not so much that we were stumped as to the figure's identity.

We were then met by a young woman who warmly welcomed us and promptly commenced a tour. We took the opportunity to ask her many questions, especially as we approached a large reproduction of a painting of Jesus by Del Parson, a much-loved Mormon artist famous among members of the Church for this picture in particular. "This," our guide told us, "is the famous portrait of Jesus." My friend and I were intrigued and asked her why, in view of the countless images of Jesus produced over the ages, the church embraced this one so fondly. She thought about it for a moment and then replied to our surprise that it showed what Jesus really looked like. When we asked her how Mormons could be sure of the likeness, she told us that the president of the Church of

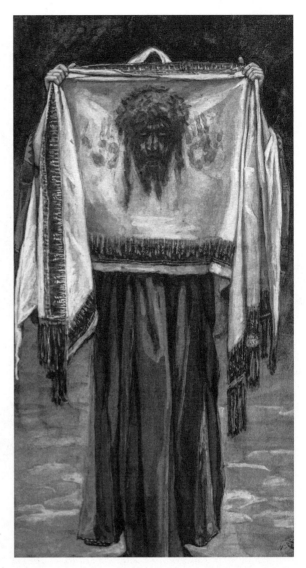

Jesus Christ of Latter-day Saints is a "prophet, priest, and revelator," and that in this office he had been privileged to speak with Jesus face-to-face on many occasions, which meant that he was able to describe to the artist what Jesus looked like.[3]

Hearing this, I thought of the long history of stories that have anchored images of Jesus to eyewitness accounts (such as the letter of Publius Lentulus, see figure 45), of the tradition of Saint Luke as artist (see plate 1), and of miraculous events that produced images such as the sacred xerography that issued in the Mandylion of Abgar (see figure 1), the Veil of Veronica (figure 47), and the Shroud of Turin. Our guide was giving us a modern version of a very old story in which a human portrayal of Jesus is corrected by

someone who knows from firsthand experience what Jesus looked like. Many images of Jesus, such as those linked to Abgar, Luke, and Veronica, involved angelic intervention as a supernatural agency certifying the authenticity of the image. Parson's picture bore the testimony of a prophetic human eyewitness. In this view of likeness, the image looks like Jesus because of an authorizing account of its origin. It looks like him because it was miraculously fashioned from his very face. One sees in the image the repetition of the original.

Whether it's the authoritative nudge of an angel's hand, the informed report of a man who talked face-to-face with Jesus, the letter of a contemporary describing the face he saw, or a piece of cloth that served as matrix to record the imprint of that face, the history of belief concerning the appearance of Jesus seems to be about likeness to the real thing. What does that mean? In the visual traditions of devotion to Jesus, likeness consists of at least three modes, which may work individually or sometimes together.

## LIKENESS AS REPETITION

First, the resemblance between an image and a prototype may be based on features they share. The image is an ontological echo of the original, consisting of contour and shape lifted from the prototype and deposited in the image. James Tissot's painting *The Holy Face* (see figure 47) displays an instance of this: the cloth, viewers understand, was handed to Jesus as he approached Calvary, his face bloodied by the ordeal. Tissot shows the imprint of the face on one side of the cloth, and even the reversed images of Jesus's handprints, pressed on the cloth's opposite side as he held the fabric to his face. The resulting image is a direct copy of his face and hands. In the visual piety of such likeness, repetition is not the loss of being, as Plato maintained, but a registration that maintains a substantial connection to its source. Yet the image is not its original, but a trace of it. As John of Damascus put it, "An image is a likeness depicting an archetype, but having some difference from it; the image is not like the archetype in every way."[4] This is why he could argue that the veneration of Jesus's image was not idolatrous worship of the material support of the image, but worship of Jesus himself. Painting was not a mindless aping of surfaces, but an ontological operation of transposition.[5] Thus the honor given to an image passes to its archetype, since the image shared in the being of the archetype without fully instantiating it.[6]

The idea is clearly expressed in the Chludov Psalter's well-known illumination of Psalm 69, showing an iconoclast about to plunge an icon of Jesus into an urn of white-wash (figure 48). We see that the medallion-portrait exactly echoes the image of Jesus on the cross, just above it. This parallel clearly suggests that abuse of his image was the same as abuse to him, and the Psalm calls down divine punishment on both those who abuse the figure whom Christians understood to be Jesus, and on latter-day abusers of his icon, according to Orthodox iconodules. The handle by which the iconoclast grasps the icon imitates the spears used to taunt the crucified figure. Even the urn is repeated

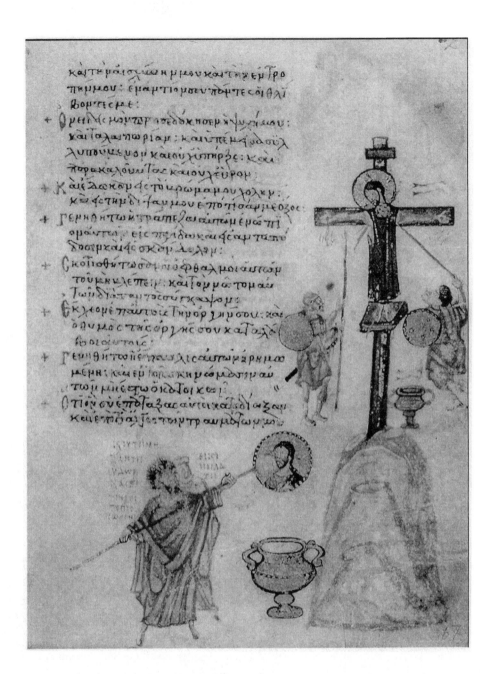

FIGURE 48

Crucifixion of Jesus, Psalm 69, *Chludov Psalter,* ninth century. Photo courtesy of WikiCommons.

by another at the foot of the cross. The visual argument is the same one that John of Damascus had asserted in the previous century: the icon is a repetition of the original that leaves something of it behind while carrying something of it. This ontological ratio of likeness is clearly at work in the story told by Pliny the Elder of the Corinthian maid who traced her lover's profile: in the morning he was gone, but he had left something of his being behind in the contour on her wall.[7] This mode of likeness always wants to become more, to morph into the thing it replaces. The Corinthian maiden may stroke and kiss the contour just as an Orthodox Christian cherishes an icon of Our Lady or of Jesus. In figure 1, for example, the face of Jesus floats like a shimmering medallion before the creased cloth held by angels, suggesting that the face as material presence is not continuous with the cloth, but hovering before it. Tissot's image reveals the tendency for the image to become its original: we note that the artist has included the suggestion of Christ's pupils in the image's eyes, a detail that could not possibly have resulted from his pressing the fabric to his face. But the image conforms to the desire that motivates it, pushing beyond itself as a copy, yearning for identity with its prototype. Yet defenders of sacred images might argue that this very yearning is what allows the image to convey the devotee's veneration to the saint or to the savior himself.

## LIKENESS AS EMULATION

The second form of likeness results from a powerful drive to emulate an archetype, that is, to become *like* the prototype. This reverses the order of the first mode of likeness, in which the image derives from its exemplar. In the second case the image seeks to liken itself to the model. This is familiar to anyone who has watched a child behave like her parent, mimicking demeanor, posture, dress, or forms of expression. The child wants to be like the parent, and is encouraged to do so in many ways by her parents. Gender roles seek to imprint behaviors and self-imagery, but emulation is also widely observable in birds and higher mammals. Whether human or otherwise, the young, the novice, the immigrant, and the underling are drawn to emulate the behavior of those with higher status or authority as a way of becoming like them, being included with them, learning how to receive recognition and approbation. Membership in the social body of the group requires emulation.

The same quest for likeness occurs in various ways in religious life. Children and novices are taught to embody suitable gestures and utterances, rhythms and dress in religious practices and ceremonies. The discipline of the group is embedded in the body, shaping flesh and bone to the social body of belief such that one behaves religiously under certain circumstances, often without thinking about it. Emulation is also a powerful way of imaging self as other, and thereby joining the holy or sacred to one's body. In late medieval and baroque Christian asceticism, for example, some sought to pattern themselves somatically after the image of Jesus. In paintings of the stigmatization of Saint Catherine of Siena, the crucifix imprints the wounds of Jesus into the saint's flesh,

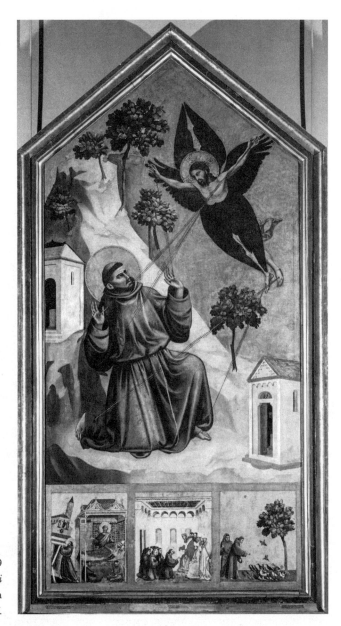

in a constellation of rays streaming from image to body. The same occurs in Giotto's portrayal of the stigmatization of Saint Francis, conforming the mortal to the prototype and enabling the human devotee to participate in the sufferings of Jesus (figure 49). In every case, the drive for likeness is the desire for self as other as self. This intimate intermingling of selves in an embodied imaging produced an experience of presence that was pivotal for centuries of monastic devotional life.

The final type of likeness is especially important for Protestant visual piety. For many Christians, the likeness of Jesus presents not so much how he *looked* but what he was *like*. In this regard, likeness is the recognition of an affinity between Jesus's appearance and what believers know, feel, or see within themselves about him. This aspect of likeness is the perception of an intimate connection that devout viewers feel between Jesus and themselves, but that connection is *affinity,* not identification, as in the previous forms of likeness. This mode of likeness turns on Jesus's ethnic, gendered, or affective resemblance to those who look at him. The difference between emulation and affinity becomes evident when we discern that, in the first case, many believers are drawn to become *like* Jesus in kindness, obedience, or suffering; in the second, others seek such visual features as race or masculinity that make him *like* me or my kind, but not identical to me. In this latter sense of likeness, the case of affinity, devotees are drawn to an imagined meeting point, driven by the desire for access to the Jesus they want. That access to knowledge of his character is coded in his appearance: his look signals his likeness, or what he is like, by indicating the basis for the viewer's connection to him. Likeness by affinity means sharing a social body with Jesus, a collective look—a masculine body, a white body, a black body, a Catholic body, a Protestant one.

The quest for likeness in its various guises may recall for some David Hume's characterization of religion as inherently idolatrous, expressing what Hume considered "an universal tendency among mankind to conceive all beings like themselves, and to transfer to every object, those qualities, with which they are familiarly acquainted, and of which they are intimately conscious."[8] No doubt Hume is correct that human beings widely engage in anthropomorphism. Yet it also seems true that imaging Jesus as a member of one's own ethnic or social group is not necessarily an idolatrous reduction. By seeking to know what Jesus looked like, the viewer may be asking what he was like as a person, since knowing what he was like reveals his accessibility and his attitude toward the viewer. The meeting point in this important mode of likeness may turn on sectarian identity, on personality type, or on ethnicity, race, gender, or sexuality—anything that announces how Jesus is to be approached and what the likelihood of his response will be. Some African Americans, for example, may want to know if he shared their features, since a Black Christ will reward their sympathies; whites may gravitate toward the European conception of a Jesus who bears their physiognomy; while Asians may be strongly inclined to envision a Jesus who looks like them, as the Chinese artist Tsui Hung-I did in his image of Jesus as the Good Shepherd (figure 50). The artist has drawn on the visual vocabulary of classical Chinese techniques of ink-on-silk painting, recalling, for instance, in the faint silhouette of the sharply descending mountain slope the work of Song Dynasty landscape painters. Jesus is a mountain recluse who cares for his flock. He is unmistakably Chinese, a kind of Taoist sage with a halo. A Western commentator pointed to the painting's "soft shades characteristic of Chinese work," but also felt

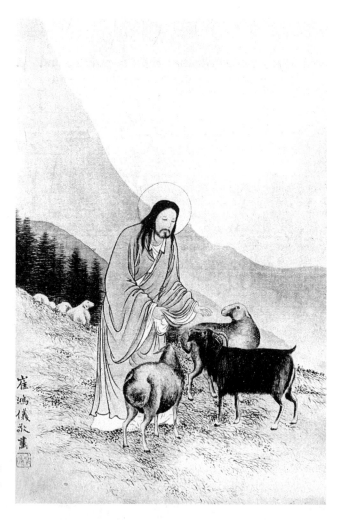

FIGURE 50
Tsui Hung-I, *Christ the Good Shepherd*, before
1939, ink on silk. Photo by author.

constrained to acknowledge that "the artist was probably not very well acquainted with
sheep. He has drawn the fat-tailed ones of Mongolia, even so one goat would seem to
have strayed among them."[9] The writer reveals the balance of sameness and difference
that makes up the dynamic of recognition. To Chinese viewers, Tsui Hung-I offered a
portrayal of an originally non-Asian deity in a familiar style, costume, and setting,
enhanced by using Mongolian sheep. Yet non-Chinese could recognize the image, too,
by virtue of the theme and the characteristic likeness signaled by the long hair, beard,
and demeanor of the gentle shepherd.

## THE ETHICS OF LIKENESS

Is it inescapably racist—or ethnocentric, sexist, or simply narcissistic—for people to seek
a Jesus who resembles them? The answer must be yes when the point is to exclude

others or to enforce a hierarchy of access. If Jesus must be white (or black) because God prefers the white (or black) race as his chosen people, or tasks them with the mission of saving the world, it is difficult not to see the resemblance as serving to privilege one group over others. Race easily becomes the principal imaginative category for envisioning divine presence and work in history and the world.[10] Nationhood, as we saw in the last chapter, is another category for installing divine preference in social affairs and political ideology. When the sacred comes packaged in race, gender, nation, or ethnicity, the prospects for bigotry and social hierarchy are perhaps inevitable. Yet these are among the most pervasive forms in which human beings sort themselves into the social groups that bestow on them their collective identities. Religion, nationhood, political ideologies, language, social hierarchies, and castes as well as historical narratives contribute to maintaining group formation. The wispy neural imagery that forms the mechanics of imagination can become Blake's "mind-forged manacles."

But a white Jesus or a black one, an Asian Jesus or a Jewish one is not necessarily racist or ethnocentric. Human beings sort themselves into various social bodies based on elective affinity, which certainly includes but is not limited to practices of oppression and privilege. Blacks tend to associate with blacks more than with whites, Protestants more with Protestants, Jews more likely with Jews. Women likely have more female friends. Gays frequent gay bars more than straights do. Does that mean they hate straights or are insensitive to them? Is someone born and raised in a racially homogeneous setting justly accused of bigotry for displaying an image of a Jesus that reflects her upbringing? These are uncomfortable questions to ask because unconsciousness of race, gender ideals, and ethnicity so readily feeds prejudice and discrimination. And any act of self-representation can be easily transformed from an emblem of group pride into an expression of hauteur. A hair's breadth can separate distinction and superiority.

By the same token, images exert a formative influence, and can affirm hierarchy and difference by promoting group identity in terms of race, gender, ethnicity, and creed. Seeing Jesus as a white man reinforces the collective imagination of him as white, which for white people means "like us." The imaging of Jesus reminds us that the pervasive drive evident in visual piety is to enhance the intimacy of the connection with one's kind, since religion is a social pattern, a visceral relation to kin, tribe, people, nation. It is crucial to grasp that the connection to Jesus always involves a strong aspect of sociality, the quest for affinity, rather than being purely personal, as many Evangelicals, on the one hand, and mystics are the other, are apt to assert. The Christian mystical tradition has long prized a union that stresses the loss of the self in the countenance of the divine, whereas Evangelicals seek what they call a "personal relationship with Jesus Christ." It seems quite likely that all three modes of likeness delineated here are often intimately interwoven in Christian experience, making it very difficult to discern where love for tribe ends and love for savior begins. We must bear this complexity in mind if we are to understand the visuality of Jesus's collective appeal.

The personal and the collective can even be identical. The modern ethos boasts an ideal of individualism, giving importance to civil liberties, individual choice, personal style, and the desire to be different, to resist the tendency of joining the crowd. But the myth of individualism becomes apparent when one looks at popular media like television or social media like Facebook. These settings reveal a strong disposition to place oneself in affinity groups, generational cohorts, and consumer trends. Life in mass culture seems to thrive on seeking out one's place within shared subcultures of style—seeing the same movies, watching the same YouTube videos, listening to the same music, wearing the same style of clothing, driving the same models of cars, even naming one's children the same names as those among whom we imagine ourselves to belong. People like to think of themselves as individuals, but what that word tends to delineate is not the idiosyncrasies of a particular individual as much as the difference between one's cohort and another. For example, it is still common for art world denizens to wear black. Recognition of group membership requires some form of uniform, insignia, or signage. To be seen as a member of the group is more important than trying to signify one's distinction within the group in a large social milieu like New York, Los Angeles, or Chicago, since all that most people know about the art world is that it is an exotic domain of people who dress the same, go to galleries, live in lofts, and cultivate the collective look of an alternative style. Clothing, hairstyle, piercings, tattoos—all of these or whatever may be their equivalents today or tomorrow announce: "I am not like you, I am not conventional, I am not bourgeois. I am different." Put another way, this signage says that "I belong to a different tribe, so don't confuse me with your people." Likeness very commonly means likeness with the people to whom I belong, or aspire to belong.

If artists have a look at any given moment, so do businesspeople, suburban parents, Iowa farmers, retired people, college professors, and so on. We signal the social body to which we belong by virtue of the look we share with its other members. Attending to this keeps our status current. I am persuaded that something of collective style applies to the history of imaging Jesus because likeness is a social construction of shared features that mark off social bodies—the groups that actually do more to define human features than the modern ideology of individuality can ever claim to do. Differences within group are much less pronounced than differences from nonmembers. Indeed, often one must be an insider to discern the subtle distinctions that separate the status of one member from another.

But how does this apply to Jesus? It suggests that the matter of his likeness pertains as much to viewers as it does to him. Some Catholics prize the Sacred Heart as speaking from and to their tradition (see figure 20). Many Protestants recognize Sallman's *Head of Christ* as a seal of authentic Protestant faith (see figure 44). Some Catholics and Protestants distributed the image in the 1940s and 1950s as part of an effort to identify America as a Christian land in opposition to godless Communism. One Indiana businessman who handed out free copies of a pocket-sized reproduction of Sallman's picture of Jesus declared that card-carrying Communists needed to be met by "card-carrying

Christians."[11] The American Legion also publically displayed the image, suggesting that the social body to which recognition of this Jesus belonged was patriotic Christian America. The likeness of Jesus was his likeness to white Americans, and his whiteness may have mattered a good deal to many. Mormons also knew what their Jesus looked like. When the leadership of the Latter-day Saints wanted the church to be seen as Christian by non-Mormons, they began to display reproductions of Thorvaldsen's statue of Jesus (see figure 46), and perceptions of the faith had indeed have moderated over time. Moreover, the Mormon imaginary itself has accommodated to Thorvaldsen's image of Jesus. One Mormon scholar studying the appropriation of Thorvaldsen's statue among Mormons—copies of it appear in nearly a dozen visitor centers in the United States and abroad—has pointed out that familiarity with the statue among the faithful is so great that when Mormon tourists visit Copenhagen and see the "original" they often wonder why the Danes have a Mormon Jesus looming above the altar of a Lutheran church.[12]

As obvious as the social function of Jesus's likeness may appear in these remarks, it is important to note that this dimension is readily masked in devotional practice, where the strong tendency among both Catholics and Protestants is to cultivate a private or personal connection to Jesus. Protestants, in particular, concentrate into Jesus the many possibilities at work in Catholic devotional relations to Mary and the saints. In both cases, devotees long for a tender figure who is accessible and affirming. If Catholics feel that is not available from Jesus, they find it in Mary, Francis, or another saint. Protestants, for their part, want to know that Jesus was the sort of person whom they can feel encouraged to approach and trust. What he looks like must comport with his personality. For the Protestant Christology of friendship, in which devotional life rides on the intimacy of a personal relationship, it is not difficult to recognize the importance of this mode of likeness. This is what many admirers of Warner Sallman's *Head of Christ* told me in letters that they found so moving about the image's portrayal of Jesus.[13]

But the issue of likeness for social creatures such as human beings is always already social. Each of the three forms of likeness we have examined is triggered by images, by seeing in the likeness of Jesus a compelling connection to the viewer's person and body, but also to those of other viewers, and to a shared history of seeing. The three varieties of likeness—the repetition of the prototype, the drive to emulate the model, the quest for affinity—bring the image of Jesus to life not only for the individual, but also for the group. Recognition is a social operation no less than a personal one. Thus, for example, Tissot's image of the Holy Face poses Veronica holding the image before her own face (see figure 47). This is just how the image is still used today during Holy Week celebrations from Brazil to Italy, where hand-made versions of the Veronica are unfurled before the faithful as the person performing the role of Veronica sings her famous song, concealing herself behind the image she unrolls, as the audience beholds the revelation of the Holy Face.[14] Tissot presented the image, in other words, in the liturgical setting of a popular devotion, lending the image a likeness that is not only recorded in the image, but staged in the event of its devotional use.

Tissot's picture helps to explain how people experience the likeness of Jesus in one or more of the ways I've outlined without any hope of securing the prototype image. The legend of Veronica and others like it notwithstanding, it is worth repeating that no one actually recorded Jesus's appearance, although in the dense history of his likeness, believers have honored as authoritative a large variety of images.[15] How is it that a likeness without an original can exist and operate so compellingly? The three modes I have sketched go some distance toward answering this question, suggesting that people find in each image what they want to find there, be it repetition, emulation, or affinity. But there is something important to learn in the visual procedure that helps construct a likeness without an original. Historical, legendary, and mythological figures who are venerated through cult imagery usually enjoy large archives of images that devotees have produced and used over time. A process of nomination repeats itself from generation to generation in order to cull from this archive the features that comprise the figure's appearance. We can see this at work in the history of images of Jesus, where a physiognomic formula was established early and reiterated over time. The result is an archive of images that draw on and refer to one another and in doing so construct an archetype, an ideal image that is a collective representation of the whole. The power of the visual archive, subtle and intuitive, consists of its operation as a selective database, acting very much like a canon, a regulated body, or a list that exerts authority. The archive is at work often in a very tacit way when viewers react negatively to an image of Jesus that does not comport with the archive's intuited rules: a fat Jesus, an ugly Jesus, an erotic or excessively effeminate Jesus, a Jesus whose ethnic or racial features depart substantially from the norm or rule. The repulsion people feel is a visceral reminder of the archive's normative impact.

The history of images of Jesus is not, of course, of one mind. Images produced from the third to the sixth centuries in Rome and Ravenna shows us that Jesus has been visualized in very different ways, as a beardless young man, for example.[16] In spite of this early plurality, before the end of the first millennium a general formula had emerged and come to shape artistic practice and devotional preference such that Jesus tended strongly to be remembered in a way that renewed itself by virtue of iteration. Thus, most images of Jesus occupy a vast web of interpictorial allusions and emulations. We see this very clearly down to the present. I began with the case of Del Parson's 1983 image, which I saw in the visitor's center at the Los Angeles LDS temple. The claim that the artist consulted with the president of the church body for first-hand corrections to his image is urban legend.[17] The actual source of the image is evident when we compare Parson's picture with one painted in the 1920s by Charles Bosseron Chambers (1883–1964), *Head of Christ*.[18] The urban legend, still widely repeated among Mormon faithful who admire the portrait, serves to conceal the fact that the artist clearly looked to the archive of images for his source. Popular visual piety is full of such reworkings. Another example is the

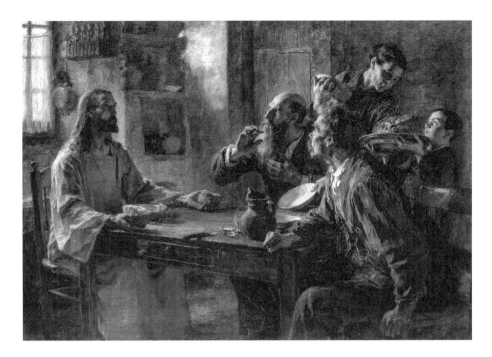

FIGURE 51

Léon Lhermitte, *The Friend of the Humble*, 1892, oil on canvas. Gift of J. Randolph Collidge, courtesy of Museum of Fine Art, Boston.

well-known picture of Jesus by Warner Sallman (see figure 44), who also drew on a particular model to create his image, in this case a late nineteenth-century French painting that had made its way to the Boston Museum of Fine Arts (figure 51). Such appropriations are driven less by theology than by piety and perceived suitability. Mormons, for example, may deliberately harvest images from the Christian archive that broadly assert their reliance on the tradition as a way of affirming their Christianity. Chambers was a Catholic artist and Thorvaldsen a Lutheran.

## THE MODERN TURN: REMBRANDT'S PORTRAIT TYPE

Beyond the matter of the particular features of Jesus's face is the equally important question of the format of modern likenesses of Jesus. Images of Jesus in the modern era, whether paintings, film stills, or lithographs, typically assume the head-and-shoulders format. This convention owes a good deal to the history of devotional icons of Jesus and of the saints, to the influence of such icons on late medieval European devotional painting, and to the history of portraiture, from oil painting to commercial photography.[19] The portrait format became synonymous in the twentieth century with personal identity—in the form of passport and driver license photographs, but also in wanted posters, glamour

stills of Hollywood stars, and high school and college class annuals.[20] We can add to this the tradition of commemorative busts as a genre tasked with monumentalizing a salient aspect of the sitter's character or personality. But for the study of the portrait image of Jesus in the modern era, the source most responsible for the format may have been Rembrandt and his studio, who marked a crucial departure from tradition, fashioning a new approach to the quest to represent what Jesus was like (plate 9). A remarkable series of images by Rembrandt and members of his studio from 1648 to 1656 engaged in the search for the human personality of the sitter, not his divinity. This is a modern quest, and Rembrandt was in its vanguard. The art historical claim for the Jewish identity of the model of some of these images of Jesus goes back at least to Erwin Panofksy in a lecture of 1920 and has continued to be confidently asserted.[21] Others followed Panofksy in making the observation, but there is very little documentary evidence to bear it out, though there is enough to demonstrate that possibly Rembrandt and certainly some of his contemporaries had conceived of the idea of portraying Jesus by using a Jewish model.[22] In pictorial terms, Rembrandt and his studio turned away from a long tradition of images showing Christ's majesty, authority, redemptive work, origin, and nature, all of which depended on symbolic devices to convey their abstract meanings. Portrayals of Jesus traditionally relied on iconography (halo, cross, banner, book, instruments of his passion, or other references to biblical narratives or events, or to devotional practices associated with the Via Dolorosa) in order to identify him and to signal his power, redemptive significance, and the particular way in which viewers might approach him.

The work of Rembrandt's studio suggests a dramatic shift from this tradition. Some of the images have been firmly attributed to Rembrandt, so I'd like to suggest that it was Rembrandt himself who selected a format that focused on the face as the site of a person. These images of Jesus operate as portraits. They convey a personality, a man whose character is meek, inward, feeling, accessible, humble, and pure. The images invite the viewer's careful inspection, and they consistently do this by addressing the viewer at eye level. They are not large images (all are roughly 10 by 8 inches), and they vary from one another in terms of angle of vision. Taken together, they compose a group whose purpose we do not know, other than to say they show a searching investigation of the subject of Jesus's face and bearing, on a very intimate scale. The result is an intimacy and directness that has continued to appeal, both in these images themselves and in a massive number of modern images of Jesus that make use of the same format. Viewers do not look up to Jesus in this series, but straight at him, creating a proximity that also suggests familiarity. And yet, if these images of Jesus recognize the fact that he was Jewish, and therefore unlike his Christian viewers, Rembrandt was thereby all the more innovative in conceiving of his subject's particularity. This difference takes the historicity of Jesus seriously, endowing him with a new kind of concreteness or reality. It favors the third form of likeness, affinity; it fulfills the desire to know what he was *like*, stopping short of the empathetic identification so important in late medieval Catholicism, and authorizing instead a Protestant sensibility of Jesus as historical personality. His Jewishness is what

made him historically particular, and shorn of the traditional accouterments of doctrine and devotion, the images from Rembrandt's studio push the ratio of likeness in a new direction.

Yet if Rembrandt was forward-looking in this respect, he had to keep his audience with him, so innovation had to accommodate the inertia of tradition. As we already noted with Tsui Hung-I's painting of Jesus (see figure 50), likeness is always a balancing act between the unique and the familiar. If Jesus looked too unique, no one would recognize him. So Rembrandt was careful not stray *too* far from the rule of the archive: it is evident that his portraits rely on the canonical conventions of Jesus's physiognomy worked out in the history of images. His Jesus looks like the one described in the letter of Publius Lentulus (see figure 45). Rembrandt appropriated a contemporary trend in showing Christ in an emotionally engaging close-up, head-and-shoulders format, with his eyes addressing the viewer.[23] This type of portrait deployed the same physiognomic tradition as sacred art since the fifth century CE, but also relied on the late medieval devotion to Christ's passion, as evident in pictures of the Veronica and the Ecce Homo. This iconography was designed to show the suffering, humiliated Christ, scourged and victimized for humanity's sins, and intended to inspire both emulation and empathy. By eliminating that most traditional indication of Jesus's divinity, the trinimbus, or three-pronged halo, Rembrandt set aside the most familiar way of recognizing Jesus. The halo had come to symbolize the aura or countenance of divine presence. People looking at these images knew that Jesus was different from others by the sense of presence he commanded—and by his halo. But without the halo, how were viewers to recognize Jesus? Rembrandt relied on his physical features alone, as promulgated by visual tradition. As a result, the portrait quality became the registration of Jesus's personality. Rembrandt could be said to have psychologized the traditional image type, infusing the face with the human person rather than relying on the symbols of deity to imbue Jesus with presence. He took the face of Jesus from the liturgical setting of the Veronica and the Via Dolorosa and relocated it before the viewer as a contemporary person. This invested in Jesus a new form of presence, making a man who occupied the same psychic space as his viewers.

## VISUAL QUESTS FOR THE AUTHENTIC JESUS

Rembrandt and his studio contributed to the nineteenth- and twentieth-century preference for portraying Christ in a head-and-shoulders portrait format that highlighted direct engagement of the personality instead of the use of traditional devices to convey theological meaning. The impact on latter-day portrayals is unmistakable. The most commercially successful images of Jesus in the last century have been those, such as Sallman's portrait (see figure 44), that eliminate symbolism and doctrinal allusions for the sake of foregrounding what is to many pious viewers a "likeable" looking fellow. People respond very personally to these images, seeing in them the person they like, with whom they feel deep affinity, but not identity. In these images they also report encountering a likeness

that is, at least for them, in their own words, "photographic," that is, authentic, the real thing.[24]

The quest for authenticity drew on psychological effects, but also often on claims to historicity, an impulse that arose in the course of the nineteenth century when modern biblical scholarship was joined by archaeology in initiating a search for the historical Jesus. Many artists in the nineteenth century made the effort of visiting Palestine to observe geography, botany, meteorology, archaeology, costume, and people first hand. The French artist James Tissot was one of these. He produced a large number of watercolors and pencil studies while in Jerusalem and in the countryside as far north as Galilee. Tissot, a Roman Catholic who underwent a revival of his religious faith, assembled hundreds of images to illustrate his own two-volume edition of the life of Jesus. He intended his project as an intervention in the Western artistic tradition, which had produced a sacred art that indulged artistic style and individual fancy at the expense of religious authenticity. "For a long time," he explained in the preface of his book project, "the imagination of the Christian world has been led astray by the fancies of artists; there is a whole army of delusions to be overturned, before any ideas can be entertained." To do so, he insisted that study on site had allowed him "to trace back from . . . modern representatives through successive generations the original types of the races of Palestine, and the various constituencies which go to make up what is called antiquity."[25] When we examine the Jesus that Tissot created, as in the picture reproduced here, *Jesus Teaches in the Synagogues* (figure 52), we find a mixture of new and familiar, unconventional and conventional. On the one hand, Tissot strongly affirmed Jesus's Jewishness by showing him in a synagogue, reading Torah, wearing the prayer shawl, surrounded by the accessories and details of Jewish ritual life. On the other hand, the slender profile of Jesus's face in this picture does nothing to suggest a physiognomy that departs from the European Christian tradition. The many images of Jesus in Tissot's book confirm the white, European identity of Tissot's Jesus. He has blue eyes, reddish hair, and presents the physiognomic formula that we have noted: long face, large, deeply set eyes, somber demeanor, shoulder-length hair parted in the center to display a broad forehead, beard parted in the center.

Orientalist painting in the nineteenth century had already established the "authenticity" of exotic clothing, Near Eastern architecture, and indigenous models. The work of Gustave Doré, published in Bibles and religious books since the 1860s, had accustomed European and North American viewers to the visual vocabulary of Orientalism, which contemporaries associated with the world of Jesus. But the quest for what we might call biblical verité did not extend to the desire to capture the likeness of Jesus. Nearly all of Tissot's portrayals of Jesus show him in a narrative mis-en-scene, in scenarios described in the Gospels and imbued with the drama of Jesus's ministry, trial, and execution. Tissot's Jesus took his place within a painted version of the lantern slide or stereographic essay, a kind of multipaneled panorama of the exotic world of ancient Palestine. But what contemporaries wanted in portraits of Jesus, in the head-and-shoulders close-up, was the man they knew, not the ancient Jewish teacher who had lived in a culture and society dramatically different from

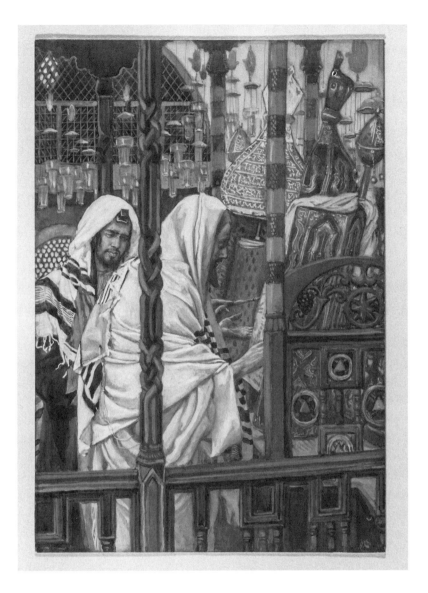

FIGURE 52
James Tissot, *Jesus Teaches in the Synagogues*, 1886–96, watercolor over graphite on paper,
Brooklyn Museum 00.159.81. Courtesy of Brooklyn Museum.

their own. Tissot offered them this Jesus of faith in the face he portrayed, but not in the
ethnographic scenography that he compiled during his trips to Palestine. Archeological
authenticity was not the same as psychological and ideological authenticity.

In the age of photography, what Jesus looked like gripped the popular imagination
with a new urgency.[26] Critical studies like those by David Friedrich Strauss and Ernest
Renan, which pointed out the many contradictions and frequent unreliability of biblical

texts, had launched a quest for the historical Jesus. But this was of less relevance to many Christians than securing a compelling image of the savior, that is, one that spoke to the present in a powerful way. The matter of his appearance meant more about how he would relate to the present world than what he looked like two thousand years ago. For those who lamented that fewer boys and men were interested in churchgoing and religious matters than women, a key feature of Christ's desired appearance was a manifest masculinity. For others, Jesus ought to bear maternal qualities; still others looked for a mystical and spiritualized Christ, one who could transcend the materialistic obsessions of the "Gilded Age" of the late nineteenth century. American Protestants were genuinely conflicted about the issue of Christ's appearance. There was no shortage of imagery—the last decades of the century saw dozens of volumes on sacred art appear as well as many engraved and lithographed portraits in popular circulation. At the same time, however, one finds prominent figures such as the Reverend Henry Ward Beecher dismissing the possibility of a satisfactory portrait of Jesus.[27] Moderns behold Jesus, Beecher claimed, through the lens of history and reputation. The historical Jesus was not accessible.

The reasons keeping a compelling modern portrayal of Jesus out of reach were legion, according to contemporaries. In 1899, the Christian periodical *The Outlook* (formerly *Christian Union*), under the editorship of the Reverend Lyman Abbott, published the results of a survey of leading clergy in New York City. Several Catholic, Protestant, and Jewish clergy were asked if the face of Christ in ancient and modern art realized "your idea of a strong face." That the very question skewed response is evident in most answers. For example, Reverend John Chadwick, pastor of the Second Unitarian Church in Brooklyn, answered with a summary "no," then added acerbically: "The majority of the paintings (and I have seen hundreds in the European galleries) suggest a personality almost as lackadaisical and gelatinous as the literary Christ in General Wallace's 'Ben-Hur.'"[28] Chadwick went on to dismiss the work of Tissot and the Hungarian painter Mihaly Munkácsy, two of the most recent and widely celebrated purveyors of historical theatricality in portraying the Passion of Christ. According to Chadwick, both well-known artists failed to "break with the conventional type."[29] In spite of Chadwick's dismissal of the painter's work, Munkácsy's large canvas *Christ Before Pilate* had garnered widespread affirmation from Christian clergy during its public display in Manhattan in 1886–87 and the acquisition of Tissot's biblical imagery by the Brooklyn Museum met with acclaim from the public and from Christian clergy in 1900.[30]

Others, such as the Reverend Dr. Charles Cuthbert Hall, president of Union Theological Seminary, echoed Beecher's point that the God-man could not be adequately represented.[31] Rabbi Gustav Gottheil, of Temple Emmanuel-El, said he had never seen "a picture of the being called Saviour of the world in which strength was a marked feature, or even indicated." But this was only natural, he pointed out, since that Savior "was not a man of flesh and blood, but the creation of theological fancy and dogmatic construction." Rabbi Gottheil noted a further problem: an image of Jesus "must of necessity be the portrait of a Jew with his racial characteristics deeply sunk in his face; and would not

this be a shock to Christian sensibilities?"[32] Henry Ward Beecher had focused on the passage of time as preventing modern Christians from understanding the ancient figure of Jesus in historically visual terms.[33] The rabbi's observation suggests that the inability to find an adequate image of Jesus may have arisen because to do so would mean gazing upon a Jewish face.

The Reverend Brockholst Morgan, of the Protestant Episcopal City Mission Society, first objected to what he called "the mistake of all painters, ancient and modern, [which] is the effeminacy of feature and untrueness to the race to which Christ as a man, belonged." But if he began by asserting the manliness of Jesus's Jewishness, Morgan turned in the next instant to long for an image of Christ that transcended race in the manner of contemporary composite photographs: "Were it possible to conceive what has never been painted, it would be a composite face belonging to no special race nor country, for Christ is the 'Son of man'—that is, of all humanity—not Jew, not Roman, not Italian nor German, but enfolded in all races and all conditions in his one humanity."[34] A Unitarian clergyman expressed the very opposite view of such composite imagination, rejecting most images as portraying someone "weak and unmanly." "If we know anything at all about him, it is that he was a Jew, but the pictures generally might be those of a person of any nationality, or no nationality at all."[35]

It appears that a genuinely historical Jesus, a Middle Eastern, Jewish, and ancient figure, was something that many nineteenth- and twentieth-century Christians avoided or preferred not to imagine because such a visual conception did not speak personally to them as modern, ethnically European believers. This suggests that modern American Protestant visual culture pivoted on a mirroring operation: what believers sought when they looked at Jesus was not a man rooted in a time and place far away, but someone who resembled them; a savior whose ethnicity and race were shared with devout viewers and whose conception of strength, moral ideals, and beauty registered their connection with him. The likeness they looked for, in other words, was a likeness of Christ to themselves. But it is important to note that this likeness was not simply a mirror-image, not mere narcissism. The result was a visual negotiation between viewer and representation, between present and past, familiarity and difference. The portrait of Jesus facilitated this negotiation much better than the full-blown historical picture, which mounted an epic theatre of spectacle and picturesque detail, but in doing so forfeited the personal immediacy and totemic command with which viewers experienced the head-and-shoulders portrait.

This approach to the likeness of Christ has remained characteristic of modern visual piety. As we have seen, Warner Sallman's portrait of Jesus (see figure 44) took the likeness of Jesus from a French tableau depicting the Supper at Emmaus (see figure 51), and reconstructed it as a head-and-shoulders portrait that looks more like contemporary photographic portraiture in college or high school annuals than traditional devotional imagery. The result was a portrait in the very modern sense that viewers admired for its intimate presentation of the man they knew. They frequently expressed their fondness

for the way in which Sallman painted the image—the soft, radiant glow, the highlights in his hair and around his head, and particularly in his face. People have seen there what they want to find, as one informant wrote to me in a letter:

> There is something more about Warner Sallman's pictures that makes me feel . . . when I see them that this artist had felt Christ's presence when he made the images . . . and you can feel Christ's presence . . . conveyed . . . to you through his images. From the image of the head of Christ I see righteousness, strength, power, reverence, respect, fairness, faithfulness, love, compassion. From the way the hair in the image is highlighted in the back and [the] highlights around the front of the head and face there seems to be a Holy radiance emitted from the image, depicting the qualities mentioned above.[36]

The image was reproduced hundreds of millions of times over the decades following its appearance in 1940. The USO distributed pocket-sized versions to American GIs going to Europe and the Pacific during World War II. The publishers offered it in numerous forms, from buttons and cards to clocks, lamps, illustrated bible covers, and devotional literature, and most widely as framed, inexpensive pictures to hang in bedrooms, living rooms, and Sunday School rooms, and to place on desks. Missionaries took this image of Jesus with them to Asia, Africa, and Latin America. For over two decades, it reigned as the unrivaled image of Jesus in the commercial marketplace in the United States until new images arrived showing a more youthful Jesus, such as Richard Hook's 1964 head-and-shoulders portrait of a hunky Jesus with a rough beard, fetching grin, and shaggy head of hair. During the 1960s and 1970s, Hook's image came to appeal more to young people, who began to see Sallman's picture as belonging to the generation of their parents, or worse, grandparents.

### SKEWING THE RATIO: WHEN LIKENESS IS DIFFERENCE

But the second half of the twentieth century eventually witnessed a challenge even to the portrait mode itself. Viewers and artists alike searched for portraits that pushed beyond the prevailing racial, ethnic, and gender assumptions of Christ's likeness to find new paradigms, although they largely kept with the established format of the head-and-shoulders portrait. In 1999, the *National Catholic Reporter* ended its international competition for a Jesus of the new millennium by selecting as winner a painting entitled *Jesus of the People*, by Janet McKenzie (figure 53). The image clearly departs from the tradition of depicting Jesus, so much so that many viewers may not recognize him. The indeterminate gender, dark skin and African features, the robes (which appear more like liturgical vestments than biblical garb), and the yin/yang symbol and black eagle feather all limn a different Jesus and conform little to the conventional expectations about Christ's appearance. These choices were made deliberately, in part because the artist herself has lamented that she "realized that my nephew, a mixed race African-American of 9 or 10

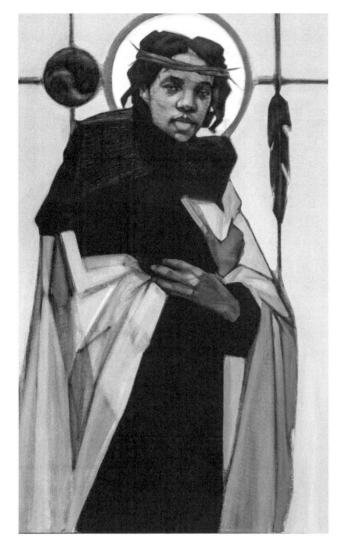

FIGURE 53
Janet McKenzie, *Jesus of the People*, 1999.
Copyright Janet McKenzie, www.janetmckenzie
.com. Courtesy of the artist.

living in Los Angeles, would never be able to recognize himself in my work," which had consisted largely of white women.[37] This lack of connection is what she wanted to change. But it did not end with race. McKenzie stated that she used a female model for the image in order "to incorporate, once and for all, women, who had been so neglected and left out, into this image of Jesus." And the Asian and Native American devices were intended to extend traditional Christian themes to broader spiritual values. The *National Catholic Reporter* reported that "the yin/yang symbol McKenzie said, represents perfect harmony, while the feather connotes transcendent knowledge and also pays homage to Native Americans. The pink in the background, McKenzie said, is both a feminine reference as well as being the color of blood—hinting at both suffering and redemption."[38]

The spiritual also included the ecological. A professor of theology saw in the image a celebration that Jesus "existed in a network of relationships extending through the biological community of Earth to the whole physical universe." Beyond the affirmation of women and people of color, McKenzie's Jesus "also honors the natural world in which all people are embedded, from which they cannot be separated, and for which they are responsible."[39]

No less bracing was a visualization of Jesus that appeared a year later in a 2001 television documentary called *Jesus: The Complete Story*, coproduced by British and American television channels. At the end of the film, an image created by a British medical artist, Richard Neave, appeared.[40] It was a striking image that handily subverted expectations, and quickly spread through media. In 2002, *Popular Mechanics* featured the image in a story about the role that forensics might play in the reconstruction of the face of Jesus.[41] Neave, who had taught forensic anthropology at the University of Manchester, modeled the image from three skulls of Palestinian Jewish men from the time of Jesus. Using digital technology to reconstruct soft tissue thickness on the face, Neave applied clay to a cast of one skull, then relied on images from archeological ruins to provide information about the length and style of hair and facial hair. Neave felt encouraged to create an image with shorter hair than the artistic tradition supplies because Saint Paul asserted that nature itself taught that "for a man to wear long hair is degrading to him, but if a woman has long hair, it is her pride" (1 Cor. 11:14–15).

This gendering in the twenty-first-century forensic artist's choice about hair recalls the history of gendering that shaped debates over the appearance of Jesus in the nineteenth and twentieth centuries. Bruce Barton opened his 1924 best seller, *The Man Nobody Knows: A Discovery of the Real Jesus*, with his memories of the humiliation of Sunday school art, where Jesus appeared in a "sissified" manner. Barton determined to find the manly Jesus that popular pious imagery had denied him. What he claims to have found was something altogether different: "A physical weakling! Where did they get that idea? Jesus pushed a plan and swung an adze; he was a successful carpenter. He slept outdoors and spent his days walking around his favorite lake. His muscles were so strong that when he drove the money-changers out, nobody dared to oppose him!"[42] Barton went on to envision a masculine Jesus who was a businessman and civic leader, the sort of character that modern boys and men would find sympathetic and inspiring.

As dubious as this sort of cultural projection may be, it creeps into even the most "scientific" endeavor, such as Neave's project to find "the real face of Jesus." The *Popular Mechanics* article indicates that "the average build of a Semite male at the time of Jesus was 5 ft. 1 in., with an average weight of about 110 pounds." This is significantly smaller than the average American or British male today. Apparently the difference caused some anxiety because the face that Neave produced was made to reflect a larger man. Further, the writers argued that, "since Jesus worked outdoors as a carpenter until he was about 30 years old, it is reasonable to assume he was more muscular and physically fit than westernized portraits suggest."[43] The replication of critique of the artistic tradition and

appeal to the masculine activities of Jesus as registered in his appearance shows the persistence of the social psychology of likeness.

The role of artistic interpretation was not limited to Neave's conclusions about Jesus's physique. Another anthropologist questioned the entire project's accuracy, pointing out that there is great room for artistic discretion in the rendition of soft facial tissue. The result is often that any given work by a forensic artist may exhibit "more resemblance with the other work of the same artist" than to the individuality of the subject.[44] In other words, the forensic artist draws on or projects the archive of his own imagery, just as Christian artists draw on and project the archive of previous portrayals of Jesus. But Neave might justifiably reply that he did not intend to produce a portrait of Jesus, but to establish a frame of reference different from traditional artistic models by portraying a male contemporary of Jesus. By envisioning the Jesus he does, Neave offers viewers a visceral reminder of Jesus's difference and poignant evidence of the sweeping visual assumptions they make about his appearance and what it means.

# 7

# MODERN ART AND
# CHRISTIANITY

It may seem odd to end a book about the history of modern Christianity with a chapter on fine art—even a book that accords the center of attention to images and visual practices. But the history of modern art in Europe and North America as well as far beyond turns out to have a great deal to do with religion, and particularly Christianity. Christianity has served as an important source of subject matter for modern artists, who continued to portray biblical themes, though increasingly for their metaphorical or symbolic value. The German landscape painter, Caspar David Friedrich, demonstrates this in his *Cross in the Mountains* (plate 10), an 1808 work that sits on the cusp of old and new. It takes the format of a framed altarpiece, designed to occupy a chapel or shrine, it carries traditional symbols of the Eucharist, and it bears the pointed form of the Gothic arch. But it is also innovative in the way it situates the crucifixion on a Northern European mountaintop seen from the rear, as the stage for contemplating not the crucifixion as much as the setting and the mood-infused moment of experiencing nature, which enshrouds a frail cross erected against an arching sky. The entire scene bears the feeling of a memory, though the broad beams of light suggest a dramatic dawn that affirms the revelation of a divine plan unfolding on a lonely peak in Northern Germany.

Modern artists have drawn for two centuries on the Christian tradition in manifold ways. Venerable theological motifs such as revelation, inspiration, spirit, soul, prophecy, purity, and veneration have been appropriated for use in the world of art. Some artists came to regard their work as pursuing a spiritual quest, and thought of the artist as prophet, pilgrim, visionary, and even mystic. On occasion, they even organized

themselves in colonies or remote groups that resembled hermitages or religious communities that were willfully set off from the rest of society for the sake of their quest for a purified art. Christianity, in other words, was a topos for artistic effort, a model for valorizing artistic creation and sacralizing art as a creative act, and a source of symbolic capital that charged social commentary.

Fine art—by which I mean objects meant for display, contemplation, and collection, and the professional discourse of criticism, appreciation, and historical study that accompanies these practices—emerged historically at a time when nations began to organize themselves as autonomous, sovereign entities dedicated to the welfare of more or less discrete peoples. This meant sorting out heritage as a people, and that meant chronicling histories as well as looking to language, religion, folklore, and the arts as principal evidence of national *spirit*. According to the Romantic understanding of culture, which did so much to shape the history of modern nationalism, spirit was the people's genius, their soul, an essence that took concrete shape especially within their history of music, dance, costume, literature, poetry, and the visual arts. Nation was the collective identity of the people, manifest in a range of cultural activities. The state, not to be confused with the nation, was the governing apparatus that protected and directed the nation.

From Hegel to Kandinsky, spirit was understood to manifest itself in art forms, which deserved to be carefully scrutinized for the evidence of spiritual development they incarnated. For Hegel and many after him, the German word *Geist,* spirit or mind, meant the inner force that animated matter and moved through time or history to realize itself *progressively* in national formations and artistic style. Nothing could be a clearer indication of what modernity means for the legacy of European thought than the idea of progress. In fact, many of the visual categories or themes that have organized the second portion of this book are necessary in order to understand Christianity as a modern reality and fine art as an invention of the modern age. Imagination, interiority, nationhood, and spirit-infused representations—whether they are words or paintings or songs—are fundamental parameters of modern art.

Many readings of modernity narrate a story of disenchantment, the loss of sacrality. There is much evidence against this view and much evidence for what I could call resacralization or spiritualization, rather than desacralization. For example, rather than the loss of spirituality, the nineteenth century witnessed the widespread spiritualization of art, in at least three fairly distinct, though not unrelated forms. The first form of spiritualization occurred in the experience of works of art as constituting a revelation and offering to viewers a kind of redemption, momentary but recurring. The second pertained to the social function of art, its mission to spiritualize its audience by recapturing the lost synthesis of beauty and religion imputed to have belonged to the sacred art of ages past. And the third took shape in the stature of the artist as a prophet, visionary, or martyr. I will examine each of these in greater detail and in doing so move from the nineteenth century through the twentieth in order to trace the modern legacy of art as a spiritual force. But first it is necessary to examine how the modern idea of art as a discrete mode

of experience produced the autonomy of art—both separating it from religion and laying the groundwork for spiritualizing the experience of art.

The story I would like to tell in this chapter is by no means a comprehensive account of modern art, nor is it remotely inclusive. I will focus on a few important strands in the history of modern art in Europe and the United States in order to show how deeply modern art has relied on the history of Christian thought and practice. Modernity in art is obviously much larger than this geographical limit, and it is also deeply shaped by many more religious traditions than Christianity alone. But I want to scrutinize the degree to which modern art has drawn on visual motifs and paradigms at work in the history of modern Christianity.

## THE ORIGINS OF MODERN ARTISTIC EXPERIENCE

Fine art in modern Europe is a product of the modern world. "Art" may be something perennial in human culture, given the appropriate circumstances. But modernity has everything to do with what we take quite for granted as art. It is necessary to define modernity if we are to understand it because fine art and modernity are fundamentally intertwined. Modernity in the sense of recent European cultural and political history originates in the confluence of sovereign nation-states, freedom of religious conscience, rapid spread of literacy, establishment of inductive science, rise of constitutional democracy, and expansive organization of capital as the medium for international and domestic markets. These are the conditions for the formation of a middle class that aspires to social mobility and uses the social medium of taste and artistic value as a fashion system for practicing distinction.[1] Fine art emerges, in other words, as a social behavior of refinement keyed to upward mobility and attendant status anxiety. The enviable qualities of beauty, grace, and splendor become something to acquire for oneself, to internalize, hone, and reproduce, to adorn one's person and domicile, to imbue in one's children and to display in one's social associations. They are signs of value and social worth, personal esteem and social station.

Fine art is the product of what sociologist Howard Becker helpfully called "art worlds." By this he meant "the network of people whose cooperative activity, organized via their joint knowledge of conventional means of doing things, produces the kind of art works that [the] art world is noted for."[2] The art world is the working apparatus that constitutes the social construction of art. It includes taste, imagination, critical discourse, galleries, critics, collectors, art schools, newspapers, and object makers known as "artists." But there is another ingredient that is of great importance here: the spirituality, consecration, ritual devotion, and solemn sensibility that regards works of art as especially compelling, as able to touch souls, move the heart, reveal insights, and impress viewers with a sense of what sometimes can only be called "sacred." This sacred sensibility may or may not be part of a formal religion. Beginning in the early modern era, taste and aesthetic discrimination acquired merit and social utility independent of institutional religion.

A vast assemblage known as "the art world" creates what we call modern art. Yet I do not intend to reduce art to an economic operation. Instead, I want to understand how art constantly sublimates these conditions in the creation of a mode of consciousness that we may call subjectivity. By this I have in mind a disposition that is represented in and representative of an Other—a work of art, a deity, a state, a nation, one's small circle of fellows, one's class, or the class to which one aspires. And this Other includes oneself. To see the work of art is to enter into relation to this Other, which includes one's ideal self. Friedrich Schiller asserted that beauty did not simply consist of features borne by an object, but was "at the same time a state of the perceiving subject, because feeling is a condition of our having any perception of it."[3] Beauty "is at once a state of our being and an activity we perform." Fine art engenders a form of consciousness, a distance from what the viewer contemplates, occupying a point of view that stands in relation to an Other, thus setting artistic experience apart from other kinds of experience.

I would like to suggest that at the heart of modern art and aesthetics is an experience that owes something fundamental to the history of Christianity. From Ignatius's *Spiritual Exercises* to Bunyan's *Pilgrim's Progress*, from Puritan introspection to Hannah More's "inward eye," from Luther's heart to the Quaker idea of the inner light, modern Christianity forged the experience of—and value of—interiority that informed the modern aesthetic conception of subjectivity. Without imagination as modernity has conceived it—as a creative faculty free from but not antagonistic to reason—modern art could not exist. The subjectivity that art requires of its viewers is rooted in the imagination, the forge of vision, that modern Christians have practiced for centuries.

In the introduction I indicated the importance of the sublime as an aesthetic sensibility that contributed to what Michel Foucault named "the genealogy of the modern subject."[4] Foucault turned from the concept of power as domination to consider what he called "technologies of the self," by which he meant "techniques which permit individuals to effect, by their own means, a certain number of operations on their own bodies, on their own souls, on their own thoughts, on their own conduct, and in this a manner so as to transform themselves, modify themselves, and to attain a certain state of perfection, of happiness, of purity, of supernatural power."[5] The shift is evident in a comparison of the panopticon, which Foucault examined in *Discipline and Punish,* and his later, evolving lectures on technologies of the self.[6] In the former work, he scrutinized the power exercised on prisoners as a nameless, faceless group, subject to the omnipresent eye of surveillance to such a degree that they internalize the penitentiary gaze. In his later work, Foucault turned to the subject's own exercise of technologies of confession and penance. In the modern era, I would like to suggest, this came to include the aesthetic technique of the sublime. Consider two prisons: Foucault's panopticon and Giovanni Piranesi's marvelous etchings of imaginary prisons, issued in 1750.[7] The panopticon is about the exercise of power in the pristinely ordered and uniformly lit interior of the prisons, where

there is no escape from the all-seeing eye of authority, a condition that produces an ontology of guilt and punishment among prisoners. Visibility, as Foucault puts it, is a trap.[8] By contrast, Piranesi regards the prison interior as a lush domain of darkness, a fantastic realm that invites the viewer's exploration. The sublime is a tourist's excursion: scary, intriguing, arousing, but short-lived and entirely self-determined. It ends when I turn my eyes away. But the panopticon is endless. There is nothing sublime about it in the aesthetic sense because it is all too real.

The sublime, I want to argue, was an aesthetic technique used by viewers on themselves. The sublime came to parallel or even displace Christian technologies such as confession and penance by offering the modern autonomous individual an aesthetic means of shaping the self-determined self. As such, the sublime marked a significant shift in the genealogy of the subject as drawn by Foucault in his late work. The Christian quest to redeem the fallen self—to mortify it or to quicken it—with the technologies of sacrament and devotional practice was rivaled in the course of the eighteenth century by a new conception of the self and an attendant set of technologies. The sublime offered a bracing experience of subjectivity, reshaping the subjective faculty of feeling and sensation in the imaginative experience of the work of art. It overwhelmed the conventional categories of scale, ordinary feeling, and mental range, plunging the perceiver into a dramatic recalibration and sense of the stature of the self. In 1731 the English clergyman Thomas Stackhouse described the sublime as "that which ravishes—that which transports, and produces in us a certain admiration mixed with wonder and surprise—that which elevates the soul, and makes it conceive a greater opinion of itself."[9] In the following decade, the Scottish theologian John Baillie expanded on the power of the sublime to invigorate the mind. He named sublime "every thing which thus raises the mind to fits of greatness, and disposes it to soar above her mother earth; hence arises that exultation and pride which the mind ever feels from the consciousness of its own vastness—that object can only be justly called the sublime, which in some degree disposes the mind to this enlargement of itself, and gives her a lofty conception of her own powers."[10] The sublime was an aesthetic experience, a range of feeling that critics and philosophers were at pains to describe and understand. This was a critical development because it defined the category of subjectivity that was fundamental for the modern experience of art, and thus contributed importantly to the discourse that was necessary for the emergence of art—since that discourse shaped taste, the market, the activities of collecting and displaying art, and the learning and conversation that spread ideas and formed social networks among artists, critics, collectors, dealers, and art lovers. So we open the discussion with consideration of some of the most important thinkers, many of whom were German, since German philosophy in the eighteenth century was actively engaged in aesthetic thought. Indeed, it was a German scholar who first coined the term "aesthetic" in 1735.

In 1793, Schiller published an essay, "On the Sublime," in which he argued that the sublime worked by subordinating our sensuous nature in order to make us aware "of the independence that, as rational beings, we assert over nature, as much *inside* as *outside*

ourselves."[11] He went on to describe the sublime as everything that makes us conscious that "there is within us a capacity to act according to laws completely different from those of the sensuous faculties, a capacity having nothing in common with natural instinct."[12] The sublime was the aesthetic perception of human freedom. Schiller based his comments on Immanuel Kant's epochal work, *Critique of Judgment* (1790), which set out to show how judgments of taste consist of intuitive, imaginative acts that are not hopelessly mired in idiomatic subjectivity, but shared by everyone and universal in scope. The faculty of taste, the recognition and evaluation of the beautiful, operated disinterestedly when it judged something to be truly beautiful. When we are gratified by something such as food or warm clothing, an interest or need is fulfilled. But when something is deemed beautiful, it is pleasing independent of any want and judged to be universally so. Its beauty does not depend on our needs. Our judgment is not compelled by anything but our pleasure in the experience of apprehending the beautiful. According to Kant, whatever satisfies the senses attends to the interest of the individual. Beauty, however, pleases independent of sensory satisfaction: "We easily see that, in saying it is beautiful and in showing that I have taste, I am concerned, not with that in which I depend on the existence of the object, but with that which I make out of this representation in myself."[13] The object of judgment is the form of a thing grasped in mental representation, not what the thing offers or threatens to inflict on our senses. Thus, the *image* of a dying person can be beautiful whereas the actual presence of someone dying is not. Judgments of beauty are disinterested, disengaged from actual circumstances. If I want to eat the food pictured in a painting, I am not having an aesthetic experience, but one driven by bodily appetite.

This putative separation was critical for Kant. In fact, it tended to drive apart art and religion since images in devotion and worship are keenly interested in such bodily matters as healing, miraculous deliverance, comfort, encouragement, and moral suasion. As the condition for aesthetic judgment or the practice of taste, disinterestedness tends to secularize art, defining it as a psychological experience that is not to be confused with nature or human need. But Kant's approach also endorsed the clarification of modern subjectivity as the framework for aesthetic experience. As the faculty of judgment, taste was a discernment based on mental apprehensions and representation. Aesthetic form was not about sensation per se, but about imagination, the act of representation that produces what Kant called "aesthetic ideas" and did so in lieu of the rational faculty of the understanding.[14] Judgment is not rational, but aesthetical, a form of intuition conducted by the imagination without reliance on a rational concept to make it universal. This distinction was critical for Kant's understanding of the sublime, which he insisted "is not to be sought in the things of nature, but only in our ideas."[15] The sublime is the mind's capacity for self-elevation because in confronting the idea of the absolutely great, the mind "finds the whole power of imagination inadequate to its ideas."[16] Imagination and reason conflict with one another. Reason says we must master the object by understanding it; imagination stretches to encompass it but cannot. The result is a kind of pleasing harmony.

Kantian aesthetics exerted a separation of art from the world around it and from the human body, setting art off as an autonomous activity. But for others art and artistic experience were better described as revelatory and redemptive. For Georg Friedrich Hegel, the history of art was the history of revelation of *Geist,* spirit or mind. Kant had separated phenomena from noumena, that is, from things in themselves, what Plato had called the ideal forms (*noumenon* derives from *nous,* the Greek word for "mind"). But Hegel rejoined them in the dialectical evolution of spirit. He posited that three principal forms of art—symbolic, classical, and romantic—designate "the three relations of the Idea to its shape in the sphere of art." These consisted of "the striving for, the attainment, and the transcendence of the Ideal as the true Idea of beauty."[17] The symbolic affixes a concept to matter; the classical eliminates what does not belong to an ideal of the human form; and the romantic is a restive pressing toward self-transcendence. Egyptian, Greek, and Gothic art correspond to these stylistic expressions. This scheme allowed Hegel to make sweeping gestures over time. The ancient world, the golden age of Greece, and medieval Christian art and architecture were the broad canvas on which he portrayed the world-historical evolution of *Geist.* As such, "art liberates the real import of appearances from the semblance and deception of this bad and fleeting world and imparts to phenomenal semblances a higher reality, born of mind."[18] But for Hegel, art was an inferior and historically determinate expression of spirit. The highest manifestation of what he also called the divine, "is essentially only present to thinking, and, as in itself imageless, is not susceptible of being imaged and shaped by imagination."[19] Only philosophy can regard the divine in a pure sense. Why bother to create art at all? Hegel believed that art answered a universal need for expression that originated "in man's rational impulse to exalt the inner and outer world into a spiritual consciousness for himself, as an object in which he recognizes his own self."[20] Art was an instrument deployed to achieve human fulfillment, a kind of spiritual technology that advanced human evolution toward greater consciousness, thus revealing progressive expressions of mind or spirit, which in some sense is humanity coming to itself. Hegel proposed a Romantic humanism in which spirituality replaced the traditional religious notion of worship of a deity.

For others the experience of art offered a mystical perception that sacralized art. This took shape in very different ways. There were, for instance, visionary artists such as William Blake in England and Philipp Otto Runge in Germany who developed highly idiosyncratic iconographies of mythical and poetic symbolism that envisioned alternate cosmologies. They each regarded artists as being charged with keen missions to attend to their revelations with art. The figure of Los in Blake's poem, *Jerusalem,* which we discussed in chapter 5 (see plate 7), was the primordial precursor of the artist/prophet, who, like Blake himself, struggled to reverse the disunity of human nature. Spectre, or the reasoning power, confronts Los, hovering over him and berating him for his longing to reunite the elements of the self into the sleeping Albion. But Los insists that reason should help him at his forge, the engine of prophetic vision:

I will compell thee to assist me in my terrible labours. To beat
These hypocritic Selfhoods on the Anvils of bitter Death.
I am inspired: I act not for myself: for Albion's sake
I now am what I am! . . .

Take thou this Hammer & in patience heave the thundering Bellows,
Take thou these Tongs: strike thou alternate with me: labour obedient.[21]

Thus inspiration addresses reason—emotion and imagination enjoin union with a rationalism that is in rebellion against the rightful, unfallen unity of human nature. So speaks the artist/prophet to religious dogma and the blind authority of institutional religion. The artist's imaginative quest is for the lost unity of human nature, and is therefore the prophetic revelation of the loftiest of religious truth.

While Blake and Runge looked through the ordinary to see its spiritual depths, some contemporaries endowed art with a spiritual power of insight and transcendence that operated as a redemption from ordinary life. Arthur Schopenhauer, German Idealist philosopher, found this separateness mystical, a momentary redemption from the teeming mass of events that form the world. He described the wonder of moments experienced before works of art or scenes of nature, when we are snatched away,

> although only for a few moments, from subjectivity, from the thralldom of the will, and transferring us into the state of pure knowledge . . . . For at the moment when, torn from the will, we have given ourselves up to pure, will-less knowing, we have stepped into another world, so to speak, where everything that moves our will, and thus violently agitates us, no longer exists . . . . We are only that one eye of the world which looks out from all knowing creatures, but which in man alone can be wholly free from serving the will.[22]

Schopenhauer understood will as the dark, blind force that propelled all life and matter into and out of existence, driving each being to scramble for its own interests. Aesthetic experience offered a brief respite from this swirling agony, enabling a kind of transcendence in which the self became a super-personal state of knowing, which abruptly ended as soon as pure contemplation gave way to the demands of individual consciousness. The subjectivity of artistic experience was for Schopenhauer something akin to a mystical moment of realization, an intermingling of self with a higher state of knowing. The same remained true at the end of the century for art connoisseur Bernard Berenson, who described what appears to be identical to Schopenhauer's mystical flight of aesthetic experience:

> In visual art the aesthetic moment is that flitting instant, so brief as to be almost timeless, when the spectator is at one with the work of art he is looking at, or with actuality of any kind that the spectator himself sees in terms of art, as form and colour. He ceases to be his ordinary self, and the picture or building, statue, landscape, or aesthetic actuality is no

longer outside himself. The two become one entity; time and space are abolished and the spectator is possessed by one awareness. When he recovers workaday consciousness it is as if he had been initiated into illuminating, exalting, formative mysteries. In short, the aesthetic moment is a moment of mystic vision.[23]

For some, spirituality was clearly a signature feature of the state of subjectivity or consciousness that fine art produces.

Another kind of mystical intermingling of ego and subject-matter in art is evident in the work of the German landscape painter, Caspar David Friedrich. In 1808, Friedrich painted *Cross in the Mountains* (see plate 10), which was intended for the King of Sweden, Gustav IV, whose Moravian Pietistic faith and staunchly anti-French sentiment pitted Sweden against the Napoleonic invasion of Germany in 1807.[24] This political stance strongly appealed to Friedrich, a fiercely patriotic German who regarded Gustav IV as the defender of the realm and had intended to offer the painting as homage to the zealous monarch. But political events intervened: Gustav was overthrown by his own army in 1809. So Friedrich was persuaded instead to sell the painting and its customized frame to the count of Thun-Hohenstein in Bohemia, where the work was installed—not in a chapel, as the artist had been promised, but in the countess's bedroom. Friedrich had produced a landscape with a crucified Jesus for the faith of a crusading king opposed to imperial aggression. The elaborate frame was intended to fit the landscape image into the tradition of altarpieces. The painter imagined the genre of landscape as an appropriate means of celebrating the sacred sovereignty of the North, protected by a Swedish overlord. But when he exhibited the painting in his studio in Dresden in 1808, its design and aesthetic were criticized by the art critic Friedrich Basil von Ramdohr, in a long essay that targeted the painting, its presentation, the artist's taste and ability, and, beyond that, the bothersome Romantic aesthetic that the image represented.

Ramdohr's response to Friedrich's painting tells us a good deal about the emergence of art as something intrinsically sacred. Early German Romanticism was a transitional moment in this century-long process. Ramdohr wished to defend the mechanics of good taste, which he felt were threatened by the young Dresden painter's violation of the aesthetic ideal of landscape. Friedrich's error was two-fold, according to Ramdohr. He tried to allegorize landscape and thereby to make the category into religious art, placing it on an altar as the focus of the liturgical rite of Holy Communion. The result was "dangerous to good taste" since it "divides public opinion," appeals to "the great crowd," and "robs the essence of painting, especially landscape painting, of its own most proper traits."[25] It was Ramdohr's charge that Friedrich, and Romanticism by extension, menaced the social operation of good taste, a sensibility that artists had the duty to cultivate among the public in order to refine it.

Friedrich's friends in Dresden rallied to his support, publishing retorts to Ramdohr. Yet Ramdohr's observation was not without accuracy: Friedrich was making landscape do something that had previously been reserved for other genres of artistic imagery. For

Friedrich the fierce German patriot, who resented the triumphant Napoleonic presence in German territory, locating the crucifixion on a German Calvary, surrounded by unmistakably German firs, was perhaps a way to recode the Roman (Latin) execution of Jesus. Or perhaps it was a way of elevating the German landscape in the hierarchy of European aesthetics, which strongly preferred the classicizing figure paintings of Nicolas Poussin and Roman landscapes of Claude Lorrain to German landscape painting. Accordingly, around 1830, viewing a collection of paintings by contemporary artists, Friedrich complained that "Our German sun, moon, and stars, our rocks, trees, and plants, our plains, lakes, and rivers no longer satisfy the art critics. Everything must be Italian to be able to make any claim to grandeur and beauty."[26] Friedrich's intermingling of national self and native subject matter in this defense of German landscape, as in his own paintings, marks a Romantic disposition that departed starkly from the Kantian aesthetic since it argued passionately for the very *interested* (rather than disinterested) nature of aesthetic experience. Art was vital precisely because it was invested with the self—personal and national. Its power was to engage the self in encountering itself in the body of the national landscape.[27]

## THE SPIRITUALIZATION OF ART AFTER THE ROMANTIC ERA

We have seen one way in which art was spiritualized and how that spiritualization unfolded at the same time that the legacy of Kant tended to secularize art by stressing its subjective or mental nature. But there are two other important ways in which art, artists, and aesthetic experience were understood to manifest spiritual power and insights. In addition to fashioning the notion that art was intrinsically spiritual, Romanticism also spawned an invigoration of explicitly religious art, that is, imagery dedicated to the community of Christian believers and fully capable of being placed in the service of the church.

Artists such as Runge produced art that they felt was spiritually moving without intending it for use in formal religious worship. But for many artists in Europe and the United States in the first half of the nineteenth century, the art world had lost the truly sacred character of images dedicated to Christian holiness. This is the second clearly discernible form of spiritualizing art: artists set out to mend the rift between art and religion by bestowing on art a Christian purpose and sense of its own history. Several young art students in Vienna formed a group in 1809, calling themselves the Brotherhood of Saint Luke, after the saint who had long been believed to be a painter as well as a gospel writer. In the following year the group migrated to Rome, where for a time they took up residence in an abandoned monastery, wore robes, and let their hair grow long. The odd features of their lifestyle earned them the tag "Nazarenes," after the ancient Israelites who vowed to separate themselves for God and did not cut their hair (Numbers 6:1–21). The Brotherhood of Saint Luke dedicated itself to purifying art and returning to the work of the young Raphael as the ideal of Christian art. But rather than simply

regurgitating the sacred art of the past, the painters, as art historian Cordula Grewe has noted, endowed their work with an unmistakable minimalism and conceptual focus, the mark of their mission to change culture by deploying painting not as pictorial narrative after the model of Renaissance art, but as polemical tableaux dedicated to teaching and proselytizing. Grewe describes the work as hieroglyphs, visual texts that set out to reinfuse theological debate into modern society.[28]

We easily sense the artist's discursive intent in Johann Friedrich Overbeck's painting *Christ in the House of Mary and Martha* (figure 54), in which the extended finger of Jesus occupies the very heart of the painting, enacting his counsel to the disgruntled woman: "One thing is needful," he tells her, and that is to listen to the teaching of the master. The deictic gesture draws the biblical text to mind (Luke 10:40–1), as everyone in the image listens to the exchange between Jesus and Martha. Martha gestures to Mary at Jesus's feet, where she listened intently to him, deeply pondering what she has heard. Like a host of Northern Renaissance images, Overbeck's picture includes a biblical scene shown through a window, where we glimpse Jesus's parable of the Good Samaritan (which immediately precedes the account of Mary and Martha in Luke). (Compare, for instance, Jerome Wierix's engraving of the Visitation, figure 6, for the same device.) But the clear contours, silent sense of the moment, focal unity, and the utter legibility of the entire scene all suggest a homiletic diction that the zealous Overbeck, a convert to Catholicism, brought to bear on his passionately tasked picture-making. Nothing distracts from the single purpose at hand.

Other members of the group, including Wilhelm Schadow, Peter Cornelius, and Julius Schnor von Carolsfeld, joined Overbeck in producing elaborate paintings for use on altars in churches, frescoes of biblical subjects, illustrated Bibles, and devotional panels for ecclesial use. In France, where the state remained an active patron of the arts, sponsoring annual salons in Paris and purchasing a great deal of work that was then placed within churches around the country, religious art remained a familiar subject among fine artists. A number of major artists produced significant work for churches, including Ingres, Delacroix, Hippolyte Flandrin, and Ary Scheffer, to name only a few very prominent painters. The hope of a renewal of modern religious art affected many French artists. The resulting work looked to a range of artists from the Renaissance and Baroque periods for inspiration, from Raphael and Nicholas Poussin to Velasquez, Zurburán, and Peter Paul Rubens.[29]

Delacroix's *Christ's Agony in the Garden of Gethsemane* is a good example of a brilliant modern painter's religious work (figure 55). On a large scale, measuring more than eleven feet wide, the scene conveys high pathos: Christ leans on one arm and appears to hold the grief-stricken angels at bay with the other in a dramatically magnanimous gesture that prefers heroic and manly pain to feminine succor. In the dark distance to the left, firebrands light the way of the armed company coming to arrest Jesus. The lazy disciples sleep soundly to his right in stark contrast to the operatic abeyance of the angelic company, which has just arrived on a cloud of heavenly light. According to Luke,

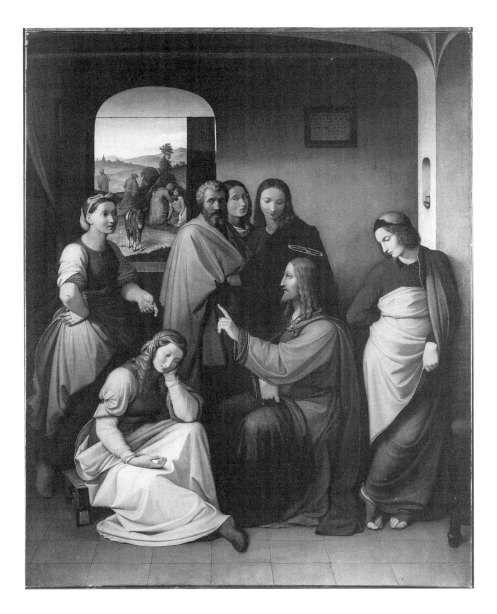

FIGURE 54

Johann Friedrich Overbeck, *Christ in the House of Martha and Mary*, 1815, oil on canvas. Courtesy of BPK, Berlin / Nationalgalerie / Jörg P. Anders, photographer / Art Resource, NY.

an angel intervened to comfort the anguishing Jesus (Luke 22:43). But Delacroix's Christ demurs, the better to heighten his valor in the face of dark fate. Casting a tragic gaze downward, refusing to receive their ministrations on this, the darkest night of his life on earth, Jesus strikes a Promethean solitude as the helpless female angels look on. It is an image designed to invoke a gendered sentiment of reverie in the viewer, awe at the heroic

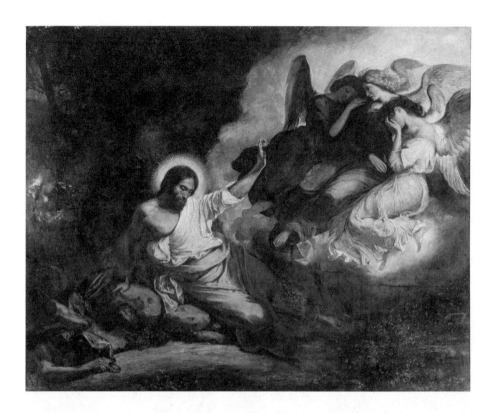

FIGURE 55
Eugene Delacroix, *Agony in the Garden of Gethsemane*, 1826, oil on canvas. Courtesy of Bridgeman-
Giraudon / Art Resource, NY.

act of endurance and the refusal to forego it. It may also recognize in the distinction of
male and female the rigor of heroic (masculine) spiritual vocation, an ideal that came
increasingly to describe the sacred stature of the avant-garde artist in the nineteenth
century. As one later critic observed, "One can dispute the religious value of the *Agony*,
and every Catholic will regret that the angels here are but weeping spectators when they
should be helpful consolers, but none would think to deny the painting's tragic grandeur
and artistic character."[30] Exhibited at the annual Salon of 1827–28 in Paris, where it was
both criticized for its artist's lack of faith and praised for its religious fervor, the painting
was placed in the Church of St. Paul and St. Louis in the city.

In England, the Pre-Raphaelite Brotherhood formed a few decades later with a goal
similar to that of the Nazarenes: to correct the debilitated artistic trends of the present by
rediscovering the Christian inspiration of Renaissance art. But the result looked very
different from the art of Overbeck and his companions. In fact, Pre-Raphaelite work was
closer in visual character to Caspar David Friedrich's than to Raphael's or Fra Angelico's.
The same profusion of symbols composed of legible natural objects that characterized

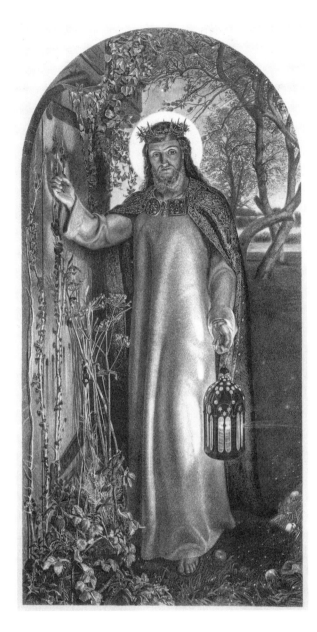

FIGURE 56
William Henry Simmons, stipple
engraving after William Holman
Hunt, *The Light of the World*,
1853. Courtesy of V & A Images,
London / Art Resource, NY.

the latter painters appealed to William Holman Hunt, whose *Light of the World*
(figure 56) also indulges in the hushed twilight and intense coloration that were Frie-
drich's signature. Hunt was fascinated equally by the pictorial language of crisply limned
contours, lavish surfaces, and closely observed, meticulously drawn detail work. *Light of
the World* reads like a loquacious text, a wordy visual field in which every object speaks
in the allegorical diction of a pious naturalism. Each leaf and thistle, rendered with
botanical accuracy, is also drawn from a lexicon of theological symbolism. And the entire

scene is a somnambulant allegory of the quiet redemption of the self-sequestered soul called from its solitude by the midnight rapping of a wordless savior. The picture triangulates redeemer, soul, and viewer in the sparkling gaze of Jesus who knocks on the door, but looks at us. This direct appeal and the infinite legibility of the picture were fondly received by Victorian viewers. The image leaps from a gnomic utterance of Jesus at the end of the New Testament: "Behold, I stand at the door and knock; if any one hears my voice and opens the door, I will come in to him and eat with him, and he with me" (Revelations 3:20). The pictured savior speaks in the glowing cast of his eyes, promising the intimate communion of a soul fondly reconciled to the one who calls for him. The picture appeals for its layers and layers of meaning, working like a puzzle whose message is put together by careful rumination on the telling fit of word and image. It is not a reflection on meaningless suffering or pointless agony, but the Evangelical promise that Jesus makes the world make sense. Meaning is abundant and stands just outside the door that is, as the artist said, "the obstinately shut mind."[31]

Both Hunt and Friedrich reflect the Protestant tradition in their treatment of a meticulously legible natural world whose forms and details operate as Holy Writ, a kind of lexicon revealing the glory of God. John Calvin did not hesitate to affirm the testimony of the natural universe to the existence of God. Calvin put the matter in bold terms when he insisted that God had been pleased "so to manifest his perfections in the whole structure of the universe, and daily place himself in our view, that we cannot open our eyes without being compelled to behold him . . . . on each of his works his glory is engraven in characters so bright, so distinct, and so illustrious, that none, however dull and illiterate, can plead ignorance as their excuse."[32] Calvin drew on the Book of Psalms and Paul's Letter to the Romans to proclaim that as the author of nature, God was evident in his work. Most strikingly, nature was a visual register that revealed God's presence—a remarkable assertion for the Protestant divine who took one of the strongest stands against the visual arts as a source of religious knowledge: "None who have the use of their eyes can be ignorant of the divine skill manifested so conspicuously in the endless variety, yet distinct and well-ordered array, of the heavenly host; and, therefore, it is plain that the Lord has furnished every man with abundant proofs of his wisdom."[33] Even Reformed Protestantism was therefore able to endorse art and imagination in its own way, and it is certainly no mistake that one of the most important traditions of landscape painting in Europe arose in the Netherlands during the seventeenth century, where Calvinism reigned as a powerfully intensive religious culture.[34]

The third form of the spiritualization of art that I want to describe developed in tandem with the artist's separation from the traditional patrons of church and state. The artists who most enthusiastically espoused the rhetoric of art's intrinsic sacrality during the final third of the nineteenth century did so by presenting themselves as priests, prophets, or visionaries. It is noteworthy that they were arguably those who faced the greatest distance from state patronage and official recognition in venues such as the annual salon exhibitions in Paris: rather, these avant-gardists of the final decades of the

nineteenth century defined their work in opposition to both the official academic work favored by the state and academy and to the increasingly popular naturalism that arose on the margins of academic taste. Instead, they relied on the rising commercial gallery and dealer market for locating patrons. Art as a spiritual good, possessing an intrinsic value, art with a mystique or aura that might confer on its owner a desirable distinction, was part of an economic strategy in a privatized market.

Artists such as Odilon Redon, Paul Gauguin, Vincent van Gogh, Fernand Khnopff, Edvard Munch, and Paul Sérusier, and the critic Albert Aurier produced and discussed work that was not calculated to operate in the academic system nor to appeal to broad, popular tastes of naturalistic styles of painting.[35] In fact, they commonly derided realistic art and cultivated instead a visual language that flattened, ornamentalized, intensified, exoticized, abstracted the appearance of objects. "The goal of painting," Aurier insisted, " . . . cannot be the direct representation of objects. Its end purpose is to express ideas as it translates them into a special language." Aurier hailed the art of Gauguin and Van Gogh as attuned to the expression of "Ideas," by which he meant Platonic verities. To that end, the artist was not to regard objects as the aim, but to see "them only as signs, letters of an immense alphabet that only the genius knows how to read."[36] The immaterial Idea stood in sharp contrast to matters of the body. Rising above all sensual interests amounted to a spiritualization of the aesthetic of disinterestedness. The quest for purification from base materialism sometimes focused on women, as in the following comment by Albert Aurier in an essay on art criticism:

> It is even easier to have true love for a work of art than for a woman, as in the work of art materiality barely exists and almost never lets love degenerate into sensualism. Perhaps this method will be ridiculed. Then I shall not answer. Perhaps it will be considered mystical. Then I shall say: yes, without a doubt, this is mysticism, and it is mysticism that we need today and it is mysticism alone that can save our society from brutalization, sensualism, and utilitarianism. The most noble faculties of our soul are in the process of atrophying.[37]

Aurier was unapologetic about the vaunted stature of the artist, who belonged to the class of latter-day philosopher-kings described by Plato in *The Republic:* "Do not those who neither see the idea nor believe in it deserve our compassion, like the unfortunate, stupid prisoners of Plato's allegorical cave?"[38]

A major aspect of the sacralization of art in the later nineteenth century articulated a sense of alienation from modern life, from the reigning systems of social authority, from materialism. This is evident in the urge to purify art of realism and traditional subject matter, and to relocate the artist to remote colonies like those that Gauguin and Van Gogh struggled to create in Pont-Aven and Le Pouldu in Brittany. Or to far-flung locales like Tahiti, where Gauguin would soon go, in search of new beginnings, where the artist would be influenced by indigenous culture and liberated from Western civilization. Gau-

guin described how misunderstood he was, but took hope in the prospect of fleeing to the tropics as an opportunity for regeneration and artistic rebirth:

> Yes, we are destined (we pioneer artists and thinkers) to succumb to the blows of the world, but to succumb so far as we are flesh. The stone will decay, the word will remain. We are in the dismal swamp, but we are not dead yet. As for me, they won't even have my skin. If I manage to get what I am now trying for, a snug berth in Tonkin [the northernmost region of Viet Nam, under French colonial rule since 1885], I can work at my painting and save money. The whole of the East—lofty thought written in letters of gold implicit in all their art—all this is well worth studying, and I feel that I shall be rejuvenated out there. The West is corrupt at the present time and whatever is herculean can, like Anteus, gain new strength in touching the soil of the East. And, one or two years later, we can return solvent.[39]

It was a scheme for achieving financial stability that would, however, rely on critics and new kinds of patrons back home to provide the necessary reception and support for the artist as prophet, mystic, and martyr.[40]

A brazen sense of the artist's specialness informs Gauguin's *Christ in the Garden of Olives*, 1889, in which the figure of Jesus is also a self-portrait of the painter (figure 57). Sulking in the lush night of the garden, Jesus leans away from the fleeing disciples to sink into dejection and a pathetic sense of betrayal. The high pathos of Delacroix's Promethean hero has dwindled to sullen self-pity. Cut off from his errant followers by the dark silhouette of a tree, Gauguin's Jesus occupies an entire half of the picture. As Debora Silverman has aptly pointed out, when he produced the work Gauguin had not in fact been betrayed by his "disciples," but shared the company of fellow artists on the western shores of France, where he painted the image in the fall of 1889.[41] But he did feel increasingly isolated from the success and attention that he believed his work merited. Gauguin lacked the support that benefited Delacroix, who enjoyed state patronage. Delacroix's *Agony* had been purchased by the state for placement within a Parisian church. Gauguin, on the other hand, had to rely on appeals to private collectors to grasp his genius. The sense of betrayal his picture enacts may derive from the resentment he felt toward art dealer Theo van Gogh who forbade his brother, Vincent, to participate in an exhibition in Paris that summer consisting of works by the group of artists in Brittany, organized by the ever-impoverished Gauguin. The venture turned out to be a commercial flop, only intensifying Gauguin's financial woes.[42] He conveyed his sense of frustration in grandiose religious terms: in a letter to an artist friend written at the time he was painting *Christ in the Garden* he complained, "I am toiling up the steps of a rugged Calvary. From Paris I am deafened by the cries my latest pictures have provoked."[43]

Gauguin's portrayal of himself as misunderstood martyr, abandoned and victimized, echoed Aurier's own sentiments about the artist, as expressed in his own poetry—which one art historian has suggested may even have inspired Gauguin's painting.[44] Aurier

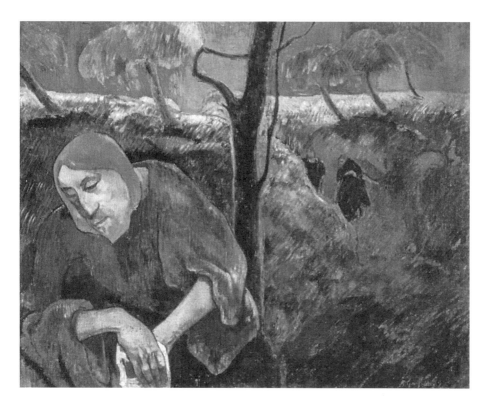

FIGURE 57
Paul Gauguin, *Christ in the Garden of Olives*, 1889, oil on canvas. Courtesy of Kharbine-Tapabor / The Art Archive at Art Resource, NY.

regarded this painting by Gauguin in particular as a provocation to ponder more than what the Gospel of Luke had to say about Jesus's state of mind. He praised the picture as "sublime" and remarked that Jesus (and Gauguin), "seated in a desolate site, seems to convey through his tears the inexpressible sorrows of the dream, the agony of the Chimera, the betrayal of contingencies, the vanity of the real and of life, and perhaps, of the beyond."[45] Clearly, subjectivity was becoming increasingly self-referential.

## SUBLIMITY AND TRANSCENDENCE

The elevation of the artist to sacred office continued into the twentieth century, and became closely associated with the development of abstraction in the thought of Russian painter and art theoretician Wassily Kandinsky. Kandinsky inherited the Symbolist critique of naturalistic painting, which he applied to the dematerializing of artistic style. He understood the artist to be a spiritual leader of humanity, a prophet who was misunderstood, recalling Gauguin's portrayal of himself as Jesus in Gethsemane. In his major theoretical statement, *Concerning the Spiritual in Art* (1912), Kandinsky characterized the

spiritual life as a progressive expansion of artistic genius that would gradually embrace the entire society. The artist was an unappreciated prophet whose work went unnoticed by the people in spite of his manifold gifts for their spiritual wellbeing: "Invisible, Moses comes down from the mountain, sees the dance round the golden calf. Yet he brings with him new wisdom for men."[46]

Kandinsky felt pressed to account for the difficulty of progressive art, for its incomprehensibility and for critical hostility among audiences who wanted simpler spiritual food than the most advanced artists were inclined to offer. Kandinsky's metaphor acknowledges both that audiences have always considered avant-garde art to be difficult and that the fashion cycle eventually makes the new and difficult into the familiar and popularly acclaimed. The movement of taste is progressive. Yet the most progressive artist is a scorned prophet, a Man of Sorrows whose suffering appears as unavoidable as it is unjust. He suffers for truth, sacrificing himself for the slow but sure advancement of society.

Kandinsky regarded the comprehensible art that the masses adored, the artistic language they understood, as using line, plane, and color to do no more than describe mere appearances. Naturalism, the descriptive celebration of familiar objects, entertained the masses and failed to push them spiritually. "The path upon which we find ourselves today," he proclaimed, "and which is the greatest good fortune of our time, leads us to rid ourselves of the external, to replace this basis by another diametrically opposed to it: the basis of internal necessity."[47] For Kandinsky as artist and theorist, this meant recognizing what he considered the intrinsic capacity of line, plane, and color for visual expression. He devoted a long section of *The Spiritual in Art* to presenting this vocabulary in the elements of the visual arts, describing the inherent properties of different colors and noting the interrelations of sound and color, which allowed him to sketch a rich psychic life within words, forms, and colors. Emotions are keyed to colors and words as well as to spiritual sensation: "The deeper the blue becomes, the more strongly it calls man toward the infinite, awakening in him a desire for the pure and, finally, for the supernatural. It is the color of the heavens, the same color we picture to ourselves when we hear the sound of the word 'heaven.'"[48]

The intrinsic or interior quality of the formal elements of art could be accessed and liberated by the artist's recognition of what Kandinsky called "inner necessity," the driving force in artistic creation. Abstraction freed the work of art from the drudgery of describing surfaces, aping appearances, by penetrating the exterior, by turning line and color from description to introspection, from surface to depth, from exterior to interior, from result to cause. Kandinsky saw this at work in children's art, in so-called primitive art, in decorative motifs, in devotional imagery, and in the work of untrained, folk artists. In every case, the impulse was not to reproduce appearances, but to indulge the artist's personality, to articulate the language of style, or to portray objects as a way of making them expressive of the driving force that led image-makers to their work. Abstraction went further, severing the tie to appearances altogether, and giving to the elements of art

an autonomy that might allow them a purely expressive function. Or at least that was the tendency around the time that Kandinsky composed and finally published his book. In fact, it took him a few years to eliminate all reference to external matters in his own painting.[49]

For example, one sees details and fragments lingering in *Improvisation 26 (Rowing)*, a characteristic example of Kandinsky's work at that time (plate 11). At first glance, the image may appear as no more than nebulous auras of color overdrawn by arcing lines. But the more one looks, the more one sees the remnants of recognizable motifs: in the upper center appear the minimal dark contours of two or perhaps three figures, from whom descend several dark lines, the oars of the title's reference to rowing. Kandinsky has abstracted, but not finally extinguished the basic visual information of figures in a boat with oars. Six "oars" might be counted, but that would suggest a boat with twelve oars in all, far more than there are figures to operate them. So perhaps we see a repetition of fewer oars. Rather than describe them, the artist plays with form and line. The edge of each oar becomes a form in itself, arcing, vibrating, dissolving. Clouds of color undulate about the "boat," which has vanished, leaving only the partial contours of the figures. Given the important role that religious iconography and biblical themes played in Kandinsky's work at this time, as Rose-Carol Washton Long has shown, one wonders if the subject of this painting might be Jesus approaching his disciples on the Sea of Galilee (Matthew 14:25–6), when he appears to them walking on the water and they do not recognize him, thinking he is a ghost.[50] But there is nothing in the image or in the documentary record to confirm such a reading. More to the point, the image operates like a riff in jazz, shapes and forms rhyming with one another, repeating and varying one another until anything recognizable fades into diffuse color and brushwork that spread over the surface of the canvas and nearly forget the descriptive purpose they once had. The "inner necessity" driving Kandinsky's visual play is a kind of stream of consciousness that engages in a playful metamorphosis with water, boat, oars, figure, landscape until it is on the verge of pure ornament. Abstraction, the painting makes clear, is a process of dematerialization that engages both play and the intrinsic characteristics of the medium. Inner necessity is a creative logic that indulges the subjectivity of maker and viewer, but does so by dismantling the sureness of an objective world in order to set loose the creative possibilities of resonance, riffing, free association, and metamorphosis. For Kandinsky, this was the opposite of materialism. It was the spiritual in art.[51]

## ABSTRACTION AND THE SUBLIME IN POSTWAR AMERICA

The narrative of the engagement of religion and modern art is far more varied and complex than one chapter can convey. I am selecting for consideration a single strand of artistic developments, in part for the cultural capital that strand has commanded as representative of the canon of the avant-garde. But there are others and I can do no more here than cite a few of them.[52]

FIGURE 58

Barnett Newman, *Stations of the Cross*, 1958–66, magna and oil on canvas. Installation photograph from *The Robert and Jane Meyerhoff Collection: 1945–1995*, on view at the National Gallery of Art, March 31–July 21, 1996. Courtesy of National Gallery of Art, Washington, Gallery Archives / Artists Rights Society (ARS), New York.

What might be called the two characters of German Expressionism, represented by the lyrical resonance of Kandinsky and Franz Marc, on the one hand, and the raw brutality of Ernst Ludwig Kirchner and Georg Grosz, on the other, achieved a momentary integration in the work of some mid-century American painters like Mark Rothko, Barnett Newman, and Jackson Pollock. Religious themes sometimes appear in their work—as in Rothko's Chapel in Houston, in Pollock's mythic imagery, and in Newman's *Stations of the Cross* (figure 58). The synthesis of the two faces of German Expressionism occurred when the legacy of Kandinsky was masculinized and invigorated. Abstraction came to encompass both the desire for raw emotion—treated in the vigorous application of paint among artists such as Pollock and De Kooning—and a longing for monumental scale, mythic grandeur, the majesty of the immemorial in Newman and Rothko, among others. For these so-called Abstract Expressionists, European painting had failed. De Kooning dismissed Kandinsky's understanding of artistic form as offering "a kind of Middle-European idea of Buddhism, or, anyhow, something too theosophic for me."[53] Newman looked to Native American art for the precedent to contemporary American work, and in doing so sounded the familiar tone of masculinization. In a statement that Newman authored for an exhibition he organized around the theme "The Ideographic Picture," he

compared contemporary abstract painters to the hide painter among the Kwakiutl, Native Americans on the Northwest coast: "The abstract shape he used, his entire plastic language, was directed by a ritualistic will toward metaphysical understanding. The everyday realities he left to the toymakers; the pleasant play of nonobjective pattern, to the women basket weavers. To him a shape was a living thing, a vehicle for an abstract thought-complex, a carrier of the awesome feelings he felt before the terror of the unknowable."[54] In an influential early work on the beautiful and the sublime (1757), Edmund Burke had gendered the beautiful as female and the sublime as male.[55] Newman clearly regarded the sublime as masculine and as the proper aesthetic aim for American artists of his day.

Newman saw American painting as emerging to command the field in lieu of the long dominance of Europe. European art and aesthetics, he claimed, had been preoccupied with the idea of beauty inherited from ancient Greece. The "natural desire in the arts to express [humankind's] relation to the Absolute" had become confused with the quest for perfect form, or beauty.[56] Inspired by Burke, Newman regarded the history of art as the history of struggle between the sublime and the beautiful, the masculine versus the feminine.[57] Newman insisted that European art had failed to achieve the sublime because it never severed its relationship to the Renaissance ideal of beauty in the human figure. Whereas late medieval Christianity had achieved a "Gothic ecstasy over the [Christ] legend's evocation of the Absolute," Renaissance art had revived the Greek figurative ideal of "eloquent nudity" and consigned subsequent art on the continent to the aesthetic of beauty. Only now, in the triumphal age of the postwar United States, could matters shift in favor of the sublime: "I believe that here in America, some of us, free from the weight of European culture, are finding the answer, by completely denying that art has any concern with the problem of beauty and where to find it. The question that now arises is how, if we are living in a time without a legend or mythos that can be called sublime, if we refuse to admit any exaltation in pure relations, if we refuse to live in the abstract, how can we be creating a sublime art?"[58] Newman ended his short statement by answering the question he posed, pressing his contemporaries to transcend history, even as American art would complete modern art's quest to destroy beauty:

> We are reasserting man's natural desire for the exalted, for a concern with our relationship to the absolute emotions. We do not need the absolute props of an outmoded and antiquated legend. We are creating images whose reality is self-evident and which are devoid of the props and crutches that evoke associations with outmoded images, both sublime and beautiful. We are freeing ourselves of the impediments of memory, association, nostalgia, legend, myth, or what have you, that have been the devices of Western European painting. Instead of making cathedrals out of Christ, man, or "life," we are making it out of ourselves, out of our own feelings. The image we produce is the self-evident one of revelation, real and concrete, that can be understood by anyone who will look at it without the nostalgic glasses of history.[59]

The outmoded legend was of course Christianity, and its props, the art and aesthetic of beauty. Yet Newman himself drew on that very legend in his *Stations of the Cross*. No figure, no signs of splendor or grace or ornament grounded in the Renaissance tradition of figural beauty are visible in the stark series of canvases, whose minimalism is so extreme that the paintings cannot be thought of as distillations of the subject nor as an abstract cinema progressing toward Jesus's death on the cross. If the traditional stations mark the pious viewer's pensive march toward Calvary on Good Friday during Holy Week, modeled on the pilgrim's trek along the Via Dolorosa in Jerusalem, what may be said of Newman's canvases lining the walls of an art gallery (see figure 58)? They surround the viewer and enact a decisive denial: this is not about beauty. But neither is the death of Jesus in the theologies that foreground his suffering. His agony is a meeting point, a dark, empathic encounter with those who share failure and pain with him. Newman's series may be a proposal for transcending the figurative fetish of artistic beauty, exchanging it for a new visual language suited to ineffability. The life-sized canvases replace the body of Jesus making his weary way to death, substituting in his stead a grim vocabulary of life-sized compositions whose black tone and linear austerity, whose raw canvas and looming silence direct the viewer toward that which cannot be embodied. The severe rhetoric of the images urges the viewer not to turn these compositions into symbols or bodies or allegories, but to struggle with their difficulty and to experience in doing so the incommensurate stature of a human life in the face of what Newman called only "the Absolute."

Yet the *Stations* do not leave one wafting in a sublime ether of void, or Void. The Other they evoke is not God, at least, not according to the artist. He commented that he "tried to make the title [of the *Stations*] a metaphor that describes my feeling when I did the paintings. It's not literal, but a cue. In my work, each station was a meaningful state in my own—the artist's—life. It is an expression of how I worked. I was a pilgrim as I painted."[60] The comment recalls the Romantic *Geist* and its evolution toward consciousness, portrayed by Hegel as the history of art. *Stations of the Cross* therefore might be regarded as the long trek or pilgrimage of the artist engaged in a creative journey of self-creation. This is not a therapeutic self-actualization, but the quest or errand of the modern autonomous self. Newman told the magazine *ARTnews* that *Stations* was not commissioned by any church: "They are not in the conventional sense 'church' art. But they do concern themselves with the Passion as I feel and understand it; and what is even more significant for me, they can exist without a church."[61] One reason they don't need a church is because their exhibition together in a single gallery space takes the place of a church interior. *Stations* may have appealed to those Americans at mid-century who felt liberated from a determinative past and looked to themselves to create their national future. Art and the art gallery became the venue for engaging in the culture of the autonomous self, the subjectivity fully realized as the spirit unfolding in America's coming of age. The result, as Newman put it, was a "revelation" and the source material was "our own feelings." Nationhood, progress, pilgrimage, imagination, and subjectivity intermingle in the mid-century American aesthetic of the sublime.

And yet, Newman kept a Jewish frame around the project. When asked what his aesthetic was and how it might offer guidance for understanding his art, he replied, "My entire aesthetic can be found in the Passover service. At the Passover seder, which was also Jesus's last meal, the blessing is always made to distinguish between the profane and the sacred: 'Blessed be thou, O Lord, who distinguishes between what is holy and what is not holy.'"[62] The ritual meal of Passover is the place where holiness happens. On the same occasion, Newman remarked that "to my mind the basic issue of a work of art . . . is first and foremost for it to create a sense of place, so that the artist and the beholder will know where they are."[63] This is perhaps just what he intended to do with *Stations,* which were to be exhibited together in the nonreligious space of an art gallery. Their unity mattered to him: "The Passion is not a protest but a declaration. I had to explore its emotional complexity. That is, each painting is total and complete by itself, yet only the fourteen together make clear the wholeness of the single event."[64]

## CONTEMPORARY ART AND RELIGION

Newman's remarks implied that modern American art would be spiritual without being explicitly religious. It is certainly true that many artists have embraced what can be called a "spiritual" approach to art.[65] Yet there is no shortage of religious, biblical, and explicitly Christian iconography and subject-matter in the work of some of the most celebrated and internationally recognized artists in the late twentieth century.[66] However, the religious themes and motifs are often used with a sense of irony and social commentary that sharply distinguishes such work from anything usually created for an explicitly religious purpose.[67] There is clearly a break between the worlds of modern fine art and modern religion. Yet the boundary is uneven and in some cases not as clear as many in the art world would like to believe. Critics and theorists have a difficult time with the relationship, but some artists appear to have less of a problem with it.[68] Why should there be a deep tension between the worlds of art and religion in the modern age? Disinterestedness certainly introduced a secularizing tendency, although there are spiritual versions of dispassionate contemplation sometimes characterized as forms of detachment. But religion is something different. Religious imagery is made for purposes that modern art has no use for. Religious art often is devoted to beauty, and beauty as traditionally defined has been less important than other goals for many modern artists.[69]

But even when it is not about beauty, contemporary religious art serves a purpose that the art world finds despicable, likely for two very different reasons. In the first case, many insist that art should cultivate a radical critique of traditional values, which are often integral to the pious art displayed in churches. And second, for those who have insisted that art for art's sake is the ideal, art is not supposed to have a purpose beyond itself, that is, beyond its own interest in artistic problems. Participation in the art world relies on taste, understood as a sensuous knowledge of allusions and references to works of art, organized in a genealogy of styles, personalities, content, and technical innovations.

Thinking and feeling in the discourse on art works in different idioms—producer, connoisseur/collector, historian/critic, aficionado, and casual or "cocktail conversant." All of these, regardless of the intricacy of their understanding, are formed around the linear structure of the genealogy because art is a fashion system stretching from old to new, predecessor to present, follower to original, convention to innovation. This system is why art and religion are not identical and often conflict with one another. Conventional religious worlds have little to do with the art world's fashion system. Faith and religious authority are not among the criteria for effectively performing the discourse's idioms, on the one hand, or delivering a proper political critique of bourgeois values, on the other.

Taste cultures are driven by criteria that matter very much to their practitioners. Age, class, ethnicity, race, gender, sexuality, religion, political leaning, education—whatever characterizes the group readily becomes integral to its style, the shared features of dress, cuisine, lifestyle, entertainment, or art that set the group apart. If faith, rather than opposition to social conventions, drives artistic taste, taste is no longer experienced as sovereign, no longer the organizing element of activity. Connoisseurship, the process of making informed distinctions about taste, is undermined as a political act. Critical acumen is compromised as a free act because participants in the discourse make judgments using "extraneous" normative guidelines. The art connoisseur distinguishes "good art" from "bad art" by judging it according to a repository of examples and a genealogy of good and bad predecessors. The faith connoisseur distinguishes "good art" from "bad art" on the basis of moral criteria, liturgical function, devotional appeal, or the relevance of its subject matter to religious narrative or scripture. Clearly, the two are relying on widely variant criteria. They serve different ends. Religious art must satisfy the norms of faith; secular art committed to progressive or to radical political ideals must conduce to political change or revolution. For example, it must promote freedom of sexual expression, the end of capitalist hegemony, or opposition to authoritarian politics. But is it possible that certain kinds of religious art might embrace radical values of transformation of the social order and thereby count as "good art" according to the criteria of secular art?

James Elkins has asserted that this is not possible: "As a rule: ambitious, successful contemporary fine art is thoroughly nonreligious."[70] Why? Because artistic quality is generated by the internal criteria of fine art, as well as by the artist's efforts to identify problems within the medium and within the history of the medium's treatment by other artists. Faith violates the integrity of that project. "Art that sets out to convey spiritual values," Elkins asserts, "goes against the grain of the history of modernism."[71] That means that when artists like Kandinsky and Piet Mondrian praise theosophical and mystical ideas, their opinions are best ignored in favor of their progressive abstract art. The genealogy of good art is not a repository of "spiritual values," but the curated record of recognized problems or topoi of artistic performance. When believers laud the power or effect of a religious painting as moving, it is unlikely that they are responding to the artist's work solely within the sanctioned archive of the medium. They are probably registering how that painting moves their religious sensibility, that is, how the truth of their

religion is affirmed by a particular characteristic of the work. By contrast, it would seem that when an art critic or other art world denizen is moved, it is not toward religious conviction nor is it fueled by religious values or by membership in a religious community. Artistic taste does not need to avail itself of those in order to render judgments that will be readily affirmed by other informed viewers, even if they exercise different preferences of taste.

And yet Elkins's claim seems overdrawn, even if we consider only art from the late nineteenth century to the present. As Bernard Berenson and Arthur Schopenhauer show, there is no reason that experiencing art cannot be a spiritual or mystical experience. And as we saw, Barnett Newman framed his aesthetic ideal and artistic aims within an affirmation of his own Jewishness. But it is difficult not to sense some ambivalence in Newman. Did he assert his Jewish identity in order to parry the suspicion of art critics that he was making Christian art? Certainly religious believers can acquire and practice informed artistic taste and apply it to works of art that involve religious subject matter. But many will feel that art that sets out to promote a political, religious, or moral issue runs the risk of becoming propaganda. Perhaps the artist who believes, but makes successful art, is one who splits his or her consciousness, behaving as an artist in one world and a believer in another.

If so, that suggests there is not, strictly speaking, a purely aesthetic mode of judgment to attain. Rather than purging oneself of all matters of politics, faith, morality, class, and social identity in order to render artistic judgment, one must instead practice compartmentalizing. The ideal of disinterestedness works only in the sealed space of what might be called "the art game." Schiller's concept of aesthetic freedom prepared the way for this experience of subjectivity in art. This domain of experience operates with a sovereignty of its own. Thus, Goethe once called the opera "a little world," and one begins to understand why. "When the opera is good," he wrote, "it freely makes for us a little world unto itself, in which all things proceed according to certain laws, will be judged according to their own rules, experienced for their own properties."[72] This quest for formal integrity, for inner or organic unity persists today—indeed, it may constitute the arch principle of modern art. James Elkins contends that the art world derives its power from focusing both on the history of a medium's treatment and on the genealogy of a discourse's chosen problems, thus forming a capacity for judgment or taste that participants develop by attending to art and its discourses. Moreover, it is a social world structured by gatekeeping mechanisms that reward certain performances and disallow others. Those who profess religion as a principal aspect of their art are far less likely to exhibit in the most important exhibitions, be collected by the most elite collectors, or be handled by the most prestigious dealers. Art critics will tend to ignore them, the best museums will be less inclined to collect or show them. The art world plays by a different set of rules. Having religion does not count among the criteria for valuing great art in the modern era.

It is certainly true that the enclave of the art world focuses intently on its own history and discursive norms: artists tend to make art about art. As a result, the art world readily

produces the dream that it operates within a neutral space of pure judgment, the domain of the exercise of taste, unbound from controlling ideologies like religion or the state. But the ideal of art for art's sake is commonly compromised for the sake of whatever values of the day have come to matter to art world denizens. The real issue, it seems to me, is what interpretive community the viewer wishes to belong to when regarding a work of art. Judgments of taste will follow that commitment. In the end, taste is not as sovereign or autonomous as art lovers would like to imagine: they repress, over-determine, and project what they want or do not want to see.

In fact, artists remain very interested in religious motifs, myths, rituals, and symbols. In particular, many important artists have made use of biblical themes and Christian subjects. One thinks, for instance, of works such as Andy Warhol's late series of paintings of the *Last Supper*, 1985–86; Andreas Serrano's *Piss Christ*, 1987; Kiki Smith's female saint figures such as *Virgin Mary*, 1992, and *Mary Magdalene*, 1994; Chris Ofili's, *The Holy Virgin Mary*, 1996; Anselm Kiefer's, *Cain and Abel*, 2006; and a number of video installations by Bill Viola, dating from the 1980s to the present and including *Room for Saint John of the Cross*, 1983, or *The Greeting*, 1995, based on a Renaissance painting of the New Testament theme of the Visitation. Some of these works were launched into stardom by controversy concerning conservative political opposition (Serrano and Ofili); some are instances of artists using themes with no discernible attempt to affirm any religious claim (Smith, Warhol, Kiefer). But perhaps others, such as Viola, use religious imagery because its sacred, mythic, or ritualistic character enables it to deliver impact, plumb depths of feeling, and spawn self-reflection. Some viewers take exception to that genre of use. Art critic Thierry de Duve observed that "when I deal with art that comes from a culture where faith or belief seems to be still functioning, I don't have the wincing reaction I have to Andres Serrano, for example, or Bill Viola."[73] For this critic, the arch boundary separating the art world from a religious world is violated by artists who seem to him to insist that the viewer share their spiritual disposition.

The sociological outline that I have offered in this chapter suggests that there is a clear and significant difference between work that wrestles with a religious theme and work that seeks to preach a message to viewers, compelling their assent. But for De Duve, the operative distinction is between a secular culture where religion no longer exists and one that remains religious. Presumably, as long as he is a visitor in the latter world, he can stomach the religion. But in his own modern, Western society, where religion is supposed to be properly defunct, there can be no hesitation in rejecting the work of artists who take religion as a matter of faith in their art, since its presence can only mean they wish to force it upon their viewers.

Perhaps matters are not so simple as that. Religion did not die in the West. The two worlds of art and religion, as different as they may seem to many of their respective inhabitants, are not so sharply sealed off from one another. Working with religious themes and the tug of their appeal when provocatively engaged in art is very subtle and powerfully seductive. If it were not so, many artists probably wouldn't be interested in

religion. We can see the intricate intertwining of art and religion in a recent work by Viola, *Ocean without a Shore* (plate 12), a video installation first presented at the Venice Biennale in 2007. Viola chose to stage the piece in the deconsecrated Renaissance church of San Gallo. The choice was not random, given that the work is about the dead and their haunting proximity to the living. Viola achieved this spectacle by mounting video screens on three altars. Pictured on the screens were figures he'd filmed moving from darkness into bright light as they passed through a thin sheet of falling water. The result is captivating and eerie. Viola operates in the art world, to which he brings questions shaped by reflection on many different religious traditions. But he is not creating his work intentionally for a religious community. His art is not about Christianity or Buddhism per se, nor is it made for the edification of church or sangha, though he would no doubt be happy if Christians, Buddhists, and others were able to connect with his treatment of myth, ritual, and spiritually moving ordeals like dying and mourning. Viola addresses the art world, but uses visual vocabularies and aesthetic sensibilities that draw from religious traditions.

*Ocean without a Shore* was inspired by a poem by Senegalese poet and storyteller Birago Diop. The poem was about, in Viola's words: "the spiritual as center of our lives and the idea of bringing it back to the domain of the self."[74] In a statement about the work in 2007, he wrote:

> *Ocean Without a Shore* is about the presence of the dead in our lives. The three stone altars in the church of San Gallo become portals for the passage of the dead to and from our world. Presented as a series of encounters at the intersection between life and death, the video sequence documents a succession of individuals slowly approaching out of darkness and moving into the light. Each person must then break through an invisible threshold of water and light in order to pass into the physical world. Once incarnate however, all beings realise that their presence is finite and so they must eventually turn away from material existence to return from where they came. The cycle repeats without end.[75]

Religion, literature, poetry, mythology, dream, ritual, and sacred art all share the use of motifs that address experiences of tragedy, rapture, ecstasy, loss, transformation, illumination. The list goes on. The artist's autobiographical statement on his website states the range of influences and interests in his art: "His works focus on universal human experiences—birth, death, the unfolding of consciousness—and have roots in both Eastern and Western art as well as spiritual traditions, including Zen Buddhism, Islamic Sufism, and Christian mysticism. Using the inner language of subjective thoughts and collective memories, his videos communicate to a wide audience, allowing viewers to experience the work directly, and in their own personal way."[76] Viola took the title of this piece from the Sufi mystic and philosopher Ibn al'Arabi (1165–1240), who wrote "The Self is an ocean without a shore. Gazing upon it has no beginning or end, in this world and the next."[77] For Viola, subjectivity unfolds to infinity, where the self may intermingle

with the divine. And he looks to the work of art to launch a quest, which is what some viewers adore about his work and what others find unbearable. *Ocean without a Shore* posits a thin membrane separating life and death; the wall of water through which figures slowly pass is the medium of the spectral encounter of the living and the dead. It recalls a Catholic sensibility we have noted in chapter 1: the next world is not far off, but poignantly near. Memory, elegy, funeral, portrait painting, letter, or a rustle in the wind can make us aware of those we've lost. There is solace in the prospect of recovering them in an act of memory, and comfort matters to the artist in this piece. Viola mentioned in an interview that after his father died, preceded a few years by his mother, he struggled with the feeling of being orphaned. But instead of resorting to religion for the spiritual care or therapy it might provide, the artist remarked "I turned to my art to find not only comfort and meaning, but also to keep moving, keep going forward and keep searching."[78] The result was *Emergence*, 2002, a video of a nude young male, a Christ-figure, arising from a sarcophagus bearing the sign of the Cross, embraced by the guiding arms of two women, surely meant to allude to the Marys who were reported in the New Testament to have gone to the tomb of Jesus on Easter morning. Five years later, *Ocean without a Shore* enacts a liminal experience of resurrection, a kind of somatic memory that resists the mortality of the self.

Metaphor and mythic allusion abound in Viola's art as he stages sublime moments, numinous passages intended to lift viewers from the smallness of their busy lives and whisk them away to the hoary heights of myth, where they may ponder in the sensations of their flesh what Newman called their "relation to the Absolute." Is this mystification? Seen from within the opaque walls of the art world, it may appear so. But seen from the world of soaring cantatas, thundering choirs, looming vaults, and mystical rites, it may do the job—at least for those whose sense of religion is strong enough to welcome the poetic resonance, or mild enough to appreciate the theatrical propping. In Venice, Viola brought art back to the church, literally. But couched in the cathedral of the self, which knows no boundaries, there is little reason for art to stay in the church. It would seem that religion and art are partners in search of something deeper, more mysterious, something that neither one is fully equipped to grasp by itself. The two worlds are not simply separate, they are each incomplete, and so they seek out one another. For Viola and many others, art and religion are collaborators in the project of being human.

# CONCLUSION

From the sixteenth century to the first half of the twentieth, the Catholic tradition—by which I have meant both the official hierarchy of the church and the laity—has consistently regarded the holy as seen and felt, that is, as a material continuity between this world and the other, which is very close, looming within earshot, a mere step away. The next world is not only "hereafter," as Protestants like to think, given as they are to temporal distinctions rather than robustly spatial ones: for Catholics, the "next" world is closely connected to the present. It is near enough for the blessed dead to be able to glimpse each devotional gesture of the faithful, to hear each plaintive sigh, to smell the incense of the Mass. This proximity presents the holy in the shape of a matrix characterized by hierarchy, in echelons moving upward and downward (as the official church practices it), and in relationships (especially important in lay piety) that offer interface with the ecclesial and celestial hierarchies. This structure, it should be clear, fits both the nature of Catholic authority and the popular devotional mechanics of intercession. Moreover, images and sacramental objects are media in the system of exchange that organizes the cosmos into a towering spiritual architecture, ranging from frail mortality to the vaunted throne of God. Imagination becomes a powerful mode of animating this medium in the meditative act of introspection, of looking within to envision the scriptural narrative and the cosmic architecture. Watching it take shape within was part of a growing popularization of imagination as a devotional faculty during the Counterreformation, and was circulated globally by the missionary zeal of the Jesuits.

Protestants have often thought of their religious lives as purged of imagery and raised above idolatrous and ritualistic materialism into a spiritual or immaterial realm of pure

thought mediated only by scripture and prayer. Time is their medium of configuring the sacred. Rather than space, moments of time are the measure by which consciousness of the divine takes shape. And yet, as we have clearly seen, Protestants of almost every kind have from the beginning made avid use of images, particularly those deployed within the vehicle of the printed word. In chapter 2, I argued for the visibility of words as a form of sacred information. A map of the Protestant world of practice shows where Protestants concentrate their efforts and how they form the center of gravity that organizes their daily lives. There, in these zones of activity, we find images well at work. If images are often absent in sanctuaries, where the polemical difference from Catholicism was driven home by an abiding discourse against idolatry, they abound in those domains where the real DNA of Protestant communities is harbored and transmitted: in homes, schools, books, and in the evangelical moments of mission work and proselytism.

The second portion of the book turned to themes that capture much of the modernity of Western Christianity: the visual mediation of exchange (what I have called "economies of the sacred"), the power of words, the imagination of nationhood, visualizations of the likeness of Jesus, and the complex relationship between Christianity and modern art. To be sure, this is a short list that might be lengthened by including a number of other visual and material topics such as space, movement, soundscape, eating, dreaming, and dressing. It should be evident that I have not aimed at comprehensiveness, but rather at suggesting what materializing the study of Christianity might pursue.

Chapter 3 contended that we may narrate the history of modern Christianity in terms of rival forms of sacred economy. These are mediated in imagery, objects, and material practices that conduct exchanges, both between devotees and divine agencies and among the devout and others they encounter in daily life. I have wished to argue that the implications of these systems for the study of religion are considerable. What does this history of competing sacred economies tell us about the history of Christianity over the last six centuries? Perhaps a few points will clarify the value of such an approach, especially with reference to the study of the materiality of religion.

First, economies of the sacred are how religious groups distinguish themselves from one another. Religions select the representative features of a rival economy, such as image veneration, and engage in iconoclastic behavior to effect a symbolic destruction of the entire cultural system and make way for their alternative. Every economy of the sacred is built on the polemical rejection of a countereconomy. Second, by scrutinizing the operation of economies of the sacred we are able to discern how materiality serves to mediate religious practice. Economic systems rely on exchange and exchange relies on a medium to conduct transactions. Money is only one medium of exchange. Images and objects often mediate exchange between divine and human and are therefore the material site of the sacred. Third, because sacred economy is the trope by which many religious traditions conceptualize their interactions with divine realities, they are often at pains to distinguish sacred from profane economies. In describing the contentious yet fluid boundary between sacred and profane economies, we stand to learn a great deal

about the value of each, their respective domains, and the definitions of public, community, commonwealth, nation, kingdom, ruler, authority, and the powers that regulate social exchange. The intricacies of controlling spiritual capital contain much to be learned about the vexed relations among spiritual and secular authorities.

Fourth, conducting sacred economies, people deal with the problems of existential uncertainty and the endless succession of human needs. Negotiating with saints and the gods is an attempt to rationalize scarcity and regulate access to spiritual resources and material favors. Sacred economies, in other words, reveal much about the lived character of religions. Fifth and finally, economies of the sacred organize and express the relations of believers to one another, marking their duties and stations in the flow of capital in one direction or another. Charity, alms, donations, gifts, and all forms of social benevolence stratify society, delineating the surfaces and boundaries of social bodies and revealing characteristic structures that form the anatomies of human worlds. There is everything to learn about the valuation of the self and social agency in studying the cultural marketplace of belief.

Chapter 4 examined the agency of one of the most ubiquitous, powerful, and authoritative bearers of reality in the modern world: printed words. Speaking is nothing new, but printing speech in the visual form of words or graphic signifiers certainly is in the history of the West. Modernity is inconceivable without the printing press. Everything we call "modern"—science, education, industry, technology, nationhood, capitalism and monetary finance, and all media since the fifteenth century—has thrived in symbiosis with the practice of printing. As modern phenomena, Protestantism and Catholicism have given print culture much of its traction just as print has mediated them for an era of new forms of production, circulation, and consumption. Of considerable influence is the way that Protestantism deployed the printed text of the Bible in order to recover and interpret the spoken language of revelation, that is, the world, people, narratives that embodied divine speech. The plain sense of scripture, Protestant divines argued repeatedly, portrays in the divinely inspired words of the text the actual events that were themselves authored by divine will. This view led to a new emphasis on the printed textuality of scripture, made available for the devout to read for themselves. As a consequence, speech became visible and paper talked. Words exercised new forms of agency that institutional authority had to accommodate. Among other things, this resulted in the particularly fractious, sectarian legacy of Protestantism. That shift in power helped the sovereign nation-state to arise and endorsed new practices and aims of education and literacy. In chapter 4 I tried to sketch the long, meandering assemblage of cultural politics, nationhood, collaborations, temporalities, and imagined communities that took shape in the medium of printed paper to envision the world as a new and characteristically modern Christendom. If we are to understand the power of words in modern Christianity, print is the ecology that enables them.

Nationhood or nationality is so second nature to moderns that it is virtually the air they breathe. The world, they easily presume, falls naturally into the shape of nations.

And these nations each tend to be composed of a single dominant religion as well as a single language and a unifying political system. These are the ingredients of nationhood. Nations tend not to last very long without them—or at least that is the assumption of those whose religion, language, and control of the political system gives them power and an almost ineluctable sense of destiny. Their nation, they come to believe, was *meant to be* the way they imagine it. One of the pervasive new religions of the modern age is nationalism, which is intricately entwined with traditional religions such as Christianity, Islam, Hinduism, or Buddhism. I have tried to show how this has operated in modern Western Christianity by focusing on the cases of Great Britain and the United States as forms of imagined community.

The problem with imagined community, however, is that it is never as durable as it seems. Americans uncomfortably realize the actual contingency of nationhood in every explosive episode of their unfinished national experiment, as for example when legal battles erupt over the question of the nation's proper heritage. In Boston in 2013, a family took a public school to court, arguing that the words "under God" in the Pledge of Allegiance violated the Equal Rights Amendment to the Massachusetts state constitution and presented a form of discrimination.[1] In 2003 a state Supreme Court chief justice in Alabama was relieved of his post as chief justice when he refused to remove a five-thousand pound sculpture of the Ten Commandments, which he had had placed in the federal court building in Montgomery. While many around the country applauded his departure from the bench, perhaps just as many lauded the judge and his "rock" when he loaded the hefty monument to the biblical heritage of America onto a semitrailer and took it on the road.[2] People on both sides of the First Amendment would like to believe that it is quite clear that the Constitution protects the religious character of the nation, or the freedom of nonbelievers and other-believers from the tyranny of the Christian majority. But ambivalence was the best the founding generation could achieve. And that may not be so bad since it ensures the opportunity to contend. In jurisprudence, the occasion to argue is the prospect to hope.

Beyond the American story, the logic of nationhood has helped shift the gravitational field of Christendom to what has come to be called the Global South and Global East. Neonationalism has enabled former colonies to emerge, since the Second World War, as autonomous dominions that have often relied on religion to help shape their national identities. Having been deposited around the world during the long era of colonialism, Christianity has taken root in many of these "new" nations and has grown, in contrast to the demographic decline of the religion in Europe and to its plateauing in North America, formerly the religion's two strong zones on the global stage. Christianity's story is not over, but its future will not strongly resemble its recent geographical past. That is hardly a surprise when we look at the longer narrative of the religion since its origin. Christianity has always been on the move. But the shift is no doubt surprising and disconcerting to many in America who sit at the close of an age, fighting as the Cold War words of their beloved Pledge of Allegiance, with its promise of one nation "under God," are gradually whittled away.

Chapter 6 took up the supremely visual topic of the likeness of Jesus. Shimmering in each head of every missionary sailing the high seas and every native convert to the new religion was an image of Jesus, founder and deity, savior and friend. Jesus has always had a look, at least since the days of catacombs and cameos. But in the modern world, his look came to be the portrait of a personality, the image of a man who wanted something—to be loved, honored, befriended, and emulated. He was not just a hero or a man of high station, not a vaunted god or the occupant of cosmic liturgical office. He was a particular person, a man whose eye and ear the devotee expected to catch because he was an entirely sympathetic sort of fellow. I tried in this chapter to explore the intricate psychology of likeness and its social functions and cultural politics. Protestant and Catholic polemicists are sometimes fond of denouncing as "kitsch" the popular images of Jesus that dominate the market and popular piety. But this accommodation of Jesus to personal interests is not only the habit of lay devotion. In his landmark piece of scholarship, *The Quest of the Historical Jesus* (1906), Albert Schweitzer noted that "each successive epoch of theology found its own thoughts in Jesus; that was, indeed, the only way in which it could make Him live. But it was not only each epoch that found its reflection in Jesus; each individual [scholar] created Him in accordance with his own character."[3] Intellectuals, no less than lay devotees, see in the blank canvas of the historical Jesus what they want to find there. The man himself was gone, Schweitzer concluded, and all that was left in his place was the Christ of faith. But this leaves plenty of room for imagining the likeness of Jesus. Indeed, it reinforces the quest for the face of Jesus as the discovery of the face the faithful already know. Each time believers encounter a picture of Jesus that is compelling, it is an experience of recognition. They see the man who turns out to be the man who was looking for them. Imagination is the medium of this encounter no less than the picture itself. Modernity is a dense visual culture, one from which there may be no egress. Images are already everywhere, mass-produced and thickly imbricated with those they erase and redeploy. Imagination is a kind of retroactive operation of finding what has been projected there to be found.

Or maybe not. The mystics and spiritual rebels, adventurers and artists of today are often staunchly iconoclastic. They revel in rigorously interrogating the imagination. In the final chapter we saw Wassily Kandinsky and Barnett Newman proclaim the power of abstraction to break through the surfaces of mere appearances in response to what Kandinsky called "inner necessity" and what Newman described as the existential quest for "absolute emotions." But artists before and after them also believed in the power of art to penetrate to the depth of feeling where an authenticity lost to modern religion, morality, and respectability was anchored. To do so, religious motifs remained quite useful. Delacroix and Gauguin each selected the dark moment of Jesus's despair in the Garden of Gethsemane as the moment for their artistic exploration of intense feeling (see figures 55 and 57). And the clearly religious motifs of mourning and resurrection occupy Bill Viola's video evocations of high pathos (see plate 12).

It is difficult, even impossible to say if these artists are religious or if they are using Christian motifs as pretexts for their work. But their personal beliefs about religious

matters are not of primary importance since the relevance of religion for their work is better measured in how it changes or contributes to the work, and whether it makes a difference in the work's reception, popular no less than critical. My interest has been to describe the complex terrain of social worlds that constitutes the landscape of modernity. The art world, I have wanted to suggest, is a social phenomenon that internalizes and generates a definition of "art" that makes important use of religion, while operating socially as a distinct world.

Yet as discrete as the two worlds are in theory, in practice they commonly overlap. Artists find the emotional power of religion irresistible. Art maps itself over the human experience that religion has long charted, drawing on religion to identify key moments or passages for the evocation of feeling and meaning, though it often does so without attending in detail, or at all, to the institutional structures of religion. Indeed, artists are often quite happy to scorn such conventions of authority. Iconoclasm is a common feature of modern art, and what makes a better eye to poke or image to shatter than the traditional authority of the church? This suggests a fascinating parasitic relation between art and religion. Artists sometimes want religion as the occasion for their work. Often this does not mean they want to convert, but rather that religion consists of a world of values they regard as objectionable. Or that they find religion takes human experiences seriously. They may admire the epic grandeur, the tragedy, the solemnity, dignity, or pathos of religion and want their art to emulate it. It seems a stretch to accuse Barnett Newman of toying with conversion to Christianity as he worked for many years on his *Stations of the Cross* (see figure 58). What he seems to have responded to was the enviable seriousness of the Passion of Christ as a subject matter, as the occasion for thinking deeply and monumentally about what art might do. Art and religion have a way of finding one another, not as long-lost partners but as cultural practices that compete, collaborate, and intersect. Both artist and evangelist rely on engaging participants in the modern marketplace of culture. We would be surprised indeed if art and religion did not borrow from one another in this regard.

The complexity of the relation of art and religion in the modern era comes fully into view when we realize that art is not so autonomous as Kantian aesthetics would like to imagine. There is a logic within modernity that wants to distinguish art, religion, science, morality, and politics as autonomous or sovereign domains. The more accurate description might be that in modernity these and many other human activities want to be sovereign in order to be free, liberated of the authority so decried by Enlightenment. The Kantian distinction, by contrast, suggests that each has its own modus operandi, its rightful logic, purview, and content, and should not, therefore, be subjugated to another domain. Each realm includes activities flowing from the inalienable rights of humankind: life, liberty, and the pursuit of happiness, as the Declaration of Independence, arch document of Enlightenment, put it. Recognizing their difference, this line of thinking goes, ensures the freedom of each. As a result, religion is recast as private opinion, or belief. Morality becomes the exercise of individual right balanced against social

constraints. Art becomes the exercise of disinterested taste. Science is the pursuit of pure knowledge, knowledge for its own sake. Politics is the exercise of representative power.

Yet it is undeniable that none of these activities is content to remain within the bounds of its respective domain. Religion often wants to dictate morality, using the state to legislate and enforce its will, for example, to outlaw art that violates its norms of value, and to challenge the authority of science. Science, for its part, wants the state to fund its inquiry without meddling, and pushes against conventions of morality and religion when they inhibit its free exercise of inquiry. Politics would limit religion, but also use it whenever it is instrumentally advantageous to do so. Art wants to denounce state, morality, and religion for the limits they would set on freedom of expression. Recognizing these incursions is critical. As Talal Asad argued of the Kantian legacy at work in Clifford Geertz's separation of religion as an autonomously definable phenomenon, the isolation of religion from politics disables the critical analysis of power at work in religion.[4] We might say just the same of the isolation of art from politics or religion.

The consequence is a level of ambivalence that ardent secularists find intolerable and committed believers dismiss as an appropriation of toothless religion. But both extremes are obsessed with pressing their agendas and may therefore be less persuaded by the careful descriptions of historical and sociological analysis. Purity is not the analytical ideal that drives my interest in studying the history of modern Christianity. Indeed, I do not think that purity is something moderns are very good at in practice, though the rhetoric of purity abounds among ideologues of modernity, on one hand, and its fiercest opponents, on the other. To Kant, the purity of art, morality, science, and religion meant the recognition of their proper domains as the basis for modern, free, and enlightened life. But to Pius IX it meant the sharp rejection of modernity as a manifold violation of the mission of the Catholic Church, true Christianity, the ship of faith tossing in the stormy sea of blasphemy, schism, and unbelief. For this most antimodern of modern popes, democracy, individualism, nationhood, Bible reading, public education, and the inviolate conscience were the stuff of latter-day anarchy.

I would like to close with a thought from Bruno Latour's fascinating book *We Have Never Been Modern,* where he argues that modernity premises itself on a logic of stark division between modern and ancient, new and old. This, he says, means two things: "a break in the regular passage of time, and . . . a combat in which there are victors and vanquished."[5] In this view, time travels in a single direction, into the future; those who work with it win, while losers work against it. Progress is the right side of history, the crest of the wave called modernity, or better, modernism. The humanism that defined the nature of progress fixed on the uniqueness of humankind and set it off from everything nonhuman. According to Latour, the tendency toward purification contrasts with another characteristically modern habit—the mediation of opposites in hybrids.

Modernity, Latour's discussion would suggest, is not secular, progressive humanism, but an often befuddling fusion of religion, politics, and art.[6] The more that modern science, art, religion, politics, or morality separate themselves from one another in practices

of purification, reductively seeking their own essence and sovereignty, the more each of them inserts itself into the domain of the others, creating hybrids like "the religion of art" or "scientific morality" or "religious politics," with countless permutations. Following Latour, it may be that the best way for the socially minded scholar to respond is by carefully describing these hybrids and their participation in the elaborate assemblages of human and nonhuman actors that constitute "art," "religion," "artistic religion," or "religious art." Anxieties about their purity and impurity need to be included in the description, but not privileged. The resulting map will be messy, but perhaps the more suggestive or even compelling for being so.

Art and religion, it has become clear, parallel one another in the modern era, particularly in the role of subjectivity. Art posits the subjective apprehension of the work of art as the proper arena for aesthetic experience and the cultivation of taste, which takes place in a state called "disinterestedness," which strictly distinguishes between actual conditions and aesthetic representation. In like manner, religion has come to occupy the private sphere of individual consciousness, residing in an inner state called "belief," and has retreated from the public domain. But both of these conceptions are suspect. Art is surely not disinterested in any thorough way, and religion is about much more than private belief.

The subjectivities that modern history has hammered out on the forge of vision are not so easily parsed by the logic of irreducible cultural essences. Because it is robustly embodied, seeing is always interested, tending not to obey the boundaries of sovereign categories. Likewise, Christianity's encounter with modernity has been resistant and cooperative, happy and resentful, tragic and triumphant. The story is richer for this impurity and a challenge to anyone who prefers a homogeneous narrative.

# NOTES

## INTRODUCTION

1. Joannis Calvini, *Institutio Christianae religionis,* in *Opera Selecta,* eds. Petrus Barth and Guilelmus Niesel, 2nd rev. ed. (Munich: Chr. Kaiser, 1957), vol. 3, 96 (book 1, ch. 11, para. 8): *"Unde colligere licet, hominis ingenium perpetuam, ut ita loquar, esse idolorum fabricam."* (Thus we may infer that human ingenuity is, so to speak, a perpetual forge of idols.)

2. For an intellectual history of this critique of vision see Martin Jay, *Downcast Eyes: The Denigration of Vision in Twentieth-century French Thought* (Berkeley: University of California Press, 1993). For a series of critical reflections on visual culture as an all-encompassing membrane of insubstantial imagery, see "Visual Culture Questionnaire," *October* 77 (Summer 1996): 25–70. I have discussed the embodiment of vision at greater length in *The Embodied Eye: Religion, Visual Culture, and the Social Life of Feeling* (Berkeley: University of California Press, 2012), esp. 3–28.

3. Thomas Hobbes, *Leviathan,* ed. Edwin Curley (Indianapolis and Cambridge: Hackett Publishing Company, 1994), part 1, ch. 4, para. 6.

4. Francis Bacon, *Novum Organum,* in *The Physical and Metaphysical Works of Lord Bacon,* ed. Joseph Devey (London: George Bell and Sons, 1904), book 1, aphorism 10, p. 384.

5. Bacon, *Novum Organum,* book 1, aphorism 49, p. 393–94.

6. Bacon, *Novum Organum,* book 1, aphorism 23, p. 387.

7. David Hume, *The Natural History of Religion,* in *Principal Writings on Religion,* ed. J. C. A Gaskin (Oxford: Oxford University Press, 1993), 159.

8. Hume, *Natural History of Religion,* 160.

9. Hume, *Natural History of Religion,* 137.

10. Aristotle, *De Anima*, in *The Basic Works of Aristotle*, ed. Richard McKeon (New York: Random House, 1941), 595 (432a, 9).

11. Martin Luther, *Against the Heavenly Prophets in the Matter of Images and Sacraments*, in *Luther's Works*, ed. Conrad Bergendoff, vol. 40 (Saint Louis: Concordia Publishing House, 1958), 99.

12. Frances A. Yates, *The Art of Memory* (Chicago: University of Chicago Press, 1966), 229; on Ficino's conception of talismanic images and the Corpus Hermeticum see Yates, 154–56.

13. Saint Augustine, *Confessions*, trans. Henry Chadwick (Oxford: Oxford University Press, 1992), 190 (book 10, xii, 19).

14. Augustine, *Confessions*, 201 (book 10, xxxiv, 53). Compare to Plato, *Republic*, trans. G. M. A, Grube, rev. C. D. C. Reeve (Indianapolis: Hackett Publishing Co., 1992), 272–73 (book 10, 602); and to Plotinus, *The Enneads*, trans. Stephen MacKenna (London: Penguin, 1991), 410–11 (book 5, 8.1).

15. Anthony Ashley Cooper, Third Earl of Shaftesbury, *Characteristics*, treatise five, part 3, section 1, excerpted in Andrew Ashfield and Peter de Bolla, eds., *The Sublime: A Reader in British Eighteenth-Century Aesthetic Theory* (Cambridge: Cambridge University Press, 1996), 72–73.

16. Michel Foucault, "About the Beginning of the Hermeneutics of the Self," in *Religion and Culture*, ed. Jeremy R. Carrette (New York: Routledge, 1999), 158–81.

17. The origin of the claim remains debatable, but an early instance is a sermon by John Tillotson (1630–94), "A Discourse Against Transubstantiation," in *The Works of the Most Reverend Dr. John Tillotson, Lord Archbishop of Canterbury*, 3 vols. (London: Printed for J. and R. Tonson, 1752), vol. 1, p. 242: "And in all probability those common *juggling* words of *hocus-pocus*, are nothing else but a corruption of *hoc est corpus*, by way of ridiculous imitation of the priests of the church of Rome and their *trick* of *transubstantiation*." Emphasis in original.

**CHAPTER 1. THE SHAPE OF THE HOLY**

1. See for instance John Plummer and John Mabry, *Who Are the Independent Catholics? An Introduction to the Independent and Old Catholic Churches* (Berkeley: Apocryphile Press, 2006); and Robert Trisco, "The Holy See and the First 'Independent Catholic Church' in the United States," in *Studies in Catholic History in Honor of John Tracy Ellis*, eds. Nelson Minnich, Robert B. Eno, and Robert Trisco (Wilmington: Michael Glazier, 1985), 175–238. My thanks for Julie Byrne for her assistance with this bibliography.

2. *The Sources of Catholic Dogma*, trans. Roy J. Deferrari, from Henry Denzinger's *Enchiridion Symbolorum*, 30th ed. (Fitzwilliam, NH: Loreto Publications, 2002), 20.

3. See the fifth-century papal assertion of St. Gelasius I, in *Sources of Catholic Dogma*, 68.

4. Council of Ephesus, 431, quoted in *Sources of Catholic Dogma*, 49.

5. For relevant discussions of Our Lady of Guadalupe see Jeanette Favrot Peterson, *Visualizing Guadalupe: From Black Madonna to Queen of the Americas* (Austin: University of Texas Press, 2014), Clara Román-Odio, *Sacred Iconographies in Chicana Cultural Productions* (New York: Palgrave Macmillan, 2013); for an art historical approach that stresses

European influence in the image and contrasts this to pious accounts of the image's origin see John F. Moffitt, *Our Lady of Guadalupe: The Painting, the Legend, and the Reality* (Jefferson, NC: McFarland, 2006).

6. This is not to imply that Protestantism has pursued some sort of anticorporeal gnosticism, but to suggest that its understanding of embodiment is different than that of Catholicism. I have explored Protestant embodiment in *The Embodied Eye: Religious Visual Culture and the Social Life of Feeling* (Berkeley: University of California Press, 2012), chap. 7.

7. Council of Nicea II, 787, excerpted in *Sources of Catholic Dogma*, 121, para. 302.

8. Council of Constance, 1414–18, in *Sources of Catholic Dogma*, 217, para. 679; Council of Trent, 1545–63, in *Sources of Catholic Dogma*, 303, para. 998.

9. Council of Trent, 1559–65, in *Sources of Catholic Dogma*, 299, para. 986.

10. See Hans Belting, *Likeness and Presence: A History of the Image before the Era of Art*, trans. Edmund Jephcott (Chicago: University of Chicago Press, 1994), 57–59.

11. "Fourth Council of Constantinople," in *Decrees of the Ecumenical Councils*, ed. Norman P. Tanner, S.J., 2 vols. (London: Sheed and Ward, and Washington, DC: Georgetown University Press, 1990), vol. 1, 168.

12. Council of Trent, session 25, in Tanner, *Decrees*, vol. 2, 775.

13. Tanner, *Decrees*, vol. 2, 775–76.

14. Two insightful studies of this development in Catholicism are Marcia B. Hall and Tracy E. Cooper, eds., *The Sensuous In the Counter-Reformation Church* (Cambridge: Cambridge University Press, 2013) and Jeffrey Chipps Smith, *Sensuous Worship: Jesuits and the Art of the Early Catholic Reformation in Germany* (Princeton: Princeton University Press, 2002).

15. For further consideration of the face see Hagi Kenaan, *The Ethics of Visuality: Levinas and the Contemporary Gaze,* trans. Batya Stein (London: I.B. Tauris, 2013); Stephen Pattison, *Saving Face: Enfacement, Shame, Theology* (Burlington, VT: Ashgate, 2013); and Morgan, *Embodied Eye*, 89–97.

16. Saint Bonaventura, *The Life of Saint Francis* (London: J. M. Dent, 1904), 138.

17. Bonaventura, *Life of Saint Francis* , 139.

18. Bonaventura, *Life of Saint Francis,* 139.

19. Roman Council, 993, in *Sources of Catholic Dogma*, 140, para. 342.

20. Patrick J. Geary, *Furta Sacra: Thefts of Relics in the Central Middle Ages* (Princeton: Princeton University Press, 1978).

21. Council of Trent, in *Sources of Catholic Dogma*, 303, para. 998.

22. "Fourth Council of Constantinople," in Tanner, *Decrees*, 1: 168.

23. See Robert A. Orsi, *The Madonna of 115th Street: Faith and Community in Italian Harlem, 1880–1950* (New Haven: Yale University Press, 1985); Jon P. Mitchell, "Performing Statues," in *Religion and Material Culture: The Matter of Belief,* ed. David Morgan (London: Routledge, 2010), 262–76.

24. On the Jesuit use of theater, see Friedrich Kittler, *Optical Media: Berlin Lectures 1999,* trans. Anthony Enns (Cambridge: Polity Press, 2010), 76–88.

25. See Jane Garnett and Gervase Rosser, *Spectacular Miracles: Transforming Images in Italy from the Renaissance to the Present* (London: Reaktion, 2013), esp. 161–89; David

Freedberg, *The Power of Images: Studies in the History and Theory of Response* (Chicago: University of Chicago Press, 1989); and William A. Christian, Jr., *Local Religion in Sixteenth-Century Spain* (Princeton: Princeton University Press, 1981).

26. Ulrich Zwingli, *Commentary on True and False Religion*, eds. Samuel Macauley Jackson and Clarence Nevin Heller (Durham, NC: Labyrinth Press, 1981), 182.

27. Zwingli, *Commentary on True and False Religion*, 181.

28. Zwingli, *Commentary on True and False Religion*, 184.

29. Zwingli, *Commentary on True and False Religion*, 211.

30. Zwingli, *Commentary on True and False Religion*, 214.

31. Zwingli, *Commentary on True and False Religion*, 224–28.

32. Zwingli, *Commentary on True and False Religion*, 229.

33. Zwingli, *Commentary on True and False Religion*, 214.

34. Zwingli, *Commentary on True and False Religion*, 331–32.

35. A few examples easily found in major museums and online are: Josse Lieferinxe, *Saint Sebastian Interceding for the Plague Stricken*, ca. 1497, Walters Art Gallery, Baltimore; Anthony van Dyke, *Saint Rosalie Interceding for the Plague-stricken of Palermo*, 1624, Metropolitan Museum, New York; Mattia Preti, *Study for the Votive Fresco of the Virgin with Saint Francis Xavier and Saint Rosalie, Interceding for Victims of the Plague of Naples*, 1656–1659, Museo e Gallerie Nazionale di Capodimonte, Naples; Pietro Liberi, *Saint Anthony of Padua Begs the Holy Trinity to Help Venice in the War for Candia*, 1652, Santa Maria della Salute, Venice; Francesco Fontebasso, *Pope Gregory I and Saint Vitalis Intercede with the Madonna for the Souls of Purgatory*, 1730–31, Kunsthistorisches Museum, Gemäldegalerie, Vienna; Jacques Louis David, *Saint Roch Interceding with the Virgin for the Plague Stricken*, 1780, Musée des Beaux-Arts, Marseilles.

36. Council of Trent, Session 25, in Tanner, *Decrees*, 2: 774.

37. Council of Trent, Session 25, in Tanner, *Decrees*, 2: 775.

38. Saint Augustine, *Confessions*, trans. Henry Chadwick (Oxford: Oxford University Press, 1991), 3.

39. For a perceptive analysis of the print see Carl C. Christensen, *Princes and Propaganda: Electoral Saxon Art of the Reformation*, Sixteenth-Century Essays and Studies, vol. 20 (Kirksville, MI: Sixteenth-Century Journal Publishers, 1992), 104–12.

40. Joseph Leo Koerner, *The Reformation of the Image* (Chicago: University of Chicago Press, 2008), 76.

41. The full title is "Die Figur der Tauff unsers Heilands Jhesu Christi, aldo die herrliche Offenbarung der ewigen einigen Gottheit in dreien Personen geschehen is, welche alle Christen in der Anruffung betrachten sollen." (The Figure of Our Savior Jesus Christ, in which took place the glorious revelation of the eternally united godhead in three persons, which all Christians should ponder in calling [on Jesus].)

42. *Den soln wir alle hörn mit vleis*
    *Und geben im allem den preis.*
    *Derhalben sehe ein jeder Christ*
    *Wenn er in angst und nöten ist*
    *Das er im trost und rettung such*
    *Nicht bey Creaturn es ist betrug*

*Die Götzen gar nicht heissen mögen*
*Ir krafft und wird ist all erlogen*
*Man sol allein Gott ruffen an.*

43. Saint Ignatius Loyola, *The Spiritual Exercises of St. Ignatius Loyola,* trans. Father Elder Mullan (New York: P. J. Kenedy and Sons, 1914), 26.

44. Loyola, *Spiritual Exercises,* 26.

45. Loyola, *Spiritual Exercises,* 30.

46. Loyola, *Spiritual Exercises,* 17.

47. Loyola, *Spiritual Exercises,* 12.

48. Loyola, *Spiritual Exercises,* 53.

49. For a study of early Jesuit imagery that argues for its contribution to the Counterreformation, see Thomas Buser, "Jerome Nadal and Early Jesuit Art in Rome," *Art Bulletin* 58, no. 3 (September 1976): 424–33. For imagery and its study see Jerome Nadal, ed., *The Illustrated Spiritual Exercises* (Scranton, PA: University of Scranton Press, 2001) and Jerome Nadal, S.J., *Annotations and Meditations on the Gospels,* 3 vols., trans. and ed. Frederick A. Homann, S.J. (Philadelphia: Saint Joseph's University Press, 2003–7).

50. Loyola, *Spiritual Exercises,* 97.

51. Loyola, *Spiritual Exercises,* 98.

52. Loyola, *Spiritual Exercises,* 97.

53. See Mary Carruthers, *The Book of Memory: A Study of Memory in Medieval Culture,* 2nd ed. (Cambridge: Cambridge University Press, 2008).

54. See the classic study by Frances Yates, *The Art of Memory* (Chicago: University of Chicago Press, 1966).

55. Walter S. Melion provides a detailed discussion of the use of the images in Nadal's work. See Melion, "The Art of Vision in Jerome Nadal's *Adnotationes et Meditationes in Evangelia,*" in Nadal, *Annotations and Meditations,* vol. 1, 1–96.

56. Loyola, *Spiritual Exercises,* 26.

57. Loyola, *Spiritual Exercises,* 12.

58. Loyola, *Spiritual Exercises,* 26.

59. For an excellent overview of the new devotional culture and its visual forms in the seventeenth-century Netherlands, see John B. Knipping, *Iconography of the Counter Reformation in the Netherlands: Heaven on Earth,* 2 vols. (Nieuwkoop: B. de Graaf and Leiden: A.W. Sijthoff, 1974), vol. 1, 109–79; in southern Germany, Chipps Smith, *Sensuous Worship;* for several essays exploring the legacy of the Jesuits in emblem books, see Pedro F. Campa and Peter M. Daly, eds., *Emblematic Images and Religious Texts: Studies in Honor of G. Richard Dimler, S.J.* (Philadelphia: Saint Joseph's University Press, 2010).

60. Antoni Sucquet, *Via vitae aeternae* (Antwerp: Martin Nuty, 1620); Antoine Sucquet, *Le Chemin de la Vie Eternele* (Anvers: Henry Aertssens, 1623). A partial English translation appeared much later: *Some Mediations and Prayers selected from The Way of Eternal Life, in Order to Illustrate and Explain the Pictures by Boetius A. Bolswert,* trans. Rev. Isaac Williams (Oxford: John Henry Parker, 1845). The English edition's images are redrawn versions of Bolswert's, and the text adds several images and discussion of them from subsequent editions.

61. An excellent discussion of Sucquet's book as well as of the *Spiritual Exercises,* particularly with regards to imagery, is Chipps Smith, *Sensuous Worship,* 23–40.

62. Jesuits made considerable use of the fashionable emblematic mode of illustration, a figurative, allegorical approach that suited visual treatments of the very spiritual states of feeling, introspection, and quest for insight that the *Spiritual Exercises* cultivated. See Ralph Deckoninck, "Maximilianus Sandeaus (1578–1656): Théoricien de l'image mystique et symbolique," in Campia and Daly, eds., *Emblematic Images and Religious Texts,* 171–81; and Dekoninck, *Ad Imaginem: Statuts, fonctions et usages de l'image dans la littérature spirituelle jésuite du XVII Siècle* (Geneva: Droz, 2005). For a wide-ranging collection of studies on Jesuit emblem production and use, see John Manning and Marc van Vaeck, eds., *The Jesuits and the Emblem Tradition: Selected Papers of the Leuven International Emblem Conference 18–23 August, 1996,* Imago Figurata Studies, vol. 1a (Turnhout: Brepols, 1999).

## CHAPTER 2. THE VISIBLE WORD

1. Ulrich Zwingli, *Commentary on True and False Religion,* ed. Samuel Macauley Jackson and Clarence Nevin Heller (Durham, NC: Labyrinth Press, 1981), 336.

2. Ulrich Zwingli, *Eine Antwort, Valentin Compar gegeben,* 27, April 1525, in Ulrich Zwingli, *Sämtlich Werke,* eds. Emil Egli and Georg Finsler (Leipzig; Verlag von M. Heinsius Nachfolger, 1927), vol. 4, 125.

3. John Calvin, *Institutes of the Christian Religion,* trans. Henry Beveridge (Grand Rapids: Wm. B. Eerdmans, 1989), 101.

4. For a brief overview of the material history of Christianity from the earliest days to the present, see David Morgan, "Material Belief," in *The Encyclopedia of Christian Civilization,* ed. George Thomas Kurian, vol. 3 (Malden, MA: Wiley-Blackwell, 2011), 1,441–449. A readable and illuminating survey of the history of representations of Jesus from the early church to the twentieth century is Gabriele Finaldi, *The Image of Christ* (London: National Gallery, distributed by Yale University Press, 2000). An accessible study of early Christian art is Robin Jensen, *Understanding Early Christian Art* (London: Routledge, 2000).

5. There is a vast literature on the Reformation and images. It will suffice here to cite some of the best of it available in English: Charles Garside, *Zwingli and the Arts* (New Haven: Yale University Press, 1966); Carlos M. N. Eire, *War against the Idols: The Reformation of Worship from Erasmus to Calvin* (Cambridge: Cambridge University Press, 1986); Margaret Aston, *England's Iconoclasts: Laws against Images* (Oxford: Clarendon Press, 1988); Sergiusz Michalski, *Reformation and the Visual Arts: The Protestant Image Question in Western and Eastern Europe* (New York: Routledge, 1993); Lee Palmer Wandel, *Voracious Idols and Violent Hands: Iconoclasm in Reformation Zurich, Strasbourg, and Basel* (Cambridge: Cambridge University Press, 1995; Julie Spraggon, *Puritan Iconoclasm during the English Civil War* (Woodbridge, Suffolk: Boydell Press, 2003).

6. Andreas Bodenstein of Carlstadt, "On the Removal of Images and That There Should Be No Beggars Among Christians," in *The Essential Carlstadt,* trans. and ed. E. J. Furcha (Waterloo, ON and Scottdale, PA: Herald Press, 1995), 103.

7. Carlstadt, "On the Removal of Images," 104.

8. Zwingli, *Commentary on True and False Religion,* 331. Zwingli's view is discussed further in chapter 3 here.

9. Martin Luther, "An Open Letter to the Christian Nobility of the German Nation Concerning the Reform of the Christian Estate," 1520, in *Three Treatises* (Philadelphia: Muhlenberg Press, 1947), 9–111.

10. Luther, "An Open Letter," 117.

11. John Foxe, *Acts and Monuments,* eds. Rev. George Townsend and Rev. Stephen Reed Cattley (London: Seeley and Burnside, 1838), vol. 5, 697.

12. Foxe, *Acts and Monuments,* 698–99. The comparison has been much discussed in secondary literature. For a very accessible biography of Edward VI, see Diarmaid MacCullough, *The Boy King: Edward VI and the Protestant Reformation* (New York: Palgrave, 1999). For a thorough study of its visual history from Henry VIII to Elizabeth I see Margaret Aston, *The King's Bedpost: Reformation and Iconography in a Tudor Group Portrait* (Cambridge: Cambridge University Press, 1993).

13. Foxe, *Acts and Monuments,* vol. 5, 698–99.

14. For important discussions of this image and others in Foxe's book, see Elizabeth Evenden and Thomas S. Freeman, *Religion and the Book in Early Modern England: The Making of Foxe's 'Book of Martyrs'* (Cambridge: Cambridge University Press, 2011), 186–231; Brian Cummings, "Images in Books: Foxe EIKONOKLASTES," in *Art Re-Formed: Re-Assessing the Impact of the Reformation on the Visual Arts,* eds. Tara Hamling and Richard L. Williams (Newcastle: Cambridge Scholars Publishing, 2007), 183–200, esp. 183–84; John N. King, *Foxe's Book of Martyrs and Early Modern Print Culture* (Cambridge: Cambridge University Press, 2006), 162–242; Thomas Betteridge, "Visibility, Truth and History in *Acts and Monuments,*" in *John Foxe and his World,* ed. Christopher Highley and John King (Aldershot: Ashgate, 2002), 145–59; Ruth Samson Luborsky, "The Illustrations: Their Pattern and Plan," in *John Foxe: An Historical Perspective,* ed. David Loades (Aldershot: Ashgate, 1999), 67–84; Margaret Aston and Elizabeth Ingram, "The Iconography of the Acts and Monuments," in *John Foxe and the English Reformation,* ed. David Loades (Aldershot: Ashgate, 1997), 66–142; and Aston, *The King's Bedpost,* 149–66.

15. On the publication history of the book as it relates to illustrations, see Luborsky, "The Illustrations;" and Evenden and Freeman, *Religion and the Book in Early Modern England,* 186–231.

16. Edmund S. Morgan, *Visible Saints: The History of a Puritan Idea* (Ithaca: Cornell University Press, 1963).

17. For a penetrating discussion of Cranach and the art of the Reformation, see Brian Cummings, on Eamon Duffy reviewing Joseph Leo Koerner's *The Reformation of the Image* (Chicago: University of Chicago Press, 2008): Cummings, "Images in Books," 187–88. For a very readable study of Cranach and Luther see Steven Ozment, *The Serpent and the Lamb: Cranach, Luther, and the Making of the Reformation* (New Haven: Yale University Press, 2011).

18. See Juliane Schmieglitz-Otten, ed., *Die Celler Schloss Kapelle: Kunstwelten, Politiken, Glaubenswelten* (Munich: Hirmer Verlag, 2012); Thomas Pöpper and Susanne

Wegmann, eds., *Das Bild des neuen Glaubens: das Cranach-Retabel in der Schneeberger St. Wolfsgangskirche* (Regensburg: Schnell and Steiner, 2011); and Christoph Weimer, *Luther, Cranach und die Bilder: Gesetz und Evangelium, Schlüssel zum reformatorischen Bildgebrauch* (Stuttgart: Clawer Verlag, 1999).

19. Zwingli, *Eine Antwort, Valentin Compar gegeben*, 120–22. Calvin, *Institutes of the Christian Religion*, 94–96.

20. Martin Luther, *Wider die himmlischen Propheten, von den Bildern und Sakrament*, 1525, in *Ausgewählte Werke*, ed. Georg Merz, 3$^{rd}$ ed. (Munich: Chr. Raiser Verlag, 1957), vol. 4, 87: *"Auch hab ich die Bilderstürmer selbst gesehen und hören lessen aus meiner verdeutschten Bibel. So weiß ich auch, daß sie dieselbige haben, lessen draus, wie man wohl spürt an den Worten, die sie führen. Nun sind gar viele Bilder in denselbigen Büchern, beide, Gottes, der Engel, Menschen und Tiere, sonderlich in der Offenbarung Hohannis und im Mose und Josua. So bitten wir sie nun gar freundlich, wollten uns doch auch gönnen zu tun, das sie selber tun, daß wir auch solche bilder mögen an die Wände malen um Gedächtnisses und bessern Verstands willen, sintemal sie an den Wänden ja so wenig schaden, also in den Büchern. Es ist je besser, man male an die Wand, wie Gott die Welt schuf, wie Noah die Arche baute und was mehr gutter Historien sind, den daß man sonst irgend weltlich unverschämt Ding malet; ja wollt Gott, ich könnt die Herren und die Reichen dahin bereden, daß sie die ganze Bibel inwendig und auswendig an den Häusern vor jedermanns Augen malen ließen, das ware ein christlich Werk."*

21. For studies of visual propaganda among Protestants, see R. W. Scribner, *For the Sake of Simple Folk: Popular Propaganda for the German Reformation* (Cambridge: Cambridge University Press, 1981) and Carl C. Christensen, *Princes and Propaganda: Electoral Saxon Art of the Reformation*, Sixteenth Century Essays and Studies, vol. 20 (Kirksville, Missouri: Sixteenth Century Essays and Studies, 1992).

22. David D. Hall, *Worlds of Wonder, Days of Judgment: Popular Religious Belief in Early New England* (Cambridge, MA: Harvard University Press, 1989), 24. On book production during the Reformation across Europe, see Jean-François Gilmont, ed., *The Reformation and the Book*, trans. and ed. by Karin Maag (Aldershot: Ashgate, 1998).

23. Andrew Pettegree, "Illustrating the Book: A Protestant Dilemma," in *John Foxe and his World*, eds. Christopher Highley and John N. King (Aldershot: Ashgate, 2002), 133–44, situates the appearance of Foxe's illustrated text fortuitously, at the outset of a period in which the influence of continental Calvinism's iconophobia spread through England. Pettegree focuses his comments on upscale book illustration of Bibles and martyrologies, a fine-art market in comparison to the popular commerce in chapbooks, almanacs, broadsides, ballads, and tracts which were also illustrated during this period, and have been studied by Tessa Watt, *Cheap Print and Popular Piety, 1550–1640* (Cambridge: Cambridge University Press, 1991). Watt shows that Foxe's book influenced this body of illustrated materials, which appealed to popular consumption in spite of the genteel tastes of Puritan iconophobia, 134–37, 158–59.

24. See Alison Adams, *Webs of Allusion: French Protestant Emblem Books of the Sixteenth Century* (Geneva: Droz, 2003) and Bernhard F. Scholz, "Religious Meditations on the Heart: Three Seventeenth Century Variants," in *The Arts and the Cultural Heritage of Martin Luther* eds. Eyolf Østrem, Jens Fleischer and Nils Holger Petersen (Copenhagen: Museum Tusculanum Press, University of Copenhagen, 2003), 99–135.

25. Perkins's diagram has been insightfully discussed by Lori Anne Ferrell, "Transfiguring Theology: William Perkins and Calvinist Aesthetics," in Highley and King, eds., *John Foxe and his World*, 160–79; for a reproduction and discussion of an acrostic poem see Watt, *Cheap Print and Popular Piety*, 232–33.

26. On illustrations and the iconicity of texts see David Morgan, *The Lure of Images: A History of Religion and Visual Media in America* (London: Routledge, 2007), 13–15; for a study of the integration and interdependence of image and text in Protestant needlework, see Maureen Daly Goggin, "Visual Rhetoric in Pens of Steel and Inks of Silk: Challenging the Great Visual/Verbal Divide," in *Defining Visual Rhetorics*, eds. Charles A. Hill and Marguerite Helmers (Mahwah, NJ: Lawrence Erlbaum Associates, 2004; reprint, New York: Routledge, 2009), 87–110.

27. See Heimo Reinitzer, *Gesetz and Evangelium: Über ein reformatorisches Bildthema, seine Tradition, Funktion und Wirkungsgeschichte*, 2 vols. (Hamburg: Christians Verlag, 2006).

28. A major resource for the study of German epitaph and the didactic panels and images placed within Protestant churches is Reinitzer, *Gesetz and Evangelium*.

29. For studies of Reformer portraits see Ozment, *The Serpent and the Lamb*, 119–47; Mary G. Winkler, "Calvin's Portrait: Representation, Image, or Icon," in *Seeing Beyond the Word: Visual Arts and the Calvinist Tradition*, ed. Paul Corby Finney (Grand Rapids: Eerdmans, 1999), 243–51; and R. W. Scribner, *For the Sake of Simple Folk: Popular Propaganda for the German Reformation* (Oxford: Clarendon Press, 1994), 14–36.

30. For an example of defacing an image of Luther, see Koerner, *Reformation of the Image*, 114–16.

31. Luborsky, "The Illustrations," 69.

32. Foxe, *Acts and Monuments*, vol. 8, 86.

33. Foxe, *Acts and Monuments*, vol. 8, 89–90.

34. Robert Parsons launched a three-volume rejoinder to Foxe's *Acts and Monuments*, *A Treatise of Three Conversions of England from Paganism to Christian Religion* (Saint-Omer, France: Francois Bellet, 1603–4) and singled out the illustrations for criticism: "his lying Acts and Monuments, a booke composed wholy to deceyue, and by judgment of many men, hath done more hurt alone to simple soules in our country, by infecting and poysoninge them vnwares, vnder the bayte of pleasant historyes, fayre pictures and painted pageants, then many other the most pestilent books togeather," vol. 3, ch. 18, p. 400.

35. Evenden and Freeman, *Religion and the Book in Early Modern England*, 221, 226. For the ongoing significance of Foxe's book in England see Peter Nockles, "The Changing Legacy and Reception of John Foxe's 'Book of Martyrs' in the 'Long Eighteenth Century': Varieties of Anglican, Protestant, and Catholic Response, c. 1760-c. 1850," in *Religion, Politics and Dissent, 1660–1832: Essays in Honour of James E. Bradley*, eds. Robert Cornwall and William Gibson (Burlington, VT: Ashgate, 2010), 219–47.

36. Calvin, *Institutes*, 100. Compare with Zwingli, who began in his major treatment of images to differentiate "idols" from "images," the first being "an image of a helper or comfort or one to which honor is given," the second "the likeness of a thing that is visible but one to which no false hope is taken nor veneration made," Zwingli, *Eine Antwort, Valentin Compar gegeben*, 96. In *Commentary on True and False Religion*, also produced in 1525, Zwingli

stipulated that only images of human figures could threaten becoming objects of worship: "Only those images ought to be abolished which offend piety or diminish faith in God, such as are all those in human shape which are set up before altars or churches, even thought they were not at first set up to saints," 336. For helpful studies of Zwingli on images, see Garside, *Zwingli and the Arts*, 146–78; and Eire, *War Against the Idols*, 73–86.

37. Calvin, *Institutes*, 101. Zwingli likewise had banned images from churches, though in the case of windows and figures on the outside he applied the criterion of use: if the images were being worshipped, they should be removed, if not, they could remain, *Eine Antwort*, 95–96. He made the same point in a major treatise, *Commentary on True and False Religion*, written at the same time (1525) as the *Answer to Valentin Compar*. Zwingli contended that decorative imagery or imagery imbued with allegorical or mystical meanings that were not being worshiped could remain in churches: "No one is so stupid as to think that we ought to do away with statues, images, and other representations, where no worship is offered them; for who is affected by the flying cherubim on the mercy seat or embroidered on the curtains, whether for their mystic meaning or for decoration, or by the palms, lions, oxen, pomegranates, and such like ornaments cunningly wrought in Solomon's temple?" Zwingli, *Commentary*, 330–31.

38. Luborsky, "The Illustrations," 68 et passim.

39. Two helpful studies of Richmond's writings are Gary Kelly, "Romantic Evangelicalism: Religion, Social Conflict, and Literary Form in Legh Richmond's *Annals of the Poor*," *English Studies in Canada* 16, no. 2 (June 1990): 165–86; and Kyle B. Roberts, "Locating Popular Religion in the Evangelical Tract: The Roots and Routes of *The Dairyman's Daughter*," *Early American Studies* 4 (Spring 2006): 233–70.

40. Reverend Legh Richmond, *The Young Cottager; A True Story*, no. 151 (London: printed for the Religious Tract Society, 1819), 5.

41. Richmond, *The Young Cottager*, 5.

42. I have explored such images and associations in *Protestants and Pictures: Religion, Visual Culture, and the Age of American Mass Production* (New York: Oxford University Press, 1999), 223–34; and "Image," in *Key Words in Religion, Media, and Culture*, ed. David Morgan (London: Routledge, 2008), 96–110.

43. Helpful work on the home and domestic interior in Protestant cultures includes: Colleen McDannell, *The Christian Home in Victorian America* (Bloomington: Indiana University Press, 1986); McDannell, *Material Christianity: Religion and Popular Culture in America* (London: Yale University Press, 1995); Tara Hamling, *Decorating the 'Godly' Household: Religious Art in Post-Reformation Britain* (New Haven: Yale University Press, 2010); and several essays in Hamling and Williams, eds., *Art Re-Formed*, 105–67.

44. Michalski, *Reformation and the Visual Arts*, 56.

45. Reverend Samuel Phillips, *The Christian Home, As It Is in the Sphere of Nature and the Church* (Social Circle, Georgia: E. Nebhut, 1861), 56.

46. Phillips, *The Christian Home*, 60.

47. Phillips, *The Christian Home*, 153.

48. Phillips, *The Christian Home*, 153–54.

49. See David Morgan, *The Sacred Gaze: Visual Culture in Theory and Practice* (Berkeley: University of California Press, 2005), 191–206.

50. The preface to a German edition printed in Pennsylvania describes the origin of Gossner's text: Johannes E. Gossner, *Das Herz des Menschen: Ein Tempel Gottoes, oder die Werkstätte des Teufels* (Harrisburg, PA: Theo. F. Scheffer, 1870), 3. The 1732 text is difficult to find, but the ten plates that comprised the booklet were reproduced in Paul Carus, "Heart of Man as Mirrored in Religious Art," *The Open Court* 12, no. 4 (April 1898): 236–42. For biographical information on Gossner, see Ingetraut Ludolphy, "Gossner, Johannes Evangelista," in *The Encyclopedia of the Lutheran Church,* 3 vols., ed. Julius Bodensieck (Minneapolis: Augsburg, 1965), vol. 2, 944–45. On Gossner's text in mission history see www.common-place.org/vol-06/no-04/tales/, accessed August 14, 2014.

51. Gossner, *Das Herz des Menschen,* 6.

52. For reproductions and discussion of this set of images see Wu Tung, *Tales from the Land of Dragons: 1,000 Years of Chinese Painting* (Boston: Museum of Fine Arts, 1997), 90–95, 197–201.

## CHAPTER 3. RELIGION AS SACRED ECONOMY

1. Emile Durkheim, *The Elementary Forms of Religious Life,* trans. Karen E. Fields (New York: The Free Press, 1995), 350.

2. Henri Hubert and Marcel Mauss, *Sacrifice: Its Nature and Functions,* trans. W. D. Halls (Chicago: University of Chicago Press, 1964), 97.

3. Hubert and Mauss, *Sacrifice,* 100. Emphasis added.

4. Marcel Mauss, *The Gift: The Form and Reason for Exchange in Archaic Societies,* trans. W. D. Halls (New York: W.W. Norton, [1925] 1990). A large literature formed in the wake of Mauss's seminal essay, especially with regard to things and images as gifts: Michel de Certeau, "What We Do When We Believe," in *On Signs,* ed. Marshall Blonsky (Baltimore: Johns Hopkins University Press, 1985), 192–202; Patrick Geary, "Sacred Commodities: The Circulation of Medieval Relics," in *The Social Life of Things: Commodities in Cultural Perspective,* ed. Arjun Appadurai (Cambridge: Cambridge University Press, 1986), 169–91; Annette Weiner, *Inalienable Possessions: The Paradox of Keeping-While-Giving* (Berkeley: University of California Press, 1992); Fred Myers, ed., *The Empire of Things: Regimes of Value and Material Culture* (Santa Fe: School of American Research Press; Oxford: James Currey, 2001); Fred Myers, "Ontologies of the Image and Economies of Exchange," *American Ethnologist* 31, no. 1 (February 2004): 5–20. A key text to which Mauss's study of the gift and the nature of gift exchange responded is Bronislaw Malinowsky, *Argonauts of the Western Pacific: An Account of Native Enterprise and Adventure in the Archipelagoes of Melanesian New Guinea* (London: G. Routledge and Sons, 1922).

5. Georges Bataille, *Theory of Religion,* trans. Robert Hurley (New York: Zone Books, 1992), 49.

6. Jill Robbins, "Sacrifice," in *Critical Terms for Religious Studies,* ed. Mark C. Taylor (Chicago: University of Chicago Press, 1998), 285–97.

7. Weiner, *Inalienable Possessions,* 41, points out that Bataille was unaware that the Northwest Coast Kwakiutl chiefs who engaged in the potlatch, giving away all their possessions, actually "schemed to keep their most renowned cloaks and coppers out of

exchange." They used the potlatch's ritual feast of expenditure to enhance the value of the objects they kept. Yet Bataille's argument that the economy of expenditure augmented social bonds seems sound and is therefore better regarded as an alternative economy rather than a nullification of economies of exchange.

8. One possible exception, pointed out to me by Brenna Keegan, is *madagh,* the Armenian Christian Church's annual practice of commemorating those victims with food offerings, most commonly lamb stew and flatbread. The animals are not ritually slaughtered or burnt, but they are butchered and roasted for the occasions on the night before.

9. Robert W. Shaffern, *The Penitents' Treasury: Indulgences in Latin Christendom, 1175–1375* (Scranton and London: University of Scranton Press, 2007), 84–87. A very instructive collection of essays on the history of indulgences is R. N. Swanson, ed., *Promissory Notes on the Treasury of Merits: Indulgences in Late Medieval Europe* (Leiden: Brill, 2006).

10. Shaffern, *Penitents' Treasury,* 87.

11. Shaffern, *Penitents' Treasury,* 40–45.

12. Clement VI, "Unigenitus Dei Filius," in *The Sources of Catholic Dogma,* trans. Roy J. Deferrari, from Henry Denzinger, *Enchiridion Symbolorum,* 30th edition (Fitzwilliam, NH: Loreto Publications, 2002), 202. For an instructive discussion of the history of sources on the treasury, see Shaffern, *Penitents' Treasury,* 79–94.

13. See Saint Louis Marie de Montfort, "The Secret of Mary," first half of the eighteenth century, reprinted in *God Alone: The Collected Writings of St. Louis Marie de Montfort* (Bay Shore, New York: Montfort Publications, 1988): "God chose her to be the treasurer, the administrator and the dispenser of all his graces, so that all his graces and gifts pass through her hands. Such is the power that she has received from him that, according to St. Bernardine, she gives the graces of the eternal Father, the virtues of Jesus Christ, and the gifts of the Holy Spirit to whom she wills, as and when she wills, and as much as she wills." Monfort contended in this letter that the task was "to discover a simple means to obtain from God the grace need to become holy," 266. Mary was the answer, and he understood her power in visual terms: "Mary is the great mold of God, fashioned by the Holy Spirit to give human nature to a Man who is God by the hypostatic union, and to fashion through grace men who are like to God . . . No godly feature is missing from this mold. Everyone who casts himself into it and allows himself to be molded will acquire every feature of Jesus Christ, true God, with little pain or effort, as befits his weak human condition," 267.

14. Winfrid Herbst, *Indulgences* (Milwaukee: Bruce Publishing Company, 1955), 14.

15. Henry Charles Lea, *A History of Auricular Confession and Indulgences in the Latin Church,* 3 vols. (Philadelphia: Lea Brothers, 1896), 3: 184. The thirteenth-century text that reports this indulgence is reprinted in Hans Belting, *Likeness and Presence: A History of the Image before the Era of Art,* trans. Edmund Jephcott (Chicago: University of Chicago Press, 1994), 543.

16. Ambrose St. John, *The Raccolta: Or, Collection of Indulgenced Prayers and Good Works* (London: Burns and Oates; New York: Benziger Brothers, 1910), xiv–xv. "Raccolta" is the title popularly used for successively issued versions of the handbook on indulgences, the *Enchiridion Indulgentiarum,* produced whenever popes change the collection. All references to *Raccolta* here are to the 1910 edition published by Benziger brothers.

17. *Raccolta*, 350.

18. Herbst, *Indulgences*, 96.

19. Herbst, *Indulgences*, 127, 147, 234, 415.

20. "Fourth Lateran Council," in Norman P. Tanner, ed., *Decrees of the Ecumenical Councils*, 2 vols. (London: Sheed and Ward; Washington, DC: Georgetown University Press, 1990), 1: 263.

21. "Fourth Lateran Council," 1: 263.

22. Albert of Mainz, "*Instructio summaria* (1515)," excerpted in *A Reformation Reader*, ed. Denis R. Janz (Minneapolis: Fortress Press, 1999), 53.

23. John Calvin, *Institutes of the Christian Religion*, trans. Henry Beveridge (Grand Rapids: Eerdmans, [1559] 1989), 94.

24. Calvin, *Institutes*, 98.

25. R. W. Scribner, *For the Sake of Simple Folk: Popular Propaganda for the German Reformation* (Oxford: Clarendon Press, 1994), 104.

26. Martin Luther, "Ninety-Five Theses or Disputation on the Power and Efficacy of Indulgences," in *A Reformation Reader*, ed. Denis R. Janz (Minneapolis: Fortress Press, 1999), 84–85.

27. *Triglot Concordia: The Symbolical Books of the Evangelical Lutheran Church* (Minneapolis: The Mott Press, 1955), part 2, art. 2, sect. 12, p. 465.

28. *Triglot Concordia*, part 2, art. 4, sect. 9, p. 473.

29. *Triglot Concordia*, part 2, art. 4, sect. 10, p. 475.

30. *Triglot Concordia*, part 2, art. 2, sect. 25, p. 468.

31. Martin Luther, "Autobiographical Fragment: Preface to the Complete Edition of Luther's Latin Writings (1545)," reprinted in Janz, ed., *A Reformation Reader*, 75.

32. Martin Luther, "A Brief Instruction on What to Look for and Expect in the Gospels," 1522, in *Martin Luther's Basic Theological Writings*, ed. Timothy F. Lull (Minneapolis: Fortress Press, 1989), 108. For the German original see *Luthers Werke*, eds. D. Buchwald, Gustave Kawerau, Julius Koestlin, Martin Rade, and Eugenio Schneider, 3rd ed. (Berlin: C.A. Schwetschke und Sohn, 1905), vol. 5, 121. Luther discussed the dual significance of Jesus as gift and example further in the same essay, providing greater elaboration of the significance for Christian life: "Therefore make note of this, that Christ as a gift nourishes your faith and makes you a Christian. But Christ as an example exercises your works. These do not make you a Christian. Actually they come forth from you because you have already been made a Christian. As widely as a gift differs from an example, so widely does faith differ from works, for faith possesses nothing of its own, only the deeds and life of Christ. Works have something of your own in them, yet they should not belong to you but to your neighbor," in Lull, *Basic Theological Writings*, 107; for the original German, see *Luthers Werke*, vol. 5, 120.

33. Council of Trent, in *Decrees of the Ecumenical Councils*, ed. Norman P. Tanner S.J, 2 vols. (London: Sheed and Ward, and Washington, DC: Georgetown University Press, 1990), 2: 796.

34. Council of Trent, 797.

35. Compare *Raccolta*, 428, and Herbst, *Indulgences*, 4–5.

36. *Raccolta*, 412, 415.

37.  *Raccolta,* ix. Emphasis in original.

38.  Herbst, *Indulgences,* 9–10. Emphasis in original.

39.  *Raccolta,* 7.

40.  For a discussion of the sacred economy of devotion to Fatima, see David Morgan, "Aura and the Inversion of Marian Pilgrimage: Fatima and Her Statues," in *Moved by Mary: Pilgrimage in the Modern World,* eds. Anna-Karina Hermkens, Willy Jansen and Catrien Notermans (Oxford: Ashgate, 2009), 49–65.

41.  Margaret Mary Alacoque, *The Autobiography of Saint Margaret Mary Alacoque,* trans. Sisters of the Visitation (Rockford, Illinois: TAN Books, 1986), 106.

42.  Father John Croiset, *The Devotion to the Sacred Heart,* 2nd ed., trans. Father Patrick O'Connell, B.D. (Rockford, Illinois: TAN Books, 1988), 76.

43.  Croiset, *Devotion to the Sacred Heart,* 242–54.

44.  For a list of indulgences dedicated to the Sacred Heart by Pius X, see *The Messenger of the Sacred Heart of Jesus* 12, no. 9 (September 1908), 530–31, and for indulgenced prayers, see *The Messenger of the Sacred Heart of Jesus* 12, no. 11 (November 1908), 671–72.

45.  "Apostolic Constitution on Indulgences," Papal Encyclicals Online, www.papalencyclicals .net/Paul06/p6indulg.htm, accessed October 8, 2012.

46.  *Indulgentiarum Doctrina,* ch. 4, sect. 8.

47.  *Indulgentiarum Doctrina,* ch. 2, sect. 5.

48.  See for instance Paul M. Kane, "Marian Devotion Since 1940: Continuity or Casualty?" in *Habits of Devotion: Catholic Religious Practice in Twentieth-Century America,* ed. James M. O'Toole (Ithaca: Cornell University Press, 2004), 89–129, esp. 91–92, 96.

49.  "First Vatican Council," in Tanner, ed., *Decrees,* vol. 2, p. 803.

50.  *Indulgentiarum Doctrina,* ch. 4, sect. 8.

51.  *Indulgentiarum Doctrina,* ch. 5, sect. 12.

52.  *Indulgentiarum Doctrina,* norm 17.

53.  *Indulgentiarum Doctrina,* ch. 5, sect. 12.

54.  John Paul II, *Incarnationis Mysterium,* 2000, para 9. www.vatican.va/jubilee_2000/docs /documents/hf_jp-ii_doc_30111998_bolla-jubilee_en.html, accessed January 19, 2014.

55.  Apostolic Penitentiary, *Manual of Indulgences: Norms and Grants,* trans. from 4th ed. (1999) of *Enchiridion Indulgentiarum: Normae et Concessiones* (Washington, DC: United States Conference of Catholic Bishops, 2006), 5.

56.  Apostolic Penitentiary, *Manual of Indulgences,* 34.

57.  Tom Kington, "Vatican offers 'time off purgatory' to followers of Pope Francis tweets," *The Guardian,* July 16, 2013, www.guardian.co.uk/world/2013/jul/16/vatican-indulgences-pope-francis-tweets?utm_source = buffer&utm_campaign = Buffer&utm_content = buffer48ca5&utm_medium = twitter, accessed July 19, 2013.

58.  "Mission Statement," Apostolate for Holy Relics website, www.apostolateforholyrelics .com/mission-statement.php, accessed August 29, 2013.

59.  "Mission Statement," Apostolate for Holy Relics.

60.  Weiner, *Inalienable Possession,* 26.

61.  Mauss, *The Gift,* 12.

62.  An insightful study of religious artifacts and their collection and display in museums is Crispin Paine, *Religious Objects in Museums: Private Lives and Public Duties* (London:

Bloomsbury, 2013). See also pertinent anthropological studies of gifting, inalienable value, and exchange as cited in note 4.

63. Thomas Shephard, "First Principles of the Oracles of God," in *Puritans in the New World: A Critical Anthology*, ed. David D. Hall (Princeton: Princeton University Press, 2004), 73. The economy was stressed throughout Puritan preaching and literature. Here is Bunyan's rendition of it: "But again, order to Pardon by *deed*, there must something be paid to God as a price, as well as something prepared to cover us withal. Sin has delivered us up to the just Curse of a Righteous Law: Now from this Curse we must be justified by way of Redemption, a price being paid for the harms we have done, and this is by the Blood of your Lord, who came and stood in your place, and stead, and died your Death for your Transgressions. Thus as he ransomed you from your Transgressions by Blood, and covered your polluted and deformed Souls with Righteousness," John Bunyan, *The Pilgrim's Progress*, ed. W. R. Owens (Oxford: Oxford University Press, 2003), 199.

64. John Winthrop, "A Modell of Christian Charity," 1630, reprinted in Conrad Cherry, ed., *God's New Israel: Religious Interpretations of American Destiny*, rev. ed. (Chapel Hill: University of North Carolina Press, 1998), 37–38.

65. Shephard, "First Principles," 75.

66. The order issued by the House of Commons on April 18, 1642 was reprinted in a later edition of Mede's book, *The Key of the Revelation, Searched and Demonstrated out of the Naturall and Proper Characters of the Visions,* trans. Richard More (London: printed by J. L. for Phil. Stephens, 1650), xi.

67. The 1650 edition of the book carried a forward by translator Richard More, which revealed that he had been approached by a man named Haydock with a letter of 1634 from Mede to himself, which indicated that the contents of the engraving already under production (figure 22) reflected a good deal of material from Haydock, whose name subsequently was included in the sealed (upper) and opened (lower) scrolls. More reproduced the letter, which included a fascinating and very important detail: Mede confided to Haydock that he was unsure whether the visions of the seals were actually read by the writer of Revelation. "At length therefore (because it seemed too unseemly a thing to affirm, that the thing was performed by a meer outward representation, the book conferring nothing thereunto), I fell into the opinion, that both were to be joined together, and that we must say that indeed the Prophesies were described and pourtrayed in the Volume, whether by signes and shapes, or letters; but that these were no otherwise exhibited to John, and other beholders of this celestiall Theater, then by a foreign representation, supplying the room of a rehearsal, not much unlike to our Academicall interludes, where the prompters stand near the Actors, with their books in their hands, whereas then neither the Lambe himself could recite any thing out of the book, neither did the Apostle stand so near (for the Lamb stood near to him that sate on the Throne) that he might read out of the hand of him who opened the Seals, it must needs be, that he apprehended all these after the manner as I have said" (Mede, *Key of the Revelation,* x–xii). In other words, John saw the seal scroll closed and opened, but was not close enough to read the words written thereon, though he heard a voice with the opening of each seal (see Rev. 6). The detail is fascinating because it suggests that Protestant

literalism actually endorsed the use of imagery to portray sacred truth on the assumption that events were both seen and heard by John as he witnessed the mystery of the Revelation. The result was, even among Puritans with their famous intolerance of sacred imagery, a respect for the importance of images in the representation of the prophetical truths of holy writ. Images and words work together for Protestants to affirm the authority of sacred text, as I argued in chapter 2.

68. Bunyan, *Pilgrim's Progress*, 86.

69. Bunyan, *Pilgrim's Progress*, 87.

70. Calvin, *Institutes*, 262.

71. J. Franklin Jameson, ed., *Johnson's Wonder-Working Providence, 1628–1651* (New York: Charles Scribner's Sons, 1910), 154. For an encompassing account of this relationship between commerce, material progress, and American Puritanism see Mark A. Peterson, *The Price of Redemption: The Spiritual Economy of Puritan New England* (Stanford: Stanford University Press, 1997).

72. Jameson, ed., *Johnson's Wonder-Working Providence*, 209.

73. Mark Valeri, *Heavenly Merchandize: How Religion Shaped Commerce in Puritan America* (Princeton: Princeton University Press, 2010), 113.

74. Valeri, *Heavenly Merchandize*, 58.

75. Several such maps of the pilgrim's progress were printed in the nineteenth century in London. J. Pitts's 1813 map (plate 5) inspired several more. The Reverend Daniel Wight used Pitts's image as the basis for a design that was produced as a lavish, large-scale engraving in 1853, entitled *Bunyan's Pilgrim*, engraved by J. Andrews, etched by E. A. Fowle, designed by Wight, drawn by H. Billings, and published by John P. Jewett and Co., Cornhill, Boston. A copy is in the collection of the American Antiquarian Society. Another version of Wight's image was produced as a wood engraving in London in 1860, as *John Bunyan's Dream of the Pilgrim's Progress, with a Key*. A version of this latter appeared as "John Bunyan, A Pilgrim's Progress," in *The Sunday at Home* 4, no. 431 (August 2, 1862): 488. Other examples of maps of the book also exist. See for example *Map of the Pilgrim's Progress* by John Melish, an American cartographer, produced sometime before 1822; an example can be found in the American Antiquarian Society. Another nineteenth-century instance is *A Plan of the road from the City of Destruction to the Celestial City, engraved for William's Elegant Edition of The Pilgrim's Progress*.

76. Louisa May Alcott, *Little Women*, ed. Elaine Showalter (New York: Penguin, 1989), 9.

77. Ulrich Zwingli, *Commentary on True and False Religion*, eds. Samuel Macauley Jackson and Clarence Nevin Heller (Durham, North Carolina: The Labyrinth Press, 1981), 331. The suggestion was, as Lee Palmer Wandel's work on reformation iconoclasm has shown, a widely shared commonplace among reforming voices in Zurich and Strasbourg; see Wandel, *Voracious Idols and Violent Hands: Iconoclasm in Reformation Zurich, Strasbourg, and Basel* (Cambridge: Cambridge University Press, 1995), 66, 79, 97–98, and 124–27.

78. See the various epistles and encyclicals of popes Pius VII (1816), Leo XII (1824), Gregory XVI (1844), and Pius IX (1864), in *The Sources of Catholic Dogma*, trans. Roy J. Deferrari, from the thirteenth edition of Henry Denziger's *Enchiridion Symbolorum* (Fitzwilliam, NH: Loreto Publications, 1955), 398–401, 409, and 437.

79. For an account, see Richard Shaw, *Dagger John: The Unquiet Life and Times of Archbishop John Hughes of New York* (New York: Paulist Press, 1977), 186–87. The burning was organized by an itinerant French friar who had crossed the Canadian border and collected forty-two Bibles from parishioners in Champlain, which he burned despite opposition from the local diocesan priest. The Bibles, distributed by a local Bible Society chapter, would have been most likely duodecimo-size (7–3/8 × 5 inches), not the costly folio-sized, heavily bound volumes shown in the illustration. The event was quickly denounced by the bishop of Montreal, but nonetheless became iconic in Nativist Protestant discourse and was tirelessly repeated.

When a Catholic priest in Providence defended the destruction of the Bibles on the basis of the "unfaithfulness of the Protestant version," anti-Catholic writer and Baptist minister John Dowling (1807–78) responded with two articles in the *Providence Journal*, and then republished these in a volume on the incident, *The Burning of Bibles: Defence of the Protestant Version of the Scriptures against the Attacks of Popish Apologists for the Champlain Bible Burners* (Philadelphia: Nathan Moore, 1843), to which he added a number of other anti-Catholic commonplaces. Dowling reprinted a letter to a newspaper editor by four Protestant inhabitants of Champlain who provided their version of the event. The letter stated that "the number burned altogether we are not able accurately to ascertain; more than one hundred no doubt; perhaps two or three hundred," 23. The letter went on to say that the president of Champlain's Bible Society had approached the priests to request that "inasmuch as the Bibles had been given by the different won Societies, they should be returned to the donors, and not destroyed," 24. The irony is worth noting: Luther had urged iconoclasts to do just this with images donated to churches, rather than sanctioning their destruction.

Dowling reprinted much of the account in the 1845 and subsequent editions of his *History of Romanism*, but there significantly reduced the number of bibles burned to "as many bibles as he [the Jesuit missionary whom he claimed had staged the burning] could carry in his arms at three times," Reverend John Dowling, *The History of Romanism: From the Earliest Corruptions of Christianity to the Present Time*, 6th ed. (New York: Edward Walker, 1845), 613. His 1845 account first carried the illustration reproduced here (figure 24). But the earlier and exaggerated estimates first publicized by Dowling remained in the literature for many years. Several years later, for example, a controversial Nativist congressman from Pennsylvania (responsible for inciting crowds in Philadelphia in 1844 to riots that ended in the burning of several Catholic churches and a monastery), opposing the establishment of a diplomatic mission to the Vatican, claimed in a speech that on this occasion "upwards of twenty Bibles were shamefully, publicly burnt" in October 1842, at Corbeau, a hamlet within the precinct of Champlain; "Speech of Mr. L(ewis). C(harles). Levin, of Penn., on the Proposed Mission to Rome, delivered in the House of Representatives of the United States, March 2, 1848 (Washington, DC: J. and G.S. Gideon, 1848), 15, note. The story was still in circulation in Reverend Samuel W. Barnum's *Romanism as It Is: An Exposition of the Roman Catholic System for the Use of the American People* (Hartford: Connecticut Publishing Company, 1871), 418, where the number of bibles burned had been scaled back to forty-two, though another source is cited as having said one hundred.

80. See Russell H. Conwell, *Acres of Diamonds* (Philadelphia: Temple University Press, 2002), 34–39.

81. Quoted from another version of Conwell's sermon, reprinted in R. Marie Griffith, *American Religions: A Documentary History* (New York: Oxford University Press, 2008), 309.

82. Griffith, *American Religions*, 305.

83. Griffith, *American Religions*, 306.

84. Conwell, *Acres of Diamonds*, 27.

85. *Autobiography of Andrew Carnegie* (Boston: Houghton and Mifflin Company, 1924), 255.

86. Kenneth Copeland, *The Laws of Prosperity* (Greensburg, PA: Manna Christian Outreach, 1974), 19.

87. Friedman made this argument in the first chapter of *Capitalism and Freedom* (Chicago: University of Chicago Press, 1962).

88. Copeland, *Laws of Prosperity*, 23.

89. Copeland, *Laws of Prosperity*, 58.

90. Copeland, *Laws of Prosperity*, 74–75. For a fascinating discussion of money, gifting, Pentecostalism, and the materializing of words, see Simon Coleman, "Materializing the Self: Words and Gifts in the Construction of Charismatic Protestant Identity," in *The Anthropology of Christianity* ed. Fenella Canenell (Durham: Duke University Press, 2006), 163–84, esp. 175–80.

91. Copeland, *Laws of Prosperity*, 33–4.

92. Copeland, *Laws of Prosperity*, 34.

93. Copeland, *Laws of Prosperity*, 9.

94. Copeland, *Laws of Prosperity*, 52.

95. Copeland, *Laws of Prosperity*, 27.

96. Copeland, *Laws of Prosperity*, 45.

97. Copeland, *Laws of Prosperity*, 50.

98. Copeland, *Laws of Prosperity*, 45.

99. Copeland, *Laws of Prosperity*, 69.

100. Not to be found in the Bible, according to Copeland, poverty entered Christianity as a religion "during the Dark Ages when the Word was taken from the people and put away in monasteries. Poverty oaths were fed into Christianity when the religious hierarchy took over. The men operating it were not born-again men," *Laws of Prosperity*, 32.

101. Asonzeh Ukah, "Roadside Pentecostalism: Religious Advertising in Nigeria and the Marketing of Charisma," *Critical Interventions: Journal of African Art History and Visual Culture* 2 (Spring 2008): 125–41; see also Asonzeh Ukah, "Branding God: Advertising and the Pentecostal Industry in Nigeria," *LIWURAM: Journal of the Humanities* 13 (2006): 83–106. For an insightful study of the role of visuality in Pentecostalism's contribution to the public sphere in Ghana, see Birgit Meyer, "Impossible Representations: Pentecostalism, Vision, and Video Technology in Ghana," in *Religion, Media, and the Public Sphere*, eds. Birgit Meyer and Annelies Moors (Bloomington: Indiana University Press, 2006), 290–312; and J. Kwabena Asamoah-Gyadu, "Of Faith and Visual Alertness: The Message of 'Mediatized' Religion in an African Pentecostal Context," *Material Religion* 1, no. 3 (2005): 340–46.

102. Facebook page of Heal the World Mission Inc., www.facebook.com/healtheworldmission /info, accessed October 15, 2012.

103. My thanks for Asonzeh Ukah for very helpful conversation on Nigerian Pentecostalism, which he has studied very closely, especially with respect to economy and advertising.

## CHAPTER 4. THE AGENCY OF WORDS

1. Louis Klopsch, "Explanatory Note," in *The Holy Bible: Red Letter Edition* (New York: Christian Herald, 1901), xvi.

2. Both pamphlets were prompt retorts to Karlstadt's tract, *On The Removal of Images*: Hieronymous Emser, *That One Should Not Remove Images of the Saints from the Churches Nor Dishonour Them and That They Are Not Forbidden in Scripture*, 1522; and Johannes Eck, *On Not Removing Images of Christ and the Saints*, 1522. All three tracts are translated and published in Bryan D. Mangrum and Guiseppe Scavizzi, trans. and eds., *A Reformation Debate: Karlstadt, Emser, and Eck on Sacred Images. Three Treatises in Translation* (Toronto: Centre for Reformation and Renaissance Studies, 1998).

3. Council of Trent, in Norman P. Tanner, S.J., ed., *Decrees of the Ecumenical Councils* (London: Sheed and Ward; Washington, DC: Georgetown University Press, 1990), session 25, vol. 2, 775. All bishops "must also teach that images of Christ, the virgin mother of God, and the other saints should be set up and kept, particularly in churches, and that due honour and reverence is owed to them, not because some divinity or power is believed to lie in them as reason for the cult, or because anything is to be expected from them ... but because honour showed to them is referred to the original which they represent." The text goes on to cite the second council of Nicea, of 787, which championed the use of icons in the Byzantine church on the basis of this claim.

4. Martin Luther, "The Second Sermon, Monday after Invocavit," *The Eight Wittenberg Sermons*, 1522, in *Works of Martin Luther* (Philadelphia: Muhlenberg Press, 1943), vol. 2, 397–98; Luther, *Ausgewählte Werke*, ed. Georg Merz, 3rd ed. (Munich: Chr. Raiser Verlag, 1957), vol. 4, 38: *"den Gott soll mans anheimgeben und sein Wort alleine wirken lassen, nicht unser Zutun und Werk. Warum? Denn ich hab nicht in meiner Gewalt oder Hand ihre Herzen (der Menschen) als der Häfner den Leimen, mit ihm zu schaffen nach meinem Gefallen. Ich kann nich weiterkommen den zu den Ohren; ins Herz kann ich nicht kommen. Dieweil ich den den Glauben ins Herze nicht gießen kann, so kann noch soll ich niemand dazu zwingen noch dringen, denn Gott tut das alleine und macht, daß er zuvor im Herzen lebt ... Man muß der Leute Herz zum ersten fangen, das geschieht aber, wenn ich Gottes Wort alleine treibe, predige das Evangelium .... Wer da folgen wollte, der folgete, wer nicht wollt, bliebe außen. Mit dem fiele das Wort unten in das Herze und wirkte."*

5. Luther, *Wider die himmlischen Propheten, von den Bildern und Sakrament*, 1525, in Luther, *Ausgewählte Werke*, vol. 4, 75: *"Das Bilderstürmen habe ich also angegriffen, daß ich sie zuerst durchs Wort Gottes aus denn Herzen risse und unwert und veracht machte: wie es den auch also schon geschehen ist, ehe denn D. Karlstadt vom Bilderstürmen träumte. Denn wo sie aus dem Herzen sind, tun sie vor den Augen keinen Schaden."*

6. See Innocent Chiluwa, "Religious Vehicle Stickers in Nigeria: A Discourse of Identity, Faith, and Social Vision," *Discourse and Communication* 2, no. 4 (2008): 371–87, esp. 378.

7. On broadsides, see Tessa Watt, *Cheap Print and Popular Piety, 1550–1640* (Cambridge: Cambridge University Press, 1901), 75–127; on house blessings and related display texts and illustrated texts in the nineteenth century, see Don Yoder, *The Pennsylvania German Broadside: A History and Guide* (University Park: The Pennsylvania State University Press, 2005), 195–283; on Protestant women's needlework, see Maureen Daly Goggin, "Visual Rhetoric in Pens of Steel and Inks of Silk: Challenging the Great Visual/Verbal Divide," in *Defining Visual Rhetorics,* eds. Charles A. Hill and Marguerite Helmers (Mahwah, NJ: Lawrence Erlbaum Associates, 2004; reprint, New York: Routledge, 2009), 87–110, and Lauren F. Winner, *A Cheerful and Comfortable Faith: Anglican Religious Practice in the Elite Households of Eighteenth-Century Virginia* (New Haven: Yale University Press, 2010), 60–89; on mottoes, see Colleen McDannell, *Material Christianity: Religion and Popular Culture in America* (London: Yale University Press, 1995), 46–52, 229–34; on Protestant textuality and healing, see Pamela E. Klassen, "Textual Healing: Mainstream Protestants and the Therapeutic Text, 1900–1925," *Church History* 75, no. 4 (December 2006): 809–48. Closer to the present, anthropologist Simon Coleman has studied with great insight the discursive practices of Pentecostals who transform narratives and biblical texts into modes of embodiment in a variety of ways, then rearticulate them in a number of practices on a scale that constitutes a global habitus, in *The Globalization of Charismatic Christianity: Spreading the Gospel of Prosperity* (Cambridge: University of Cambridge Press, 2000), 117–42.

8. Pat Robertson, "The Law of Miracles," *The Secret Kingdom,* Christian Broadcasting Network, CBN TV www.cbn.com/tv/1405564599001, accessed February 28, 2013.

9. My thanks to colleagues Shalom Goldman and Marc Brettler for their assistance with identifying the Hebrew letter.

10. In addition to Luther and Philipp Melanchton, the group includes Johannes Bugenhagen, Caspar Cruciger, Justus Jonas, and Matthäus Aurogallus. Before them lie a variety of open books labeled "Greek Bible," "German Bible," "Latin Bible," "Hebrew Bible," "Targum," and "Rabbis."

11. A Dutch example of the engraving, *The Candle is Lighted,* is in the Rijksmuseum in Amsterdam, and dates to sometime between 1640 and 1684. For an English version of the print (though inaccurately titled), seehttp://en.wikipedia.org/wiki/History_of_Calvinism#mediaviewer/File:Leading_Theologians_of_the_Middle_Ages.jpg, accessed February 26, 2015.

12. Johann Muthmann, "Vorede: Von der Schätzbarkeit der deutschen Uebersetzung Lutheri," in *Evangelische Deutsche Original-Bibel,* 5. Emphasis in original. Muthmann paraphrased Psalm 36: 9 at the close of his preface, p. 24. The "Oriental" in the lower banner of the frontispiece may have derived from Muthmann's figure of *"der Aufgang aus der Höhe."* In traditional astronomical use, *Aufgang* refers to the ascension of the sun in the east, and therefore signifies the Orient.

13. Of course, this was not restricted to the Lutheran view of scripture. Calvin understood the authority of the Bible in a comparable manner: the scripture "came to us, by the instrumentality of men, from the very mouth of God," John Calvin, *Institutes of the Christian Religion,* trans. Henry Beveridge (Grand Rapids: Wm. B. Eedrmans, 1989), 72.

14. Calvin, *Institutes*, 38. Although first published in 1536 as *Institutio Christianae Religionis*, I am using the English translation of the last and much expanded Latin edition of the text, published in 1559: Joannis Calvini, *Institutionis Christianae religionis*, in *Opera Selecta*, 2nd rev. ed., eds. Petrus Barth and Guilelmus Niesel (Munich: Chr. Kaiser, 1957), vol. 3.

15. Calvin, *Institutes*, 43; *Institutionis Christianae religionis*, 45: "*sed ita se patefecit in toto mundi opificio, ac se quotidie palam offert, ut aperire oculos nequeant quin aspicere eum cogantur. Essentia quidem eius incomprehensibilis est, ut sensus omnes humanos procul effugiat eius numen: verum singulis operibus suis certas gloriae suae notas insculpsit, et quidem adeo claras et insignes u tsublata sit quanlibet rudibus et stupidis ignorantiae excusatio.*"

16. Calvin, *Institutes*, 51. Wesley A. Kort has argued that Calvin's reading of nature's texts as "second scriptures" was an important turn toward modern practices of reading nature, history, and poetry as scriptures; "Calvin's Theory of Reading," *Christianity and Literature* 62, no. 2 (Winter 2013): 189–202, esp. 199.

17. Calvin, *Institutes*, 59; *Institutionis Christianae religionis*, 56: "*stetuum enim cuique ingenium instar labyrinthi est, ut mirum non sit singulas Gentes in varia commenta diductas esse; neque id modo, sed singulis prope hominibus proprios fuisse deos.*"

18. Calvin, *Institutes*, 62–3; *Institutionis Christianae religionis*, 60: "*Simul enim ac modicum divinitatis gustum ex mundi speculatione delibavimus: vero Deo praetermisso, eiius loco somnia et spectra cerebri nostri erigimus.*"

19. Calvin, *Institutes*, 64.

20. Calvin, *Institutes*, 64–65.

21. Calvin, *Institutes*, 66; *Institutionis Christianae religionis*, 62–63: "*Ergo quanvis hominem serio oculos intendere conveniat ad consideranda Dei opera, quando in hoc splendidissimo theatro locates est ut eorum esset spectator: aures tamen praecipue arrigere convenit ad verbum, ut melius proficiat . . . . Quum itaque palam sit, Deum erga eos omnes quos unquam erudire cum fructu voluit, subsidium verbi adhibuisse, quod effigiem suam in pulcherrima mundi forma impressam, parum esse efficacem provideret: hac recta via contendere expedit, si ad synceram Dei contemplationem serio aspiramus. Ad verbum, inquam, est venienum, ubi probe, et ad vivum, nobis a suis operibus describatur Deus, dum opera ipsa non es iudicii nostril pravitate, sed aeterna veritatis regular aestimantur.*"

22. Calvin, *Institutes*, 67.

23. Calvin, *Institutes*, 37.

24. Calvin, *Institutes*, 69.

25. Calvin, *Institutes*, 71; *Institutionis Christianae religionis*, 68–69: "*Itaque summa Scripturae probatio passim a Dei loquentis persona sumitur . . . Imo si puros oculos, et integros sensus illuc afferimus, statim occurret Dei maiestas, quae subacta reclamandi audacia, nos simi parare cogat.*"

26. Calvin, *Institutes*, 72.

27. Calvin, *Institutes*, 72–73, italics added; *Institutionis Christianae religionis*, 70–71: "*Neque qualiter superstitionibus solent miseri homines captivam mentem addicere: sed quia non dubiam vim numinis illic sentimus vigere ac spirare, qua ad parendum, scientes quidem ac volentes, vividius tamen et efficacius quam pro humana aut voluntate, aut scientia trahimur et accendimur.*"

28. Calvin, *Institutes*, 72; *Institutionis Christianae religionis*, 70: "*Illius ergo virtute illuminati, iam non aut nostro, aut aliorum iudicio credimus, a Deo esse Scripturam: sed supra humanum iudicium, certo certiius constituimus (non secus acsi ipsius Dei numen illic intueremur) homineum ministerio, ab ipsissimo Dei ore ad nos fluxisse.*"

29. John Calvin, *A Treatise on Relics*, trans. Count Valerian Krasinki, 2$^{nd}$ ed. (Edinburgh: Johnstone, Hunter and Co., 1870), 162. Project Gutenberg eBook, www.gutenberg.org /ebooks/32136, accessed July 20, 2013. Jean Calvin, *Traité des reliques*, 1543, *Avertissement contre l'astrologie: Traité des reliques* (Paris: Librairie Armond Colin, 1962), 40–41: "*Or, le premier vice, et comme la racine du mal, a été, qu'au lieu de chercher Jésus-Christ en sa parole, en ses sacrements et en ses graces spirituelles, le monde, selon sa coutume, s'est amuse à ses robes, chemises et drapeaux; et en ce faisant a laissé le principal, pour suivre l'accessoire.*"

30. Calvin, *Treatise on Relics*, 163; *Traité des reliques*, 41: "*Car il [Paul] proteste de ne le connoître plus selon la chair, après sa resurrection, admonestant par ces mots que tout ce qui est charnel en Jésus-Christ se doit oublier et mettre en arrière, afin d'employer et mettre toute notre affection à le chercher et posséder selon l'esprit.*"

31. See Carlos M. N. Eire, *War against the Idols: The Reformation of Worship from Erasmus to Calvin* (New York: Cambridge University Press, 1990), 72–73, for a discussion of his differences with Zwingli and others.

32. Martin Luther, "A Brief Instruction on What to Look for and Expect in the Gospels," 1522, in Timothy F. Lull, ed., *Martin Luther's Basic Theological Writings* (Minneapolis: Fortress Press, 1989), 110; "Ein kleiner Unterricht, was man in den Evangelien suchen und gewarten solle," in *Luthers Werke*, ed. D. Buchwald et al, 3$^{rd}$ ed. (Berlin: C. A. Schwetschke und Sohn, 1905), vol. 5, 123: "*Und Evangelium eigentlich nicht Schrift, sondern mündlich Wort sein sollte, das die Schrift hervor trüge, wie Christus und die Apostel gethan haben. Darum auch Christus selbst nichts geschrieben, sondern nur geredet hat, und seine Lehre nicht Schrift, sondern Evangelium, das ist, eine gute Botschaft oder Verkündigung genannt hat, das nicht mit der Feder, sondern mit dem Munde soll getrieben warden.*"

33. R. W. Scribner, *For the Sake of Simple Folk: Popular Propaganda for the German Reformation* (Oxford: Clarendon, 1994), 161.

34. Raymond A. Mentzter, Jr., has discussed the use of biblical inscriptions in Huguenot churches. He points out that "decalogue boards" appeared in French and Dutch churches in the sixteenth and seventeenth centuries. These were tables displaying the Ten Commandments and appeared on walls behind and above the pulpit; see Mentzer, "The Reformed Churches of France and the Visual Arts," in Paul Corby Finney, ed., *Seeing Beyond the Word: Visual Arts and the Calvinist Tradition* (Grand Rapids: Eerdmans, 1999), 216–17.

35. The text is signified by portions of the following French, imitating the abbreviated Latin inscriptions on Roman altars and public tablets, which the pedestal forms in the painting recall: "*Tu aimeras le Seigneur ton Dieu de tout ton coeur, de toute ton âme et de tout ton esprit,*" and "*Tu aimeras ton prochain comme toi-meme.*" For a discussion of Lyon's religious upheaval at this moment, see Timothy Watson, "Preaching, Printing, Psalm-Singing: The Making and Unmaking of the Reformed Church in Lyon, 1550–1572," in Raymond A. Mentzer and Andrew Spicer, eds., *Society and Culture in the Huguenot World 1559–1685* (Cambridge: Cambridge University Press, 2002), 10–28; and on Huguenot

temples see, in the same volume, Andrew Spicer, "'Qui est de Dieu oit la parole de Dieu': The Huguenots and Their Temples," 175–92; and Hélène Guicharnaud, "An Introduction to the Architecture of Protestant Temples Constructed in France before the Revocation of the Edict of Nantes," in Finney, ed., *Seeing Beyond the Word*, 133–55, esp. 142. For an essay devoted to the architecture of the Temple de Paradis, see Bernard Reymond, "D'où le temple Paradis (1564–1567) tenait-il son modèle?" in *Le Bulletin de la Société de l'Histoire du Protestantisme Français*, no. 145 (April-June 1999): 263–84.

36. Calvin, *Institutes*, 324.

37. D.-F. Sécousse, ed., *Memoires de Condé*, 6 vols. (London: Claude de Bosc et Guillaume Darrés, 1743), vol. 2, 372.

38. Sécousse, ed., *Memoires de Condé*, 370.

39. The Edict of Saint Germaine (1562) allowed private construction outside walled cities and the Edict of Amboise (1563) allowed worship in certain cities, in the suburb of one city in each magistrate's jurisdiction, and on the grounds and in the homes of certain nobles. For further discussion see Spicer, "'Qui est de Dieu'," 180–81; Mack P. Holt, *The French Wars of Religion, 1562–1629*, 2nd edition (Cambridge: Cambridge University Press, 2005), 50–75; and Olivier Christin, "From Repression to Pacification: French Royal Policy in the Face of Protestantism," in *Reformation, Revolt and Civil War in France and the Netherlands 1555–1585*, eds. Philip Benedict, Guido Marnef, Henk van Nierop, and Marc Venard (Amsterdam: Royal Netherlands Academy of Arts and Sciences, 1997), 201–14, esp. 211–12.

40. For a historical overview of the religious landscape in England in the late eighteenth century, see David Hempton, "Enlightenment and Faith," in *The Eighteenth Century, 1688–1815*, ed. Paul Langford. Short Oxford History of The British Isles (Oxford: Oxford University Press, 2002), 71–100; for a narrative on British and American Evangelicals in the period, see Richard Cawardine, *Trans-Atlantic Revivalism: Popular Evangelicalism in Britain and America, 1790–1865* (Westport: Greenwood Press, 1978).

41. As archdeacon of St. Alban's in 1787, Samuel Horsley attacked Evangelical ministers as unequal to the calling of Established clergy; see Horsley, *A Sermon, preached in the Cathedral Church of Glocester, at the Public Ordination of Priests and Deacons, On Sunday, September 9, 1787, by the Rev. Samuel Horsley, LL.D, F.R.S., Archdeacon of St. Alban's and Prebendary of Glocester. Published by the command of the Right Rev. The Lord Bishop of Glocester* (Glocester: R. Raikes, 1787). Horsley continued his attack on Methodists and Dissenters after he was elevated to the rank of bishop and took a seat in Parliament; see "The Charge of Samuel, Lord Bishop of St. David's, to the Clergy of his Diocese; delivered at his primary Visitation, in the year 1790," 32–34, and "The Charge of Samuel, Lord Bishop of Rochester, to the Clergy of his Diocese; delivered at his second general visitation, in the year 1800," 148, both in *The Charges of Samuel Horsley, LL.D. F.R.S. F.A.S. Late Lord Bishop of St. Asaph; delivered at his several Visitations of the Dioceses of St. David's, Rochester, and St. Asaph* (Dundee: Robert Stephen Rintoul, for James Chalmers, 1813).

42. *The Debate in the House of Commons on Mr. Beaufoy's Motion for the Repeal of Such Parts of the Test and Corporation Acts as affect the Protestant Dissenters, on Friday the Eighth of May, 1789* (London: Printed for J. Johnson, 1789), 70: "Mr. Pitt declared, he was ready to do justice to the Dissenters of former times, as he was ready to do justice to the

present. It was not on the ground that they would do any thing to affect the civil Government of the country, that they had been excluded from holding civil offices, but that if they had any additional degree of power in their hands, they *might*."

43.	See "The Charge of Samuel, Lord Bishop of Rochester, to the Clergy of his Diocese; delivered at his second general visitation, in the year 1800," 145.

44.	*Debate on the Repeal of the Test and Corporation Act, Wednesday, March 28, 1787* (London: John Stockdale, 1787), 60: Ayes, 100; Noes, 178; Majority against the motion to repeal, 78; *The Debate in the House of Commons on Mr. Beaufoy's Motion for the Repeal of Such Parts of the Test and Corporation Acts as affect the Protestant Dissenters, on Friday the Eighth of May, 1789* (London: J. Johnson, 1789), 98: Ayes, 102; Noes, 122; majority against the motion to repeal, 20; *The Debate in the House of Commons, on the Repeal of the Corporation and Test Acts, March 2, 1790.* 2nd ed. (London: John Stockdale, 1790), 59: Ayes, 105; Noes, 294; majority against repeal, 189.

45.	David Bogue and James Bennett, *History of Dissenters, from the Revolution in 1688, to the Year 1808.* 4 vols. (London: printed for the authors, 1808–12), vol. 4, 187, 212, 217, 250, and 433.

46.	Andrew Fuller, *A Sermon on the Importance of a Deep and Intimate Knowledge of Divine Truth* (Elizabethtown, NJ: Shepard Kollock, [1796]), 34.

47.	Fuller, *A Sermon* , 16.

48.	Fuller, *A Sermon* , 16.

49.	I have examined the same process in the premillennial theology of William Miller in the United States; David Morgan, *Protestants and Pictures: Religion, Visual Culture, and the Age of American Mass Production* (New York: Oxford University Press, 1999), 124–28. Also a Baptist, Miller may very well have read Fuller's sermon.

50.	"Objections against a Mission to the Heathen, Stated and Considered, preached at Tottenham Court Chapel, before the Founders of the Missionary Society, On Thursday the 24th September, 1795, by David Bogue, of Gosport," in *Sermons, Preached in London, at the Formation of the Missionary Society, September 22, 23, 24, 1795* (London: T. Chapman, 1795), 130.

51.	For an account of the voyage, see John Griffin, *Memoirs of Captain James Wilson: Containing an Account of His Enterprises and Sufferings in India, His Conversion to Christianity, His Missionary Voyage to the South Seas, and His Peaceful and Triumphant Death,* 2nd ed. (London: Williams and Son, [1815?]).

52.	See the following works by members of the magazine's editorial board: George Burder, *Village Sermons, or, Short and Plain Discourses for the Use of Families, Schools, and Religious Societies* (London: Black, Parry and Kingsbury, 1812); William Kingsbury, *An Apology for Village Preachers* (London: T. Baker, 1798). For a polemical reply by two editors of the *Evangelical Magazine* to Samuel Horsley's criticism of Dissenter Sunday schools in his "Charge" of 1800, see John Townsend, *Hints on Sunday Schools and Itinerant Preaching; in a Letter to the Bishop of Rochester* (London: printed for the author, 1801) and Rowland Hill, *An Apology for Sunday Schools: The Substance of a Sermon, preached at Surry Chapel, February 22, 1801 . . . with Incidental Remarks on the late Charge of the Right. Rev. The Lord Bishop of Rochester* (London: C. Whittingham, and T. Williams, [1801]).

53.	[Reverend David Bogue,] *An Address to Christians, on the Distribution of Religious Tracts,* No. 1 (London: Printed for the RTS by P. Applegath and E. Cowper, [1799]), 3.

54. *Report of the Directors to the Members of the Missionary Society, at the Fourth General Meeting* (London: T. Chapman, 1798), 16.

55. *Report of the Directors to the Members of the Missionary Society, At their Fifth Annual Meeting* (London: T. Chapman, 1799), vi-vii.

56. *An Account of the Origin and Progress of the London Religious Tract Society* (London: Printed by A. Paris, 1803), 32.

57. Bogue, *Address,* 5.

58. Bogue, *Address,* 15.

59. *Proceedings of the First Twenty Years of the Religious Tract Society* (London: Benjamin Bensley, 1820), 257.

60. Bogue, *Address to Christians,* 10–11.

61. David Bogue, *The Diffusion of Divine Truth: A Sermon preached before the Religious Tract Society, on Lord's Day, May 18, 1800* (London: S. Rousseau for the Religious Tract Society, 1800), 10.

62. Bogue, *Diffusion of Divine Truth,* 10–11, 41.

63. John Gillies, quoted in Harry S. Stout, *The Divine Dramatist: George Whitefield and the Rise of Modern Evangelicalism* (Grand Rapids: Eerdmans, 1991), 140.

64. Morgan, *Protestants and Pictures,* 6–8.

65. I have discussed this in David Morgan, "Protestant Visual Piety and the Aesthetics of American Mass Culture," in *Mediating Religion: Conversations in Media, Religion and Culture,* eds. Jolyon Mitchell and Sophia Marriage (London: Continuum, 2003), 107–20, and in *The Lure of Images: A History of Religion and Visual Media in America* (London: Routledge, 2007), 31–36.

66. Bogue, *An Address to Christians,* 11.

67. *Anecdotes, Part I,* Tract No. 162 (London: A. Applegath and E. Cowper, [1808]), 7–8.

68. For a fascinating overview of the history of Evangelical fiction and reading in nineteenth-century America, see R. Laurence Moore, *Selling God: American Religion in the Marketplace of Culture* (New York: Oxford University Press, 1994), 12–39.

69. C. I. Latrobe, *A Concise Account of the Present State of the Missions of the United Brethren (Commonly called Moravians)* (London: Glendinning, 1801), 9.

70. Samuel Greatheed, "Plan of a General Union among Real Christians," *General Union Recommended to Real Christians, in a Sermon, preached at Bedford, October 31, 1797* (London: T. Conder, W. Button, and T. Chapman, 1798), xvii. The editors of the *Evangelical Magazine* enthusiastically promoted the Bedfordshire Union plan, "Befordshire Union," *Evangelical Magazine* 5 (October 1797), 425–28.

71. Bogue, "Objections against a Mission to the Heathen," in *Sermons,* 127.

72. A very fine study of the place of writing in British mission efforts is Anna Johnston, *Missionary Writing and Empire, 1800–1860* (Cambridge: Cambridge University Press, 2003).

73. Marilla Baker Ingalls, *Ocean Sketches of Life in Burmah* (Philadelphia: American Baptist Publication Society, 1858), 48.

74. "From a Speech of C. S. Dudley, Esq., at a late meeting of the Southampton Bible Society, England," 1817, reprinted in *Proceedings of the First Twenty Years,* 178. It is impossible to know with certainty how much of this account was concocted or assembled from

numerous other narratives. Of course, its accuracy was of little importance to the cultural work it performed among Christians in the United States. But the anecdote's details are suggestive. The final detail regarding the merchant's inability to return to China may also reflect a real circumstance: ostracism for betraying family and clan might await a Christian convert in China.

75. Letter from Reverend Joseph Edkins, 12 April 1852, in *Missionary Sketches*, no. 137 (October 1852), 2. Edkins went on to become a learned and well-published scholar of Chinese and Chinese religions.

76. *The Kan Ying Pien: Books of Rewards and Punishments*, trans. James Webster (Taipei: Ch'eng Wen, 1971).

77. For a discussion of Christian textualism and textual imperialism in Indian mission efforts, see Richard King, *Orientalism and Religion: Postcolonial Theory, India and 'The Mystic East'* (London: Routledge, 1999), 101–8.

78. David Shaw King, *Food for the Flames: Idols and Missionaries in Central Polynesia* (San Francisco: Beak Press, 2011), 30–31.

79. For discussion of such objects and the LMS Museum, see Sujit Sivasundaram, *Nature and the Godly Empire: Science and Evangelical Mission in the Pacific, 1795–1850* (Cambridge: Cambridge University Press, 2005), 181–85; David Morgan, "Thing," *Material Religion* 7, no. 1 (March 2011), 140–46; and Rosemary Seton, "Reconstructing the Museum of the London Missionary Society," *Material Religion* 8, no. 1 (2012): 98–102.

80. "Destruction of Idols," *Missionary Register*, March 1820, 127.

81. "Amboyna," *Twenty-sixth Report*, 1820, 39.

82. For a harrowing account of the series of temple and image burnings in 1830 on the island of Rarotogna, see the "Translation of a Letter received from Papeiha, Native Teacher at Rarotogna," Transactions of the Missionary Society, April 1831, in *Quarterly Chronicle* (1833), 291–93. The LMS expressed general approbation of this iconoclastic violence in *Missionary Sketches*, see "Destruction of Idols," no. 22 (July 1823), 4.

83. "Abolition of Idolatry," *Missionary Register*, February 1818, 68. See King, *Food for the Flames*, for careful documentation and narration of LMS mission history and its interaction with indigenous culture in Polynesia. For fascinating and insightful studies of the museum formed from the collection of cult objects from Oceania and elsewhere by the LMS, see King, *Food for the Flames*, 53–67, and 195–206; for the LMS catalogue and the portion of its collection that went to the British Museum, see Christopher Wingfield, "The Moving Objects of the London Missionary Society," PhD thesis, University of Birmingham, 2012.

84. "Java," *Twenty-third Report of the Missionary Society*, 1817, 10; see also Supper's letter to Steinkopf, dated August 12, 1816, reproduced in the appendix to the same issue, 54.

85. "Twenty-first Annual Report of the Religious Tract Society," abstracted in *Missionary Register*, December 1820, 512–14.

86. "Nineteenth Report of the Religious Tract Society," abstracted in *Missionary Register*, October 1818, 407.

87. Twenty-third Report of the Religious Tract Society," abstracted in *Missionary Register*, November 1822, 467,

88. "Circulation of Chinese and Malay Scriptures and Tracts," *Missionary Register,* May 1820, 216.

89. "Twentieth Report of the Religious Tract Society," abstracted in *Missionary Register,* September 1819, 392.

90. "Anecdotes and Incidents interspersed throughout the foregoing Journal," Tranquebar, March 15, 1805, in *Transactions in the Years 1803–1806,* vol. 2, 423.

91. "Extracts from the Journal of the Missionary Ringeltaube," *Transactions to the end of the Year 1812,* vol. 3, 138–39.

## CHAPTER 5. CHRISTIANITY AND NATIONHOOD

1. I do not undertake an intellectual history of the imagination, but limit my remarks to the role of nationhood and the likeness of Jesus as principal and characteristic forms of engaging imagination among Protestants and Catholics in the modern era. For a brief sketch of key contributions to the history of the imagination in Western philosophy and theology, see the Introduction. For work on the modern history of imagination, see Horst Bredekamp, Christiane Kruse, and Pablo Schneider, eds. *Imagination und Repräsentation: Zwei Bildsphären der Frühen Neuzeit* (Munich: Wilhelm Fink, 2010); Volkard Wels, "Zur Vorgeschichte des Begriffs der 'kreativen Phantasie,'" *Zeitschrift für Ästhetik und Allgemeine Kunstwissenschaft* 50 (2005): 199–226; Alessandro Nova and Klaus Krüger, eds., *Imagination und Wirklichkeit: Zum Verhältnis von mentalen und realen Bildern in der Kunst der frühen Neuzeit* (Mainz: Philipp von Zabern, 2000).

2. Richard King, *Orientalism and Religion: Postcolonial Theory, India, and "The Mystic East"* (London: Routledge, 1999), 96–117; and Brian K. Pennington, *Was Hinduism Invented? Britons, Indians, and the Colonial Construction of Religion* (Oxford: Oxford University Press, 2005).

3. For the importance of the idea of the nation as body in the Orientalist construction of India, see Ronald Inden, *Imagining India* (Bloomington: Indiana University Press, 2000), 7–13.

4. John Calvin, *Institutes of the Christian Religion,* trans. Henry Beveridge (Grand Rapids: Wm. B. Eerdmans Publishing Company, 1989), 97; Jean Calvin, *Institution de la Religion Chrestienne,* ed. Abel Lefranc, Henri Chatelain and Jacques Pannier (Paris: Librairie Honoré Champion, 1911), 131: *"Premierement l'entendement de l'homme, comme il creve d'orgueil et de temerité, ose imaginer Dieu selon son apprehension: et comme il est plein de rudesse et ignorance, au lieu de Dieu, il ne conceoit que vanité et un phantasme."* A fascinating study of the theological evolution of the idea of imagination in the Reformed tradition is William A. Dyrness, *Reformed Theology and Visual Culture: The Protestant Imagination from Calvin to Edwards* (Cambridge: Cambridge University Press, 2004).

5. Thomas Shepard, *The Sincere Convert,* in *The Works of Thomas Shepard,* vol. 1 (New York: AMS Press, 1967), 107.

6. John Bunyan, *The Pilgrim's Progress,* ed. W. R. Owens (Oxford: Oxford University Press, 2003), 10.

7. Dante Alighieri, *The Divine Comedy I: Inferno,* trans. and ed. Robin Kirkpatrick (London: Penguin, 2006), p. 3 (canto 1, lines 1–3).

8. For a study of the literary form of the late medieval dream vision and its history see J. Stephen Russell, *The English Dream Vision: Anatomy of a Form* (Columbus: Ohio State University Press, 1988).

9. Thomas Hobbes, *Elements of Law Natural and Public*, ed. Ferdinand Tönnies (London: Simpkin, Marshall, 1889), part 1, chap. 1, para. 8, p. 2.

10. Hobbes, *Elements of Law*, part 1, chap. 3, para. 1, p. 8.

11. John Milton, *Paradise Lost*, ed. Scott Elledge, Norton Critical Edition, 2nd ed. (New York: W. W. Norton, 1993), book 5, lines 105–8, p. 116.

12. Bunyan, *Pilgrim's Progress*, 11.

13. Bunyan, *Pilgrim's Progress*, 14.

14. Bunyan, *Pilgrim's Progress*, 15.

15. Milton, *Paradise Lost*, book 5, lines 571–76, p. 128. Reference to Milton by David Hawkes, in John Bunyan, *The Pilgrim's Progress* (New York: Barnes and Noble Classics, 2005), 344–45.

16. Alberto Ronco, *Fortezza reale del cuore humano* (Modena: Cassian, 1628), 55: *"Cosi puoi dire, ò anima mia, riuolta al dolcissimo Giesù, metre lo comtempli sedente nel tuo cuore, e che l'adorna, fregia, dipinge, e riccama cò i colori delle virtù; tu mi creaste, o signore, e doppò d'hauermi creata ponesti la mano della tua gratia nel mio cuore per abbellirlo, e qui potrai anima mia far guiditio dell'affettione, & amore del tuo Dio verso di te, mentre non solo ti creò ad imagine, e somiglianza sua, quando disse,* faciamus hominem ad imaginem, & similitudinem nostrum, *mà ti fregiò di tanti doni, e fauori."*

17. Ronco, *Fortezza reale*, 1.

18. Hannah More, *Practical Piety*, in *The Works of Hannah More*, 7 vols. (New York: Harper and Brothers, 1855), vol. 4, 14.

19. More, *Practical Piety*, 113. The idea of the inner eye may derive from Adam Smith's notion of the internal spectator as described in his *Theory of Moral Sentiments* (1759).

20. Hannah More, "The Sunday School," *Stories for Persons of the Middle Ranks*, in *The Works of Hannah More*, 2 vols. (Boston: S. G. Goodrich, 1827), vol. 1, 180.

21. Hannah More, *The Shepherd of Salisbury Plain* (West Smithfield: J. Evans and Co., printers to the Cheap Repository for Moral and Religious Tracts; London: Hatchard; Bath: S. Hazard, 1795), 2–3.

22. More, *Shepherd of Salisbury Plain*, 6.

23. More, *The Shepherd of Salisbury Plain* , 16–17.

24. More, *Practical Piety*, 119.

25. More, *Practical Piety*, 122.

26. More, *Practical Piety*, 94.

27. More, *Practical Piety*, 98.

28. More, *Practical Piety*, 100.

29. The image of Leviathan has been very carefully and insightfully discussed by Horst Bredekamp, "Thomas Hobbes's Visual Strategies," in *The Cambridge Companion to Hobbes's Leviathan*, ed. Patricia Springborg (Cambridge: Cambridge University Press, 2007), 29–60; and Bredekamp, *Thomas Hobbes Visuelle Strategien Der Levithan: Urbild des modernen Staats* (Berlin: Akademie Verlag, 1999).

30. Ernest Kantorowicz, *The King's Two Bodies: A Study in Medieval Political Theology* (Princeton: Princeton University Press, 1957), 9.

31. Thomas Hobbes, *Leviathan*, ed. Edwin Curley (Indianapolis: Hackett, 1994), 109 (part 2, ch. 17, para. 13).

32. Bredekamp, "Thomas Hobbes's Visual Strategies," 30–3.

33. Hobbes, *Leviathan*, 106 (part 2, ch. 17, para. 1).

34. Hobbes, *Leviathan*, 109 (12, 13). For consideration of Hobbes within the history of early modern British political thought, see Glenn Burgess, *British Political Thought, 1500–1660* (Houndmills: Palgrave Macmillan, 2009), 296–323; for a fascinating study of images of kingship in England, see Richard C. McCoy, *Alterations of State: Sacred Kingship in the English Reformation* (New York: Columbia University Press, 2002).

35. This is a highly condensed characterization, but I prefer to direct the reader to specialists engaged in the much-contested topic of the nation and its origin. For a very fine and learned introduction to the definition of nationhood see Peter Hoppenbrouwers, "The Dynamics of National Identity in the Later Middle Ages," in *Networks, Regions and Nations: Shaping Identities in the Low Countries, 1300–1650*, eds. Robert Stein and Judith Pollmann (Leiden: Brill, 2010), 19–41. Hoppenbrouwers makes a case for situating the birth of nationhood in the late Middle Ages. Adrian Hastings, *The Construction of Nationhood: Ethnicity, Religion and Nationalism* (Cambridge: Cambridge University Press, 1997), is a spirited argument not only for a medieval basis for nations, but for an explicitly Christian influence, according religion a principal role in the formation of nationhood. Patrick J. Geary mounts strong opposition to dating the process to the earlier Middle Ages, *The Myth of Nations: The Medieval Origins of Europe* (Princeton: Princeton University Press, 2002). For the perennial account of nationalism see John Armstrong, *Nations Before Nationalism* (Chapel Hill: University of North Carolina Press, 1982). Among the most influential modernist explications of nationhood are Eric Hobsbawm, *Nations and Nationalism since 1780* (Cambridge: Cambridge University Press, 1990), Benedict Anderson, *Imagined Communities: Reflections on the Origin and Spread of Nationalism* (London: Verso, 1991), and Liah Greenfeld, *Nationalism: Five Roads to Modernity* (Cambridge: Harvard University Press, 1992). A very clear and informed overview of the debate, and one that favors in the end a modern definition of nation and nationalism, is Anthony D. Smith, *The Nation in History: Historiographical Debates about Ethnicity and Nationalism* (Hanover, NH: University Press of New England, 2000), 27–51.

36. Anderson, *Imagined Communities*, 37–46.

37. Hannah More, *Moral Sketches of Prevailing Opinions and Manners, Foreign and Domestic* (Boston: Wells and Lilly, 1819), 5.

38. More, *Moral Sketches*, 12–13.

39. More, *Moral Sketches*, 66.

40. More, *Moral Sketches*, 53.

41. See Raymond Jonas, *France and the Cult of the Sacred Heart: An Epic Tale for Modern Times* (Berkeley: University of California Press, 2000), 24–27.

42. Margaret Mary Alacoque, letter 100, to Mother de Saumaise, June 1689, *The Letters of St. Margaret Mary Alacoque, Apostle of the Sacred Heart*, trans. Father Clarence A. Herbst, S.J. (Rockford, IL: TAN Books, 1997), 147. The French original, Sainte Marguerite-Marie, *Oeuvres choisies* (Paray-Le-Monial: Monastère de la Visitation Sainte-Marie, 1962), 238–39, reads: *"Il désire donc, ce me semble, entrer avec pompe et magnificence dans la*

*maison des princes et des rois, pour y être honoré autant qu'il y a été outragé, méprisé et humilié en sa Passion, et qu'il reçoive autant de plaisir de voir les grands de la terre abaissés et humiliés devant lui, comme il a senti d'amertume de se voir anéanti à leurs pieds. Et voici les paroles que j'entendis au sujet de notre Roi: 'Fais savoir au Fils aîné de mon sacré Cœur que, comme sa naissance temporelle a été obtenue par la dévotion aux mérites de ma sainte Enfance, de même il obtiendra sa naissance de grâce et de gloire éternelle par la consecration qu'il fera de lui-même à mon Cœur adorable, qui veut triompher du sien, et par son entremise, de celui des grands de la terre. Il veut régner dans son palais, être peint dans ses étendards et gravé dans ses armes, pour les render victorieuses de tous ses ennemis, en abattant à ses pieds ces têtes orgueilleuses et superbes, pour le render victorieux de tous les ennemis de la sainte Eglise.'"*

43. I have examined the history of the Sacred Heart in this regard, see *The Embodied Eye: Religious Visual Culture and the Social Life of Feeling* (Berkeley: University of California Press, 2012), 127–36.

44. Jonas offers a helpful historical account of the Sacré-Coeur within French national history and the Sacred Heart of Jesus: *France and the Cult of the Sacred Heart*, 198–223.

45. John Winthrop, "A Modell of Christian Charity," 1630, reprinted in Conrad Cherry, ed., *God's New Israel: Religious Interpretations of American Destiny*, rev. ed. (Chapel Hill: University of North Carolina Press, 1998), 39. For a compelling history of the republican ideal in British Protestantism from Tudor England to the Massachusetts Bay Colony see Michael P. Winship, *Godly Republicanism: Puritans, Pilgrims, and a City on a Hill* (Cambridge: Harvard University Press, 2012).

46. Winthrop, "A Modell," 40.

47. Winthrop, "A Modell," 39.

48. Winthrop, "A Modell," 40.

49. Jonathan Edwards, "The Latter-Day Glory Is Probably to Begin in America," 1743, reprinted in Cherry, ed., *God's New Israel*, 54–58.

50. Bunyan, *The Pilgrim's Progress*, 229.

51. See Hawkes, commentary to Bunyan, *The Pilgrim's Progress*, 361n21.

52. Bunyan, *The Pilgrim's Progress*, 202.

53. I have discussed Boughton's picture and its historical situation, "Painting as Visual Evidence," in *Using Visual Evidence*, eds. Richard Howells and Robert W. Matson (London: Open University Press, 2009), 8–23, and in "The Protestant Image of the Bible in America," in *The Bible in the Public Square*, eds. Carol Meyers, Mark Chancey, and Eric Meyers (Atlanta: Society of Biblical Literature, 2014), 102–4.

54. William George Read, *Oration Delivered at the First Commemoration of the Landing of the Pilgrims of Maryland* (Baltimore: John Murphy, 1842), 6.

55. Father Andrew White provided his own account in a report to the superior general of the Society of Jesus in Rome: "On the day of the annunciation of the Holy Virgin Mary, on the 25th of March, in the year 1634, we offered in this island [which they'd named Saint Clement's Island, just off the coast of the mainland, downstream from where the Potomac intermingles with the Chesapeake Bay], for the first time, the sacrifice of the mass: in this region of the world it had never been celebrated before. Sacrifice being ended, having taken up on our shoulders the great cross which we had hewn from a tree, and going in procession to the place that had been designated, the Governor, commissioners, and other

catholics participating in the ceremony, we erected it as a trophy to Christ the Saviour, while the litany of the holy cross was chaunted humbly on our bended knees, with great emotion of soul," Father Andrew White, *A Relation of the Colony of the Lord Baron of Baltimore, in Maryland, near Virginia; a Narrative of the Voyage to Maryland*, trans. N. C. Brooks Force, Collection of Historical Tracts, vol. 4, no. 12 (Washington, DC, 1846), 19.

56. Read, *Oration*, 15.

57. Read, *Oration*, 44n1.

58. Read, *Oration*, 29.

59. *Address of the Editorial Committee of the Catholic Tract Society of Baltimore to the Public* (Baltimore: Catholic Tract Society, 1839), 2. Both this tract and Read's *Oration* were printed by John Murphy in Baltimore, which may account for the availability of the engraving for the cover of Read's speech.

60. See for example Theodore Maynard, *The Catholic Church and the American Idea* (New York: Appleton-Century-Crofts, 1953), 26: "The true line of descent therefore of the Founding Fathers was from Locke to Hooker and from Hooker to the scholastics."

61. Read, *Oration*, 31–32. The "Act of Religious Toleration" has been viewed in different ways over the years. For the text of the Act, see "Maryland's Act of Religious Toleration (1649)," in Mark Massa, S.J., with Catherine Osborne, ed. *American Catholic History: A Documentary Reader* (New York: New York University Press, 2004), 17–19; for historical discussions of the Act and the Maryland colony see James Hennesey, "Roman Catholicism: The Maryland Tradition," 41–54, and Gerald P. Fogarty, S.J., "Property and Religious Liberty in Colonial Maryland Catholic Thought," 55–82, in *Early American Catholicism, 1634–1820: Selected Historical Essays*, ed. Timothy Walch (New York: Garland Publishing, 1988).

62. Read, *Oration*, 32.

63. Robert Michaelson, "Common School, Common Religion? A Case Study in Church-State Relations, Cincinnati 1869–1870," *Church History* 38, no. 2 (June 1969): 201–17; R. Laurence Moore, "Bible Reading and Nonsectarian Schooling: The Failure of Religious Instruction in Nineteenth-Century Public Education," *Journal of American History* 86, no. 4 (March 2000): 1,581–599; Tracy Fessenden, "The Nineteenth-Century Bible Wars and the Separation of Church and State," *Church History* 74, no. 4 (December 2005): 784–811; and for a detailed discussion of the Catholic history of the topic, see Jon Gjerde, *Catholicism and the Shaping of Nineteenth-Century America*, ed. S. Deborah King (New York: Cambridge University Press, 2012), 138–75. For the visual history of the Bible and later flag controversies, see Morgan, *The Sacred Gaze*, 220–55, and "The Image of the Protestant Bible in America," in *The Bible in the Public Square*, eds. Carol Meyers, Mark Chancey, Eric Meyers. Biblical Scholarship in North America (Atlanta: Society of Biblical Literature, 2014), 93–120.

64. "Archbishop John Hughes Condemns the Public School Society of New York and New York Politicians," in Massa, ed., *American Catholic History*, 48.

65. See Moore's helpful research in, "Bible Reading and Nonsectarian Schooling." For discussion of the bible controversy in Cincinnati, see Michealson, "Common School, Common Religion?" and Fessenden, "Nineteenth-Century Bible Wars," 801–6.

66. Cited in Reverend George W. Gue, *Our Country's Flag* (Davenport, IA: Edbert, Fidlar, and Chambers, 1890), 95. Gue was a member of the GAR and pastor of the First Methodist

Episcopal Church of Rock Island, Illinois. He included in his book a poem entitled "Our Country's Flag on God's Sacred Altars," by J. W. Temple, 93. On the page opposite Temple's poem is an illustration of public school and a church flying the flag. As many of the quotations, speeches, verse, and hymns in Gue's volume demonstrate, flag piety was born in the crisis of the Civil War.

67. Newton Bateman, "The Patriot's Flag," in Gue, *Our Country's Flag*, 137.

68. Thus, the author of one well-known guide to the veneration of the flag in public schools, Colonel George T. Balch, criticized sectarian religious schooling, insisting that all Americans attend public schools, where they might be properly engaged in the civic piety of the nation; Balch, *Methods of Teaching Patriotism in the Public Schools* (New York: D. Van Nostrand, 1890), xviii. Catholic prelates meeting in the First and Second Plenary Councils of Baltimore (1852 and 1866) issued policies that required Catholic parents in America to send their children to Catholic schools. In 1875 the Vatican reinforced the councils' directives; see "Instruction of the Propaganda Fide Concerning Catholic Children in American Public Schools," in Massa, ed., *American Catholic History*, 54–7.

69. See Scot M. Guenter, *The American Flag, 1777–1924: Cultural Shifts from Creation to Codification* (Cranbury, NJ: Associated University Presses, 1990); Robert Justin Goldstein, ed., *Desecrating the American Flag: Key Documents of the Controversy from the Civil War to 1995* (Syracuse, NY: Syracuse University Press, 1996); Cecilia Elizabeth O'Leary, *To Die For: The Paradox of American Patriotism* (Princeton: Princeton University Press, 1999), esp. 172–93; and Morgan, *The Lure of Images*, 187–95.

70. Guenter, *The American Flag*, 178.

71. Owen Chadwick, *A History of the Popes 1830–1914* (Oxford: Clarendon Press, 1998), 72.

72. Chadwick, *A History of the Popes*, 92.

73. "Syllabus of Errors," excerpted in *The Sources of Catholic Dogma*, trans. Roy J. Deferrari, from the thirteenth edition of Henry Denziger's *Enchiridion Symbolorum* (Fitzwilliam, NH: Loreto Publications, 1955), 439.

74. "Syllabus of Errors," 440.

75. Jay Dolan, *In Search of an American Catholicism: A History of Religion and Culture in Tension* (New York: Oxford University Press, 2002), 37.

76. Dolan, *In Search*, 54.

77. The image also appeared soon after on the cover of a brochure to promote the construction of the National Shrine of the Immaculate Conception in Washington, DC. The image is discussed in Thomas A. Tweed, *America's Church: The National Shrine and Catholic Presence in the Nation's Capital* (New York: Oxford University Press, 2011), 158, 185–86; see also Morgan, *The Sacred Gaze*, 245–47.

78. Read, *Oration*, 23. A contemporary speech celebrating Calvert, White, and their founding of the colony also made a point of holding up their peaceful and forthright relations with local Indians: "What is now St. Mary's county was immediately purchased and payment made, not in fire arms or fire-water, but in hatchets, axes, hoes, and cloth. In other plantations pretended purchase were but bribes of present drunkenness for future slaughter, but here the means of tilling the soil and covering their nakedness were the substantial benefits conferred. If such had been the conduct of all the settlers, what protracted contexts, what sacrifice of human life, what national dishonor what terrible

offerings on the altar of the Evil One might have been avoided!" William A. Stokes, "The Pilgrims of Maryland," *The Religious Cabinet* 1, no. 4 (April 1842), 197.

79.  See Tweed, *America's Church*, 206–14, esp. 211 regarding Pfisterer.

80.  An instructive survey of Black nationalist movements in the nineteenth and twentieth centuries is E. U. Essien-Udom, *Black Nationalism: A Search for an Identity in America* (Chicago: University of Chicago Press, 1962), 17–62. A more recent study of the topic, and one that includes a chapter on religion, is James Lance Taylor, *Black Nationalism in the United States: From Malcolm X to Barack Obama* (Boulder: Lynne Rienner Publishers, 2011). A study of the nineteenth-century African colonization movement in the United States is P. J. Staudenraus, *The African Colonization Movement 1816–1865* (New York: Columbia University Press, 1961). For a discussion of the racially grounded understanding of nationhood that informed the colonization idea, and the visceral reaction against it from many Black leaders, see Morgan, *The Embodied Eye*, 140–45. For an excellent tracing of the history of Black nationalism from Harlem to the present with respect to the legacy of African religious influence, see Tracey E. Hucks, *Yoruba Traditions and African American Religious Nationalism* (Albuquerque: University of New Mexico Press, 2012).

81.  Marcus Garvey, "An Appeal to the Conscience of the Black Race to See Itself," 1923, reprinted in *Let Nobody Turn Us Around: Voices of Resistance, Reform, and Renewal: An African American Anthology*, eds. Manning Marable and Leith Mullings (Oxford: Rowan and Littlefield, 2000), 266.

82.  Quoted in in Bruce J. Dierenfield and John White, *A History of African-American Leadership*, 3rd ed. (Harlow, England: Pearson, 2012), 97.

83.  Garvey on the UNIA, 1914, quoted in Dierenfield and White, *A History of African-American Leadership*, 94.

84.  Garvey, "An Appeal," 267.

85.  See www.jonmcnaughton.com/vedio3/, accessed November 27, 2012. On the history of the pledge see Ralph J. Ellis, *To the Flag: The Unlikely History of the Pledge of Allegiance* (Lawrence, KS: University Press of Kansas, 2005).

86.  http://lds.about.com/od/historyfamilyhistory/a/Church-Dispensations.htm, accessed November 27, 2012. See also the entry "dispensation" in the Bible Dictionary of the Church of Jesus Christ of Latter-day Saints, www.lds.org/scriptures/bd/dispensations?lang = eng&letter = d, accessed November 27, 2012.

87.  A pertinent study of the American jeremiad tradition to the present day is Andrew R. Murphy, *Prodigal Nation: Moral Decline and Divine Punishment from New England to 9/11* (New York: Oxford University Press, 2009).

## CHAPTER 6. THE LIKENESS OF JESUS

1.  For a discussion of the letter of Publius Lentulus and its visual history, see Alexander Sturgis, "Diptych with the Head of Christ and the Lentulus Letter," in *The Image of Christ*, ed. Gabriele Finaldi (London: National Gallery, 2000), 94–97.

2.  The French text reads: *"Je vous envoie ce Portrait et vous donne quelques détails d'un home d'une vertu singuliere que est en Judée dans ce moment, et qu'on appelle JÉSUS-CHRIST; Les*

*barbares le croient prophète, mais ses sectateurs l'adorent comme descendu des Dieux immortels. Il ressucite les morts et guérit toutes sortes de maladies par la parole ou l'attouchement. Il est d'une taille grande et bien formée; il a l'air doux et vénérable; ses cheveux sont d'une couleur qu'on ne saurait guere comparer; ils tombent en boucles jusqu'au dessous des oreilles, et se répandent sur les épaules ave beaucoup de grace, partagés sur le sommet de la tête à la maniere des Nazarèens; son front est uni et large, et ses joues ne sont marquées que d'une amiable rougeur; son nez et sa bouche sont formés avec une admirable symetrie, sa barbe épaisse; et d'une couleur qui correspond à celle de ses cheveux, descend un ponce au dessous du menton, et se divisant vers le milieu fait à peu près la figure d'une fourche; ses yeux sont brillants clairs et sereins. Il censure avec majesté, exhorte avec douceur; soit qui'l parle on qu'il agisse, il le fait avec élégance et gravité. Jamais on ne l'a vu rire mais on l'a vu souvent pleurer; il est fort tempéré, fort discret, et fort sage. C'est un homme enfin qui, par son excellente bonté et ses divines perfections surpasse les enfants des hommes."*

3. Conversation with the author, October 5, 2000, Los Angeles Temple Visitors Center, Los Angeles, California.

4. Saint John of Damascus, *Three Treatises on the Divine Images*, trans. Andrew Louth (Crestwood, NY: St. Vladimir's Seminary Press, 2003), 25.

5. John quoted Gregory of Nyssa on the perception of divine beauty as comparable to the way in which "painters transfer human forms on to tablets by means of certain colors, applying corresponding paints by imitation, so that the beauty of the archetype is transferred with accuracy to the likeness," *Three Treatises*, 47.

6. Appealing to the Byzantine tradition in which images of the emperor could stand in for the absent emperor, John commented that "if the image of the emperor is the emperor, and the image of Christ is Christ, and the image of the saint is a saint, then the power is not divided nor the glory shared, but the glory of the image becomes that of the one depicted in the image," *Three Treatises*, 42.

7. Pliny the Elder, *Natural History*, trans. H. Rackham, Loeb Classical Library (Cambridge: Harvard University Press, 1952), book 35, ch. 43, para. 152, p. 373.

8. David Hume, *The Natural History of Religion*, in *Principal Writings on Religion*, ed. J. C. A Gaskin. Oxford's World Classics (Oxford: Oxford University Press, 1993), 141.

9. E. F., *Son of Man: Pictures and Carvings by Indian, African and Chinese Artists* (London: Society for the Propagation of the Gospel, 1946), 4.

10. An excellent study of the history of race in American Christian thought, practice, and social history is Edward J. Blum and Paul Harvey, *The Color of Christ: The Son of God and the Saga of Race in America* (Chapel Hill: University of North Carolina Press, 2012). A fascinating historical study of Christian belief and practice on the matter of race and imagination is Willie Jennings, *The Christian Imagination: Theology and the Origins of Race* (New Haven: Yale University Press, 2010).

11. See David Morgan, "The Likeness of Christ in Sallman's Art," in *Icons of American Protestantism: The Art of Warner Sallman*, ed. David Morgan (New Haven: Yale University Press, 1996), 192–93.

12. Matthew O. Richardson shared this anecdotal account at a conference at Brigham Young University Museum of Art, November 16, 2006. For a brief history of images of Christ among Latter-Day Saints, see his essay "Bertel Thorvalden's *Christus:* A Latter-Day Saint

Icon of Christian Evidence," in Herman du Toit and Doris R. Dant, eds., *Art and Spirituality: The Visual Culture of Christian Faith* (Provo: BYU Studies, 2008), 189–201. For a television piece produced by Brigham Young University on Thorvaldsen and his statue, see www.byutv.org/show/66d6413f-c116-441a-a094-33a8a9c0226f/bertel-thorvaldsens-christus, accessed March 9, 2015.

13. I invited readers of two dozen Christian magazines and newsletters to send their evaluations of Warner Sallman's imagery to me. The result was 531 letters, which I analyzed in *Visual Piety: Religious Visual Culture in Theory and Practice* (Berkeley: University of California Press, 1998). See also Morgan, ed., *Icons of American Protestantism*.

14. For an example of the event today in Brazil, see www.youtube.com/watch?v=JzNcovNKqwk, accessed March 9, 2015.

15. This is of course the historian's perspective, not that of believers who can point to a long tradition of conviction that Jesus's likeness was recorded in one way or another. The belief that there were ancient and authentic portraits of Jesus was firmly asserted by the learned sixteenth-century Flemish theologian Johannes Molanus in his monumental *Treatise on Sacred Images* (1570); see Molanus, *Traité des sainte images,* trans. François Bœspflug, Olivier Christin, and Benoît Tassel (Paris: Les Éditions du Cerf, 1996), vol. 1, 286–89.

16. See Robin Margaret Jensen, *Face to Face: Portraits of the Divine in Early Christianity* (Minneapolis: Augsburg Fortress Press, 2005) and Thomas F. Matthews, *The Clash of the Gods: A Reinterpretation of Early Christian Art,* rev. and ex. ed. (Princeton: Princeton University Press, 1999).

17. Here is an instance of the story as it continues to circulate: "We've all heard the story about how Del Parson took the first painting to Spencer W. Kimball himself (or a different prophet), who said that it didn't look enough like the Savior, and then gave Brother Parson further instructions until he was finally able to produce a painting that looked enough like the Savior to be appropriate." Inspiring Stories (blog), Nov. 23, 2010, http:// jbb-inspiringstories.blogspot.com/2010/11/del-parsons-painting-christ-in-red-robe .html, accessed September 19, 2012.

18. For reproductions of each picture and the suggestion that Chambers's image influenced Parson's, see Seeking Zion (blog), August 15, 2012, http://seekingzion.blogspot .com/2012_08_01_archive.html, accessed November 29, 2014.

19. See Sixten Ringbom, *Icon to Narrative: The Rise of the Dramatic Close-Up in Fifteenth-Century Devotional Painting* (Doornspijk: Davaco, 1984); Henk van Os, with Eugène Honée, Hans Nieuwdorp, Bernhard Ridderbos, *The Art of Devotion in the Late Middle Ages in Europe, 1300–1500,* trans. Michael Hoyle (Princeton: Princeton University Press, 1994); Ena Giurescu Heller, ed., *Icons or Portraits? Images of Jesus and Mary from the Collection of Michael Hall* (New York: Gallery at the American Bible Society, 2002).

20. On portrait imagery as modern means of personal identification, see Richard Brilliant, *Portraiture* (London: Reaktion, 1991), 40–43.

21. See Seymour Slive, *Dutch Painting 1600–1800* (New Haven: Yale University Press, 1995), 93.

22. See Michael Zell, *Reframing Rembrandt: Jews and the Christian Image in Seventeenth-Century Amsterdam* (Berkeley: University of California Press, 2002), 56–57; although

he is not referring to the series of images from 1648 to 1656, Franz Landsberger, *Rembrandt: The Jews and the Bible,* trans. Felix N. Gerson (Philadelphia: The Jewish Publication Society of America, 1946), 116, confidently states that "Rembrandt was the first artist courageous enough to show Jesus with Jewish features." For a technical analysis, dating, and attributions of the group of images see Mark Tucker, Lloyd DeWitt, and Ken Sutherland, "The Heads of Christ: A Technical Survey," in *Rembrandt and the Face of Jesus,* ed. Lloyd DeWitt (Philadelphia: Philadelphia Museum of Art, 2011), 31–72.

23. Lloyd DeWitt, "Testing Tradition Against Nature: Rembrandt's Radical New Image of Jesus," in *Rembrandt and the Face of Jesus,* 109–45.

24. As reported to the author; see Morgan, "Warner Sallman and the Visual Culture of American Protestantism," in *Icons of American Protestantism,* 32–33.

25. James Tissot, *The Life of Our Saviour Jesus Christ* (New York: Doubleday and McClure, 1898), vol. 1, ix.

26. On the prominent example of F. Holland Day, a photographer who created artistic imagery of Jesus, see Kristin Schwain, *Signs of Grace: Religion and American Art in the Gilded Age* (Ithaca: Cornell University Press, 2008), 71–103.

27. Henry Ward Beecher, *The Life of Jesus, the Christ* (New York: J. B. Ford, 1871), 102: "No man will ever succeed in so reproducing an age long past that it shall seem to the beholder as it did to those who lived in it. Even if one is in possession of all the facts, and has skill to draw a perfect picture, he cannot prevent our looking upon a past age with modern eyes, and with feelings and associations that will put into the picture the coloring of our own time . . . . We cannot see [Jesus] in Galilee, nor in Judea, just as he was. We look back upon him through a blaze of light. The utmost care will not wholly prevent our beholding Jesus through the medium of subsequent history. It is not the Jesus who suffered in Palestine that we behold, but the Christ that has since filled the world with his name."

28. Kate P. Hampton, "The Face of Christ in Art: Is Portraiture of Jesus Strong or Weak?" *The Outlook* 61, no. 13 (April 1, 1899): 736.

29. For a contemporaneous catalogue of newspaper adulation of Munkácsy's painting, see Charles M. Kurtz, *Christ before Pilate: The Painting by Munkascy* [sic] (New York: published for the exhibition, 1887); I have discussed the reception of Munkácsy's image and its relation to contemporary visual media in David Morgan, *The Lure of Images: A History of Religious Visual Media in America* (London: Routledge, 2007), 170–72. Not everyone appreciated the painting or its promotion in Manhattan. A review in the *New York Times* was largely critical of the image itself, but especially contemptuous of what the reviewer alleged was the painting's financially motivated hyping, evident, for example, in its theatrical staging at the Twenty-third Street Tabernacle, where the picture debuted "in the presence of a number of clergymen" in November 1886: "Christ Before Pilate: Munkacsy's Picture as a Star," *New York Times,* November 1886, 5. When the *Times* reviewed Tissot's biblical imagery when it appeared in Manhattan in 1898, the writer recalled the controversy over Munkácsy's painting, but refused to treat Tissot's project as having been undertaken with "thought of gain" ("The Tissot Pictures and Drawings," *New York Times,* November 15, 1898, 6). In 1892, Gustave Doré's art was brought to Manhattan, where an entire gallery of work (thirty-eight canvases) was displayed in Carnegie Music Hall

for several months; see Eric Zafran, "'A Strange Genius': Appreciating Gustave Doré in America," in *Fantasy and Faith: The Art of Gustave Doré,* ed. Eric Zafran, with Robert Rosenblum and Lisa Small (New Haven: Yale University Press, 2007), 156–57.

30. On Tissot's reception, see Judith F. Dolkart, "*The Life of Christ* Comes to the "Acropolis of Brooklyn," in *James Tissot: The Life of Christ,* ed. Judith F. Dolkart (Brooklyn: Brooklyn Museum; London: Merrell, 2009), 35–47.

31. Hampton, "The Face of Christ in Art," 744.

32. Hampton, "The Face of Christ in Art," , 740.

33. See note 26 above.

34. Hampton, "The Face of Christ in Art," 746. For a contemporaneous example of composite photography, in which different portraits were overlaid photographically to produce a single, collective image, see H. P. Bowditch, "Are Composite Photographs Typical Pictures?" *McClure's Magazine* 3 (September 1894), 331–42.

35. Hampton, "The Face of Christ in Art," 748.

36. Letter 274, May 10, 1993, correspondence file, Sallman Archives, Jessie Wilson Art Galleries, Anderson University.

37. Pamela Schaeffer and John L. Allen Jr., "Jesus 2000," National Catholic Reporter Online, December 24, 1999, http://natcath.org/NCR_Online/archives2/1999d/122499/122499a .htm, accessed November 27, 2012.

38. Schaeffer and Allen, "Jesus 2000."

39. Elizabeth A. Johnson, "Jesus of the People," in Susan Perry, ed., *Holiness and the Feminine Spirit: The Art of Janet McKenzie* (Maryknoll, NY: Orbis Books, 2009), 73.

40. The image is available online at "Why Do We Think Christ was White?" BBC News, March 27, 2001, http://news.bbc.co.uk/2/hi/1244037.stm, accessed August 19, 2014. For further discussion see Megan Rosenfeld, "Putting a Fresh Face on Jesus: Discovery, PBS Specials Explore Changing Images," *The Washington Post,* April 15, 2001, www .highbeam.com/doc/1P2-434970.html, accessed March 9, 2015.

41. Mike Fillon, "The Real Face of Jesus," *Popular Mechanics* 179, no. 12 (December 2002): 68–71.

42. Bruce Barton, *The Man Nobody Knows: A Discovery of the Real Jesus* (Indianapolis: Bobbs-Merrill Company, [1924] 1925), vi.

43. Fillon, "The Real Face of Jesus," 71. For further discussion of the modern American history of the masculinity of Jesus in religious imagery see Morgan, *Visual Piety,* 97–123.

44. Fillon, "The Real Face of Jesus," 71.

## CHAPTER 7. MODERN ART AND CHRISTIANITY

1. Pierre Bourdieu, *Distinction: A Social Critique of the Judgment of Taste,* trans. Richard Nice (Cambridge: Harvard University Press, 1984).

2. Howard S. Becker, *Art Worlds* (Berkeley: University of California Press, 1982), x

3. Friedrich Schiller, *Letters on the Aesthetic Education of Man,* in *Essays,* eds. Walter Hinderer and Daniel O. Dahlstrom (New York: Continuum, 1993), 164.

4. Michel Foucault, "About the Beginning of the Hermeneutics of the Self," in *Religion and Culture,* ed. Jeremy R. Carrette (New York: Routledge, 1999), 159.

5. Foucault, "About the Beginning," 162.

6. Michel Foucault, *Discipline and Punish: The Birth of the Prison,* trans. Alan Sheridan (New York: Vintage Books, 1995), 195–228.

7. John Wilton-Ely, *Giovanni Battista Piranesi: The Complete Etchings* (San Francisco: Alan Wofsy, 1994).

8. Foucault, *Discipline and Punish,* 200.

9. Thomas Stackhouse, *Reflections on the Nature and Property of Languages* [1731], excerpted in *The Sublime: A Reader in British Eighteenth-Century Aesthetic Theory,* eds. Andrew Ashfield and Peter de Bolla (Cambridge: Cambridge University Press, 1996), 49. It is worth pointing out that the sublime was not without an important precedent in earlier Protestant thought. John Calvin taught that the glory of God was imprinted on the physical features of the created universe. Although God's essence was "incomprehensible, utterly transcending all human thought," his splendor was visible indeed, and Calvin described its effect in terms that recall the language of sublimity. "Wherever you turn your eyes," Calvin wrote, "there is no portion of the world, however minute, that does not exhibit at least some sparks of beauty; while it is impossible to contemplate the vast and beautiful fabric as it extends around, without being overwhelmed by the immense weight of glory." John Calvin, *Institutes of the Christian Religion,* trans. Henry Beveridge (Grand Rapids, MI: Wm. B. Eerdmans, 1989), 51 (chap. 5, para. 1). Yet for Calvin this overwhelming glory did the important work of obviating any human excuse not to affirm the existence of God. The visceral force of its manifest facticity stood in stark contrast to the abject failure of human reason and imagination to apprehend the transcendent deity. God's very glory was proof of his sovereignty and of the affront of human attempts to circumscribe him in the forge of idols that the mind could only be. The eighteenth-century sublime, by contrast, was something that even clergymen could embrace as a compelling sensation of the expansive and glorious life of the human mind.

10. John Baillie, *An Essay on the Sublime* [1747], excerpted in Ashfield and De Bolla, *The Sublime,* 88.

11. Friedrich Schiller, "On the Sublime (Toward the Further Development of Some Kantian Ideas)," 1793, in *Essays,* 22. Emphasis in original.

12. Schiller, "On the Sublime," 43.

13. Immanuel Kant, *Critique of Judgment,* tr. J. H. Bernard (New York: Hafner Publishing Company 1951), 39.

14. Kant, *Critique of Judgment,* 37, 157.

15. Kant, *Critique of Judgment,* 88.

16. Kant, *Critique of Judgment,* 95.

17. G. W. F. Hegel, *Aesthetics: Lectures on Fine Art,* trans. T. M. Knox (Oxford: Clarendon Press, 1975), vol. 1, 81.

18. G. W. F. Hegel, *On Art, Religion, Philosophy,* ed. J. Glenn Gray (New York: Harper Torchbooks, 1970), 31.

19. Hegel, *Aesthetics,* 175.

20. Hegel, *On Art,* 59.

21. William Blake, *Jerusalem: The Prophetic Books of William Blake,* eds. E. R. D. MacLagan and A. G. B. Russell (London: A.H. Bullen, 1904), stanza 5, lines 15–18, 39–40, p. 8.

22. Arthur Schopenhauer, *The World as Will and Representation*, trans. E. F. J. Payne (Indian Hills, Colorado: The Falcon's Wing Press, 1958), vol. 1, 197–98. Schopenhauer called the state of knowing in aesthetic experience "objectivity" and the state of normal rational consciousness "subjectivity," since the former meant rising above the self and the latter meant sinking into it. But the aesthetic ideal that I am describing does not conform to his Platonist scenario, which neatly recapitulates what Plato described as the reincarnation of the soul in *Phaedrus*.

23. Bernard Berenson, *Aesthetics and History* (Garden City, NY: Doubleday, [1948] 1954), 93.

24. For an instructive summary account of the painting and its fascinating reception, see Joseph Leo Koerner, *Caspar David Friedrich and the Subject of Landscape*, 2nd edition (London: Reaktion Books, 2009), 56–61.

25. F. W. B. von Ramdohr, "Über ein zum Altarblatte bestimmtes Landschaftsgemälde von Herrn Friedrich in Dresden, und über Landscahftsmalerei, Allegorie und Mystizismus überhaupt," *Zeitung für die elegante Welt* 9 (1809): 89–95, 97–104, 108–11, 113–19; reprinted in Sigrid Hinz, ed., *Caspar David Friedrich in Briefen und Bekenntnissen* (Berlin: Henschelverlag, 1968), 138: *"es teilt die Meinung des Publikums; es macht Effekt auf den großen Haufen. Und wenn ich nun sehe, daß die Tendenz, die hier das Talent nimmt, dem guten Geschmack gefährlich wird, daß sie dem Wesen der Malerei, besonders der Landschafts-malerei, ihre eigenthümlichsten Vorzüge raubt."*

26. Hinz, ed., *Caspar David Friedrich*, 89: *"Denen Herren Kunstrichtern genügen unsere teutsche Sonne, Mond und Sterne, unsere Felsen, Bäume und Kräuter, unsere Ebenen, Seen und Flüsse nich mehr. Italienisch muß alles sein, um Anspruch auf Größe und Schönheit machen zu können."* For a discussion of the occasion and the resulting text, see Hinz, ed., *Caspar David Friedrich*, 251.

27. I have said nothing about the importance of landscape painting in the Romantic tradition in the United States and elsewhere. The literature is quite large and I am happy to point the reader to it in order to address the massive ranges of material that space will not allow me to consider: William H. Truettner and Alan Wallach, eds., *Thomas Cole: Landscape into History* (New Haven: Yale University Press and Washington, DC: National Museum of American Art, 1994); Diane Apostolos-Cappadona, *The Spirit and the Vision: The Influence of Christian Romanticism on the Development of Nineteenth-Century American Art* (Atlanta: Scholar's Press, 1995); John Davis, *The Landscape of Belief: Encountering the Holy Land in Nineteenth-Century American Art and Culture* (Princeton: Princeton University Press, 1996); and Andrew Wilton and Tim Barringer, *American Sublime: Landscape Painting in the United States 1820–1880* (London: Tate Publishing, 2002). I have also not taken up the legacy of Swedenborgianism and other sorts of mystical and hermetic traditions. For work in these areas see Adrienne Baxter Bell, *George Inness and the Visionary Landscape* (New York: National Academy of Design and G. Braziller, 2003); David Bjelajac, *Washington Allston, Secret Societies, and the Alchemy of Anglo-American Painting* (New York: Cambridge University Press, 1996); and Regina Soria, Joshua C. Taylor, Jane Dillenberger, and Richard Murray, *Perceptions and Evocations: The Art of Elihu Vedder* (Washington, DC: Smithsonian Institution Press, 1979).

28. See Cordula Grewe, *Painting the Sacred in the Age of Romanticism* (Burlington: Ashgate, 2009), 2–4, 149–85. See also Cordula Grewe, *The Nazarenes: Romantic Avant-Garde and*

*the Art of the Concept* (University Park, Pennsylvania: The Pennsylvania State University Press, 2015); Lionel Gossman, *The Making of a Romantic Icon: The Religious Context of Friedrich Overbeck's* Italia und Germania (Philadelphia: American Philosophical Society, 2007); and William Vaughan, *German Romantic Painting* (New Haven: Yale University Press, 1980), 163–90.

29. See Bruno Foucart, *Le renouveau de la peinture religieuse en France, 1800–1860* (Paris: Arthena, 1987) and Michael Paul Driskel, *Representing Belief: Religion, Art, and Society in Nineteenth-Century France* (University Park: Pennsylvania State University Press, 1992).

30. Alphonse Germain, "L'art religieux au XIXe siècle en France," *Le Correspondent* (1907): 244, quoted in Foucart, *Renouveau,* 247.

31. Quoted in Linda Nochlin, ed., *Realism and Tradition in Art 1848–1900: Sources and Documents* (Englewood Cliffs, NJ: Prentice-Hall, 1966), 108. For further discussion see Tim Barringer, Jason Rosenfeld, and Alison Smith, *Pre-Raphaelites: Victorian Avant-Garde* (London: Tate Publishing, 2012), 124–25.

32. John Calvin, *Institutes of the Christian Religion,* trans. Henry Beveridge (Grand Rapids, Michigan: Eerdmans, 1989), 51.

33. Calvin, *Institutes ,* 52.

34. See William A. Dryness, *Reformed Theology and Visual Culture: The Protestant Imagination from Calvin to Edwards* (Cambridge: Cambridge University Press, 2004).

35. See Henri Dorra, ed., *Symbolist Theories of Art: A Critical Anthology* (Berkeley: University of California Press, 1994); Patricia Townley Mathews, *Aurier's Symbolist Art Criticism and Theory* (Ann Arbor: UMI Research Press, 1986); Jean-Marc Debenedetti and Serge Baudiffier, *Les Symbolistes* (Paris: Henri Veyrier, 1990); Reinhold Heller, *Munch: His Life and Work* (Chicago: University of Chicago Press, 1984); Debora Silverman, *Van Gogh and Gauguin: The Search for Sacred Art* (New York: Farrar Straus and Giroux, 2000).

36. G. Albert Aurier, "Symbolism in Painting: Paul Gauguin," 1891, in Dorra, ed. *Symbolist Theories of Art,* 199.

37. Albert Aurier, "Essay on a New Method of Criticism," ca. 1890, reprinted in Herschel B. Chipp, *Theories of Modern Art* (Berkeley: University of California Press, 1968), 87.

38. Aurier, "Symbolism in Painting," 198.

39. To Emile Bernard, from Le Pouldu, June 1890, in Maurice Malingue, ed., *Paul Gauguin: Letters to his Wife and Friends,* trans. Henry J. Stenning (Cleveland and New York: The World Publishing Company, 1949), 144.

40. See Silverman, *Van Gogh and Gauguin,* 31–35, and 278–303, for aspects of this.

41. Silverman, *Van Gogh and Gauguin,* 297.

42. Adding insult to injury, Vincent, his erstwhile comrade in art, expressed disappointment in the method of Gauguin's picture, accusing him of relying on memory as a way of distancing the image from nature. Vincent referred to Gauguin and his painting explicitly in a letter to his brother; see Richard Brettell, François Cachin, Claire Frèches-Thory, and Charles F. Stuckey, *The Art of Paul Gauguin* (Washington, DC: National Gallery, 1988), 161–63.

43. To Emile Schuffenecker, from Le Pouldu, November 16, 1889, in Malingue, ed., *Paul Gauguin,* 131.

44. See Sven Loevgren, *The Genesis of Modernism: Seurat, Gauguin, van Gogh, & French Symbolism in the 1880's,* rev. ed. (Bloomington: Indiana University Press, 1971), 142. Yet Loevgren goes on to suggest that Gauguin may have regarded Aurier himself as a Judas in 1890 for choosing not to continue to hail his work in public, 147.

45. Aurier, "Symbolism in Painting," 202.

46. Wassily Kandinsky, *Concerning the Spiritual in Art and Painting in Particular,* 2nd edition (1912), in *Kandinsky: Complete Writings on Art,* eds. Kenneth C. Lindsay and Peter Vergo (New York: Da Capo Press, 1994), 133–34, 137.

47. Kandinsky, *Concerning the Spiritual ,* 177.

48. Kandinsky, *Concerning the Spiritual ,* 181.

49. For a study of veiled figures, especially figures drawn from religious imagery, in Kandinsky's work around 1911–12, see Rose-Carol Washton Long, *Kandinsky: The Development of an Abstract Style* (Oxford: Clarendon Press, 1980).

50. Washton Long, *Kandinsky,* 96–97, 108–22.

51. An especially insightful discussion of Kandinsky and his art as spiritual is a presentation by the art historian and critic Donald Kuspit, "Reconsidering the Spiritual in Art," *Blackbird* 2, no. 1 (Spring 2003): http://blackbird.vcu.edu/v2n1/gallery/kuspit_d/reconsidering_text.htm, accessed March 9, 2015.

52. I have already cited studies of the Romantic landscape tradition and the various traditions of mystical, hermetic, masonic thought and practice in the visual arts (see note 27 above); on the occult and theosophical, see note 65 below; to these may be added several other lines of inquiry that examine different aspects of art and religion in the twentieth century: Sally M. Promey, *Painting Religion in Public: John Singer Sargent's* Triumph of Religion *at the Boston Public Library* (Princeton: Princeton University Press, 1999); Joanne Cubbs and Eugene W. Metcalf, eds., *Hard Truths: The Art of Thornton Dial* (Indianapolis: Indiana Museum of Art, and Munich: Prestel, 2011), and Samantha Baskind, *Jewish Artists and the Bible in Twentieth-Century America* (University Park: Pennsylvania State University Press, 2014).

53. Willem De Kooning, "What Abstract Art Means to Me," 1951, reprinted in *Abstract Expressionism: A Critical Record,* eds. David Shapiro and Cecile Shapiro (New York: Cambridge University Press, 1990), 222.

54. "Northwest Coast Indian Painting," 1946, reprinted in Barnett Newman, *Selected Writings and Interviews,* ed. John P. O'Neill (New York: Alfred A. Knopf, 1990), 108.

55. Edmund Burke, *A Philosophical Enquiry into the Origin of Our Ideas of the Sublime and Beautiful,* ed. J. T. Boulton (Notre Dame: University of Notre Dame, 1958).

56. Barnett B. Newman, "The Sublime is Now," 1948, reprinted in Shapiro and Shapiro, eds., *Abstract Expressionism,* 325.

57. See Wendy Steiner's fascinating study, *Venus in Exile: The Rejection of Beauty in Twentieth-century Art* (Chicago: University of Chicago Press, 2001), where she strongly critiques the aesthetic of the sublime in modernism as rooted in misogyny. Steiner's point is corroborated by Aurier's remark about the sensualism of women and by Newman's consignment of basketwork design to women.

58. Newman, "The Sublime in Now," 328.

59. Newman, "The Sublime in Now," 328. In this essay, Newman contrasted invigorated American art, in quest of the sublime, with the sensualism of European art driven by the ideal of figural beauty.

60. Quoted in *Newsweek*, May 9, 1966, 100; reprinted in Newman, *Selected Writings*, 187–88.

61. "The Fourteen Stations of the Cross, 1958–1966," *ARTnews* 65, no. 3 (May 1966): 26–28, 57; reprinted in Newman, *Selected Writings*, 189.

62. His comments came on the occasion of a symposium entitled "Spiritual Dimensions of Contemporary Art," 1967, reprinted in Newman, *Selected Writings*, 290

63. Newman, *Selected Writings*, 289.

64. Newman, *Selected Writings*, 190, see also 284.

65. Lynn Gamwell, *Exploring the Invisible: Art, Science, and the Spiritual* (Princeton: Princeton University Press, 2002); Richard Francis, ed. *Negotiating Rapture: The Power of Art to Transform Lives* (Chicago: Museum of Contemporary Art, 1996); Roger Lipsey, *An Art of Our Own: The Spiritual in Twentieth-Century Art* (Boston: Shambhala, 1989); Andreas C. Papadakis, ed., *Abstract Art and the Rediscovery of the Spiritual* (London: Art & Design, 1987); Maurice Tuchman, ed., *The Spiritual in Art: Abstract Painting, 1890–1985* (Los Angeles: Los Angeles County Museum of Art, 1986).

66. For an exhibition that included a good deal of such work by major artists, see Meg Cranston and John Baldessari, *100 Artists See God* (New York: Independent Curators International, 2004). I organized a forum on this exhibition in a journal that I coedit: "100 Artists See God: A Forum," *Material Religion* 3, no. 1 (March 2007): 120–42. There is no shortage of other publications that document the broad interests among contemporary artists in religion. See Paul C. Burns, ed., *Jesus in Twentieth-century Literature, Art, and Movies* (New York: Continuum, 2007). S. Brent Plate, *Blasphemy: Art That Offends* (London: Black Dog, 2006); Eleanor Heartney, *Postmodern Heretics: Catholic Imagination in Contemporary Art* (New York: Midmarch Arts Press, 2004); Erika Doss, "Robert Gober's 'Virgin' Installation: Issues of Spirituality in Contemporary American Art," in David Morgan and Sally M. Promey, eds. *The Visual Culture of American Religions* (Berkeley: University of California Press, 2001): 129–45; Kay Turner, *Beautiful Necessity: The Art and Meaning of Women's Altars* (London: Thames and Hudson, 1999); Rosemary Crumlin, *Beyond Belief: Modern Art and the Religious Imagination* (Melbourne: National Gallery of Victoria, 1998); Jane Daggett Dillenberger, *The Religious Art of Andy Warhol* (New York: Continuum, 1998).

67. See for example Karen von Veh's studies of contemporary South African artists who make use of Christian subject matter: "The Intersection of Christianity and Politics in South African Art: A Comparative Analysis of Selected Images since 1960, with an Emphasis on the Post-Apartheid Era," *De Arte*, no. 85 (2012): 5–25.

68. See James Elkins and David Morgan, eds., *Re-Enchantment* (New York: Routledge, 2009), for a documentation of the mess of sorting out the conflicted relation. For a range of other views, see Ena Giurescu Heller, ed., *Reluctant Partners: Art and Religion in Dialogue* (New York: Gallery at the American Bible Society, 2004).

69. See Steiner, *Venus in Exile*, esp. 1–31.

70. James Elkins, *On the Strange Place of Religion in Contemporary Art* (New York: Routledge, 2004), 20.

71. Elkins, *On the Strange Place*, 20.

72. Johann Wolfgang von Goethe, "Ueber Wahrheit und Wahrscheinlichkeit in der Kunst-werke," 1798, reprinted in *Goethe's Sämmtliche Werke* (Stuttgart: J. G. Cotta'schen Verlag, 1855), vol. 5, 304: *"Wenn die Oper gut is, macht sie freilich eine kleine Welt für sich aus, in der alles nach gewissen Gesetzen vorgeht, die nach ihren eigenen Gesetzen beurtheilt, nach ihren eigenen Eigenschaften gefühlt seyn will."*

73. Thierry de Duve, in *Re-Enchantment*, 160–61.

74. Paco Barragán, "Interview with Bill Viola," *ArtPulse Magazine*, http://artpulsemagazine .com/interview-with-bill-viola, accessed January 9, 2014; also published in Selene Wendt and Paco Barragán, eds., *When a Painting Moves . . . Something Must be Rotten!* (Milan: Edizione CHARTA, 2011), 31–35.

75. http://filefestival.org/site_2007/filescript_pop.asp?cd_pagina=311&id=2&cd_materia=414, accessed March 9, 2015.

76. "Artist Biography," Bill Viola (website), www.billviola.com/biograph.htm, accessed January 9, 2014.

77. www2.artsmia.org/blogs/art-remix/the-remixes/bill-viola/, accessed March 9, 2015.

78. Barragán, "Interview with Bill Viola."

## CONCLUSION

1. See www.huffingtonpost.com/2013/09/04/pledge-of-allegiance-challenge_n_3866087 .html, accessed March 9, 2015.

2. See Joshua Green, "Roy and His Rock," *The Atlantic* (October 1, 2005): 70–82, and Joshua Green, "What Happened to Roy Moore's Ten Commandments Monument?" *The Atlantic* (March 30, 2011): www.theatlantic.com/politics/archive/2011/03/what-happened-to-roy-moores-ten-commandments-monument/73221/, accessed July 2, 2013. Moore was reelected chief justice of the Alabama Supreme Court in November 2012.

3. Albert Schweitzer, *The Quest of the Historical Jesus: A Critical Study of Its Progress from Reimarus to Wrede*, 2nd ed., trans. W. Montgomery (London: Adam and Charles Black, 1910), 4.

4. Talal Asad, *Genealogies of Religion: Discipline and Reasons of Power in Christianity and Islam* (Baltimore: Johns Hopkins University Press, 1993), 27–54.

5. Bruno Latour, *We Have Never Been Modern*, trans. Catherine Porter (Cambridge, MA: Harvard University Press, 1993), 10.

6. See for instance the massive hodgepodge of essays, *Iconoclash: Beyond the Image Wars in Science, Religion, and Art*, eds. Bruno Latour and Peter Weibel (Karlsruhe: Center for Art and Media, and Cambridge, MA: MIT Press, 2002).

# SELECTED BIBLIOGRAPHY

*An Account of the Origin and Progress of the London Religious Tract Society.* London: Printed by
A. Paris, 1803.

Adams, Alison. *Webs of Allusion: French Protestant Emblem Books of the Sixteenth Century.*
Geneva: Droz, 2003.

Alacoque, Margaret Mary. *The Autobiography of Saint Margaret Mary Alacoque.* Translated by
Sisters of the Visitation. Rockford, IL: TAN Books, 1986.

———. *The Letters of St. Margaret Mary Alacoque, Apostle of the Sacred Heart.* Translated by
Father Clarence A. Herbst, S.J. Rockford, IL: TAN Books, 1997.

Anderson, Benedict. *Imagined Communities: Reflections on the Origin and Spread of Nationalism.*
London: Verso, 1991.

Apostolic Penitentiary. *Manual of Indulgences: Norms and Grants.* Translated from the fourth
edition (1999) of *Enchiridion Indulgentiarum: Normae et Concessiones.* Washington, DC:
United States Conference of Catholic Bishops, 2006.

Apostolos-Cappadona, Diane. *The Spirit and the Vision: The Influence of Christian Romanticism
on the Development of Nineteenth-Century American Art.* Atlanta: Scholar's Press, 1995.

Armstrong, John. *Nations Before Nationalism.* Chapel Hill: University of North Carolina Press,
1982.

Asad, Talal. *Genealogies of Religion: Discipline and Reasons of Power in Christianity and Islam.*
Baltimore: Johns Hopkins University Press, 1993.

Asamoah-Gyadu, J. Kwabena. "Of Faith and Visual Alertness: The Message of 'Mediatized'
Religion in an African Pentecostal Context." *Material Religion* 1, no. 3, (2005): 340–46.

Ashfield, Andrew, and Peter de Bolla, eds. *The Sublime: A Reader in British Eighteenth-Century
Aesthetic Theory.* Cambridge: Cambridge University Press, 1996.

Aston, Margaret. *England's Iconoclasts: Laws against Images*. Oxford: Clarendon Press, 1988.

———. *The King's Bedpost: Reformation and Iconography in a Tudor Group Portrait*. Cambridge: Cambridge University Press, 1993.

Aston, Margaret, and Elizabeth Ingram. "The Iconography of the Acts and Monuments." In *John Foxe and the English Reformation,* edited by David Loades, 66–142. Aldershot: Ashgate, 1997.

Augustine. *Confessions*. Translated by Henry Chadwick. Oxford: Oxford University Press, 1991.

Bacon, Francis. *The Physical and Metaphysical Works of Lord Bacon*. Edited by Joseph Devey. London: George Bell and Sons, 1904.

Balch, Colonel George T. *Methods of Teaching Patriotism in the Public Schools*. New York: D. Van Nostrand, 1890.

Barringer, Tim, Jason Rosenfeld, and Alison Smith. *Pre-Raphaelites: Victorian Avant-Garde*. London: Tate Publishing, 2012.

Barton, Bruce. *The Man Nobody Knows: A Discovery of the Real Jesus*. Indianapolis: Bobbs-Merrill Company, [1924] 1925.

Baskind, Samantha. *Jewish Artists and the Bible in Twentieth-Century America*. University Park: Pennsylvania State University Press, 2014.

Bataille, Georges. *Theory of Religion*. Translated by Robert Hurley. New York: Zone Books, 1992.

Becker, Howard S. *Art Worlds*. Berkeley: University of California Press, 1982.

Beecher, Henry Ward. *The Life of Jesus, the Christ*. New York: J. B. Ford, 1871.

Belting, Hans. *Likeness and Presence: A History of the Image before the Era of Art*. Translated by Edmund Jephcott. Chicago: University of Chicago Press, 1994.

Berenson, Bernard. *Aesthetics and History*. Garden City, NY: Doubleday, 1954.

Betteridge, Thomas. "Visibility, Truth and History in *Acts and Monuments*." In *John Foxe and his World,* edited by Christopher Highley and John King, 145–59. Aldershot: Ashgate, 2002.

Bjelajac, David. *Washington Allston, Secret Societies, and the Alchemy of Anglo-American Painting*. New York: Cambridge University Press, 1996.

Blake, William. *Jerusalem: The Prophetic Books of William Blake*. Edited by E. R. D. MacLagan and A. G. B. Russell. London: A. H. Bullen, 1904.

Blum, Edward J., and Paul Harvey. *The Color of Christ: The Son of God and the Saga of Race in America*. Chapel Hill: University of North Carolina Press, 2012.

Bogue, David. *An Address to Christians, on the Distribution of Religious Tracts*, No. 1. London: Printed for the RTS by P. Applegath and E. Cowper, [1799].

———. *The Diffusion of Divine Truth: A Sermon Preached before the Religious Tract Society, on Lord's Day, May 18, 1800*. London: S. Rousseau for the Religious Tract Society, 1800.

Bogue, David, and James Bennett, *History of Dissenters, from the Revolution in 1688, to the Year 1808*. 4 vols. London: Printed for the authors, 1808–12.

Bonaventura. *The Life of Saint Francis*. London: J. M. Dent, 1904.

Bredekamp, Horst. "Thomas Hobbes's Visual Strategies," in *The Cambridge Companion to Hobbes's Leviathan,* edited by Patricia Springborg, 29–60. Cambridge: Cambridge University Press, 2007.

Brilliant, Richard. *Portraiture*. London: Reaktion, 1991.

Briscese, Rosangela, and Joseph Sciorra, eds. *Graces Received: Painted and Metal Ex-Votos from Italy: The Collection of Leonard Norman Primiano*. New York: John D. Calandra Italian American Institute, Queens College, City University of New York, 2012.

Bunyan, John. *The Pilgrim's Progress*. Edited by W. R. Owens. Oxford: Oxford University Press, 2003.

Burgess, Glenn. *British Political Thought, 1500–1660*. Houndmills: Palgrave Macmillan, 2009.

Burke, Edmund. *A Philosophical Enquiry into the Origin of Our Ideas of the Sublime and Beautiful*. Edited by J. T. Boulton. Notre Dame: University of Notre Dame, 1958.

Calvin, Jean. *Institution de la Religion Chrestienne*. Texte de la première edition française, edited by Abel Lefranc, Henri Chatelain, and Jacques Pannier. Paris: Librairie Honoré Champion, 1911.

———. *Avertissement contre l'astrologie. Traité des reliques*. Paris: Librairie Armond Colin, 1962.

Calvin, John. *Institutes of the Christian Religion*. Translated by Henry Beveridge. Grand Rapids: Wm. B. Eerdmans, 1989.

Calvini, Joannis. *Institutionis Christianae religionis*. In *Opera Selecta*, Vol. 3. 2nd rev. ed., edited by Petrus Barth and Guilelmus Niesel. Munich: Chr. Kaiser, 1957.

Campa, Pedro F. and Peter M. Daly, eds., *Emblematic Images and Religious Texts: Studies in Honor of G. Richard Dimler, S.J.* Philadelphia: Saint Joseph's University Press, 2010.

Carlstadt, Andreas Bodenstein. *The Essential Carlstadt*. Translated and edited by E. J. Furcha. Waterloo, Ontario and Scottdale, PA: Herald Press, 1995.

Carnegie, Andrew. *Autobiography of Andrew Carnegie*. Boston: Houghton and Mifflin Company, 1924.

Carruthers, Mary. *The Book of Memory: A Study of Memory in Medieval Culture*. 2nd ed. Cambridge: Cambridge University Press, 2008.

Cawardine, Richard. *Trans-Atlantic Revivalism: Popular Evangelicalism in Britain and America, 1790–1865*. Westport: Greenwood Press, 1978.

Chadwick, Owen. *A History of the Popes 1830–1914*. Oxford: Clarendon Press, 1998.

Cherry, Conrad, ed. *God's New Israel: Religious Interpretations of American Destiny*. Rev. ed. Chapel Hill: University of North Carolina Press, 1998.

Chiluwa, Innocent. "Religious Vehicle Stickers in Nigeria: A Discourse of Identity, Faith, and Social Vision," *Discourse and Communication* 2, no. 4 (2008): 371–87.

Chipp, Herschel B. *Theories of Modern Art*. Berkeley: University of California Press, 1968.

Christensen, Carl C. *Princes and Propaganda: Electoral Saxon Art of the Reformation*. Sixteenth-Century Essays and Studies, 20. Kirksville, MI: Sixteenth-Century Journal Publishers, 1992.

Christian, Jr., William A. *Local Religion in Sixteenth-Century Spain*. Princeton: Princeton University Press, 1981.

Christin, Olivier. "From Repression to Pacification: French Royal Policy in the Face of Protestantism." In *Reformation, Revolt and Civil War in France and the Netherlands 1555–1585*, edited by Philip Benedict, Guido Marnef, Henk van Nierop, and Marc Venard, 201–14. Amsterdam: Royal Netherlands Academy of Arts and Sciences, 1997.

Coleman, Simon. *The Globalization of Charismatic Christianity: Spreading the Gospel of Prosperity*. Cambridge: University of Cambridge Press, 2000.

———. "Materializing the Self: Words and Gifts in the Construction of Charismatic Protestant Identity." In *The Anthropology of Christianity*, edited by Fenella Cannell, 163–84. Durham: Duke University Press, 2006.

Conwell, Russell H. *Acres of Diamonds*. Philadelphia: Temple University Press, 2002.

Copeland, Kenneth. *The Laws of Prosperity*. Greensburg, PA: Manna Christian Outreach, 1974.

Cranston, Meg, and John Baldessari. *100 Artists See God*. New York: Independent Curators International, 2004.

Croiset, John. *The Devotion to the Sacred Heart*. Translated by Father Patrick O'Connell. 2nd ed. Rockford, Illinois: TAN Books, 1988.

Cummings, Brian. "Images in Books: Foxe EIKONOKLASTES." In *Art Re-Formed: Re-Assessing the Impact of the Reformation on the Visual Arts*. Edited by Tara Hamling and Richard L. Williams, 183–200. Newcastle: Cambridge Scholars Publishing, 2007.

Davis, John. *The Landscape of Belief: Encountering the Holy Land in Nineteenth-Century American Art and Culture*. Princeton: Princeton University Press, 1996.

De Certeau, Michel. "What We Do When We Believe." In *On Signs,* edited by Marshall Blonsky, 192–202. Baltimore: Johns Hopkins University Press, 1985.

Dekoninck, Ralph. *Ad Imaginem: Statuts, fonctions et usages de l'image dans la littérature spirituelle jésuite du XVII Siècle*. Geneva: Droz, 2005.

DeWitt, Lloyd, ed. *Rembrandt and the Face of Jesus*. Philadelphia: Philadelphia Museum of Art, 2011.

Dierenfield, Bruce J., and John White. *A History of African-American Leadership*. 3rd ed. Harlow: Pearson, 2012.

Dolan, Jay. *In Search of an American Catholicism: A History of Religion and Culture in Tension*. New York: Oxford University Press, 2002.

Dolkart, Judith F., ed. *James Tissot: The Life of Christ*. Brooklyn: Brooklyn Museum; London: Merrell, 2009.

Dorra, Henri, ed. *Symbolist Theories of Art: A Critical Anthology*. Berkeley: University of California Press, 1994.

Doss, Erika. "Robert Gober's 'Virgin' Installation: Issues of Spirituality in Contemporary American Art." In *The Visual Culture of American Religions,* edited by David Morgan and Sally M. Promey, 129–45. Berkeley: University of California Press, 2001.

Dowling, John. *The History of Romanism: From the Earliest Corruptions of Christianity to the Present Time*. 6th ed. New York: Edward Walker, 1845.

Durand, Jorge, and Douglas S. Massey. *Miracles on the Border: Retablos of Mexican Migrants to the United States*. Tucson: University of Arizona Press, 1995.

Durkheim, Emile. *The Elementary Forms of Religious Life*. Translated by Karen E. Fields. New York: The Free Press, 1995.

Dyrness, William A. *Reformed Theology and Visual Culture: The Protestant Imagination from Calvin to Edwards*. Cambridge: Cambridge University Press, 2004.

Eire, Carlos M. N. *War against the Idols: The Reformation of Worship from Erasmus to Calvin*. Cambridge: Cambridge University Press, 1986.

Elkins, James. *On the Strange Place of Religion in Contemporary Art*. New York: Routledge, 2004.

Elkins, James, and David Morgan, eds. *Re-Enchantment*. New York: Routledge, 2009.

Ellis, Ralph J. *To the Flag: The Unlikely History of the Pledge of Allegiance*. Lawrence, KS: University Press of Kansas, 2005.

Essien-Udom, E. U. *Black Nationalism: A Search for an Identity in America*. Chicago: University of Chicago Press, 1962.

Evenden, Elizabeth, and Thomas S. Freeman. *Religion and the Book in Early Modern England: The Making of Foxe's "Book of Martyrs."* Cambridge: Cambridge University Press, 2011.

Ferrell, Lori Anne. "Transfiguring Theology: William Perkins and Calvinist Aesthetics." In *John Foxe and his World,* edited by Christopher Highley and John N. King, 160–79. Aldershot: Ashgate, 2002.

Fessenden, Tracy. "The Nineteenth-Century Bible Wars and the Separation of Church and State," *Church History* 74, no. 4 (December 2005): 784–811.

Finaldi, Gabriele. *The Image of Christ.* London: National Gallery, distributed by Yale University Press, 2000.

Finney, Paul Corby, ed., *Seeing Beyond the Word: Visual Arts and the Calvinist Tradition.* Grand Rapids: Eerdmans, 1999.

Foucart, Bruno. *Le renouveau de la peinture religieuse en France, 1800–1860.* Paris: Arthena, 1987.

Foucault, Michel. *Discipline and Punish: The Birth of the Prison.* Translated by Alan Sheridan. New York: Vintage Books, 1995.

————. *Religion and Culture.* Edited by Jeremy R. Carrette. New York: Routledge, 1999.

Foxe, John. *Acts and Monuments.* Edited by Reverend George Townsend and Reverend Stephen Reed Cattley. London: Seeley and Burnside, 1838.

Freedberg, David. *The Power of Images: Studies in the History and Theory of Response.* Chicago: University of Chicago Press, 1989.

Friedman, Milton. *Capitalism and Freedom.* Chicago: University of Chicago Press, 1962.

Fuller, Andrew. *A Sermon on the Importance of a Deep and Intimate Knowledge of Divine Truth.* Elizabethtown, NJ: Shepard Kollock, [1796].

Garnett, Jane, and Gervase Rosser. *Spectacular Miracles: Transforming Images in Italy from the Renaissance to the Present.* London: Reaktion, 2013.

Garside, Charles. *Zwingli and the Arts.* New Haven: Yale University Press, 1966.

Geary, Patrick J. *Furta Sacra: Thefts of Relics in the Central Middle Ages.* Princeton: Princeton University Press, 1978.

————. "Sacred Commodities: The Circulation of Medieval Relics." In *The Social Life of Things: Commodities in Cultural Perspective,* edited by Arjun Appadurai, 169–91. Cambridge: Cambridge University Press, 1986.

————. *The Myth of Nations: The Medieval Origins of Europe.* Princeton: Princeton University Press, 2002.

Gilmont, Jean-François, ed., *The Reformation and the Book.* Translated and edited by Karin Maag. Aldershot: Ashgate, 1998.

Giurescu Heller, Ena, ed. *Reluctant Partners: Art and Religion in Dialogue.* New York: Gallery at the American Bible Society, 2004.

Gjerde, Jon. *Catholicism and the Shaping of Nineteenth-Century America.* Edited by S. Deborah King. New York: Cambridge University Press, 2012.

Goethe, Johann Wolfgang von. *The Sorrows of Young Werther and Selected Writings.* Translated by Catherine Hutter. New York: Signet, 1962.

Goggin, Maureen Daly. "Visual Rhetoric in Pens of Steel and Inks of Silk: Challenging the Great Visual/Verbal Divide." In *Defining Visual Rhetorics,* edited by Charles A. Hill and Marguerite Helmers, 87–110. Mahwah, NJ: Lawrence Erlbaum Associates, 2004; reprint, New York: Routledge, 2009.

Goldstein, Robert Justin, ed. *Desecrating the American Flag: Key Documents of the Controversy from the Civil War to 1995.* Syracuse: Syracuse University Press, 1996.

Gossner, Johannes E. *Das Herz des Menschen: Ein Tempel Gottoes, oder die Werkstätte des Teufels.* Harrisburg, PA: Theo. F. Scheffer, 1870.

Greenfeld, Liah. *Nationalism: Five Roads to Modernity.* Cambridge, MA: Harvard University Press, 1992.

Grewe, Cordula. *Painting the Sacred in the Age of Romanticism.* Burlington: Ashgate, 2009.

———. *The Nazarenes: Romantic Avant-Garde and the Art of the Concept.* University Park, PA: Pennsylvania State University Press, 2015.

Griffith, R. Marie. *American Religions: A Documentary History.* New York: Oxford University Press, 2008.

Guenter, Scot M. *The American Flag, 1777–1924: Cultural Shifts from Creation to Codification.* Cranbury, NJ: Associated University Presses, 1990.

Hall, David D. *Worlds of Wonder, Days of Judgment: Popular Religious Belief in Early New England.* Cambridge, MA: Harvard University Press, 1989.

———., ed., *Puritans in the New World: A Critical Anthology.* Princeton: Princeton University Press, 2004.

Hall, Marcia B., and Tracy E. Cooper, eds. *The Sensuous in the Counter-Reformation Church.* Cambridge: Cambridge University Press, 2013.

Hamling, Tara. *Decorating the "Godly" Household: Religious Art in Post-Reformation Britain.* New Haven: Yale University Press, 2010.

Hampton, Kate P. "The Face of Christ in Art: Is Portraiture of Jesus Strong or Weak?" *The Outlook* 61, no. 13 (April 1, 1899): 735–48.

Hastings, Adrian. *The Construction of Nationhood: Ethnicity, Religion and Nationalism.* Cambridge: Cambridge University Press, 1997.

Heartney, Eleanor. *Postmodern Heretics: Catholic Imagination in Contemporary Art.* New York: Midmarch Arts Press, 2004.

Hegel, G. W. F. *Aesthetics: Lectures on Fine Art.* 2 vols. Translated by T. M. Knox. Oxford: Clarendon Press, 1975.

Heller, Reinhold. *Munch: His Life and Work.* Chicago: University of Chicago Press, 1984.

Hempton, David. "Enlightenment and Faith." In *The Eighteenth Century, 1688–1815*, edited by Paul Langford, 71–100. Short Oxford History of the British Isles. Oxford: Oxford University Press, 2002.

Herbst, Winfrid. *Indulgences.* Milwaukee: Bruce Publishing Company, 1955.

———. *New Regulations on Indulgences.* Rockford, IL: TAN Books, 1970.

Hinz, Sigrid, ed. *Caspar David Friedrich in Briefen und Bekenntnissen.* Berlin: Henschelverlag, 1968.

Hobbes, Thomas. *Elements of Law Natural and Public.* Edited by Ferdinand Tönnies. London: Simpkin, Marshall, 1889.

———. *Leviathan.* Edited by Edwin Curley. Indianapolis: Hackett, 1994.

Hobsbawm, Eric. *Nations and Nationalism since 1780.* Cambridge: Cambridge University Press, 1990.

Holt, Mack P. *The French Wars of Religion, 1562–1629.* 2nd ed. Cambridge: Cambridge University Press, 2005.

Hoppenbrouwers, Peter. "The Dynamics of National Identity in the Later Middle Ages." In *Networks, Regions and Nations: Shaping Identities in the Low Countries, 1300–1650*, edited by Robert Stein and Judith Pollmann, 19–41. Leiden: Brill, 2010.

Hubert, Henri, and Marcel Mauss. *Sacrifice: Its Nature and Functions.* Translated by W. D. Halls. Chicago: University of Chicago Press, 1964.

Hucks, Tracey E. *Yoruba Traditions and African American Religious Nationalism.* Albuquerque: University of New Mexico Press, 2012.

Hume, David. *Essays Moral, Political, and Literary.* Rev. ed., edited by Eugene F. Miller. Indianapolis: Liberty Classics, 1987.

———. *The Natural History of Religion.* In *Principal Writings on Religion,* edited by J. C. A. Gaskin. Oxford: Oxford University Press, 1993.

Janz, Denis R., ed. *A Reformation Reader.* Minneapolis: Fortress Press, 1999.

Jennings, Willie. *The Christian Imagination: Theology and the Origins of Race.* New Haven: Yale University Press, 2010.

Jensen, Robin Margaret. *Understanding Early Christian Art.* London: Routledge, 2000.

———. *Face to Face: Portraits of the Divine in Early Christianity.* Minneapolis: Augsburg Fortress Press, 2005.

John of Damascus. *Three Treatises on the Divine Images.* Translated by Andrew Louth. Crestwood, NY: St. Vladimir's Seminary Press, 2003.

Johnston, Anna. *Missionary Writing and Empire, 1800–1860.* Cambridge: Cambridge University Press, 2003.

Jonas, Raymond. *France and the Cult of the Sacred Heart: An Epic Tale for Modern Times.* Berkeley: University of California Press, 2000.

Kane, Paul M. "Marian Devotion Since 1940: Continuity or Casualty?" In *Habits of Devotion: Catholic Religious Practice in Twentieth-Century America,* edited by James M. O'Toole, 89–129. Ithaca: Cornell University Press, 2004.

Kant, Immanuel. *Critique of Judgment.* Translated by J. H. Bernard. New York: Hafner, 1951.

Kantorowicz, Ernest. *The King's Two Bodies: A Study in Medieval Political Theology.* Princeton: Princeton University Press, 1957.

Karlstadt, Andreas Bodenstein. *See* Carlstadt, Andreas Bodenstein.

Kelly, Gary. "Romantic Evangelicalism: Religion, Social Conflict, and Literary Form in Legh Richmond's *Annals of the Poor.*" *English Studies in Canada* 16, no. 2 (June 1990): 165–86.

King, John N. *Foxe's Book of Martyrs and Early Modern Print Culture.* Cambridge: Cambridge University Press, 2006.

King, John Shaw. *Food for the Flames: Idols and Missionaries in Central Polynesia.* San Francisco: Beak Press, 2011.

King, Richard. *Orientalism and Religion: Postcolonial Theory, India, and "The Mystic East."* London: Routledge, 1999.

Kittler, Friedrich. *Optical Media: Berlin Lectures 1999.* Translated by Anthony Enns. Cambridge: Polity Press, 2010.

Klassen, Pamela E. "Textual Healing: Mainstream Protestants and the Therapeutic Text, 1900–1925." *Church History* 75, no. 4 (December 2006): 809–48.

Knipping, John B. *Iconography of the Counterreformation in the Netherlands: Heaven on Earth.* 2 vols. Nieuwkoop: B. de Graaf, and Leiden: A.W. Sijthoff, 1974.

Koerner, Joseph Leo. *The Reformation of the Image.* Chicago: University of Chicago Press, 2008.

———. *Caspar David Friedrich and the Subject of Landscape.* 2nd ed. London: Reaktion Books, 2009.

Kurtz, Charles M. *Christ before Pilate: The Painting by Munkascy* [sic]. New York: published for the exhibition, 1887.

Landsberger, Franz. *Rembrandt: The Jews and the Bible*. Translated by Felix N. Gerson. Philadelphia: The Jewish Publication Society of America, 1946.

Latour, Bruno. *We Have Never Been Modern*. Translated by Catherine Porter. Cambridge, MA: Harvard University Press, 1993.

Lea, Henry Charles. *A History of Auricular Confession and Indulgences in the Latin Church*. 3 vols. Philadelphia: Lea Brothers, 1896.

Loevgren, Sven. *The Genesis of Modernism: Seurat, Gauguin, van Gogh, and French Symbolism in the 1880s*. Rev. ed. Bloomington: Indiana University Press, 1971.

Lindsay, Kenneth C., and Peter Vergo, eds. *Kandinsky: Complete Writings on Art*. New York: Da Capo Press, 1994.

Loyola, Ignatius. *The Spiritual Exercises of St. Ignatius Loyola*. Translated by Father Elder Mullan. New York: P. J. Kenedy and Sons, 1914.

Luborsky, Ruth Samson. "The Illustrations: Their Pattern and Plan." In *John Foxe: An Historical Perspective*, edited by David Loades, 67–84. Aldershot: Ashgate, 1999.

Lull, Timothy F., ed. *Martin Luther's Basic Theological Writings*. Minneapolis: Fortress Press, 1989.

Luther, Martin. *Works of Martin Luther*. Philadelphia: Muhlenberg Press, 1943.

———. *Three Treatises*. Philadelphia: Muhlenberg Press, 1947.

———. *Luther's Works*. Edited by Jaroslav Pelikan, Hilton C. Ostwalt, and Helmut T. Lehmann. 55 vols. St. Louis: Concordia Publishing House, 1955–86.

———. *Ausgewählte Werke*. 3rd ed, edited by Georg Merz. Munich: Chr. Raiser Verlag, 1957.

MacCullough, Diarmaid. *The Boy King: Edward VI and the Protestant Reformation*. New York: Palgrave, 1999.

Malingue, Maurice, ed. *Paul Gauguin: Letters to his Wife and Friends*. Translated by Henry J. Stenning. Cleveland and New York: The World Publishing Company, 1949.

Mangrum, Bryan D., and Guiseppe Scavizzi, trans. and eds. *A Reformation Debate: Karlstadt, Emser, and Eck on Sacred Images: Three Treatises in Translation*. Toronto: Centre for Reformation and Renaissance Studies, 1998.

Manning, John, and Marc van Vaeck, eds. *The Jesuits and the Emblem Tradition: Selected Papers of the Leuven International Emblem Conference 18–23 August 1996*. Imago Figurata Studies, 1a. Turnhout: Brepols, 1999.

Marable, Manning, and Leith Mullings, eds. *Let Nobody Turn Us Around: Voices of Resistance, Reform, and Renewal: An African American Anthology*. Oxford: Rowan and Littlefield, 2000.

Massa, Mark, with Catherine Osborne, eds. *American Catholic History: A Documentary Reader*. New York: New York University Press, 2004.

Matthews, Thomas F. *The Clash of the Gods: A Reinterpretation of Early Christian Art*. Rev. and ex. ed. Princeton: Princeton University Press, 1999.

Mauss, Marcel. *The Gift: The Form and Reason for Exchange in Archaic Societies*. Translated by W. D. Halls. New York: W.W. Norton, 1990.

McCoy, Richard C. *Alterations of State: Sacred Kingship in the English Reformation*. New York: Columbia University Press, 2002.

McDannell, Colleen. *The Christian Home in Victorian America*. Bloomington: Indiana University Press, 1986.

————. *Material Christianity: Religion and Popular Culture in America*. London: Yale University Press, 1995.

Melion, Walter S. "The Art of Vision in Jerome Nadal's Adnotationes et Meditationes in Evangelia." Nadal, *Annotations and Meditations,* vol. 1, 1–96.

Mentzer, Raymond A. and Andrew Spicer, eds. *Society and Culture in the Huguenot World 1559–1685.* Cambridge: Cambridge University Press, 2002

Meyer, Birgit. "Impossible Representations: Pentecostalism, Vision, and Video Technology in Ghana." In *Religion, Media, and the Public Sphere,* edited by Birgit Meyer and Annelies Moors. Bloomington: Indiana University Press, 2006, 290–312.

Michaelson, Robert. "Common School, Common Religion? A Case Study in Church-State Relations, Cincinnati 1869–1870." *Church History* 38, no. 2 (June 1969): 201–17.

Michalski, Sergiusz. *Reformation and the Visual Arts: The Protestant Image Question in Western and Eastern Europe.* New York: Routledge, 1993.

Milton, John. *Paradise Lost.* Edited by Scott Elledge. Norton Critical Edition, 2$^{nd}$ ed. New York: W.W. Norton, 1993.

Mitchell, Jon P. "Performing Statues." In *Religion and Material Culture: The Matter of Belief,* edited by David Morgan, 262–76. London: Routledge, 2010.

Moffitt, John F. *Our Lady of Guadalupe: The Painting, the Legend, and the Reality.* Jefferson, NC: McFarland, 2006.

Moore, R. Laurence. *Selling God: American Religion in the Marketplace of Culture.* New York: Oxford University Press, 1994.

————. "Bible Reading and Nonsectarian Schooling: The Failure of Religious Instruction in Nineteenth-Century Public Education." *Journal of American History* 86, no. 4 (March 2000): 1,581–599.

More, Hannah. *The Works of Hannah More.* 7 vols. New York: Harper and Brothers, 1855.

Morgan, David. *Protestants and Pictures: Religion, Visual Culture, and the Age of American Mass Production.* New York: Oxford University Press, 1999.

————. *The Sacred Gaze: Visual Culture in Theory and Practice.* Berkeley: University of California Press, 2005.

————. *The Lure of Images: A History of Religion and Visual Media in America.* London: Routledge, 2007.

————. *The Embodied Eye: Religious Visual Culture and the Social Life of Feeling.* Berkeley: University of California Press, 2012.

————. "The Image of the Protestant Bible in America." In *The Bible in the Public Square,* edited by Carol Meyers, Mark Chancey, and Eric Meyers, 93–120. Biblical Scholarship in North America. Atlanta: Society of Biblical Literature, 2014.

Murphy, Andrew R. *Prodigal Nation: Moral Decline and Divine Punishment from New England to 9/11.* New York: Oxford University Press, 2009.

Myers, Fred, ed. *The Empire of Things: Regimes of Value and Material Culture.* Santa Fe: School of American Research Press; Oxford: James Currey, 2001.

Nadal, Jerome. *Annotations and Meditations on the Gospels.* 3 vols., translated by Frederick A. Homann, S.J. Philadelphia: Saint Josephs University Press, 2003–2007.

Nadal, Jerome, ed. *The Illustrated Spiritual Exercises.* Scranton, PA: University of Scranton Press, 2001.

Nockles, Peter. "The Changing Legacy and Reception of John Foxe's 'Book of Martyrs' in the 'Long Eighteenth Century': Varieties of Anglican, Protestant, and Catholic Response, c. 1760–c. 1850." In *Religion, Politics and Dissent, 1660–1832: Essays in Honour of James E. Bradley*, edited by Robert Cornwall and William Gibson, 219–47. Burlington, VT: Ashgate, 2010.

Newman, Barnett. *Selected Writings and Interviews.* Edited by John P. O'Neill. New York: Alfred A. Knopf, 1990.

O'Leary, Cecilia Elizabeth. *To Die For: The Paradox of American Patriotism.* Princeton: Princeton University Press, 1999.

Orsi, Robert A. *The Madonna of 115th Street: Faith and Community in Italian Harlem, 1880–1950.* New Haven: Yale University Press, 1985.

Ozment, Steven. *The Serpent and the Lamb: Cranach, Luther, and the Making of the Reformation.* New Haven: Yale University Press, 2011.

Paine, Crispin. *Religious Objects in Museums: Private Lives and Public Duties.* London: Bloomsbury, 2013.

Pattison, Stephen. *Saving Face: Enfacement, Shame, Theology.* Burlington, VT: Ashgate, 2013.

Pettegree, Andrew. "Illustrating the Book: A Protestant Dilemma." In *John Foxe and his World*, edited by Christopher Highley and John N. King, 133–44. Aldershot: Ashgate, 2002.

Phillips, Samuel. *The Christian Home, As it is in the Sphere of Nature and the Church.* Social Circle, GA: E. Nebhut, 1861.

Plate, S. Brent. *Blasphemy: Art That Offends.* London: Black Dog, 2006.

*Proceedings of the First Twenty Years of the Religious Tract Society.* London: Printed for the Society by Benjamin Bensley, 1820.

Promey, Sally M. *Painting Religion in Public: John Singer Sargent's* Triumph of Religion *at the Boston Public Library.* Princeton: Princeton University Press, 1999.

Read, William George. *Oration Delivered at the First Commemoration of the Landing of the Pilgrims of Maryland.* Baltimore: John Murphy, 1842.

Reinitzer, Heimo. *Gesetz and Evangelium: Über ein reformatorisches Bildthema, seine Tradition, Funktion und Wirkungsgeschichte.* 2 vols. Hamburg: Christians Verlag, 2006.

Richardson, Matthew O. "Bertel Thorvalden's *Christus:* A Latter-Day Saint Icon of Christian Evidence." In *Art and Spirituality: The Visual Culture of Christian Faith*, edited by Herman du Toit and Doris R. Dant, 189–201. Provo: BYU Studies, 2008.

Richmond, Legh. *The Young Cottager; A True Story.* No. 151. London: Religious Tract Society, 1819.

Ringbom, Sixten. *Icon to Narrative: The Rise of the Dramatic Close-Up in Fifteenth-Century Devotional Painting.* Doornspijk, Netherlands: Davaco, 1984.

Robbins, Jill. "Sacrifice." In *Critical Terms for Religious Studies*, edited by Mark C. Taylor, 285–97. Chicago: University of Chicago Press, 1998.

Roberts, Kyle B. "Locating Popular Religion in the Evangelical Tract: The Roots and Routes of *The Dairyman's Daughter.*" *Early American Studies* 4 (Spring 2006): 233–70.

Russell, J. Stephen. *The English Dream Vision: Anatomy of a Form.* Columbus: Ohio State University Press, 1988.

Schiller, Friedrich. *Letters on the Aesthetic Education of Man.* In *Essays*, edited by Walter Hinderer and Daniel O. Dahlstrom. New York: Continuum, 1993.

Scholz, Bernhard F. "Religious Meditations on the Heart: Three Seventeenth Century Variants," in *The Arts and the Cultural Heritage of Martin Luther,* edited by Eyolf Østrem, Jens Fleischer and Nils Holger Petersen, 99–135. Copenhagen: Museum Tusculanum Press, University of Copenhagen, 2003.

Schopenhauer, Arthur. *The World as Will and Representation.* 2 vols. Translated by E. F. J. Payne. Indian Hills, CO: The Falcon's Wing Press, 1958.

Schwain, Kristin. *Signs of Grace: Religion and American Art in the Gilded Age.* Ithaca: Cornell University Press, 2008.

Schweitzer, Albert. *The Quest of the Historical Jesus: A Critical Study of Its Progress from Reimarus to Wrede.* 2nd ed. Translated by W. Montgomery. London: Adam and Charles Black, 1910.

Scribner, R. W. *For the Sake of Simple Folk: Popular Propaganda for the German Reformation.* Cambridge: Cambridge University Press, 1981.

Sécousse, D.-F., ed. *Memoires de Condé.* 6 vols. London: Claude de Bosc et Guillaume Darrés, 1743.

Shaffern, Robert W. *The Penitents' Treasury: Indulgences in Latin Christendom, 1175–1375.* Scranton and London: University of Scranton Press, 2007.

Shapiro, David, and Cecile Shapiro, eds. *Abstract Expressionism: A Critical Record.* New York: Cambridge University Press, 1990.

Shaw, Richard. *Dagger John: The Unquiet Life and Times of Archbishop John Hughes of New York.* New York: Paulist Press, 1977.

Silverman, Debora. *Van Gogh and Gauguin: The Search for Sacred Art.* New York: Farrar Straus and Giroux, 2000.

Sivasundaram, Sujit. *Nature and the Godly Empire: Science and Evangelical Mission in the Pacific, 1795–1850.* Cambridge: Cambridge University Press, 2005.

Slive, Seymour. *Dutch Painting 1600–1800.* New Haven: Yale University Press, 1995.

Smith, Anthony D. *The Nation in History: Historiographical Debates about Ethnicity and Nationalism.* Hanover, NH: University Press of New England, 2000.

Smith, Jeffrey Chipps. *Sensuous Worship: Jesuits and the Art of the Early Catholic Reformation in Germany.* Princeton: Princeton University Press, 2002.

*The Sources of Catholic Dogma,* trans. Roy J. Deferrari. From the 30th ed. of Henry Denzinger, *Enchiridion Symbolorum.* Fitzwilliam, NH: Loreto Publications, 2002.

Spraggon, Julie. *Puritan Iconoclasm during the English Civil War.* Woodbridge, Suffolk: Boydell Press, 2003.

Staudenraus, P. J. *The African Colonization Movement 1816–1865.* New York: Columbia University Press, 1961.

Steiner, Wendy. *Venus in Exile: The Rejection of Beauty in Twentieth-Century Art.* Chicago: University of Chicago Press, 2001.

St. John, Ambrose. *The Raccolta: Or, Collection of Indulgenced Prayers and Good Works.* London: Burns and Oates; New York: Benziger Brothers, 1910.

Stout, Harry S. *The Divine Dramatist: George Whitefield and the Rise of Modern Evangelicalism.* Grand Rapids: Eerdmans, 1991.

Sucquet, Antoni. *Via vitae aeternae.* Antwerp: Martin Nuty, 1620.

———. *Via Vitae Aeternae.* Illustrated by Boetius A. Bolswert, translated by Reverend Isaac Williams. Oxford: John Henry Parker, 1845.

Sucquet, Antoine. *Le Chemin de la Vie Eternele.* Anvers: Henry Aertssens, 1623.

Swanson, R.N., ed. *Promissory Notes on the Treasury of Merits: Indulgences in Late Medieval Europe.* Leiden: Brill, 2006.

Tanner, Norman P. S.J., ed. *Decrees of the Ecumenical Councils.* 2 vols. London: Sheed and Ward; Washington, DC: Georgetown University Press, 1990.

Taylor, James Lance. *Black Nationalism in the United States: From Malcolm X to Barack Obama.* Boulder: Lynne Rienner Publishers, 2011.

Tissot, James. *The Life of Our Saviour Jesus Christ.* 2 vols. New York: Doubleday and McClure, 1898.

*Triglot Concordia: The Symbolical Books of the Evangelical Lutheran Church.* Minneapolis: Mott Press, 1955.

Tweed, Thomas A. *America's Church: The National Shrine and Catholic Presence in the Nation's Capital.* New York: Oxford University Press, 2011.

Ukah, Asonzeh. "Branding God: Advertising and the Pentecostal Industry in Nigeria." *LIWURAM: Journal of the Humanities* 13 (2006): 83–106.

———. "Roadside Pentecostalism: Religious Advertising in Nigeria and the Marketing of Charisma." *Critical Interventions: Journal of African Art History and Visual Culture* 2 (Spring 2008): 125–41.

Valeri, Mark. *Heavenly Merchandize: How Religion Shaped Commerce in Puritan America.* Princeton: Princeton University Press, 2010.

Van Os, Henk, with Eugène Honée, Hans Nieuwdorp, Bernhard Ridderbos. *The Art of Devotion in the Late Middle Ages in Europe, 1300–1500.* Translated by Michael Hoyle. Princeton: Princeton University Press, 1994.

Von Veh, Karen. "The Intersection of Christianity and Politics in South African Art: A Comparative Analysis of Selected Images since 1960, with an Emphasis on the Post-Apartheid Era." *De Arte,* no. 85 (2012): 5–25.

Walch, Timothy, ed. *Early American Catholicism, 1634–1820: Selected Historical Essays.* New York: Garland Publishing, 1988.

Wandel, Lee Palmer. *Voracious Idols and Violent Hands: Iconoclasm in Reformation Zurich, Strasbourg, and Basel.* Cambridge: Cambridge University Press, 1995.

Washton Long, Rose-Carol. *Kandinsky: The Development of an Abstract Style.* Oxford: Clarendon Press, 1980.

Watt, Tessa. *Cheap Print and Popular Piety, 1550–1640.* Cambridge: Cambridge University Press, 1991.

Weiner, Annette. *Inalienable Possessions: The Paradox of Keeping-While-Giving.* Berkeley: University of California Press, 1992.

Wilton, Andrew, and Tim Barringer. *American Sublime: Landscape Painting in the United States 1820–1880.* London: Tate Publishing, 2002.

Wingfield, Christopher. "The Moving Objects of the London Missionary Society." Ph.D dissertation, University of Birmingham, 2012.

Winkler, Mary G. "Calvin's Portrait: Representation, Image, or Icon." In *Seeing Beyond the Word: Visual Arts and the Calvinist Tradition,* edited by Paul Corby Finney, 243–51. Grand Rapids: Eerdmans, 1999.

Winner, Lauren F. *A Cheerful and Comfortable Faith: Anglican Religious Practice in the Elite Households of Eighteenth-Century Virginia.* New Haven: Yale University Press, 2010.

Winship, Michael P. *Godly Republicanism: Puritans, Pilgrims, and a City on a Hill.* Cambridge, MA: Harvard University Press, 2012.

Yates, Frances. *The Art of Memory.* Chicago: University of Chicago Press, 1966.

Yoder, Don. *The Pennsylvania German Broadside: A History and Guide.* University Park, PA: Pennsylvania State University Press, 2005.

Zafran, Eric, ed., with Robert Rosenblum and Lisa Small. *Fantasy and Faith: The Art of Gustave Doré.* New Haven: Yale University Press, 2007.

Zell, Michael. *Reframing Rembrandt: Jews and the Christian Image in Seventeenth-Century Amsterdam.* Berkeley: University of California Press, 2002.

Zwingli, Ulrich. *Eine Antwort, Valentin Compar gegeben,* 27. April 1525, in *Sämtliche Werke,* edited by Emil Egli and Georg Finsler. Vol. 4. Leipzig: Verlag von M. Heinsius Nachfolger, 1927.

———. *Commentary on True and False Religion.* Edited by Samuel Macauley Jackson and Clarence Nevin Heller. Durham, NC: The Labyrinth Press, 1981.

# INDEX

Abbott, Lyman, 190
Abgar, 174–75
Abraham, 72–73
abstraction in art, 214–19
*Acts and Monuments*. See *Book of Martyrs*
affinity, 179–80
Alacoque, Margaret Mary, 86–87, 149–51
Al'Arabi, Ibn, 223
Albion, 5, 135
Alcott, Louisa May, 95; *Little Women*, 95
Allen, Ethan, 120
American Civil War, 154
American Revolutionary War, 119, 154
American Sunday School Union, 96, 154
American Tract Society (ATS), 58–59, 96, 124, 154
Anderson, Alexander, 59; illustration, 60, 97
Anderson, Benedict, 148
anthropomorphism, 179
Antichrist, 115
apostolic age, 13, 16, 57, 75, 127–28
Aristotle, 3
art worlds, 198
artist as prophet, 214

aura, 124–26, 118. *See also* presence
Aurier, Albert, 211–13
authenticity, 21, 188, 189
authority, 13–14, 16–18, 147–48, 225; ecclesiastical, 18, 43, 57, 75; of the image, 20; papal, 36, 157, 162; Satanic, 102; scriptural, 108, 110, 113, 252n13
*Ave Regina Caelorum*, 21–22

Bacon, Francis, 2
Baillie, John, 200
Bartlett, William Henry, 154
Barton, Bruce, 194
Basil the Great, 106
Bataille, Georges, 73–74, 243–44n7
beauty, 199, 201–2, 217, 219
Beecher, Henry Ward, 190–91, 268n27
Becker, Howard, 198
belief, 50–60, 168, 232
Benjamin, Walter, 126
Bereneson, Bernard, 203–4, 221
Bertram, Master, 72–73; *Sacrifice of Isaac*, plate 4
Bible, 3, 10, 19, 21, 48, 98; agency of, 108; destruction of, 98–99, 249n79; Evangelical

modernity, 1–2, 5–7, 111, 148, 160, 197, 229, 231; in art, 198

Molanus, Johannes, 267n15

Mondrian, Piet, 220

Montfort, Louis Marie de, 244n13

Moore, Roy, 228

Moravianism, 121, 127–28, 204

More, Hannah, 124, 142–46, 149, 199; *The Shepherd of Salisbury Plain*, 143–44

Mormons. *See* Latter-day Saints

Moroni, 166

Moses, 20, 106, 108

Munkácsy, Mihaly, 190, 268n29

Nadal, Jerome, 37–39

*National Catholic Reporter*, 192–93

nationalism, 197, 205, 228, 261n35. *See also* Black nationalism

nationhood, 8, 136, 143, 146–67, 228, 261n35

Nazarenes (Brotherhood of Saint Luke), 205–6

Neave, Richard, 194–95

*New England Primer*, 58

Newman, Barnett, 216–19, 221, 224, 229–30; *Stations of the Cross*, 216

*Nine Dragons*, 64

obedience, 14, 16

Olukilede, Tola, 102–4

orality, 123–26

orientalism, 188

Origen, 20

Orthodox Christianity, 15, 19–20, 175, 177

Overbeck, Johann Friedrich, 206; *Christ in the House of Mary and Martha*, 206

Paine, Thomas, 120, 156

Panofsky, Erwin, 186

panopticon, 199

Parson, Del, 173, 184, 267n17

Passover, 219

Peace of Westphalia, 8, 46, 153

penance, 19, 22, 35, 49, 74–75, 150

Pentecostalism. *See* Protestantism

Périssin, Jean, 116; *Sermon in the Reformed Church*, plate 6

Perkins, William, 53

Pfisterer, Raphael, 162–63; *Mary Immaculate*, 163

Phillips, Samuel, 61

pilgrimage, 19, 22, 26–27, 36, 43, 49, 74–75, 218

Pilgrims, 154–55

*Pilgrim's Progress*. *See* Bunyan, John

Piranesi, Giovanni, 199–200

Plato, 3–4, 175, 211, 271n22

Pledge of Allegiance, 159–60, 228

Pliny the Elder, 177

Plotinus, 3–4

Pollock, Jackson, 216

Pomare, 132

pope, 13, 79–80, 83, 115, 148, 157, 161–63

popes: Clement VI, 75, *Unigenitus*, 75; Francis, 89; Gregory the Great, 51; Innocent III, 76, 79; John Paul II, 89; Paul III, 35–36; Paul VI, 85, 104; Pius IV, 26; Pius IX, 160–62, 231; Pius X, 87

*Popular Mechanics*, 194

Porteus, Beilby, 142

portraiture, 54–58, 168, 185–87, 229

preaching, 14, 27, 48–49, 96, 114–15, 116–19, 123, 125

Pre-Raphaelite Brotherhood, 208

presence, 27, 105, 107, 114, 124–26, 187

Priestly, Joseph, 118

print culture, 124–25, 227, 252n7; as Protestant sacred information, 124; as social agent, 111; and speech, 105, 124. *See also* Protestantism; tracts

procession, 27

propaganda, 33, 44, 49, 221, 240n21

proselytism, 51, 61–67

Protestantism, 5–6, 8, 13–14, 16, 28–29, 31–33, 227; Charismatic, 106; Dissenters, 117–18; and images, 42–67; Methodist, 118, 119, 121; and motherhood, 61; and nationhood, 154–56; Nativism, 157; Pentecostalism, 102–4, 250n90, 250n101, 252n7; and print, 105–34; Unitarian, 188, 158

Providence, 91, 94–95, 98, 115, 123, 129, 133–34, 142, 151

public school controversy, 154, 158–59, 263n63

Publius Lentulus, 168–70, 187; *True Portrait of Our Lord Jesus Christ*, 170

purgatory, 84, 88

Puritans, 91–95, 151–56

*Raccolta*, 76, 78, 84, 87, 244n16

race, 64–66, 164–65, 181, 266n10

Ramdohr, Friedrich Basil von, 204–5
Raphael, 205–6, 208
Read, William George, 156–58, 162
Reagan, Ronald, 100
recognition, 49, 169–70, 183, 229
Reformation, 10, 13, 23, 32–33, 53; and icono-
    clasm, 42–48; and images, 238n5
relics, 22, 26, 28, 36, 40, 43, 114; and Apostolate
    for Holy Relics, 89–90; commodification of,
    89; as inalienable possession, 90
Religious Tract Society (RTS), 58, 122–23,
    126–27, 133
Rembrandt van Rijn, 185–87; *Head of Christ*,
    plate 9
Renan, Ernest, 189
revelation, 113, 117, 135, 140, 202, 210, 218
revivalism, 111, 121, 128, 152
Richmond, Legh, 58–59; *The Young Cottager*, 58,
    60
Ringeltaube, Wilhelm, 134
Robertson, Pat, 107, 111
Romanticism, 4, 197, 202–5, 271n27
Ronco, Alberto, 62–64, 140; "Paint the Heart,"
    141; *Royal Fortress of the Human Heart*, 62,
    140; "Sweep the Heart," 63
Runge, Philipp Otto, 202–3, 205

sacrament, 28, 30, 32, 48–49, 86, 114, 118, 200
sacred economy, 9, 71–104; apparitions, 85; and
    black market, 79; Catholic, 22, 26, 74–80,
    83–85, 88–91; and circulation, 78; and class,
    97–98; Counterreformation, 83–85;
    definition, 72, 74, 243n4; and gift, 50,
    80–83, 90, 97–98, 245n32; implications of,
    226–27; and inflation, 76, 100; lateral
    reciprocation, 95–98; medieval treasury,
    74–80; paying forward, 83, 96; prosperity
    gospel, 98–104; Protestant, 43, 49–50,
    80–83, 91–95, 95–98, 98–104; and
    Protestant media hierarchy, 112; Puritan,
    91–95, 247n63; reparations, 85–88, 150–51;
    and secular economy, 76, 89, 92–93, 104
Sacré-Coeur de Montmartre, 150
Sacred Heart of Jesus, 24, 84–87, 140, 149–51,
    182; indulgence card, 87; "Most Sacred
    Heart," 151; *Sacred Heart of Jesus*, 86
sacred information, 124
sacrifice, 72–74

Saint Peter's Basilica, 161–62
saints: Anthony, 40; Augustine, 3, 4, 29, 31, 34;
    Bonaventure, 24; Catherine of Siena, 177;
    cult of the saints, 20, 26, 28, 29–31, 74–75,
    106; Francis, 24, 170, 178, 183; Jerome, 41;
    John the Baptist, 29, 32–33, 37; Luke, 20,
    174–75; Mary, *see* Virgin Mary; Paul, 40,
    82–83, 170; Peter, 13, 16, 29, 170; Santa
    Muerte, 17; Stephen, 29, 55, 57. *See also*
    intercession
Sallman, Warner, 182–83, 185, 187, 191–92,
    267n13; *Head of Christ*, 144
sanctification, 92
*Salve Regina*, 21–22
Satan, 63, 64, 82, 91, 102, 129
Schiller, Friedrich, 199, 200, 221
Schopenhauer, Arthur, 203, 221, 271n22
Schweitzer, Albert, 229
Scribner, Robert W., 80, 115
Sebald Beham, Hans, 114; *Papal Throne Torn
    Down*, 115
Second Great Awakening, 96
separation of church and state, 6, 154, 161,
    166–67
*Seven-Headed Papal Beast*, 81
Shaffern, Robert, 75
Shaftesbury, Earl of. *See* Cooper, Anthony Ashley
Shepard, Thomas, 91–92, 137
Shroud of Turin, 174
Silverman, Debora, 212
Smith, Joseph, 165
social body, 6
Society for the Propagation of the Gospel, 64
Spectre, 5
speech, 107–8, 114–15, 121, 124
speech-acts, 50, 107, 115
*Spiritual Exercises*. *See* Ignatius of Loyola
spiritualization of art, 197, 202–13
Squibb, Jane, 58
Stackhouse, Thomas, 200
stigmatization, 177–78
Strauss, David Friedrich, 189
subjectivity, 5, 37, 64, 197, 199–201, 203, 215,
    232
sublime, 4–5, 199–201, 213, 217–18, 270n9,
    273n57
Sucquet, Antoine, 39–40; *Via Vitae Aeternae*, 40
Sunday Schools, 58–59, 119, 122